Latin among Lions

Other books by Diana Holman-Hunt

My Grandmothers and I
My Grandfather His Wives and Loves

Latin among Lions:
Alvaro Guevara

Diana Holman-Hunt

Michael Joseph
London

First published in Great Britain by Michael Joseph Ltd
52 Bedford Square, London WC1B 3EF
1974

ISBN 0 7181 1290 3

Set and printed in Great Britain by
Tonbridge Printers Ltd, Peach Hall Works, Tonbridge, Kent
in Garamond eleven on twelve point on paper supplied by
P. F. Bingham Ltd, and bound by James Burn
at Esher, Surrey

I dedicate this book with my gratitude and love to those who have contributed most generously.

Contents

Illustrations

Unless otherwise stated, illustrations are reproduced by kind permission of Mrs Meraud Guinness Guevara

Between pages 92 and 93

Alvaro and Susana at their sister's wedding in 1899, by kind permission of Mrs Susana Guevara Mueller

Alvaro, Sibila and Edmundo, by kind permission of Mrs Susana Guevara Mueller

Alvaro in 1912, aged 18, by kind permission of Mrs Susana Guevara Mueller

Michio Ito, the Japanese dancer, by kind permission of the International Museum of Photography at George Eastman House, Rochester, New York. Photographed by Alvin Langdon Coburn

Mrs Lewis of the Cavendish, portrait of Rosa Lewis (1915), by kind permission of Loel Guinness Esq.

The Editor of Wheels, portrait of Edith Sitwell (1916), by kind permission of the Trustees of the Tate Gallery and the National Portrait Gallery

At the Swimming-Bath (1917)

Café Scene (1917)

Portrait of Ronald Firbank (1919), by kind permission of Mrs Ivan Kyrle Fletcher and Faber and Faber, from *Ronald Firbank, A Memoir* by Ivan Kyrle Fletcher

Portrait of Nancy Cunard (1919), by kind permission of the National Gallery of Victoria, Melbourne, Australia

Self-Portrait (1921), by kind permission of Mrs Susana Guevara Mueller

Between pages 188 and 189

Christopher Wood, by kind permission of The Redfern Gallery
Alvaro in 1929

Author's Note

This is a venture in biography aimed at the general reader who may be interested in the personal life of an unusual artist. For those particularly interested in painting or certain aspects of the social scene in Europe and Chile during the first fifty years of this century, I have included as Appendix II a chronology of events closely related to Alvaro Guevara's life.

I have omitted such events of historical interest as the General Strike of 1926 which do not appear to have affected him personally, and, necessarily, others about which I have failed to find any evidence as to his reaction.

It is usual when attempting to interpret the personal life of a subject to be able to draw upon letters to and from intimate associates. In the case of Alvaro Guevara it was a daunting challenge to discover early on that his personal correspondence to which I could secure access consisted of only three, not very revealing, letters to his sister.

This lack of material obliged me to seek his reflection in the periphery of famous or notorious people by whom he seemed to have been surrounded; hence the title 'Latin among Lions'.

As Appendix III I have added some items extracted from an historical novel, *At the Foot of the Summit,* written in Spanish by his sister, Susana Guevara Mueller, for her children. Anyone trying to understand Alvaro Guevara, the painter or the man, may find these genealogical speculations of some assistance.

As examples of Alvaro Guevara's paintings have been included among the illustrations, I have tried to do justice to his literary talents as well by including extracts from his last written work, the *Dictionnaire Intuitif,* in Appendix IV.

In order to eliminate footnotes, when books are quoted their titles are given in the narrative and details are listed in a select bibliography. People or letters quoted in the text are confirmed and identified in my acknowledgements, as far as possible in the order that they or their contributions appear in the story.

My few editorial comments are given in Appendix I, p. 271.

11

The art magazines, catalogues, periodicals and newspapers that I have consulted are too numerous to list. Those which include particularly interesting reviews are noted under the relevant exhibition in the chronology.

Acknowledgements

First of all I would like to express my gratitude to Alvaro Guevara's sister, Mrs Susana Guevara Mueller, whose help has been both generous and invaluable. She has allowed me to use her manuscript describing her and Alvaro's youth in Chile, the many adventures and misadventures of the Guevara family and their first few years in Europe between 1910 and 1916. I have extracted the facts relevant to Alvaro Guevara and entirely reconstructed this material in narrative form interpolating various quotations from her diaries. Her intimate account, which she entitled *Alvaro and I*, was written in the first person without much attention to chronology. To their shared youthful experiences she added the impressions she received on the occasions that they met after 1916; these rare letters, together with press-cuttings lovingly collected, have proved most useful contributions. She has also shown immense patience in answering my persistent queries with innumerable letters from California which have solved many problems.

Mrs Meraud Guinness Guevara, Alvaro's widow, and their daughter Nini, Mme Martin Lacroix, have both proved willing and enlightening sources not only through a frequent exchange of letters over the past three years but by our many friendly discussions. Their vivid recollections have enabled me to describe the behaviour and emotions of some of the main characters involved with confidence.

Other relations to whom I am intensely grateful include his nephew, Senor Octavio Senoret and his great-nephew Senor Ricardo Guevara. Chilean family friends, most especially Senor Alvaro de la Fuente, have been extraordinarily kind; also his compatriots Senor Fernando Concha, Senor Mario Valenzuela and Senor Lucho Vargas, sometime Director of the Museum of Fine Arts in Santiago.

I should particularly like to thank Sir John Rothenstein for drawing my attention to the bound volumes of Christopher Wood's letters to his mother, hitherto unpublished, and also Mr Rex Nan Kivell, Christopher Wood's literary executor, for his co-operation and permission to publish extracts from them; the

British Library Board who have kindly agreed that I may quote an extract from a letter of Mr Duncan Grant's in their possession, also Romilly John, literary executor of Augustus John, for allowing me to publish extracts from his father's letters.

In the literary and academic world my grateful thanks are due to Mr Michael Holroyd for his advice on which books, periodicals and catalogues to study, and whom I should contact for further information; also to Mr Richard Shone for sharing with me his intimate knowledge of the Bloomsbury Group; Mr Martin Butlin and Mr Richard Morphet of the Tate Gallery; Miss Pauline Vogelpoel; Dr Roy Strong of the Victoria and Albert Museum; Mr Richard Ormond of the National Portrait Gallery; the President of the Royal Academy, Sir Thomas Monnington, and the Secretary, Mr Sidney Hutchison; and to Sir William Coldstream, Professor of the Slade School of Fine Art, University College, Mr Ian Tregarthen Jenkin, the Secretary, and Mr George Charlton, at one time an important member of the staff.

My heartfelt thanks go to Miss Bridget Lakin of the Society of Genealogy for her thorough and untiring research which resolved many varied problems; also to Mr Villiers Bergne for assisting me with his free translations of Spanish and of extracts from a style of French used by the Surrealists which is totally beyond me; on so many occasions his suggestions have been most constructive.

I am much indebted to the following people who have contributed helpful information: Mrs Theodosia Townshend, Mr Gilbert Spencer, Mr John Nash, Mr Duncan Grant, the Lady Diana Cooper, Lady Ashton, the Lord Esher, Mr Guy Worsdell, Mr David Garnett, Mr Raymond Mortimer, Mr David Rutherston, Mr Adrian Daintrey, Mrs C. R. W. Nevinson, Lady Epstein, Mr Luke Gertler, Professor Quentin Bell, Mrs Barbara Bagenal, Mr Richard Carline, Christabel Lady Aberconway, Mrs Pamela Diamand, Mr Claude Rogers, Mr Keith Baynes, Mr Rodney Burn, Mr Allan Gwynne-Jones, Mr Anthony Thwaite, Professor D. J. Gordon, Professor Arthur Mizener, Sir Sacheverell Sitwell bt., Mr John Lehmann, Mr Beverley Nichols, Mr Guy Deghy, Mr John Woodeson, the late Mr Fred Hoyland Mayor and Mrs Mayor, Mr James Mayor, Mr Peter Warren, the Rev. G. Irving, Mrs Mary Keene, Mrs Viva King, Miss

Lucy Norton, Mrs Igor Vinogradoff, Sir Rupert Hart-Davis, Mrs T. S. Eliot, Mrs Allanah Harper, Mrs Sybille Bedford, Miss Elizabeth Salter, Mr James Laver, Sir Harold Acton, Mr William Gaunt, Mr Wilson Plant, Mr H. S. Ede, Mr Michael Wishart, the Earl of Rosse, Sir Robert Abdy bt., Mr Anthony Powell, the late Hon. Nancy Mitford, Mrs Anthony Crossley, Mrs Curtis Moffat, Mr Ivan Moffat, Professor Hugh Ford, Mr Christopher Moorsom, the late Mr John Banting, the Hon. Mrs Xan Fielding, the late Mr David John, Admiral, Sir Caspar John, Mr Robin John, Mr Edwin John, Mr Romilly John, Mrs Poppet Pol, Mme Francis Picabia, Mme Germaine Everling Picabia, Mr Virgil Thompson, M. Jacques Renault, Mrs Marie-Jacqueline Lancaster, Mr Aram Mouradian, Mr S. W. Hayter, Mrs Polly Drysdale, Mrs William Einstein, Sir Cecil Beaton, Mr Edward Wolfe, Mr William Scott, Mr Curtis Harrington and Mr Edward M. Burns. 'Jeannot' prefers not to give his full name and one or two other sources would like to remain anonymous. For the sake of susceptibilities I have given the following characters fictitious names: Leila Potter, Maurice, Miss Clark, Raymon and Louisette.

I have much appreciated the assistance rendered by Mr Anthony d'Offay, Mr Mark Glazebrook of P. and D. Colnaghi and Co. Ltd., Mr Gerald Burdon of Sotheby and Co., the staff at the libraries of the British Museum, the Victoria and Albert Museum, the Kensington and Chelsea Public Library, also the co-operation of James Bourlet and Sons Ltd.

I gratefully acknowledge permission to use quotations from the following publishers and copyright owners: Jonathan Cape Ltd., *Carrington: Letters and Extracts from her Diaries,* edited by David Garnett, London, 1970. Chatto and Windus Ltd., *I Must Say,* Adrian Daintrey, London, 1963. Chilton Book Co. *Nancy Cunard: Brave Poet, Indomitable Rebel 1896–1965,* edited by Hugh Ford, Philadelphia, New York, London, 1968. Faber and Faber Ltd., *The Early Memoirs of Lady Ottoline Morrell,* edited with an introduction by Robert Gathorne-Hardy, London, 1963. William Heinemann Ltd., *Lytton Strachey: The Years of Achievement, 1910–1932,* Michael Holroyd, London, 1968. *I Married the World,* Elsa Maxwell, London, 1955. Hollis and Carter Ltd., *Light on a Dark Horse: An Autobiography 1901–1935,* Roy Campbell, London, 1931. Alfred A. Knopf, *The Flowers of Friendship: Letters Written to Gertrude Stein,* edited

by Donald Gallup, New York, 1953. Macmillan and Co. Ltd., *Noble Essences or Courteous Revelations,* Osbert Sitwell, London, 1930. Methuen and Co. Ltd., *Paint and Prejudice,* C. R. W. Nevinson, London, 1937. Redman Books Ltd., *The Passionate Years,* Caresse Crosby, London, 1955. Southern University Illinois Press, *These Were the Hours: Memories of my Hours Press,* Nancy Cunard, 1969.

Finally, I would like to thank the following people for their practical assistance: Mrs Elizabeth Burt, the Hon. Guy Strutt, Mr Peter Leslie for his many welcome suggestions and criticisms; Mr Andrew Best of Curtis Brown Ltd. for devoting so much time to helping with my final corrections; also Miss Diana Porter, my patient and devoted secretary who has shown so much interest in this work. And last, but by no means least, I am grateful to both Miss Sophia Ryde and Mrs Rosemary Bergne who have proved extremely helpful coming to my rescue in emergencies on fraught occasions.

PART ONE

A Chilean Childhood
1894-1909

I

In 1852, Alvaro's father Luis Guevara, an enterprising twelve year old, ventured out on horseback from his family's Chilean home at Rengo. After riding for many miles, he reached the hills above Valparaiso. The view of the harbour below was so impressive and beautiful that he determined to build a house there when he was grown-up and rich. [This was the same view which inspired Whistler to paint his famous picture of Valparaiso Harbour in 1866.]

He was not able to indulge this whim for over twenty years, until 1876, when he built a large one-storeyed house on the Cerro Alegre. He was then thirty-nine and a prosperous importer of English woollens.

In 1873, Papa had married a sixteen year old Danish girl called Ida Reimers who was both well-born and well-endowed. If anyone remarked on the twenty years' difference between their ages, he protested that it was: 'Most suitable – not at all improper.'

Indeed, she proved an admirable wife, physically and mentally robust. In twenty-three years she bore him twelve children. Alvaro was the tenth child, born in 1894. Closest to him were two sisters; Sibila who was two years older and Susana who was two years younger. The twelfth and youngest offspring, a boy, was always referred to as 'little Edmundo'.

Papa Guevara was an Anglophile, although he could speak no more than a few words of the language. Confidently, he would state: 'The British are the most competent and honourable nation in the world.' Frequently he quoted at length from translations

17

of Shakespeare and Lord Chesterfield's letters. He sent his children to the best English schools in Chile and, like all their aristocratic friends, the Guevaras employed an English 'Miss'. She changed into tight, dark taffeta dresses for dinner every night and was known by the servants as the *gringa*. She read to the children not only from the classics but also stories from *Chatterbox*, Rider Haggard and Jules Verne.

Alvaro enjoyed visiting his German maternal Grandmama, who lived nearby, and listening to her stories as she sat in the window knitting. Being a widow, she wore a little black lace cap.

Papa's dream house had twenty rooms. One side of the grounds was protected by a ravine and the other by high stone walls, around which clustered a primitive village, providing local labour. A narrow, steep cobbled street led to the property from the city. This was patrolled every night by a priest bearing a lighted candle: a guardian against trespassers who might creep up from the slums of Valparaiso in search of gold supposedly buried on the Cerro Alegre. Despite precautionary measures, including watchdogs, the children would stumble upon freshly dug holes in the garden almost every morning.

When Alvaro was seven, Papa decided to make various improvements to the house. Mama, having several nubile daughters, wisely agreed that while these were in progress, they should rent a furnished house in the port below, on the Calle Esmeralda. Alvaro was delighted with this temporary move; before dawn, he tiptoed through the drawing-room, pushed aside the lace curtains imported from Nottingham, opened the French windows and stepped on to the balcony. Leaning on the rococo iron balustrade, he waited for the first sign of life in the street below. The day started with silent women shrouded in long black hooded cloaks, gliding through the sea mist after early mass. When the sun broke through, the sombre, damp buildings and wet pavements shimmered with gold. Veiled laundresses followed, dressed in brown. He could see their bronzed figures, balancing bundles of washing on their heads, respectfully greeting the robed and hatted priests who emerged from their churches.

All at once, street cries announced the approach of fishermen and market-gardeners with flat, round baskets of seaweed and iridescent fish, glowing fruit and vegetables, passing to and fro beneath the balcony.

18

By now the whole city stirred with life. There was a crescendo of noise; trams screeched on their rails, horses' hooves clacked on the cobbles. Nearer, there was a click of spurs; a farmer from the hills, wearing a gay poncho and black sombrero, dismounted and led his horse, laden with paniers of squawking chickens, to the back door and shouted for the cook. The baker arrived on horseback with his cowhide boxes full of loaves. That was the moment for Alvaro to close the window quietly: he scampered back to bed in time to be woken by the nurse.

A natural voyeur, by eleven o'clock he was back on the balcony. This was the hour of the apéritif and flirtation. The ladies, each dressed in the latest creation from Paris, carried parasols. The gentlemen wore straw boaters with their Savile Row suits, and sported doeskin gloves and gold knobbed canes. Officers, gaudy in naval and military uniforms, mingled with the tall thin British in their solar topees and crumpled linen. Alvaro, with a sidelong glance at his governess, nudged his giggling sisters and whispered: 'Just look at the scrawny *gringos*!'

The most picturesque were the immigrants from Italy, Germany and Spain, all in their national dress. Ragged beggars, pressed against the walls by the crowd, stretched out bony hands. Pedlars pleaded, offering feather dusters, toys, brushes, rush-seated chairs, even puppies.

By noon the Calle Esmeralda was jammed with carriages and carts. Passengers clung, like swarms of bees, to the steps of over-crowded trams. The shouting conductresses wore wide-brimmed, black straw hats and white lace-trimmed aprons over their black dresses.

At midday the cannons at the Naval Academy boomed the hour. This was the signal for shops to close their shutters until three o'clock. The crowd vanished but still Alvaro lingered, watching, as the wind rose and whirled dust and wastepaper in the empty street. Minutes later, sweepers appeared, leading donkeys bearing baskets and brooms. Only when all the rubbish had been cleared was Alvaro persuaded to get ready for luncheon. He had occupied a front seat at the theatre since dawn.

One day, he was woken by the hooting of ships' sirens from the bay. The circus had arrived. Mama promised to take tickets. The tent was vast; the Guevara family sat in a box. Alvaro was enchanted by the lovely ballerina who danced on the back of a

19

large white horse. Beautiful ladies in pink tights flew about and perched on wires like butterflies, or hung from trapezes like drooping flowers.

If only Alvaro could fly he would catch one in his butterfly net. He rarely laughed aloud but his face beamed. He had never enjoyed himself so much or experienced such visual delight. He clapped his hands and jumped up and down, telling Susana that he was sure he could fly. Sure enough, as soon as they got home, he arranged a mountain of chairs to help him climb on to a high windowsill in the nursery, excitedly shouting: 'Come everyone! Come and see *me* fly! One day I shall catch a fairy!'

The household was busy; only Susana and little Edmundo sat down to watch. There was a piercing scream and a terrifying clatter as Alvaro crashed on to the chairs. All the family and servants rushed in. He was not seriously hurt; his tears were of disappointment and frustration.

Alvaro was seven when tragic news arrived from England – the death of Horacio, the Guevaras' second son, aged twenty-two.

The verdict was suicide. The children were told that he had 'committed suicide because he had become fanatically Catholic and could not unravel the Holy Trinity'. In fact, he had jumped out of his window in Queen's Gate, South Kensington, using his umbrella as a parachute. He had already stabbed himself with a knife twenty-six times. He left a letter addressed to King Edward, warning of a plot to assassinate him during the Coronation procession. Although Horacio was apparently sane when he left Chile, the fact that he went mad in London did nothing to prejudice Papa: he remained a staunch Anglophile and sent his next eldest son Lucho to study the wool trade in England.

Soon after this sad event, one of the elder Guevara girls, Elisa, became engaged to Wilfred Page, an eligible young man. Neither Alvaro nor Susana quite understood what this meant, while they stood in front of the mirror being measured for the clothes they would wear at the wedding. They were told that the ceremony would take place in church. Alvaro thought that he must be rehearsing for an important part in some solemn play; this strongly appealed to him, especially when Mama said that he would bear the bride's train. He had no idea what this signified, but his new black velveteen suit trimmed with white braid and pearl buttons delighted him. When the time came for the final

fittings, the nurse and the nursery maid, chattering with excitement, summoned the other servants. Hearing the commotion, the family joined them. Poor Susana in her pink tulle dress was jostled aside. Everyone was exclaiming: 'Look at Alvaro! Look at the handsome bridegroom!' A child actor in his first performance, he paraded with his hand on his hip.

On the day of the wedding, he and Susana drove in the same Victoria accompanied by their nurses. Alvaro whispered: 'I am the bridegroom. I am Elisa's bridegroom.' He was mystified and a little frightened at having been chosen to play this privileged rôle and hoped that the whole family would be proud of him.

After the bright sunlight in the streets, the interior of the church seemed like a dark, dank grotto, resonant with music. The scent of flowers and incense was overpowering. As they approached the altar, the stained glass glowed purple and blue and Elisa's jewels danced in the candlelight. Whereas the visit to the circus had proved exciting and bewitching, this ceremony was awe-inspiring and mysterious.

The reception that followed was also bewildering. The bride stood under a chandelier sparkling like the wedding cake. Hundreds of guests filed by, embracing her. The noise was deafening: loud congratulations and laughter mingled with the clinking of glasses, popping of corks and the rustle of silk dresses. Alvaro sat in a corner, ignored, inexplicably rejected. He covered his face with his hands. His body shook with sobs as he pointed to the stranger in a tail-coat who stood beside *his* Elisa, his bride. He clung to his nurse moaning: 'He took her away! Why did he take her from me?'

When the family returned to their country house on the Cerro Alegre, Susana was eight. She had met her cousin Erich at a house-warming party at her German uncle's palatial residence, recently built nearby, and had already fallen in love with him.

There was much competition between rich Chilean settlers to provide material evidence of their prosperity. Perhaps this was why Herr Dietrich had dared to commission a three-storey building in a country often shaken by earthquakes.

Not to be outdone by their German cousins, the Guevaras had employed Italian craftsmen to decorate their reception rooms. Cream, violet and olive green mosaics with an elaborate central

medallion and Pompeian border covered the hall floor and stretched outside to the patio. A life-size statue of Joan of Arc stood at the foot of the stairs. Gold-leaf glowed everywhere. The drawing-room walls were decorated with purple and mauve arabesques in repetitive patterns, bordered by intricate friezes. The sofas were tightly buttoned in yellow satin, lavishly trimmed with silk bobbles, tassels and fringes. Louis XV commodes and occasional tables, Moorish style, were laden with aspidistras and huge vases.

Alvaro and Susana secretly missed the whitewashed walls and the banished local bamboo furniture with its whorls and scrolls of wickerwork. However, Papa was immensely proud; this sumptuous expression of his eminence was designed to remind everyone that 'the Guevaras were not descended from lackeys but from the aristocracy of Spain', indeed they had *royal* blood. Even Mama was of noble birth : her ancestors were the great Vikings of Denmark. Papa added, with a glance at Miss Hills as he strode round the fabulous hall, that Mama greatly resembled Queen Alexandra of England.

Mama reigned over a large household : besides nine children, there were twelve indoor servants. The outdoor servants, gardeners and grooms, were ruled by Papa.

As well as the children's donkeys, the family owned ten horses, including sorrels and palaminos. There were also many dogs – among them a St Bernard.

In the gardens, Alvaro and Susana found balustraded steps and an Italian pergola covered with exotic creepers and ornamental vines. Alvaro was even more delighted to find swings and trapezes, just like those at the circus, suspended between the giant rubber trees.

When they reached the end of the orange grove, he announced in a solemn voice : 'On the eve of St John we shall come here at midnight and kneel. If the fig tree flowers, our wishes will come true!' He paused. '*I* shall wish for oil paints.'

If the magic worked, Susana decided to accept an elephant. Alvaro took her hand and led her off to inspect the new tennis-courts. These were elaborately buttressed by high stone walls. According to the cook the tennis-courts became a hallowed place for mystical rites when the swallows returned to build their nests under the copings. One night the priest holding his candle had

been seen on the edge of the ravine. It was there that the gold must be buried. Although it would be unthinkable to admit this in Chile, the cook must have had Indian blood, and it was she who passed on such folklore to Alvaro. He found it fascinating.

Susana was terrified of heights but Alvaro, nimble as a cat, helped her along the narrow edge of the ravine. The chasm was yellow with giant fennel and poppies; the cook was right – someone had indeed dug a hole! They crammed their pockets with small chunks of glittering rock which they found. On their way back to the house they passed the quarantine rooms which had been rebuilt at great expense. Epidemics still raged in Chile. There was red glass in the windows, which filtered the glare and protected the eyes of smallpox victims. When they proudly produced their treasure, Papa disillusioned them at once. It was only 'fools' gold': iron pyrites.

The family enjoyed a happy routine of tennis tournaments, *thés dansants* and dinner parties. Musical evenings were attended by Alvaro's accomplished married sisters, who performed at the piano or sang arias from the operatic works of the great European composers. Some evenings, with the aid of his new magic-lantern, Papa would give instructive lectures on the architectural and artistic splendours of Europe.

Alvaro's elder sisters were all married to men of different nationalities. It was thought most advanced that they had been allowed to choose their husbands, although Mama had of course seen that their selection was limited to appropriate suitors. Alvaro was soon fairly fluent in English, German and French as well as Spanish.

Among visitors most welcome to Alvaro were Herr Schaub, the music master, and Dona Rosita, the dancing mistress. Herr Schaub's hair reached to his shoulders. He always wore gloves, although otherwise shabbily dressed. While counting out loud in time to the metronome, he ate cherries from a paper bag. If his pupils played a wrong note, he would spit the stones back into the bag and scream: *'Gott im Himmel!'*

But when Alvaro appeared, Herr Schaub would bow low and greet the boy with effusion: 'My child prodigy!' Mama, Papa, German Grandmama, leaning forward on her cane, and the younger children, would sit in the hall in silence, enjoying Alvaro's faultless playing.

23

Dona Rosita, although short and stout, was a most energetic lady. She taught the four youngest children the quadrille, mazurka, fandango, waltz, tango and even 'el Highland Fling'. Alvaro excelled at them all.

Herr Schaub and Dona Rosita had a rival in Senor Yanez, the drawing and painting master. Although Papa insisted that an artistic career was 'not a proper occupation for a gentleman ... Nowadays, most painters are Bohemian and immoral, and invariably die of tuberculosis or malnutrition,' he had agreed to set aside a studio for Alvaro where he spent hours alone painting. Most of the family agreed with Senor Yanez that he was a genius.

Within a year, Alvaro produced a remarkable life-size portrait of Mama which caused a sensation when exhibited in the window of a fashionable shop in the Calle Esmeralda; at that time there were no art galleries in Valparaiso. Papa bought a heavy gold frame. The picture attracted crowds of admirers and led to Alvaro's first commission from a family friend.

One day in 1906, Papa summoned Sibila, Susana and Alvaro to the library. They hoped this signified the announcement of some treat, such as a visit to the theatre. However, Papa solemnly proclaimed that all three children were to be prepared for confirmation. The Bishop had called and been profoundly shocked by their heathen names. As Roman Catholics, they should have been called after saints. He had left a list of suitable Christian names. In future therefore, Papa had decided, Sibila would be known as *Maria* and Susana as *Graciela*. Brushing aside their objections, he added: 'and you Alvaro, from now on will be ...' Before he could finish the sentence, Alvaro interrupted. 'I refuse to change my name or be confirmed.' He bowed and left the room. This unprecedented rebellion passed unpunished, thanks to Mama's intercession.

Alvaro was equally at loggerheads with secular education. He was aloof and individual. His knowledge of languages, his artistic and musical talents, his preoccupation with folklore and a somewhat theatrical manner, alienated the other boys at Mackay's, the British school patronized by the grand Chilean families. His sense of humour was unusual. Children are always suspicious of sarcasm; at school he found that the wit which earned him praise at home, made him disliked by his fellows. Friendship eluded

him although he had reached an age when he needed to communicate, even to be in physical touch with other adolescents.

One day at school, with no obvious provocation, he suffered a brutal attack from a notorious bully. Alvaro fought back with all his strength but was badly beaten. As he limped home, his mood became increasingly resentful. His mother and sisters were ignored; he must see his father. With one hand over his blackened eye, shaking with rage and shame, he stuttered an ultimatum; he, a Guevara, had been humiliated, forced to his knees in front of a mob of jeering boys. For once, father and son were united by Spanish and masculine pride.

According to accounts given by Alvaro to many people he met later in life, Papa secretly – for the family would have been amazed and disapproving – engaged the best boxing coach he could find to teach him to fight with craft and skill, as well as with his natural strength and courage.

When at last he returned to Mackay's, he was confident enough to challenge and defeat the bully, and his victory was sensational. Maybe the bodily contact of the fight was what he needed to compensate for the lack of masculine company. Most of the time he was surrounded by women.

From childhood onwards his personality craved an audience; he was obsessed with the theatre all his life and would take his place on one side of the footlights or the other. Perhaps actors and boxers are by nature lonely creatures who find in applause a substitute for the love from an individual which so often escapes them. Whatever the psychological explanation, after this encounter at Mackay's, boxing became irresistible to Alvaro: a tough fight gave him an undeniable thrill.

He and Susana would explore the hills above the Cerro Alegre to admire the magnificent views. Alvaro was an expert horseman. Susana would envy him as she followed on her donkey, plodding along, always behind, while he sat high and confident in a native saddle on his favourite sorrel.

They would dismount amidst vivid patches of wild flowers and he would entertain her with impersonations of imaginary creatures, giants, dwarfs, will-o'-the wisps and elves and elusive winged fairies – inspired by Miss Hills' readings from Shakespeare.

Sometimes the two children would secretly venture into the

25

slum below. The stench and smoke would reach them long before they arrived at the cluster of hovels. Seeing Susana holding her nose, Alvaro would point to the sky above the tin roofs. Coloured paper kites, their tails like brilliant butterflies, wafted in the breeze and soared towards the sky, their knotted strings held by swarms of ragged children.

Griselda the laundress, who lived in this wretched place, washed in a wooden tub. Her boiler was an old oil drum over a charcoal brazier, on which she also heated her flat-irons and goffering tongs. Each week the Guevaras' laundry was draped on the bushes round her shack to dry and bleach in the sun.

Every Monday, the fierce chambermaid would check and re-check the laundry in case some small item, a lace doyly or a handkerchief, should be missing. A typical week's washing would include damask tablecloths and linen, twelve servants' uniforms (which were changed twice a day), lace curtains, frilled coverlets, elaborately embroidered linen for fifteen beds, gentlemen's evening shirts with deep starched collars and cuffs, innumerable underclothes and delicate ladies' and children's blouses and dresses. As the household was predominantly female there were dozens of more intimate items. Griselda's sixteen children were employed most of the time guarding the bushes.

Every week, Griselda strode up the cobbled hill with the heaviest bundles on her head, followed by her family staggering on rickety legs with the biggest burdens they could carry. One week she did not come and so, on the Eve of St John, the cook encouraged Alvaro and Susana to go down to the slum to discover why the laundry was a whole week late. Griselda explained that she had just had another baby – her seventeenth! It was very ill indeed, being under a curse from neighbours envious of her privileged position as the Guevaras' laundress. The witch-doctor squatted outside her hovel mumbling spells and burning aromatic herbs. They noticed a vulture hovering overhead. Alvaro and Susana returned home with the news.

When darkness fell, the older members of the family were suitably occupied enjoying the pianola or magic-lantern. While the servants were eating their supper, Alvaro quietly entered Susana's room and said: 'Come, the moon is full. We must go and pray on the sacred ground above the tennis-courts.'

Susana had been impressed when some months before – doubt-

26

less due to the success of his spell – Alvaro had been granted his oil-paints. That morning as usual she had felt sick of her donkey – so inferior to Alvaro's horse. But now she saw herself in a howdah on her own elephant.

Alvaro whispered: 'The owls are announcing a death!' By now Susana was assailed by doubts, and regretted leaving her warm bed. Where would she keep her elephant and what would it eat? On second thoughts she would prefer a small slave – perhaps an amiable dwarf.

Sounds of shouting, clapping and singing reached them now from the slums beyond the ravine. Wild music from concertinas and guitars rose in a crescendo, but Alvaro seemed preoccupied as he searched for something among the artichokes.

He reappeared holding a golden chalice and, as if in a trance, proclaimed: 'I am the Arch-Priest, the High Magician. As I offer this cup to the moon, repeat after me: "I, Susana, desire an elephant..."' 'No! No!' interrupted Susana, 'I want a good, snow-white dwarf.' As far as she could see the fig tree showed no sign of bursting into flower.

'No matter,' replied Alvaro, 'say after me: "Beloved moon, I am your devoted slave, send me a loyal obedient dwarf. Your servant Alvaro has in his goblet poison to destroy your enemies – wine, pepper and toadstools, the devil's mushrooms."'

Solemnly, Susana repeated the words. Suddenly there was a hiss – a bullet had whizzed passed her ear.

'Someone is shooting!'

Alvaro dropped the chalice: 'We must be targets against the sky in such a bright light, we can be seen from beyond the ravine. Who can have given us away? Duck your head and run for the shade.'

Both he and Susana were terrified. Could the villagers' envy have turned to violence? They reached the terrace. There the cook met them, but instead of scolding them, she shook her fist at the moon and cried: 'A death! A death!'

Both children were exhausted and crept upstairs to their rooms to fall asleep at last, although somewhere outside Titan, the St Bernard, was groaning.

They awoke late the next day to hear little Edmundo sobbing beneath their windows, intoning: 'Titan is dead! Titan is dead!' Big as a pony, Titan lay stretched out below on the mosaic. The

bullet that missed Susana had killed him. Then it was found that a hundred chickens were missing, which led to another horror: a hundred chickens' heads were laid out in a straight line by the tennis-courts – a sacrifice.

After breakfast, the head gardener explained to Papa that last night there had been a wake. The laundress Griselda's baby had died; for several nights to come its body would be passed from shack to shack as an excuse for revelry and shocking orgies, until at last the vultures led the police to the tiny, rotting body.

Papa Guevara decided not to replace the chickens just yet, and Mama suggested that the whole family would benefit from a change of air in the south of Chile.

2

Papa Guevara had invested a great deal of money in a country estate in Arauco; the journey, by land and sea, took a day and a night. Mama agreed to manage with a skeleton staff: she would take only the cook, kitchen maid, parlourmaid and nurse. They would make do with the bare essentials. Sternly she refused to allow Susana to take her favourite doll.

Despite these restrictions, when they were ready to go south there were over a hundred pieces of luggage; carts piled high with crates of silver, china, linen, cooking utensils, medicines and leather trunks followed the carriages down to the port.

The children watched their possessions being rowed out to sea. A cow and a load of hay were hoisted off a barge on to a ship for some friends who were sailing to Europe and disliked tinned milk.

The Guevara party suffered a sickening voyage as far as the first port of call. They were thankful to disembark and board a train which took them by the inland route as far as Temuco.

From here onwards, their path lay through the forest. They were met by covered wagons drawn by oxen. Indian guides went ahead with their *machetes*, slashing at the undergrowth to make a way through the bamboo, festoons of creepers and giant fern. The three youngest children rode with the servants, who sang and played their guitars.

Velvety moss and beards of lichen covered the tree trunks. Animals and birds shrieked as the convoy advanced. Brilliantly coloured cockatoos, parakeets and humming-birds swooped and flashed above. The air was fragrant with the scent of weeping

resin, honey and bruised herbs. Alvaro was in his element.

The nurse called out: 'Do look, children, at those funny trees all decked out with bits of coloured wool.'

Alvaro answered at once: 'Those are the sacred trees. The Indians decorate them with presents. Listen! Can you hear the *Tabanos*?'

'All I can hear besides the music are the wheels and the bees,' said Susana.

Alvaro explained: 'Although they sting those are not ordinary bees: the Indians believe they are the souls of warriors who perished in battle.'

'Heavens child! Where did you pick up this rubbish?' the nurse laughed. The cook only smiled as she twanged her guitar.

When at last the party reached the clearing, they saw charred black trees silhouetted against a crimson sky and to one side a huge volcano.

'It is wicked to burn the forest to make room for *us*,' muttered Alvaro, watching the clouds of fire-flies. Papa had only recently enlarged the estate and rebuilt the farmhouse, which was surrounded by apple orchards and vast fields of lucerne. In the distance there was a lowing of cows from the corrals.

The servants began to unpack, and prepared a light meal. Without warning, there was a terrifying sound and the children rushed to the windows.

'We should never have come to this cursèd place. The gods do not welcome us. An evil omen!' cried the cook.

Huge flames and sparks were shooting into the sky from the volcano. A fusillade of ash and rocks cannoned off the new roof. The house shook.

Under the bombardment, the Indian porters fled, leaving panic-stricken oxen blundering about. Wailing servants cowered in the kitchen while Papa and Mama tried to keep everybody calm. No irrevocable damage was done, but for several days Susana lay in bed whimpering for her doll.

The Indians accepted Alvaro as one of themselves. He seemed to understand the chattering, olive-skinned children who pursued him as he wandered among the beehives in the orchard or explored the new dairy, where dozens of vast cheeses lay in rows on wooden shelves.

30

One morning he awoke to hear the click of spurs. Mama had sent all the way to the Cerro Alegre for Susana's doll.

Soon after this holiday, Susana dreamt that all her teeth had fallen out. The next morning she told Alvaro, and when the cook heard, they knew from her expression that it was a fearful omen. A learned friend of Papa's divulged that a certain Egyptian papyrus carried the same message of doom.

German Grandmama had dined at the house the night before to welcome the family home. She was eighty-six and was found dead the next day by her servant. No one attributed this to natural causes; she was obviously cursed.

On the day of the funeral, all the shutters of her house were closed and the gas chandeliers turned low. Alvaro had always loved her; when he entered the drawing-room, she was lying in her coffin dressed in her black satin gown.

His female relations were talking in undertones in a corner of the room:

'To think she was a *Protestant* . . .'

'But she did order a marble cross for her tomb!'

'A Protestant? How dreadful! She can't hope for Eternal Life.'

Alvaro broke up this discussion: 'There are Indian, Egyptian, Chinese and Negro angels and spirits, as well as Roman Catholic Chileans!'

Scandalised, the ladies swept from the room, trailing crêpe and dabbing their eyes with black-bordered handkerchiefs, murmuring: 'Poor boy, he has much to learn.'

One of the most important and influential days in Alvaro's life was 16 August 1906.

The children were awoken by a gust of wind rattling their shutters. They heard foghorns wailing from the bay.

Their eldest brother, Lucho, was expected that morning from a vital English centre of culture: the Bradford Technical College. He had left Chile five years before.

Upstairs Mama was singing. Sibila and Susana however, could see no cause for rejoicing: in such weather Papa would never allow them to go out on the launch with the pilot and the doctor to meet Lucho.

Mama instructed the girls to put on their sailor suits, galoshes,

raincoats and sou'westers, black ribbed stockings and button boots. They would have to wait on the quay with her and little Edmundo, while only Alvaro accompanied Papa.

Alvaro was proud of his sailor suit and crammed on his cap, the rim encircled by a black band inscribed in gold *Esmeralda*, after a famous Chilean warship. It was his favourite hat and he hoped that it made him look like an English prince. According to Miss Hills, the English royal children always dressed in such nautical clothes.

By ten o'clock the two youngest girls and little Edmundo were standing on the wharf with Mama, watching the S.S. *Orita*. Beyond the breakwater, waves thundered against the rocks. Valparaiso Bay was one of the most dangerous in the world, and every year there were numerous wrecks.

It was still dark and they all shivered with cold and fright, peering out to sea through veils of spray. Suddenly, the black sky split and pale yellow light shone through the crack. This was obviously an evil omen. At last the ship hove into sight; they could see the launch alongside, Alvaro and their father on board, frantically tossing about. Surely Alvaro knew that he might be drowned; he must be terrified! His sisters sobbed and hid their faces in Mama's soaking skirt.

At last the launch arrived, miraculously intact; everyone was shouting, laughing, waving and kissing. Alvaro was drenched but looked proud of himself. Lucho seemed a stranger. He had grown a moustache like the Kaiser's.

The family clambered into their carriages. When they arrived at the Cerro Alegre all the Guevara relations, including the married sisters with their husbands, were assembled in the drawing-room. Lucho seemed gratified rather than surprised by this formal welcome.

To Alvaro's disappointment, even on this special day, he was forbidden to join the grown-ups for luncheon in the dining-room. He sat silently with his sisters and Miss Hills in the next room.

He listened while Lucho dominated the conversation. After recounting the awful experience of his voyage, he began laying down the law. Neither Papa nor Mama interrupted. He insisted that the Chilean house and estate must be sold at once: the family should move to Bradford. Alvaro and little Edmundo

would be trained, as he had been, at the Technical College there. As for the girls – there was an Academy for Young Ladies in Harrogate well spoken of.

Why did Papa allow Lucho to talk so much? Alvaro frowned: obviously he did not approve of these plans, nor did Miss Hills.

Meanwhile menservants were staggering into the hall with crates and trunks. But it was not until after tea that everyone gathered round to watch Lucho unpack them. Savouring every surprise he held the stage like a conjuror.

The girls hoped that he had remembered to bring presents for them. They had enough dolls already from Paris – mostly wax and very well-dressed. Alvaro was interested only in Lucho's clothes.

One Christmas German Grandmama had sent Lucho a beautiful grospoint waistcoat. Alvaro had coveted it during the months it had taken her to make. When the fourth case was unpacked, it was clear that Lucho had never even worn it. Alvaro's eyes lit up; perhaps it would now become his.

'Here, Edmundo,' said Lucho, 'you may have this.' Although up to his knees in presents, little Edmundo was delighted. He also grabbed Lucho's collapsible opera hat and put it on his head. Alvaro envied him. Papa was presented with a small statue of Shakespeare. By the time all the trunks and crates were empty, the family was tired and no one bothered to change for dinner. To entertain them, Papa asked Alvaro to play a piece on the piano. Alvaro was in a sullen mood: instead of something appropriate and gay, he played Chopin's *Funeral March*. One of his married sisters had picked up the evening paper. She interrupted: 'Just listen to this: "Captain Cooper of the S.S. *Orita* declares that tonight at 8.30 p.m. there will be an earthquake of such intensity that it will destroy the city." '

'The man must be mad!' Lucho scoffed.

'What time is it?' asked Mama.

Pulling a large gold watch from his waistcoat pocket, Papa answered: 'It is exactly eight o'clock.'

Lucho grumbled that if this were so, dinner was late. In Bradford everyone dined precisely at seven. Smiling, Mama protested that he must have forgotten that in Chile dinner was never served before nine. Seeing his face, she went on to suggest that tonight they would dine early.

33

'Oh please don't ring, Mama!' Susana cried. 'Let me take a message.'

Apparently unconcerned, Alvaro continued playing and, in time to the music, Susana goose-stepped across the hall, down the flagged passage and through the kitchen.

The servants were all noisily eating and screaming at each other. She climbed on to the table and, ignoring the hubbub, pointed to the clock on the wall: 'Five minutes from now there will be an earthquake which will destroy . . .' She hesitated, trying to remember and then added, 'will destroy the *city*.'

'Holy Mother!' shouted the cook, making signs against the evil eye. Tears ran down her face. The odd job man fell on his knees, beating his chest and muttering prayers.

It was a dark night and pelting with rain. Suddenly, it ceased. There was a hush. Everybody waited for the dreaded, only too familiar sound which heralds an earthquake. Sure enough, there was a deep sinister rumbling. They all ran for their lives out of the house. They could hear the horses and donkeys shrieking in the stables. There was a roar of tumbling masonry. All around them people were yelling, babies wailing and dogs howling. Glass splintered.

Those who had escaped through the front door were stumbling over the flowerbeds. They were reunited at last far from the buildings, clinging together and praying. It was pitch dark, so no one could see who was who among the hysterical group.

There was a sudden flash and an explosion below. A moment later, the city was blazing against a lurid sea. The sky was orange and black, the ground rocked violently and the wall above the tennis-court collapsed. Raquel, one of the elder sisters, was frantically calling her husband's name: 'Alberto, Alberto!'

The glare discovered little Edmundo, still wearing his green waistcoat and opera hat, pathetic, yet comical.

Finally Alberto appeared, like a ghost, between the tossed-up roots of the trees. His wife fainted. The parlourmaid sprinkled her forehead with water from a pool of rain, murmuring; 'A true lady, she swooned!'

After an eternity, Papa and Lucho appeared with Mama between them. Her face was grey with dust and her hair glittered with fragments of glass, but as a true matriarch, she took charge at once and returned with the braver servants to what remained

of the house. They soon reappeared with flares and a huge pot of soup, which the family drank in turn from a ladle. A tray of roast pigeons followed, which everyone devoured without knives or forks except Miss Hills, who sniffed her bottle of smelling salts. The grown-ups huddled together on rattan chairs. Now and then the earth lurched to and fro; loose chunks of masonry continued to fall.

Alvaro awoke to hear Lucho's commanding voice telling the children to keep away from the buildings. The servants were dragging blankets and mattresses out of the house and the gardeners were erecting a tent supervised by Papa.

'Where are the dogs? Have the horses been shot?' Alvaro asked. He took Susana's hand and together they slunk over the rubble towards the ruins.

The sun had risen. Festoons of wisteria hung between the cracks in the walls. Thousands of bees were at work and there was a delicious scent of orange blossom. Talking to himself, Alvaro slowly turned away and led Susana back over the violets.

One of the maids ushered some people into the courtyard. A procession of grey puppets lurched in – refugees from the city below, bearing with them wounded and moaning victims.

'Their bones are broken: Amelita's leg will be cut off,' Alvaro announced with apparent calm and then stood watching in silence. The Day of Judgement was at hand – the Resurrection of the Dead. In fact, the cemetery of Valparaiso was in a state of literal upheaval. Not only had the graves opened, but corpses were sitting up in their coffins and sacred remains were thrown about. Someone else reported seeing Blanche, Alvaro's cousin, writhing in labour in the middle of the flaming Calle Esmeralda. This birth had been precipitated by the appalling shock of the earthquake.

Respectfully, the crowd made way for Cousin Erich Dietrich, wearing his sailor suit. He whispered to Alvaro that his mother and sisters, as they tried to escape, had been crushed to death by their grand new house.

Alvaro seemed unable to speak for a moment, but then, patting Erich on the back, said 'I'm so glad you've come to stay with us.' Stammering, Erich explained that this was impossible. His father was taking him to Berlin to live with a German uncle.

Susana, who loved Erich, burst into tears.

Alvaro took charge: 'Come on you two. We'll go down to the tennis-courts and see if the swallows' nests are still there.'

He led them through the garden. All that remained of the sacred ground was a pile of rocks which had once formed part of the retaining wall. What an evil omen: the poor swallows' nests had been crushed! A few lizards were scuttling about.

To distract his weeping companions, Alvaro suggested that they should all three investigate what was left of the house, although he knew that Papa had put the ruins out of bounds.

The garden was being transformed. Makeshift shelters were rising everywhere, made from the collapsed beams of the pergola, with tarred paper roofs. There were nearly a hundred people, including servants and refugees, milling around with beds, chairs and chamber-pots. Papa and Lucho were still in charge. Mama and the cook were bustling in and out of a lean-to hut, stirring huge pans on a charcoal stove. No one noticed the children.

The front door was open. Only the statue of Joan of Arc stood intact, leaning against what remained of the staircase. The ornamental ceiling had collapsed, submerging the furniture. The mosaic floors were topsy-turvy and covered with grit and dust; the vast mirrors were shattered and the metal frames of the chandeliers dangled crazily from broken beams, their pendants gone.

Alvaro disappeared. Suddenly Susana and Erich heard music. Although it had lost a leg, the grand piano had survived. Squatting on the debris, Alvaro was once more playing the *Funeral March*.

'Stop it! Stop it!' shouted Susana.

Laughing, Alvaro stood up and announced: 'Shakespeare has lost his head!' Lucho's decapitated present lay on the ground.

'Follow me!' Alvaro's eyes were shining with excitement. 'We'll find him a suitable grave in the kitchen.'

How could he have known that a deep, dark hole was waiting? He dropped the headless statue into its tomb. Picking up a wooden spoon he scattered some dust, chanting a solemn incantation.

Clumsily, Erich and Susana stumbled after him back into the garden.

PART TWO

The Bohemian Gentleman

1910-1925

3

In 1910, on Lucho's advice, Papa and Mama decided to send Alvaro and their two younger daughters Sibila and Susana to England, in the charge of Raquel and Alberto. The parents would follow in a few months.

Alvaro was to go to be trained at the Bradford Technical College for work in the family wool-mills; the girls were destined to pay a round of educational visits to some of their European relations before attending the Academy for Young Ladies in Harrogate.

The family was still in mourning for the death of German Grandmama. Such observances were strictly adhered to: for the first year they wore black cashmere dresses and crêpe; for the second, black without crêpe; in the third year, white or lavender.

The girls, now aged fourteen and thirteen respectively, were equipped with hundreds of black-bordered handkerchiefs. The crochet or lace on their underwear was laboriously threaded with black satin ribbon.

In preparation for the rigours of the English climate, Mama included flannel petticoats, patent metal hot-waterbottles and bedsocks in their luggage. Thirty trunks were sent on ahead. In one box Sibila had forty pairs of shoes.

In their light luggage they had, as well as umbrellas to shelter them from the English rain, black parasols and fans – Mama warned them that these were essential to protect their complexions when crossing the equator. Raquel was instructed that one large valise should never be out of sight. It contained disinfectants,

first-aid kits, mustard plasters and a white enamel can with rubber tubing attached.

The whole family assembled for the farewell tea. Alvaro was silent throughout, gazing gloomily at an engraving of *The Stag at Bay*. Everyone was relieved when at last it was time for the sombrely clad travellers, laden with bouquets of carnations, to climb into the carriage.

Alvaro was slightly consoled when the train which took them via Santiago to a small town at the base of the Andes, reached its top speed of 35 m.p.h.

They spent the night in a primitive hotel, little better than a shack. From the balcony they could see gangs of men hacking at the rock to make way for a railway tunnel.

Guides and mules were waiting for them early the next day. These provided the only means of crossing the Andes. Icy winds swept over the glaciers on each side of the track. There were walls of snow, twelve feet high in places. After a dangerous climb, the party dismounted. Alberto pointed out the bronze statue of *Christ of the Andes* and explained that it had been erected only recently to commemorate a peace treaty between Chile and Argentina. Alvaro remarked with confidence that civilised countries would never fight each other again.

The highest mountain in America towered above them. No one spoke as they made the descent but all silently thanked God that they had been able to ride since early childhood. At long last, perished with cold, they boarded the train for Buenos Aires.

Alvaro became very excited as they crossed the desert in clouds of dust. When they reached the pampas, the train disturbed flocks of ostrich. Every minute it grew hotter: the girls were thankful for their parasols and fans in Buenos Aires.

The electric lights, the trams and automobiles delighted Alvaro. When they actually drove in a motorcar, he stood up in his seat shouting: 'Fifteen miles an hour! What a wonderful feeling – like sliding in stockinged feet across a polished floor!'

Next they had to cross the mouth of the River Plate in a small boat. Alvaro paced the decks wearing his first long trousers and a new bowler hat, imported from Lock's. His companions suddenly observed that, although only fifteen, he was already a man. What none of them realised, perhaps he least of all, was

that the pattern of his life was already formed by the experiences that he had suffered or enjoyed so far.

When the family party eventually reached Montevideo there was such a storm that in order to board the transatlantic liner they had to be loaded by crane, two at a time, in a crate, as if they were helpless cattle.

Within a couple of days they reached calm seas along the coast of Brazil. Swarms of brilliant butterflies invaded the decks: Alvaro was entranced and tried to catch one. The girls fidgeted in their hot black cashmere dresses and abandoned their flannel petticoats.

Christmas Day was spent at Las Palmas. That night on board they celebrated Christmas in German style; Alvaro was fascinated by the tinsel decorating the tree. One day he would try to paint a 'glitter', and the shimmer of light on water.

Reaching Cherbourg on New Year's Eve, they celebrated their arrival in Europe with a delicious meal. This proved a waste as the English Channel was abominably rough. They disembarked at Southampton at dawn on New Year's Day, 1910.

In comparison with Valparaiso, it was a dreary port, and as for the English sun, it looked like a ball of fire but gave neither warmth nor light through the fog.

The day turned into night as their 40 m.p.h. express train approached London, where thousands of chimneys were belching smoke.

Lucho was waiting for them at the Grosvenor Hotel, Victoria. Before they had even had time to sit down, he suggested that a walk would do them good. They protested that it was raining and they had spent a miserable night. Lucho brushed aside their objections: it was usually raining in London; the winters were long, artificial lights burned all day and night because of the fog. They would all go to Regent Street and buy Burberry raincoats. He added proudly that the cloth was manufactured in Bradford.

It was a long, tiring expedition on foot, especially for Raquel in high-heeled boots. Alvaro had never seen so many motorcars or buildings more than three storeys high.

'There have been no recent earthquakes here,' said Lucho.

The next few days were devoted exclusively to sight-seeing. On visiting the National Gallery, Alvaro was much affected by Whistler's picture, painted from the site of the Guevara home.

That evening, dining at the station hotel they were all assailed by a fearful nostalgia.

Lucho announced his plans for their futures. Sibila and Susana must leave the next day for Germany, chaperoned by Raquel and Alberto; they would enjoy a few weeks' cultural tour staying with suitable relatives abroad. Alvaro would begin his studies at Bradford Technical College tomorrow and be sent to fetch his sisters at Easter for their first term at the Academy for Young Ladies in Harrogate. When Edmundo arrived with Papa, he would be sent to Wellington College at once.

'But when are we going home to Chile?' Susana asked. Lucho replied that the house, recently restored, was to be let; Papa was nearly seventy now and had made him, Lucho, responsible for them all.

Alvaro made no comment. His face was pale. It was obvious to the others that he resented Lucho's dictatorial manner.

Alvaro was wretched at Bradford; he felt completely alien and abandoned. It rained incessantly during the early spring of 1910 and he counted the days until the Easter vacation.

He had felt no particular need to make friends in Valparaiso: his large family and their social life had engulfed him as soon as he got home from school. Now aged fifteen, lacking the stimulation of an admiring audience, he longed for friends as never before.

Alone in his lodgings, after a boring day at the Technical College, he wrote a miserable letter to Mama, imploring her to hurry to England. Shivering in bed, he read and re-read his letters from Sibila and Susana. How lucky they were! Not only was there no rain in Dresden: for the first time they had actually seen a snowfall! They had even witnessed the King of Saxony and all the Royal family in gala dress in a box at the opera! They had attended balloon races one afternoon when visiting Erich, Susana's beau, and had watched the first dirigible, designed by Count Zeppelin, through their binoculars.

Alvaro's great consolation was his bowler hat. At least his reflection in the bedroom looking-glass gave him satisfaction. Every day, as he strode to work through the grimy streets, he protected it with his umbrella.

While other students attended lectures and diligently applied

themselves to the mysteries of wool, he sat dreaming and hummed Spanish songs. He escaped into fantasy, basking in the sun on the Calle Esmeralda, riding his favourite sorrel over the hills and wandering through the forests. Instead of writing technical essays, he doodled tree ferns, butterflies, lizards, puppets, ballerinas and ladies in mantillas. His teachers despaired.

Lucho was preoccupied in the evenings, courting Miss Joyce Nelson, a Protestant girl from Manchester, according to him an even more desirable city than Bradford. However, he managed to find time to introduce his young brother to some suitable people in the wool trade.

Fortunately for Alvaro this circle included the Rothenstein family, whose fortune was also derived from the local mills. Charles Rothenstein, the head of the family business, had a notable collection of pictures in his Bradford house, where Alvaro met his brothers William and Albert. William Rothenstein had attended Bradford Grammar School before becoming a student at the Slade under Legros, and then had studied in Paris for four years. He was thirty-eight now, and a distinguished artist living in London. His brother Albert, who was ten years younger, had attended the same schools and was to earn a reputation as an original painter and designer.

Although Albert was thirty – double Alvaro's age – a friendship between them developed; this was to prove of immense importance to Alvaro. Albert was no homosexual; in fact at that date he was regarded as a womaniser. Both he and William took pity on this attractive young tropical fish-out-of-water. They heard him play the piano after a party at the Majestic Hotel. He showed them his drawings. William, who had encouraged many young artists, suggested that instead of spending his evenings alone, Alvaro should attend evening classes at the local Art School.

The Rothenstein brothers were surprised when Alvaro confided that he was also very keen on boxing and dancing. Albert therefore introduced him to an acquaintance who took him at weekends to a boxing club. Fortunately, Lucho was so busy with Miss Nelson that he had no time to learn of these distractions.

At Easter, Alvaro set out for Berlin to fetch his sisters. By the time they returned to Bradford, Mama and Papa had arrived from Chile and were recuperating in Harrogate, at the Majestic Hotel. It was mid-term when the girls were dispatched to school.

The other pupils crowded round the new arrivals. Why were they not wearing their native costume – grass skirts and feathers?

The matron was stupefied when she unpacked for them: trunk after trunk of black clothes! The girls insisted that they were in mourning for their grandmother. The headmistress, Miss Jones, ruled that most of the luggage be returned: they must wear the regulation uniform.

The spartan life, and the sulphurous smell from the waters of Harrogate, so disgusted Sibila that one week-end she escaped to the Majestic and refused to return. Alvaro was most sympathetic. When Lucho protested vehemently at Sibila's behaviour, he also harped upon Alvaro's shocking frivolity and idleness; the dark circles under his young brother's eyes must be due to late hours and a life of dissipation.

There is no record to show how and with whom Alvaro visited the first Post-Impressionist exhibition arranged by Roger Fry at the Grafton Galleries in London. Perhaps he played truant with other art students from Bradford, including Edward Tracey and Geoffrey Nelson, the teenage boys mingling with the crowd of jeering top-hatted gentlemen from St James's clubs and their many elegant ladies, who poked fun, even parasols, at the exhibits which they found ridiculous. As far as these people were concerned the painters, who included Cézanne, Matisse and Van Gogh, were as deranged as Mr Fry himself.

Later, Alvaro confessed that he had felt both excited and confused by the Post-Impressionists' pictures; his work was certainly influenced. Before 1910 he had particularly admired Constable and Whistler, as well as the traditional Spanish painters. He had only recently heard of Whistler's pupil, Sickert, and so far had seen none of his work. During fevered discussions among the more intelligent art students at Bradford, he gathered that the New English Art Club was considered avant-garde for being influenced by the French Impressionist school.

Alvaro was so preoccupied in his thoughts that he could scarcely concentrate on Susana, when she confessed that, for the second time, she had fallen in love. She confided in Alvaro that although Erich was a very nice boy, she would like to marry, or at least become engaged to, an Englishman. Alvaro agreed that

this was perfectly reasonable. After all, she was nearly fifteen now. None of the Guevaras, except Lucho, realised that love in a cold climate was different. He had discovered this for himself. Neither Mama nor any of the family knew that he had secretly married Joyce Nelson at Knaresborough Registry Office on 31 July 1911, spending the week-end at the Cairn Hydro. Lucho was fourteen years older than his wife, who was still a minor. He described himself on the marriage certificate as a merchant shipper and her father as a furrier.

Mama spoke broken English with a strong Spanish accent. The following week, when she took Susana back to school, she asked to see the headmistress and announced: 'Susana is betrothed. She will receive the love letters from her suitor Leslie as he is in the Royal Army and leaves for Gibraltar where is his regiment.'

Miss Jones was flabbergasted and protested that Susana was only a child.

Mama, having been married at sixteen herself, nodded: 'Yes, yes. I say to him: why not take Sibila? She is older and prettier, but he say no, he want Susana.'

Every day the hall table was piled with letters, books, magazines, boxes of sweets, bouquets and baskets of expensive flowers: Susana's dormitory was fragrant with the scent of lilies and roses. Parcels arrived from Gibraltar, full of painted fans, embroidered Chinese coats, lace mantillas, antique silver jewellery and ornaments. Susana wore a photograph of her fiancé in a pearl locket, and her diamond and sapphire engagement ring hung on a gold chain around her neck, to the envy of the other girls.

In the summer of 1912 Lucho, still a Roman Catholic, married Joyce Nelson officially in the local Presbyterian church. Alvaro was now eighteen and was thrilled with his top-hat and tail-coat. The bridesmaids, Sibila and Susana, 'were dressed in pale yellow *charmeuse* and large black velvet hats with yellow ostrich plumes, and carried bouquets of pink carnations tied with black velvet bows'.

Soon after the wedding, Papa was taken very ill in his luxurious suit at the Majestic Hotel. He clung to Mama on his deathbed and pointed with a shaking finger to a dark corner of the room, croaking: 'Look, look, Horacio is there!'

43

The nurse covered his face with a sheet and summoned Lucho and Alvaro. The sound of sobbing from Mama and the girls, mingled with the dance music floating up from the winter garden below.

Papa was buried beside Horacio in a small cemetery on the Yorkshire moors. He had a modest six-foot granite column as a memorial instead of a marble cross.

After the funeral, during a dinner overshadowed with gloom, Lucho announced with disgust that Alvaro had disgraced himself and completely failed to qualify for any situation in the mill. He threw up his arms in despair: a man with no future was an object of scorn!

Ignoring this outburst, Alvaro calmly turned to the others and told them that for the past two years he had secretly attended night classes at the local art school. To their astonishment, he added that he had won a scholarship to the Slade in London, explaining to them that this was part of London University. Fifty other Bradford students, all English of course, had also submitted work, but his illustrations to Shakespeare and Bunyan had won the award.

Lucho made a quick recovery: the futility and decadence of artistic life in London were notorious, but it must be admitted that a system that showed no racial discrimination was fair.

Despite Lucho's objections, Mama was proud of her favourite son and perhaps relieved to have a good excuse to leave for London herself. Her arguments were always simple and sensible: Lucho and his bride should continue to enjoy their stimulating life in the Midlands, but Sibila and Susana were to be placed *en pension* in Paris at a finishing school. Before Papa died he had agreed to this idea.

She asked Lucho to rent a furnished house in London for herself and Alvaro. It was decided that his duty lay with his bereaved mother for the next three months and therefore he would not take up his scholarship in September, at the beginning of the school year, but postpone his attendance until the following term.

44

4

During the autumn of 1912, Mama Guevara and Alvaro moved into 79 Holland Park. The South American diplomatic world respected their deep mourning for Papa, although the Chilean Minister's wife advised that as they were now living in England, the strictest Chilean conventions could and should be relaxed for the sake of the girls. When they returned from France, they must be presented at Court and take their places as debutantes.

An informal life suited Mama and Alvaro well enough for now. Left on their own they could attend concerts and theatres.

Alvaro was free from filial duties during the day and explored London on foot, visiting museums and contemporary art exhibitions. It was two years since Roger Fry had organised the first Post-Impressionist show, which had so shocked the English public. This winter of 1912, Fry's second Post-Impressionist exhibition opened at the Grafton Galleries.

Knowing that Fry would be his lecturer at the Slade, Alvaro paid particular attention to this. The style of many exhibits still bewildered him, but the younger generation of students and the rich or sophisticated, who thought nothing of popping over to Paris for a few days, were acquiring a taste for this foreign work already accepted in France.

When Mama heard that most art students had bicycles, she bought him the latest model. Lucho was pained by Alvaro's wish to take exercise on an expensive horse in Rotten Row, and disapproved of his boxing and his wishing to join the International Sporting Club.

Alvaro had grown several inches during the last two years. His

top-hat and morning coat, which had been bought for Lucho's wedding, had also proved useful for Papa's funeral; but Mama was sure they would prove indispensable when he escorted his debutante sisters in London. At Lucho's suggestion, the trousers and sleeves of Alvaro's black suits had been let down, but they were still not really comfortable; even his bowler hat was too small and his raincoat from Burberry's was worn out.

After consultation with the Chilean expert on protocol, the Minister's wife decreed that Alvaro should be allowed to wear half-mourning when he attended the Slade; pale grey suits were ordered from Savile Row and fine white silk shirts from Jermyn Street: his shoes were made to measure at Lobb's, and a new bowler hat ordered from Lock's.

He wrote to his sisters that although he detested the pea-soup fogs, London seemed paradise compared with Bradford. When the bad weather confined him to the house, he painted from still-life, drew portraits of Mama, or struggled to read a new, and to him incomprehensible, book on art by the young critic, Clive Bell.

It was evident from the girls' letters, which Alvaro and Mama perused on quiet evenings, that they too were enjoying themselves. In fact, Susana's ecstatic reports made them feel that their own life was drab by comparison.

The girls' finishing school was run by a successful and charming couple, M. and Mme Villemin, who rented a splendid house in Paris from an American lady, the Countess of Spottiswoode. It was rumoured that she had paid the Pope such a fabulous sum for her title that she could no longer afford to maintain her sumptuous establishment, with its marble stairs, wrought iron banisters and grilles, red brocade-covered walls and gilded chairs. All this was just like home to the Guevara girls. Even their bathroom was luxurious; its walls were painted with swans swimming among waterlilies in azure blue, under weeping willows. There was nothing like this at 79 Holland Park.

To Mama's relief, it seemed that Mme Villemin was a sophisticated woman, and unlike Miss Jones of Harrogate, sympathetic to Susana's engagement. Indeed, according to the latest letter, only last night another pupil called Romola had not joined them in the *salon* after dinner because she was going to marry the Russian dancer Nijinski. Both sisters raved about the Russian

ballet, *divine* Sarah Bernhardt, the superb actress Rejane, the opera singer Feodor Chaliapin ... Mama must let Alvaro join them in Paris as soon as possible.

Not to be outdone, Alvaro wrote back that the Diaghilev Company was coming to London again next year. Lucho's face was grim when yet another lively instalment arrived from Susana. Her best friend was Isobel, the daughter of Bonar Law. Susana had dressed her uncontrollable hair for a visit to the Prince of Monaco's box at the ballet. During a breathtaking moment in *Sacré du Printemps,* Isobel's coiffure had collapsed with a clattering shower of pins and impedimenta into the stalls! Really, Lucho and Joyce wondered if Papa had been ill-advised to choose such a frivolous establishment. Mama seemed unaware of their disapproval and declared she would take Alvaro to Paris the following spring; the girls would be needing new clothes.

During Alvaro's clandestine attendance at Bradford Art School, he had discovered to his relief that when in the mood, he was a fairly good mixer. Provided he was not bored, when he became silent and morose, he developed a talent for picturesque conversation. Once condemned for sarcasm, he was now appreciated for ironic wit. If an English word escaped him, he would improvise, quickly substituting a poetic image that conveyed his meaning. Thus an elusive *field* might become 'a length of earth where men sow seeds' or *blood*, 'that red liquid that flows through our veins'.

However, occasionally his Latin exuberance embarrassed his English friends. It was acceptable for foreigners to kiss the hands of married ladies, but not the cheeks of unmarried men. Geoffrey Nelson, his best friend at Bradford Art School, equally good looking, explained carefully that in England if you embraced your men friends, the gesture could be misinterpreted. After this advice, for the rest of his life, Alvaro contented himself with throwing his arms round their necks and patting them on the back.

In fact, Geoffrey Nelson and Edward Lacey, who had been attending the Slade since the beginning of the school year, proved invaluable guides and mentors. They not only showed him around the University and initiated him into many of its mysterious conventions, but introduced him to various students, past and

47

present, so that he would feel less of a stranger when he enrolled the following term. Among the first were David Bomberg and Isaac Rosenberg. Bomberg had just won a certificate for drawing, but was not much comforted by this, as he was depressed by the recent death of his mother. Alvaro's father having just died, the two boys were naturally drawn together. Bomberg was not only small and stooping but growing a wispy beard; he was not particularly physically attractive. However, Alvaro was fascinated by his ideas, especially when he raved about a group of French painters called the Cubists. He was saving up for a visit to Paris.

Rosenberg had great trouble in paying his fees at the Slade, although few of the students were aware of his predicament. He would disappear now and then for a couple of days to work in the East End for a furniture remover. Like Alvaro, he and Bomberg both secretly wrote poetry.

Although Geoffrey Nelson always seemed to be broke and was a borrower, Alvaro had no idea how improverished many artists were, or how privileged he was, as a foreigner in London, to have made a few friends in Bradford. Henri Gaudier, a young French sculptor, and Sophie Brzeska, the Polish woman with whom he lived, told him that they spent nine months in London before they had found anyone even remotely congenial. In fact this was an exaggeration; but while Alvaro was preening himself in Savile Row, Henri thought himself wildly extravagant when he bought a twenty-six shilling suit, having earned two pounds by a stroke of luck. In order to raise a few pence to spend on food, Sophie would dress as a beggar and disguise a bundle as a baby in a tattered shawl.

Another Jewish refugee who particularly interested Alvaro was Mark Gertler. He had been brought by his family to England from Poland some years before. Mark still lived with them in Whitechapel, but longed to escape. Although he had recently left the Slade, he still kept in touch with the staff and students. He and Alvaro at once made friends, despite their contrasting backgrounds; perhaps because, when in the mood, they were both natural entertainers. Mark was a gifted mimic and a born raconteur.

During their free time, Alvaro and Mark and others visited puppet-shows, circuses and boxing matches. He and Mark were

popular at the public-houses frequented by past and present beer-drinking Slade students. Alvaro could coax exciting music from the most battered piano, however out of tune. His sense of rhythm was enough to impel his audience to tap its feet or jig about. He could also bewitch them with Spanish, French or German songs and would even croon weird Indian lullabies or Negro spirituals.

During his first three months in London, with his Latin temperament, he found Jewish refugees easier to understand than most of the English. After all, in Bradford it was the Rothensteins, of partly Jewish heritage but by then long-established in England, who had encouraged him to attend the Art School, and it was through them that he met the sculptor Epstein. At first he had been inclined to regard the typical English as cold, grey-faced *gringos,* but his circle was rapidly widening.

Stanley Spencer and his contemporaries, including the Nash brothers, John and Paul, and Ben Nicholson, were among the friends Alvaro met at nearby studios and pubs. Now and then they were joined by older and more established artists, ex-students such as C. R. W. Nevinson, now in his twenties and sometimes over from Paris, where he and Modigliani shared a studio. He had left London the year before suffering from unrequited love for Dora Carrington, one of the present Slade students.

On several occasions, the diminutive William Orpen, now a successful painter in his forties, was brought along by Albert Rothenstein – himself small in stature – to whom Alvaro was introduced with accompanying cheers, as 'a defender and champion of men of middle height'. Everyone called Albert Rothenstein '*little* Albert', except Orpen who called him 'little pimp'! Surprisingly, Albert seemed not to resent this; but Alvaro was bewildered by such tolerance. As a Latin, he thought any slight to masculine pride intolerable. In Chile, Albert should have challenged Mr Orpen to a duel, or at least a fight, whereas Englishmen apparently made light of such shocking insults. More and more he found himself prefacing remarks or diatribes with: 'In Chile . . .' So it was that within a few weeks he was dubbed 'Chile' by most people, and so he remained for the rest of his life.

Gilbert Spencer, Stanley's younger brother, appealed to Alvaro immediately; he was known as 'Cookham Two'. His brother

Stanley, who was leaving the Slade that term, had been known simply as 'Cookham', after the village where the Spencers lived and to which they so often referred. Stanley was under five feet tall and Gilbert was also small, delicate and shy. He confided to Alvaro that he greatly feared being bullied and teased. Alvaro was now eighteen, over six feet tall, with a magnificent physique. Flexing his muscles and clenching his fists, he assured Gilbert, with a flashing grin, that anyone who annoyed or threatened him would have to reckon with the Chilean boxer – Don Alvaro Ladron de Guevara. Since his own experience in Chile, he had always felt protective towards boys smaller than himself. Throughout his life most of his men friends were smaller, with a few notable exceptions such as Geoffrey Nelson and Sacheverell Sitwell. Considering the prevalent merciless mocking and the practical jokes that the students played on each other, it was indicative of the way he was regarded at the Slade that no one ever commented if he appeared with a black eye or a bruise.

During the winter of 1912, in the evenings when Alvaro left Mama at home, the two main topics of discussion at informal parties were sex and art. He was passionately interested in both.

It was a time of sexual emancipation, and the art world was inspired with a similar spirit of adventure and experiment.

When the conversation at the Slade turned to sex, Alvaro admitted that he spent at least ten shillings a week on superior prostitutes, whom he persisted in calling 'toms' instead of tarts. How surprising it was that some charged nothing! His friends warned him that however selective he was, he ran a serious risk of venereal disease: no official control existed as in France. There, if one had the wherewithal, according to Nevinson and little Albert, one could visit a brothel or *maison de passe* in confidence.

When Alvaro heard that there were only eighty-three men at the school against two hundred girls, he found this encouraging, but at once 'Cookham Two' disillusioned him, explaining that some were very old; Miss Williams – forty if a day – had caused him a lot of bother last term by complaining about his frivolous conduct to Brown and Tonks. Alvaro, assuming that Stanley had made amorous advances, protested that surely, taking the lady's age into account, courageous rather than frivolous should be the word? Not at all! The ladies' lavatories were in a row

50

in the basement – a sort of moat each side of the entrance – and ventilated by small round apertures cut in the doors. Stanley often amused himself in the lunch hour by throwing half-penny buns at these holes from the lawn in the 'quad'. His aim was infallible. When Miss Williams had nervously perched on the wooden seat, a volley of buns had shot on to her lap, accompanied by unseemly roars of masculine applause. Cookham had been severely reprimanded by the Professor.

Except casually, Alvaro had so far met scarcely any of the girls. They were rarely invited to join the men at the local pubs, for economic, rather than conventional reasons : girls never paid for themselves. It seemed that most of the more interesting or attractive ones had been snapped up already; Gertler was madly in love with Carrington – as Nevinson had been the year before. 'Why are ladies called by their *Sire* names?' Alvaro asked.

Perhaps it was fortunate that he and Dora Carrington were not physically attracted. He approved of her bobbed hair – not simply because it suited her : in those days it was an extreme gesture of independence. Nevertheless, he confided in a friend that he feared for Gertler : her front teeth were strange; perhaps at night she turned into a vampire! Carrington's cronies were Barbara Hiles and Dorothy Brett. Alvaro disliked the thought of his own girl belonging to any feminine *coterie* : it smacked of conspiracy. Surely their relationships would be discussed relentlessly?

Unattached girls sat on the radiators in the hall, or draped themselves against the banisters, hoping to capture an admirer from among the men as they passed up and down. Alas, none of these wilting wallflowers appealed to Alvaro.

By the time Alvaro enrolled at the Slade on 6 January 1913, he was by no means a stranger to many of the students. His professor, Frederick Brown, interviewed the prize winners and scholars from provincial art schools. Alvaro presented himself with a courteous bow. He was as curious to see Brown as the Professor was to see this Chilean scholar from Bradford.

Within a short time, the whole staff and their friends, including Augustus John, who had left the Slade fifteen years before, were not only impressed by Alvaro's talent, but by his capacity for work. Although his methods were unusual, Brown

allowed him exceptional independence in the life-class. Many students complained that Tonks, the Assistant Professor, only favoured those 'who imitated him, imitating Ingres'. Their drawings must be strictly limited in proportion to the size of their paper. Alvaro would make dozens of studies of one feature from many angles. While the others drew the whole figure, he would concentrate on producing meticulous drawings of hands, feet, eyes or whatever detail obsessed him.

One Monday morning, Cookham Two asked him what he had done during the previous week-end. Alvaro replied that he had been boxing on Saturday night – what a fight it had been: blood all over the place! He had spent Sunday at the British Museum, drawing napes.

'Napes?' Gilbert was nonplussed.

'The backs of necks,' explained Alvaro. 'The parts to be found beneath the hairs.'

He was always the first to arrive and the last to leave. Precisely at nine, having parked his bicycle, he would put the coat of his splendid grey suit on a hanger and reverently place his beloved bowler hat on the shelf above. As the days went on, it was not elegant clothes like these but the dirty old mufflers, shabby raincoats and caps which became conspicuous. He refused to wear an overall, protesting that he would not be seen dead in such a thing – the Guevaras were not lackeys . . . There was never a smudge of charcoal or a spot of paint on his white silk shirt but he did not appear at all effeminate. The girls used to tease him by pretending to notice a stain, saying: 'We see you had a boiled egg for breakfast this morning, Chile!'

Of the fifty men in the painting class, only five were poor, five were quite comfortably off and the rest as rich as they needed to be to survive as painters. When studying from the nude, the sexes were segregated. When it was time for the model to rest, the students left their easels and stood back in a semi-circle to survey their attempts. An arc of rippling yellow light appeared as the majority flicked open their gold cigarette cases – smoking was allowed during the break. John Nash said that had he not been to a public school he would have found the affluence and snobbery alarming.

Of all the staff, Alvaro found Wilson Steer the most baffling. Many fellow students agreed with him that as a teacher, Steer

was useless and inarticulate. Steer was now fifty-three, 'a large, comfortably lazy man'. He would shuffle from one easel to another, rarely troubling to speak, glancing nervously at the door, for fear of a draught. According to George Moore, he would say: 'Draughts are like wild beasts, always on the watch for whom they may devour.'

If a student in difficulty appealed to him, he would merely advise: 'Just muddle on, muddle on . . .' He referred to his own work with vague modesty as 'my job muddling about with paints'. When even this lethargic routine required too much exertion, he would sit down among the class and doze. It was as if he grudged diverting any of his small store of energy away from his own painting.

When considering one of Alvaro's studies, he mumbled at last: 'It is – er – I mean, you are – er – curiously – um – limp. Flat!' Alvaro took this harmless remark as a personal insult and a reflection on his virility. Scowling at the other men and patting his fly-buttons, he protested that he was by no means flat, *far* from impotent!

One day, Steer stood behind Bomberg's drawing for a long time. There was silence while the whole class waited: for once the oracle might speak. A piece of charcoal dropped on the floor. Startled, Steer looked up at the north light and said: 'Er – I think it may rain.'

He loved cats and, like them, dreaded getting wet. His old nanny, Mrs Raynes, now aged ninety, would come all the way from Cheyne Walk in bad weather bringing him an umbrella and an enormous pair of galoshes. One day, Alvaro saw them both waiting for a hansom-cab in Gower street; as it stopped, the wheel ran over the empty toes of the galoshes and, for some minutes, Steer was trapped.

By the end of Alvaro's first term, despite his various successes, he still felt completely at sea where English girls were concerned. Their manners and morals bewildered him. Not only his male friends, but his instinct warned him not to become emotionally involved with any of them. Fortunately, none was attractive enough to tempt him. Even little Albert was infatuated with Carrington now.

At eighteen, Alvaro was in no position to marry; if one made love and reached satisfaction, however careful one resolved to

be, more likely than not the girl, as Nevinson said, would become 'in the family way'. Alvaro realised that he could not risk such a calamity.

To his astonishment, well-born and so called respectable girls would pose in the nude for their artist friends of both sexes because professional models were too expensive. Gertler wrote to Carrington: 'Tonight we danced at Brett's. That little German girl you drew nude, dances *excellently*. She has a lovely little figure to clasp. Barbara [Hiles] is going to sit nude to Brett and me! That will be useful as I can't afford a model. Dodgson, Chile and young Spencer all thought that my "Apples" was the best thing in the New English [Exhibition].'

If these girls missed the last bus home, they could not afford to take a cab and would spend the night wherever they happened to be, even sleeping with the men two or three in a bed. The next morning they would make some fictitious excuse to their parents.

According to Mark Gertler and Geoffrey Nelson, these apparent opportunities did not lead to orgies – far from it! Such self-control and sexual inhibition were extraordinary to a young man with a Latin temperament. As for the beds, more often than not they had no sheets, and were just crumpled nests of grubby old coats and blankets, as far as he could see. Also, most of the girls looked slovenly and unkempt. Several artists he knew, such as Henri Gaudier and David Bomberg, lived in squalid bug-ridden rooms cadging meals or surviving on stale buns and scraps.

Although repelled by such sordid scenes, he was intrigued by the contrast with life in Chile, where his mother and sisters changed their linen every day and the modest, mysteriously veiled women had strongly attracted him. He wondered if his ideal type was truly one of them, or if he were still hoping to catch an elusive butterfly. Alvaro decided to experiment: boys could not have babies; moreover, they appealed to him both erotically and aesthetically. If he resorted to 'toms' it seemed there was always the risk of some dreadful disease.

During the spring vacation, true to her resolution, Mama Guevara took Alvaro to Paris. 'Little' Edmundo had grown into an enormous youth and was in the middle of a nightmare term at Wellington. Mama was able to justify her plan to Lucho; as

well as a cultural tour, the visit would be 'a mission of mercy'. A letter had arrived from Mme Villemin – apparently *une catastrophe emotionelle* had recently befallen Susana. Her fiancé, Leslie Moor-Aintree, had written to say that his mother insisted he break off his engagement. Poor Susana had taken to her bed for the last three days. In such dire circumstances, girls were known to 'go into a decline'.

Certainly when Mama and Alvaro arrived in Paris – where else but at the Hotel Majéstique? – Susana was consoled for some hours a day and she was able to forget her troubles.

When Paris became too crowded and hot, M. and Mme Villemin took a few privileged pupils to their villa near the sea at St Valery-en-Caux for 'Summer School'. How delightful if Mama and Alvaro could stay nearby! Mama thought this a capital plan: Edmundo could join them later. A telegram, requesting funds, was despatched forthwith to Lucho.

The Villemins' villa could not have been more different from their grand Parisian establishment. Susana noted in her diary that it was a pink and white cottage, in a tangle of rambler roses, small and pretty. In the *salon* there was always a scent of *potpourri*, which Madame kept in large bowls to overcome the smell of drains. There was no bathroom. The girls walked to the village for hot salt-water baths every morning.

The young Guevaras thoroughly enjoyed themselves. There were tennis parties in the afternoon, and they dined with the Villemins, who had a marvellous cook, or sampled *ménus gastronomiques* at local restaurants. The girls danced at the casino with their many admirers. Alvaro waltzed until he was dizzy. There were golden days when they and their friends drove in open carriages along cliff-top lanes past fields of corn to deserted coves. Alvaro acquired a becoming tan while the girls protected their complexions with sunbonnets and parasols.

To everyone's relief, when an ardent love letter arrived for Susana from Leslie, in which he defied his mother, she recovered her high spirits. She accompanied Alvaro on painting expeditions, they sat in the shade of poplars sketching thatched cottages which she described charmingly in her diary as: 'white broody hens sitting on nests of flowers'.

Each confided many secrets in the other. One afternoon, having shared and admired Leslie's letters and sonnets, Alvaro produced

55

a letter of his own, admitting that he would not show it to another soul. Susana wondered if it could be from a girl; but no, it began: 'Chile, you are a genius!' and was signed, 'John'. She was mystified.

Alvaro explained that in London he was now called 'Chile' by everyone, just as the Spencers were dubbed 'Cookham One' and 'Cookham Two'. 'John' was Augustus John, who still took a great interest in the Slade. He was a marvellous and famous painter. He admired Alvaro's work more than that of any other student. John had 'taken him up', introduced him to all the most interesting people in the artistic and social world; his wife Dorelia was intensely sympathetic as well as lovely. Their parties were incredible: guests turned up in fantastic clothes, much influenced by Bakst and dancing went on until dawn; some friends would stay even later and Dorelia would invite them to English breakfasts.

John loved to make Alvaro dance. There was a craze for dancing in London. Gertler's girl, Carrington, and her friend Barbara Hiles, were so afraid of wearing out their only silk stockings that they took them off before they walked home. Susana thought of the dozens of pairs in her own chest of drawers – what would be the point of wearing them out at diplomatic balls, flirting with pompous bores? She listened spellbound to Alvaro describing his adventures with John in London.

It was John who had first introduced him to the Café Royal, where he held court; it was an honour to be invited to his table. Other students, such as Gertler, Bomberg and Rosenberg, would never presume to join his entourage, which could become very wild. No, he could not possibly take Susana and Sibila along: no one would take a sister there! There were of course a few girls. Nina Hamnett was one. Although she sometimes drank too much, she was a talented girl. By Chilean standards she sounded brazen and had even taken Alvaro to 'The Cave of the Golden Calf', a nightclub. It had been decorated by Wyndham Lewis and some of his friends, whom Alvaro knew.

He went on so about John that Susana was both exasperated and envious. The artistic world sounded so much more interesting, so much more fun than the conventional social round!

John had been the first to take him to breakfast in Fitzroy Street with Whistler's pupil, Walter Richard Sickert. Susana had

never heard of him but Alvaro explained that he too had been a student at the Slade a long time ago. He was in his fifties now and surrounded by an admiring circle of painters. Alvaro was in sympathy with the subjects that Sickert chose, such as the interiors of cafés and music-halls; Sickert liked to paint scenes of people in action – even misbehaving themselves! He said that figures, or even the subject of a portrait should be closely related to the furniture. Yes, the tables and chairs and carpets – the setting. He insisted that one should never overpaint, loading the canvas with 'Tuesday's paint on top of Monday's'. Alvaro scarcely knew whether Sickert or John impressed him more.

Roger Fry's exhibition 'Manet and the Post-Impressionists' had had a tremendous effect on Alvaro and many other students at the Slade. Despite the School's tradition for draughtsmanship, perhaps it was true that once one had mastered it, one could afford to throw it away? Susana did not agree; but Alvaro insisted that all artists should experiment in order to find themselves.

The second Post-Impressionist show at the Grafton had included some English work by painters he knew, or at least knew of, such as Wyndham Lewis, Duncan Grant and Vanessa Bell. Vanessa Stephen had married Clive Bell years ago. Alvaro wondered if Susana had met that young Spaniard in Paris, Picasso? He had contributed lots of things but he was a Cubist of course. David Bomberg and Nevinson were not the only ones who raved about the Cubists, who had probably inspired Severini and Marinetti, the Italian Futurists. It was a shame that he had missed their first exhibition at the Sackville Gallery last year.

When Alvaro and Susana were living in Chile, they had discussed modern English painting and found it hard enough to comprehend the aims of the Pre-Raphaelites. Now it seemed that the '-ites' were finished and replaced by the '-ists'. Really it was all terribly complicated – what with the Impressionists, Post-Impressionists, Futurists, Cubists, Symbolists, – and as for the Expressionists, headed by that Russian painter Wassily Kandinsky —his pictures of free-floating shapes in space were very strange; and in England now there were even the Vorticists.

After all, Alvaro felt bound to admit that fundamentally he was a traditionalist, a naturalist; or would he be called a 'naturist' in English? The two of them came to the conclusion

that the Spanish painters such as El Greco, Goya and Velasquez were the greatest.

While he and Susana were puzzling over these conflicting influences, Lucho had decided that Alvaro's artistic temperament had been sufficiently indulged. In a severe letter to Mama, Lucho wrote that he intended to terminate the lease of the London house. Alvaro should return to Bradford immediately. After his abysmal failure at the Technical College he must expect 'to start at the bottom of the ladder' in the wool trade: probably sweeping the factory floor. Even Professor Brown had said that it was impossible for an artist to earn a living.

Susana watched Alvaro writing his reply. It included some well-worn clichés – he 'would rather starve in a garret!' and suchlike.

Lucho took him at his word: Mama and the girls would not be requiring a London address in the future, so Alvaro would receive a pound a week to support himself: the resulting economic problems would surely bring him to his senses. For Alvaro, this idyllic interlude was at an end, and after a month in Paris, Mama and the girls returned to Harrogate and were once more installed at her usual hotel. Mama requested a new motorcar and of course engaged a chauffeur. Lucho and his wife Joyce were aghast at their extravagance although they themselves owned a Daimler and a Rolls-Royce.

Their disapproval increased when, a few weeks later, the Guevara ladies became restless and bored with the restrictions of provincial life.

Alvaro rented a ramshackle studio near the Slade in Maple Street. Most of the houses there were inhabited by 'toms', who frequented the Roebuck, a pub where he and fellow students often went for a glass of beer and a sandwich. He was very popular with these local ladies, who emerged from their dingy rooms around noon, wearing bedroom slippers and lace-trimmed pink flannel dressing-gowns. They would greet Alvaro affectionately and, now and then, he would treat them to port and lemon. Presumably in emergencies he resorted to a pawnbroker nearby in the Tottenham Court Road.

Despite his comparative poverty, Alvaro's letters to Susana made London sound so enviable that Mama decided that she

would like to rent another house in the capital. Alvaro, poor boy, must be starving on his meagre allowance: he could live with them. Life in Harrogate no longer suited the girls. Susana was miserable parted from Alvaro, and Leslie's letters had become unsatisfactory and rare. Mama thought she would invite Cousin Erich, Susana's first love, to stay in London the following year when he and Alvaro would prove admirable escorts at parties. She added that she was sure Lucho would be delighted to hear that dear Alvaro had just won the Second Prize for Head Painting and a Certificate for Drawing at the end of his first year at the Slade.

Once more, in face of such reasonable arguments, Lucho gave in and rented a house on Campden Hill for the recalcitrant members of the family.

This venture was not entirely successful. Alvaro proved of little use to his sisters socially; he seemed determined not to introduce them to his exotic and exciting new friends. Susana longed to meet Augustus John, but Alvaro ignored her entreaties and continued to live an independent, even secretive life. In the family circle, he became more and more reserved.

Disappointed, Susana wrote in her diary: 'Of course Mama won't allow *us* to go to the Café Royal', nor were the sisters allowed to visit such dubious places as a restaurant near the Slade called the Eiffel Tower, owned by an Armenian, Rudolph Stulik. Augustus John had made it a fashionable rendezvous for artists and their friends. Also, it was exasperating that 'The Golden Calf' was out of bounds.

Susana was not only interested to see the place where Alvaro danced until the small hours but longed to hear Lilian Shelley sing and to meet Nina Hamnett and Betty May. Alvaro stubbornly insisted that neither Sibila nor Susana would have anything in common with these emancipated girls.

It was also sad for his sisters that they never met their compatriot, Dona Errazuriz, and her nephew, Don Antonio Gandarillas. Antonio was in his twenties, and although *en poste* at the Embassy in Paris, often visited his Aunt Eugenia in London. It was Ambrose McEvoy who first took Alvaro to her house. She was still beautiful, although in her fifties. Sargent had painted her, as had many contemporary painters, including

Jacques Emile Blanche, Boldini and Augustus John. After discarding her husband, a diplomat and a mediocre artist, Dona Errazuriz divided her life between London and Paris, entertaining the *haut monde* and original, creative young men such as the Spaniard, Pablo Picasso. It was she who encouraged Stravinsky with the gift of a piano. After his ornate and luxurious home in Chile, Alvaro found her stark, simple rooms refreshing. She had innovated a style of interior design which had an important influence.

The Guevara girls had to content themselves with the less inspiring patronage of Mama's ally, the Chilean Minister's wife, Dona Olga Edwards. She herself supervised their fittings for the white satin dresses they would wear when she presented them to the King and Queen the following year. She coached them in court etiquette, taught them how to secure diadems surmounted by the Prince of Wales' feathers in their *coiffures*, how to curtsey gracefully without bending – all debutantes practised this feat with bags of beans on their heads – and how to walk backwards from the Royal Presence without tripping over their cumbersome trains.

Alvaro found these rehearsals at home very comical. He grinned delightedly when their knees cracked, or they toppled over. As if to compensate for his neglect, he agreed to accompany them on Sunday mornings to the church parade in Hyde Park. He made a handsome escort, wearing his silk hat, but confided in Susana that he thought the dowagers 'looked like circus horses in their elaborate trappings and some of the *gringos* resembled armchairs upholstered in Chintzes'.

Mama's tolerance of Alvaro's apparent indifference towards his social obligations proved justified when he and his prize-winning work won increasing prestige with the staff and students at the Slade.

During the summer term he had found favour with the lecturer, Roger Fry, who had suggested that he should join the group of young artists at the Omega Workshops which Fry had founded in January 1913 and opened in July 1913 at 33 Fitzroy Square for the production and sale of applied art. Many of those who had been invited to participate had attended the Slade at some time, including Wyndham Lewis, who was now over thirty, little Albert Rothenstein and Edward Wadsworth, who had left

the term before Alvaro took up his scholarship. Duncan Grant was another and only slightly younger than Lewis.

The Omega Workshops proved a blessing to Alvaro's impoverished contemporaries. Nina Hamnett introduced Henri Gaudier, who was able to earn a few shillings an hour painting fabrics, rickety furniture, lampshades, screens and trays. Lately, Henri and Nina had been reduced to robbing graveyards of odd bits of marble and stone to provide material for his sculpture. Those artists who were regularly employed were paid thirty shillings a week.

Alvaro had little time to join in the Workshops' activities because Brown and Tonks had both encouraged him to exhibit his canvases at a gallery with which the Slade was affiliated – the New English Art Club, founded by Wilson Steer in 1886. Also, Augustus John recommended him as a portrait painter to patrons among the avant-garde. The life-class was amazed when Alvaro showed them a cheque for forty pounds, an advance on a commission from a titled lady – this was an enormous sum for a beginner.

During the winter term he became even more elusive. He was often away for the night, or for a whole week-end. Mama rarely asked him to explain. She was proud of her handsome son, but had no idea of the devastating effect he had on both sexes. His family would have been horrified had they known that the young tradesmen and errand boys who called with frames and photographic plates, especially one recommended in all innocence by Augustus John, were either succumbing to his blandishments or at pains to resist them.

Later Alvaro confessed that, during torturing moments of introspection, these homosexual experiments filled him with shame. He determined to find a woman. Nina had already proved available, but at times he found her repulsive.

Many of the girls at the Slade were infatuated with Chile. Miss Williams was a notable exception and referred to him as that 'dreadful South American'. Alvaro was amused. When she was out one day, he painted the back of her canvas with a large Union Jack and superimposed an unflattering sketch of her priggish face.

The fact that she now, understandably, refrained from using the ladies' lavatories had not escaped notice. As if for her per-

sonal convenience, a battered tin 'po' would appear mysteriously in conspicuous places on the most inappropriate occasions. A row of top-hats on the window-sills in the hall would herald the approach of the Visitor, Sir Edward Poynter, P.R.A. and an entourage of distinguished guests. Together with the staff they would make a tour of the building. The hierarchy were at pains to ignore the 'po', filled with suggestive coloured water and soggy paper, under Miss Williams' 'donkey', as the stools on which students sat were called.

Whether Alvaro or one of the Cookhams was responsible for this rather cruel prank is not recorded.

As far as the other girls were concerned, Chile seemed more aware of their femininity than his English counterparts. They admired his 'powerful physique, his exotic good looks, honey-coloured skin, blue-black hair, flashing eyes and teeth'. His foreign accent and speech, so evocative and original attracted them; but at times they were baffled by his sense of humour. They were not sure if he were in earnest or joking at their expense in some subtle way. It was exciting to watch him box on the lawn in the lunch hour with the Italian model, Fred Mancini. He taught them the tango, and even Carrington and her friend Barbara Hiles agreed that it was great fun to dance with Chile.

Among Alvaro's most ardent admirers was Theodosia Townshend, a small, pretty girl who took her work very seriously. She was well-born so it was unthinkable to seduce her. Nevertheless, he liked her so much that she became his confidante. She was susceptible to handsome men and worshipped Professor Brown. She admitted that her hand always shook when she waited for him to criticise her drawing. One day, when she was gazing up at him in awe, waiting for the verdict, her heart gave a jump – he was staring back at her! 'Before striding away "There's a smut on your nose," was all he said.'

Among the newcomers during the winter term of 1913, were two girls who were bosom friends: Diana Manners and Iris Tree. Diana was the third daughter of the Duke of Rutland. So far as Brown was concerned she was wasting his time and hers. As a rule, titles prejudiced him; however it was studio gossip that he was hoist with his own petard and had fallen in love with the Hon. Dorothy Brett. The more plebian students were impressed by the aristocrats among them: 'Brett' as she was called,

was unfortunately deaf. It was rumoured breathlessly that since childhood she had been on familiar terms with all the Royal family and actually called the younger members by their Christian names!

All this gossip and more was relayed by Theodosia to Chile. She confided over a glass of beer at the Roebuck that one morning the Lady Diana had arrived disgracefully late, wearing a décolleté red velvet dress. Perhaps she had been up all night at a ball and had not been to bed? Anyway, Brown was livid and his criticism of her work in front of the class had been withering.

Professor Brown would ask such girls, of whom he disapproved, suspecting that they were simply filling in time until they made a suitable marriage: 'Can you cook? Can you sew?' If they answered: 'Yes,' he would advise them brutally to go home and do it. If they said 'No', he would walk away spitting out the word 'Pity!'

He was even less lenient with the boys. When young Bernard Leach arrived as a potential student, he asked his father if he were rich: he would need to be if his son wished to be an artist. In the men's life-class Brown would stealthily approach some earnest attempt, crouching like a tiger about to spring, and growl: 'What is it? What is it? An insect? *Horrible!*' Alvaro was a favourite, but even he did not escape the occasional rebuke. At a meeting of the sketch club, Brown brusquely announced that while the men must remain standing, the girls might sit. With a sharp look at Miss Williams, and presumably Dorothy Brett, he added, 'ladies' under his breath. Alvaro did not take this as a command to remain at attention and leaned back against the wall. Brown shouted: 'I did not say *lounge*, I said stand, Guevara!'

Lady Diana fared better with Ambrose McEvoy. He was much loved by the students, who knew that he was in fact impoverished despite his eyeglass and astrakhan collar. He lived in a damp, ramshackle studio on the embankment with a devoted wife and three children who were terribly pale and thin, according to Theodosia. He was by now bored with the Slade and obsessed with painting beautiful women. Lady Diana sat to him several times and was invited to his Bohemian parties. On her first visit, she noticed a conversation piece of Don Antonio

63

Gandarillas with his wife and children, which had been commissioned by his Aunt Eugenia Errazuriz.

Although Alvaro later became more involved with Lady Diana when his brother-in-law married her niece, he preferred Iris Tree, the daughter of Beerbohm Tree, the actor. Her connection with the theatre appealed to him and when he discovered that she wrote poetry, this created an even stronger tie.

To students such as Keith Baynes – of whom Sickert said 'he made a modest talent go a long way, whereas only too often a so-called genius proved but a flash in the pan' – Alvaro 'seemed to float through life, on the crest of a wave. He appeared unspoilt, although rich, talented and handsome. He was welcome and at ease, whether with buskers or duchesses, he was always ready with a funny story – he had been caught drunk and naked in the hall by his landlady, lost his bicycle under comical circumstances, become involved in some dramatic fight.' Keith wondered if in order to be loved Chile deliberately played to the gallery. To most of the students he gave the impression of being a privileged boy of eighteen without any worries. Few realised that in fact he was tormented by an overwhelming problem. He had given up hope of finding a girl with whom he could establish a natural relationship.

His friends, Rothenstein and Nevinson, confided that whores disgusted them now and neither had made any progress with the fascinating Carrington – she seemed to hypnotise most men in or out of school. Unlike Alvaro, a passionate Latin, they felt no temptation to sublimate their energies by provoking a brawl in the Café Royal, or to engage in casual homosexual encounters.

In Alvaro's mind, due to his upbringing and respect for his sisters, female students, however desirable, were taboo if they were *ladies*. The models who posed in the nude were mostly recruited from Soho and related to that superior boxer Mancini. Alvaro did not care to risk a vendetta with him.

These gloomy facts were bemoaned over many a glass of beer in front of his confidante Theodosia. It was just possible for a girl like her to visit the local pub in the morning – but never after six. She had resigned herself to a platonic relationship with Chile; he did not introduce her to his family. In Theodosia's opinion he and Geoffrey Nelson were the most attractive men at the Slade, but 'Geoffrey was a terrible flirt and a shameless

borrower'. She was sure that Chile, having Spanish blood, was far more original and passionate.

Not all the models were Italian; sometimes a local Cockney tart, wanting to fill in time, was engaged to sit at a shilling an hour. Occasionally there were even educated girls, mostly traditional vicars' daughters from the north, who had been turned out, or run away from home after some minor scandal, hoping to find a more sympathetic life in the capital. The students scarcely ever spoke to these unfortunates. After work, huddled in cloaks, they scuttled back to their lonely suburban bedsitting-rooms.

As if in answer to the young men's prayers, in the winter term of 1913 Brown engaged an entirely exceptional model. Alvaro could scarcely believe his eyes when he first saw her: true, she was not his fair butterfly ballerina, as her skin and hair were dark – she could have been Spanish. Her face was remarkably distinguished and bereft of cloak and mantilla she revealed a mature and luscious figure.

During the break he could not believe his ears. In a musical voice, she held her own in discussions on contemporary art and literature. Her name was Leila Potter.

Theodosia was impressed by Chile's goddess, and slightly jealous. He raved about her to Nevinson and Rothenstein: she was a vision, a miracle – at last the fig tree had flowered! This expression, although typical of Alvaro, was lost on them: perhaps they found it ambiguous. Although sceptical, they had to see her: any excuse would serve for them to call in on the life class before lunch one day. There she stood on the dais, just as Chile had described her – tall, beautiful, magnificent.

When she was dressed, Alvaro suggested that she should join the three of them and his friend Theodosia at the Roebuck. As they walked down the street Alvaro and Leila dwarfed the others: it was curious how much they resembled each other. At first, the men were tongue-tied. They were embarrassed by her clothes – not that they were unbecoming or unsuitable, far from it, but the fact that she wore any at all made her look so dignified, well-bred – and therefore unapproachable. She was smiling and seemed completely confident as she drew off her French suede gloves and adjusted her spotted veil to drink her glass of beer. They listened, ill at ease, while she made sophisticated conversa-

65

tion with Theodosia. After his second pint, Alvaro asked her if she had Spanish or Italian blood. Perhaps. She shrugged and seemed not to care. She was reticent about her past, but amazingly frank about the present. She was twenty-seven! To Alvaro, this seemed incredibly old – for a while he became inarticulate. In Chile, women of thirty were ... In Chile! The others all laughed.

Within a week she told them that she was being kept by a man whom she did not care for particularly. But he paid her rent, made her an allowance. Their hearts sank – they had all noticed that her boots were kid and her stockings were silk. She was free all day and, being interested in art, had decided to try her luck as a model.

After a few more meetings without Theodosia, the three men decided to make Leila a proposition. She had become rather cool lately. Over a drink, Alvaro explained that alas, none of them could afford to replace her protector, or employ her every evening as a model, but if he and his two good friends shared responsibility for her, would she consent to *pose* for them after school? It was difficult to find a model whose company was so agreeable.

She promised to think it over. For the next two or three weeks they were all on tenterhooks. Leila was inscrutable; there were no more meetings at the Roebuck. Theodosia wondered what could have gone wrong. Alvaro was evasive when they met in the breaks and seemed preoccupied, engaged in endless discussions with Nevinson and Rothenstein.

The three men agreed that if they succeeded in persuading her, she could pose for them all any night, but each must take his turn to stay on after the others. Alvaro pointed out that at week-ends he had family obligations: he must accompany his sisters to mass and afterwards to that absurd fashion parade in Hyde Park. All of them had commissions to fulfil, so eventually they decided to draw up a rota and divide six nights of the week between them, leaving her free on Sundays.

By the end of the winter term negotiations with Leila reached a satisfactory conclusion. According to the devoted 'toms', Alvaro's old studio in Maple Street was available and thanks to commissions Alvaro was able to pay his share of the rent.

Throughout the following year his family rarely saw him. He

would dash back from the Slade, bath, change and rush out again.

According to Susana's journal, in June she and Sibila were presented at court together with 'Princess Henry of Battenburg, Princess Victoria of Schleswig-Holstein and her sister Marie-Louise; Lady Irene Curzon and Miss Elizabeth Asquith. A party of Indian Princes and Princesses were dazzling with their rich jewels and colourful costumes. King George wore the uniform of the Royal Horse Guards, Queen Mary in glittering brocade, a train of Irish lace and her superb emeralds and diamonds.'

The night before, one of the debutantes, a protégée of Mrs Pankhurst, instead of curtseying to their Majesties, had darted forward flourishing a petition headed *Votes for Women*. She was hustled out as sheaves of paper fluttered around the thrones. To everyone's relief no such embarrassment marred Susana's presentation.

But by a curious coincidence, on the following day, Mrs Pankhurst herself found refuge in a house on Campden Hill directly opposite the Guevaras. When the police arrived to arrest her, Alvaro heard her cry: 'They must give us freedom or death!' This was her ninth imprisonment.

On June 28 1914 Susana commented in her diary on a game of cricket. The assassination of an Austrian archduke in Sarajevo reported in the same day's evening paper passed unremarked.

In August, the end of the London season, Mama Guevara rented a furnished house in Scotland. She, Alvaro and the girls spent the summer holidays in a 'simple cottage with six bedrooms near Aboyne, about forty miles from Aberdeen'. Edmundo had gone to stay with schoolfriends. Cousin Erich Dietrich was due soon after they arrived.

They had no car and the minimum of servants. After the frivolities of their life in London, Lucho decreed a simple, healthy existence.

For the first few days the young Guevaras followed his advice, playing golf and taking long walks in the rain over the moors with friendly neighbours. The climate did not appeal to Alvaro: how different it was from summer on the Cerro Alegre! Perhaps he regretted losing his place on the Maple Street rota.

In June, Wyndham Lewis had edited and published the first

number of a magazine called *Blast*. The title was appropriate:
even the typography and layout were violent in style with their
heavy blocks of black and white and savage underlining. Most
of the contributions were from writers and artists in their twenties
well-known to Alvaro, including Epstein, Nevinson, Wadsworth,
Roberts, T. S. Eliot and Gaudier-Brzeska.

Lately, Lewis had broken away from Fry's Workshops with
other human splinters who as Alvaro and Susana already knew,
called themselves Vorticists. This appropriate pseudonym was
coined by Ezra Pound the poet.

Although the *Morning Post*, a popular paper with Chileans,
had described this journalistic experiment as a 'vast folio in
pink paper, full of irrepressible imbecility...' the *Manchester
Guardian* had found much to praise and *The Times'* criticism
had been lenient.

Just as nearly seventy years before another group of rebellious
young artists, the Pre-Raphaelites, had concocted a curiously in-
consistent list of Immortals, so the Vorticists produced their own
incongruous collection of personalities and characteristics deemed
fit for beatification; they blessed the Pope and that deserving
Patron of the Arts, Lord Howard de Walden; the sympathetic
critics Konody and Rutter, Gertie Millar, the gaiety girl, Madame
Strindberg, the notorious proprietress of 'The Golden Calf';
Frank Harris, the controversial writer, the Commercial Press Co.
[sic] and castor-oil.

Alvaro found that many of his friends were blasted: Pro-
fessor Tonks, the Chenil Gallery and Clan Strachey were lumped
together with Beecham (pills, opera and Thomas) and cod liver
oil.

Alvaro abhorred quarrels, especially between his friends and
was always at pains to keep the peace and remain neutral. Unless
actually boxing, or goaded to violence by personal jealousy,
physical or emotional, according to many contemporaries he
possessed the most gentle of natures at variance with his pugilistic
appearance.

His loyalty to Fry, one of the first to appreciate his work, was
as strong as his devotion and gratitude to John and Sickert.
After three years in England, his English although still original
was excellent. Nevertheless, he was not a little disturbed by this
first puce-covered issue of *Blast*.

68

Lying on springy beds of heather below the screes above the moor, poring over his well-thumbed copy, Alvaro could forgive his family and the conventional Scottish neighbours for assuming that all or most of the illustrations were by the editor, Wyndham Lewis. Certainly there was little difference between his style and that of Nevinson and Wadsworth.

Of course he agreed with the Vorticist dictum that 'intrinsic beauty is in the Interpreter and Seer, not in the object or content' and that 'Popular art' did not mean 'the art of the poor people', as supposed, but the art of the individual. Such sentiments certainly met with his approval. Also, the more conventional Pre-Raphaelites before him, and Norman Douglas, whom he had not yet met, agreed that it was 'not necessary or preferable for an artist to be an outcast, Bohemian, poor, or unkempt, any more than it was to be handsome, rich and elegantly dressed'.

There were, however, some Vorticist diatribes with which he could not identify: such as 'the poor are detestable animals . . .' The plight of Griselda the laundress and the slums of Valparaiso still haunted him. Such victims of injustice and misfortune were not bestial; only too human! 'The rich are bores without exception.' In his view this statement was absurd and yet, in their manifesto, the Vorticists claimed to be the 'Primitive Mercenaries of the Modern World'.

Aesthetically, he felt buffeted and bruised by the spiky angularity of the illustrations, especially those by Edward Wadsworth, a fellow student at the Slade. To Alvaro, a romantic, such acute observation conjured up the image of a dangerous reef. As a Latin it was natural that he should find the draughtsmanship and classical allegories of John more sympathetic; he thought his portraits quite admirable, and in the finest Spanish tradition. The sensuous curves and arabesques of Matisse, which inspired Fry and the young who clustered around him, were far more appealing to him than the Vorticists' work at this time.

He also felt bludgeoned by some of their poetry. He preferred to take refuge in rhythmic verbal music, alliteratively soothing, sonorous and soporific, a style already innate in that strangely beautiful girl Edith Sitwell, whom he had already met. She had made an extraordinary impression.

On the other hand, he realised that his love of poetry and

music was allied to a compulsion to dance and indulge at random in dizzy waltzes, voluptuous tangos or wild fandangos.

During that summer of 1914, there were dark moments when he felt despair as he struggled with all these conflicting ideas, he wondered if he could ever again find in himself the true stimulation which artists derive from experiment. He wished that he and Leila were in each other's arms, or doing a cakewalk *chez* Madame Strindberg. His sisters, who had learnt *el Highland Fling* from Dona Rosita, enjoyed cutting a caper with the locals. Presumably, the reels, like the whisky, were invented to keep the natives warm. How extraordinary they were, eating their porridge standing up or walking about while bagpipes wailed round the breakfast table! His sisters were now wearing kilts. The more hideous geometrical plaids and tartans seemed like Vorticist designs to him.

These reflections on the remote and isolated society of the Highlands were already being overtaken by shattering events elsewhere. Although Alvaro affected to ignore the rumours, they were all alarmed by newspaper reports forecasting war: the Germans had seized Luxembourg. Firing had been heard in the North Sea; they had crossed the Belgian border.

On the morning of August 5, the girls' personal maid rushed into Susana's room waving a copy of *The Scotsman*. Black headlines announced that England had declared war on Germany. Seizing her dressing-gown and gibbering hysterically, Susana ran downstairs to Alvaro, who was staring moodily at a grey heap of porridge. No, he had not heard the news. He was incredulous.

War, against Germany in particular, was inconceivable to all the Guevaras. They had loved German Grandmama; to regard Cousin Erich as an *enemy* was ridiculous! Why, he was due to arrive tomorrow. Susana's first thoughts were of Leslie: his regiment was in Africa. Would he be sent to France, or would he return to England? Panic-stricken, she clung to her brother. He tried to reassure her: while admitting that the Kaiser was too ambitious, Alvaro was certain that England would only enter Belgium as a matter of form. 'There will be no fighting and it will all blow over in less than a month.'

When Lucho wrote, Mama read out scraps from his letters: 'The bank rate has gone up; what will become of us all? An increase of five points has just been announced ... in wartime,

how can a business prosper?' He wished that *he* had the time to enjoy long walks in the country. He made it clear that the responsibilities weighed heavily on his shoulders: indeed he was sleepless with anxiety. 'The family should show more concern: since Papa's death, you all hold shares in the company.'

An unsigned card arrived from Erich with a Belgian postmark. The message was short: 'Trying to get back to Germany.' Germany! By now the very name evoked hatred and horror in Britain. 'But Chile is neutral!' Alvaro kept reminding them all, 'Susana is engaged to an English officer and we are all domiciled in England'.

'And don't forget that in order to live, as Lucho says, we depend on our mills,' Sibila added.

At last on September 15, a long telegram arrived from Leslie. In a few days he was embarking for France. He implored Susana to join him and his parents, who were still hostile towards her, at a Southampton hotel.

Mama agreed that she might leave. Alvaro could accompany her as far as London. She assumed that despite the emergency, the winter term at the Slade would soon begin.

Alvaro tried to comfort Susana. They sat up all night on the train with many other bewildered people. When they reached London and he saw her off to Southampton, they were speechless with emotion and their faces were wet with tears.

5

Alvaro discovered that his English friends were extremely divided in their attitude towards the war. Within the first few months some, inflamed by patriotic fever, rushed off to volunteer and were deeply critical of any who were not wearing a uniform of some kind.

The question of whether England should enter the war at all would never have been debated had it not been for a courageous protest from Philip Morrell, the Liberal member of parliament for Burnley. His wife Lady Ottoline had hoped that the Prime Minister, Herbert Asquith, would make her husband an under-secretary, but this pacifist speech ruined his political career – the House shouted him down and he was suspected of pro-German sympathies.

Anti-German propaganda was intensified. Even dachshunds were stoned and kicked as the whole country clamoured for conscription, but as yet Lord Kitchener, the Secretary of State for War, had only decreed that volunteers could choose between serving abroad or at home defending their country. Huge sentimental posters appeared on the hoardings pointing an accusing finger at those who might hesitate to join the armed forces or assist the war effort in some acceptable way. Such shirkers were condemned as cowards, to be despised by their nearest and dearest.

Detestation of the Germans at last became so violent that not only members of the Royal Family but many others changed their names, such as Albert Rothenstein to Rutherston, and Nina Hamnett's husband from de Bergen to Kristian.

Alvaro, so obviously physically fit and still dressed in elegant mufti, was accosted by hysterical people in the streets who attempted to stick white feathers in his lapels or on the handlebars of his motorbike. He would protest his neutrality and offer to take on any one of the crowd in a fight there and then.

It was natural that he should be drawn into the circle round the Morrells which consisted of painters, writers, university students and the more liberal members of the upper classes who were mostly anti-war although by no means unpatriotic. Bertrand Russell, Lady Ottoline's lover, was the prime leader of the pacifist campaign.

Ottoline was susceptible to brilliant or attractive men. Philip was unpossessive; his attitude to marriage was as liberal as his politics and allowed his wife a certain freedom. The arts had always appealed to her, but she herself was interpretative rather than creative, gifted with an infallible instinct for recognising the exceptional qualities which would make some recent young acquaintance famous or at least distinguished in the future.

A few years before the war, she and her husband had encouraged the foundation of the Contemporary Art Society, whose meetings took place at their house, 44 Bedford Square. Among others, Roger Fry and Clive Bell were members of the committee, so it was probably Fry who introduced Alvaro to the Morrells.

Sir Leslie Stephen's unconventional daughters, Virginia and Vanessa, were their Bloomsbury neighbours. One of the guests who impressed Lady Ottoline most at their informal parties was Lytton Strachey, a delicate, rather alarming man whose literary reputation had yet to be established. He was already airing his conscientious objection to the war and influencing those intellectuals who gathered around him. He and Ottoline became close friends although he was an obvious homosexual.

Alvaro found Ottoline a formidable, eccentric hostess. She was exceptionally tall and, by his standards, certainly not beautiful; with her noble features she resembled a handsome horse, at times even a circus horse. To compensate for what she lacked in feminine looks, she determined to make a dramatic impact: she not only dyed her hair a flamboyant red but dressed, or rather dressed-up, in a style which he found extravagantly elaborate. She applied the same stage management to her personality. Sadly

aware of being intellectually inadequate, she cultivated a manner so disarming and intimate that the most timid and newest acquaintance was subjected to probing questions or embarrassing confidence.

In his biography of Lytton Strachey, Michael Holroyd describes her: 'Loudly sucking and crunching between her prominent equine teeth a succession of bull's-eye peppermints, she would subject some of the shyer poets and more inarticulate painters to a series of insistent questions concerning their work and the specific details of their love-affairs. "M-m-m. Does your friend have *no* love-life?" she once complained in her drawling, deep, resonant voice to a poet who had brought some particularly reticent friend to tea.'

She took a fancy to Alvaro. The first time he was invited to Bedford Square was in March 1915. He probably felt completely at ease as his fellow students, Geoffrey Nelson and Dorothy Brett, were also there. Always impatient of polite exchanges, he found her direct conversation and unorthodox manner appealing. When he took his leave, bowed and thanked her for receiving him, she said: 'But you must come again,' adding vaguely, 'and do bring anyone you like.'

Even among the most critical, few could resist her and the general effect she created, but like all women with strong personalities, she could not avoid making enemies and their attacks were sometimes malicious.

When Alvaro next visited the Morrells in Bedford Square he chose to take along a young Japanese dancer called Michio Ito, whom Lady Ottoline found delightful. According to her 'he had a long, dark, antique type of face, like a monk, and as he danced his movements were marvellously beautiful'. She wrote that she would 'never forget the dance that he invented to "Yip i Yaddy i Ya"! He would ask Philip to play a tune through, then think about it for a few minutes, and then start his interpretation of it, wild and imaginative, with intense passion . . .'

Gordon Craig, the theatrical designer, inspired by Noh, had lately created a craze for masks. The girl students whom Mark Gertler brought from the Slade to Ottoline's parties: Brett, Faith Bagenal, Barbara Hiles and of course, Carrington, with whom Gertler was still wildly and unhappily in love, found that these masks compensated for their informal appearance in trousers

and cotton shirts. They could not afford to compete with the exotic fancy dress worn by other guests and were ushered into the drawing-room as 'mysterious strangers'.

Small wonder that Alvaro found the company at Ottoline's more relaxing than some of the smart soirées to which he was invited. Ottoline rightly believed that the pressure of unhappiness caused by the war was so appalling that these weekly giddy diversions were welcomed by those who, being pacifists, felt the horror most intensely. Certainly, these conscientious objectors were not heartless or callous, and deserved – needed – a few hours escape from the dark anguish and 'dull grinding agony of war'.

Poor Susana received three long letters from Leslie, giving horrifying accounts of the long marches, the fighting and the appalling conditions in the trenches. After an alarming silence, she heard from Leslie's parents that he was missing and when last seen he had been wounded in the leg. Perhaps he had been taken prisoner? Alvaro promised to call on various neutral friends and beg them to make enquiries through their embassies in Berlin. The results were negative: Leslie was presumed missing.

Fearing that she might collapse under the strain, Mama suggested that Susana should join Sibila and herself at Harrogate. They could all stay with Lucho and Joyce. She was aware that neither the *ménage* nor the environment would appeal, so added, as an inducement, that Alvaro would join them now and then.

When he arrived for week-ends, he found the overcrowded house full of tension. The sisters thought Lucho unsympathetic, not realising that he too faced innumerable business problems. Each morning before leaving for the mill, he warned in sepulchral tones: 'Be prepared for the *worst* – any time an official telegram will arrive from the Foreign Office confirming that Leslie has been killed in action.'

Alvaro's sympathies were divided. Susana found work in a local hospital, but even this distraction was forbidden when Lucho heard what menial and degrading tasks she did. The old family slogans were angrily repeated: the Guevaras were not serfs; they had royal blood; Papa would turn in his grave.

Alvaro was now twenty and mature for his age. When confronting Lucho on behalf of his mother and sisters, his manner

was authoritative. Suitable work could be found for both girls in London through a host of acquaintances. Mama had already agreed that there was no need to rent extravagant premises with a retinue of servants. A modest flat with four bedrooms somewhere in Kensington would suffice: they would manage with a couple of daily domestics. Alvaro himself offered to take responsibility, well aware that Lucho was engaged in complicated negotiations to land a contract to provide cloth for the blue-grey uniforms worn by the Imperial Russian Army.

Since long before the war the manufacture of synthetic dyes had been a German monopoly. When Russia turned to Britain for supplies, no firm succeeded in producing samples of the correct traditional shade. It was Lucho who triumphed finally by evolving a method of blending variously toned woollen threads into a fine worsted, which produced the desired effect. For the next three years the family mill prospered, working overtime to produce this exclusive material under the name of *Anglotex*.

The dread news of Leslie's death duly arrived; Susana took to her bed for four days. Mama sat by her side, hands folded in her lap, generating silent sympathy.

The move to London was precipitated by the tragedy. Alvaro decided to live with Mama and his sisters in London at 47 Holland Park Avenue, while retaining his share in the Maple Street studio.

It was during the winter of 1914 that Alvaro first met Nancy Cunard. They were introduced by his old friend from the Slade, Iris Tree. Describing this meeting years later, Nancy wrote: 'It was at the Eiffel Tower restaurant. The menu, printed in French, sported a cover by Wyndham Lewis, and at the bottom appeared a note describing the Vorticist room, a special private room with paintings and ornamentations by William Roberts. Seeing Chile there for the first time I was nonplussed by the tall, rather slouchy South American dressed in a black suit somewhat short in the arm. But I was struck by his fine, sensitive hands, which he always kept thrust deep in his pockets as he shambled down streets, with, of all things, a bowler hat on his fine massive head.'

During the next eight years, Nancy and her mother Maud had an increasingly profound effect on Alvaro's life. Nancy became his feminine prototype. In order to understand their friendship,

it is vital to know something of her background and her hypothetical parentage.

Legitimately and ostensibly, she was the daughter of Sir Bache Cunard, grandson of the founder of the shipping line. Although rich and well-established, with an estate in Northamptonshire and a magnificent house, Nevill Holt, he was modest and retiring – a typical country gentleman.

He was considerably older than Maud, his American bride, who married him when she was an ambitious girl of twenty-three, justifying marriage, cynically for her age, as 'a necessary spring-board to broader horizons'. Her origins have been described as 'the *haut demi-monde* of San Francisco'.

A year before the New York wedding, on a visit to London, she had fallen in love with the novelist George Moore, who was even older than Sir Bache. He was flattered and attracted by his young, vivacious admirer, so ravishingly pretty, and was gratified to discover her also highly intelligent. From their first meeting, he worshipped her for nearly forty years until he died.

Sir Bache was a tolerant husband, preoccupied with country pursuits. Within a year of their marriage, in 1896, Nancy was born, and George Moore became a frequent visitor at Nevill Holt.

Maud was determined to climb the English social ladder. She was bored by county neighbours: neither hunting nor shooting amused her. She had plenty of time, therefore, to transform the vast house. She banished Victorian clutter, made the rooms comfortable and wisely provided excellent food. Gradually, Nevill Holt attracted more entertaining guests. The frequent presence of George Moore obviously appealed to intellectuals; but much credit was due to Maud herself who, with her charming looks, wit and rare intelligence claimed many successful painters, writers and composers, as well as various aristocratic admirers as members of her entourage. The most amusing parties took place when Sir Bache was away, stalking in Scotland. At Nevill Holt he and his wife occupied different wings.

Maud succeeded in becoming 'a *fashionable* hostess', a derogatory term in the more conservative strongholds, disdainful of upstart Americans. She was condemned as 'fast', but when she suffered the occasional rebuff, she simply shrugged her shoulders

and turned it into a joke at the expense of 'the stuffy Old Guard'.

She was never maternal: Nancy grew up mostly behind the green baize doors, except when dressed-up to be shown off. Other children were rarely invited. The last of a procession of nurses and governesses was a strict disciplinarian, whom Nancy loathed. This paragon, and the servants indoors and out, always referred to 'Her Ladyship', never 'your mother'; the daughter followed suit.

Nancy was an unusually perspicacious, analytical child, acutely aware of the injustices perpetrated by grown-ups on the young, and by one class upon another – the gardener could not pick flowers for *his* little girl, only for the daughter of the house. The only creature she loved was her lame dog.

She was fond of Sir Bache in a distant way; but as she approached adolescence, it became increasingly obvious how much she resembled George Moore, who was known as G.M. On his long visits to Nevill Holt they delighted in each other and a conspiratorial affinity developed between them. He became more and more appreciative of her original personality as he realised that she was a natural poet.

'Are you my father, G.M.?' she asked, one day.

Despite his passionate interest in Nancy, he always remained loyal to Maud and replied: 'You must ask your mother.'

All this and far more, Nancy eventually confided in Alvaro; but she was no more than a reluctant debutante when they first met in 1914.

By then Maud had separated from Sir Bache and climbed the social scale to dizzy heights. The Prime Minister, Herbert Asquith himself, had rented her his London house. 'A young lady has to come out,' Maud said.

To G.M.'s disgust, political, diplomatic and musical interests now took precedence over literary priorities. Maud had fallen in love with Thomas Beecham. Because of Beecham's association with Diaghilev's Russian Ballet, she had furnished Mr Asquith's house, regardless of expense, in a style which might well have been designed by Bakst. A huge Chinese incense burner stood in the hall; there were bronze and black lacquer screens; painted backcloths. The dining-room was festooned with acid green lamé; the dining-table was a vast round slab of lapis lazuli. The whole effect was extravagantly exotic.

Like many women, especially Americans who have battled victoriously against prejudice in the world of their choice, she became almost absurdly intolerant and conventional. In her own way she was apt to lay down the law regarding correct behaviour for 'young ladies': they must always wear stays and never appear *maquillées*.

Nancy grew as sick of the pale tulle dresses from Paris as she did of the unnecessary stays. She was exceptionally slim, and had a fastidious appetite. Later, Alvaro was to remark that she was 'like a green stick caterpillar who survived by nibbling a dandelion's leaf'.

During the last London season before the outbreak of war, she had attended three or four balls a night, chaperoned by Her Ladyship. Maud had temporarily restricted her social life to the *milieu* she felt appropriate, and thoughtfully made lists of eligible men; after all, Nancy was not only beautiful but rich, and Maud was determined that her daughter should make 'a brilliant match'. Fortunately, Osbert Sitwell had passed muster as a desirable friend: he and Nancy sat on gilt chairs 'talking poetry'. But almost without exception (and what a medley of queer exceptions they finally proved) Nancy found the marriage market stocked with dull candidates. The champagne and decorous dancing did little to compensate. She preferred red wine and Negro jazz and Hawaiian bands, brought over from America by a reckless millionaire, who inveigled the dazzling Diana Manners into inviting her friends to his spectacular parties. Nancy too was a favourite of this picaresque character, whose name was George Gordon Moore, by coincidence.

In the midst of triumph, poor Maud suffered a setback: Queen Mary showed her enduring disapproval of Lady Cunard by inviting her and Nancy to a Garden Party instead of to a Court Ball. This blow was softened by the young Prince of Wales, susceptible from an early age to American hostesses, who danced with Nancy at her own coming-out party.

While Alvaro was in Scotland with his family, his two friends from the Slade, Diana Manners and Iris Tree, were staying with Maud and Nancy in a Palazzo she had rented in Venice.

On their return to England war had already been declared: a very different atmosphere prevailed. In order to escape from

the restrictions imposed by Her Ladyship, Nancy and Iris rented a clandestine studio in Soho near the Slade where they could compose and recite poetry, concoct fancy dresses and entertain unsuitable men. Iris wrote later that she, Diana and Nancy were like bandits' girlfriends with their cigarette smoking, chalk-white face powder and scarlet lipstick. They joined Augustus John at the Café Royal, and met Horace de Vere Cole and Osbert Sitwell in studio attics with the Bloomsbury Clique. Stray Tommies offered them lifts home on their motor bikes. These brilliant exuberant young people united at the Cavendish Hotel, the Cheshire Cheese, pubs in Limehouse, cab shelters and river barges.

As Alvaro was already painting Iris, it was inevitable that he should be included in many of their Bohemian parties and wild escapades, such as moonlight bathing in the Serpentine. Nancy was not only attracted by his striking appearance, but enjoyed his dancing: American jazz had a euphoric effect on both of them. She found his poetry fascinating and admired his painting so much that she introduced him to Her Ladyship.

Maud took a fancy to Chile. She had already heard his praises sung by those talented Sitwells, Professor Tonks and Augustus John. She commissioned him to paint her portrait; he saw plenty of Nancy while he was painting her mother.

During the spring of 1915, Lady Ottoline was preoccupied with the conversion and decoration of a Tudor manor house. Love at first sight had compelled her and Philip to buy this property in Oxfordshire – Garsington. The house was typical of its period, built of Cotswold stone with steep roofs and mullioned windows. On fine nights Lady Ottoline would sometimes sleep *al fresco* wedged between the tall chimney-stacks. The dark malachite green of cypress trees and gnarled holm-oaks chattering with jays, and of the yew hedges contrasted dramatically with the paler sloping lawns and graceful elms, under which scented china tea would be poured from a silver urn for guests reclining in the shade, nibbling wafer-thin bread and butter before the rich fruit cake.

The old fishpond, though covered with waterlilies, still enabled Lady Ottoline to indulge an erratic impulse to bathe, and orna-

mental statuary scattered around provided the perfect setting for *tableaux vivants* or impromptu plays.

It was a garden for peacocks. Lady Ottoline imported a predominantly masculine flock which performed, as if directed by Diaghilev, a stately pavane across the lawns, courting and spreading their tails to delight the spectators. A more lively diversion was provided by a pack of pugs which either tangled their beribboned leads around Lady Ottoline like ecstatic dancers round a maypole or, when released, proved pests to the visitors, snuffling and snorting and jumping on to their laps, and scratching and scrabbling at their thighs for titbits at mealtimes.

Ottoline could not leave the oakbeamed and panelled interior of the old manor house alone as most others might have. Anything 'acceptable' was horribly boring. The original beams and panelling soon disappeared under vivid coats of paint and layers of gold leaf, or were obscured by the modern pictures of such artists as Mark Gertler and Duncan Grant and by stencilled hangings from the Omega Workshops with designs inspired by the Cubists. Instead of linen curtains and rush matting, the windows were festooned with shot silk and the floors littered with oriental poufs and Persian carpets. A squawking parrot in a scarlet lacquered cage hung from a beam and interrupted the conversation of the guests as they struggled to resist the fumes from innumerable incense burners and joss sticks. Ottoline staged her personal appearance to suit this oriental setting. Beneath her huge feathered hats her hair became redder and fell in cascades of Cavalier curls. Herself a peacock, her fringed, tasselled, sequined cloaks and embroidered skirts swept the lawns.

Unconventional behaviour always attracts gossip. It is certainly true that many intelligent young men have at least one affair with an older woman of strong personality. The fact that during the summer of 1915 Alvaro was invited for three week-ends in quick succession caused some speculation. However, it is most unlikely that he found her in the least physically attractive, especially as on the first occasion he was accompanied by his devastating friend, the Japanese dancer Michio Ito. The relationship between these two men can only be surmised. The other guests were Bertrand Russell, Gilbert and Mary Cannan, D. H. Lawrence and his German wife, Frieda, Duncan Grant, Clive

Bell and Mary Hamilton. Maria Nys was one of the family, a Belgian refugee, a protégée of the Morrells. Lady Ottoline had arranged for her to be coached for a university education by Lytton Strachey. She was such a lovely girl that even her homosexual tutor was tempted to caress her.

The Morrells' nine year old daughter Julian was also there. She had already met Alvaro and some of his friends from the Slade at Ottoline's 'evenings' at Bedford Square. Between 1914 and 1921 she formed an impression of Alvaro as a man who was 'dark and attractive, rather shy and smiling a lot'. She saw that Mark Gertler was jealous of Chile, not only as an artist – he had followed John's example by becoming the Senior Student at the Slade and had won the Melville Nettleship Prize for Figure Competition and First Prizes for both Head and Figure Painting – but of his success in all strata of society. This was sad, as two or three years before they had been close friends. Gertler teased him and tried to make fun of Alvaro's passion for boxing, in the hope that the Morrells would find this absurd. It is understandable that Gertler, with his Jewish and East End background and his emotional problems with Carrington, should have resented Alvaro's privileged background and his success with girls, although never with Carrington. In fact her references to him and Augustus John in her letters to Lytton Strachey were mostly derogatory, though it appears that she admired Alvaro as a painter rather more than she did as a man: the sight of them both drunk at the Café Royal had disgusted her: 'John like a diseased Fish King... with a white cod-faced Chile...'. She told Strachey that Ralph Partridge, whom she eventually married, had been 'accosted' by Chile. However, as a back-handed compliment, on a visit to a New English Art Club exhibition she had to admit that: 'Even Chile's pictures were a disgrace...'

It would have been unfortunate if Ottoline had invited Gertler and Carrington with the Cannans that week-end. Gilbert had just begun writing *Mendel,* the novel he based on Gertler's life, which was to infuriate both him and Carrington when it was published the following year, 1916. Mary Cannan was the former wife of J. M. Barrie, who had divorced her so that she could marry Gilbert.

D. H. Lawrence, being a miner's son, was another who felt ill at ease with the upper classes in England, although his German

wife was well-born. David Garnett had introduced him, with good intention but disastrous result, to these Bloomsbury friends, thinking that they were bound to sympathise over the recently successful prosecution and confiscation by the police of Lawrence's book *The Rainbow*, less on the grounds of obscenity than for its condemnation of the war. To no avail Philip Morrell had asked questions in the House about its suppression.

Despite the difference in their backgrounds, Lawrence and Alvaro were drawn to each other. Lawrence regarded Alvaro as his masculine ideal – a prototype he could never hope to match because of his poor physique. To him Alvaro was totally hetero-sexual, passionate and sensual. Never by word or gesture did Alvaro betray his ambivalence. They shared an increasing dis-approval of the manners and morals of Garsington and Blooms-bury. When sex was discussed, Alvaro was always reserved. He did not condemn these people for their morals, how could he being bisexual himself, but for their bad manners and evident lack of shame. At first he listened with interest to the uninhibited conversation at Garsington, but the liberal way in which buggery was freely discussed before ladies appalled him. For a Chilean, such revelations were embarrassing – he felt that people should keep their secret lives to themselves and relapsed into silence.

Clive Bell, although scrupulously fair in his reviews of Alvaro's work, found him either tongue-tied and dull or, when his tongue was loosened by alcohol, tediously garrulous. Duncan Grant admired Chile as an original character and also as a painter, but Duncan had many emotional preoccupations at the time and they never became really intimate.

According to one of Duncan's letters to Vanessa Bell, both he and Alvaro were invited to Garsington again the following month. For nearly a year after this he seems to have avoided all but a few on the fringe of the pacifist, mainly homosexual Bloomsbury Group, preferring the company of less sexually com-plicated creatures such as Sickert, Augustus John, Nevinson, the Sitwell brothers and Matthew Smith.

As far as sex was concerned, Alvaro and his two friends, Nevinson and Rothenstein, were still content to share the favours of Leila.

In the summer of 1915, Theodosia noticed Leila's figure grow

gracefully pear-shaped. 'She looked like a Cranach: a delicate tracery of blue veins appeared on her distended, petal-white skin.' But no girl in the painting school so much as commented: even the word 'pregnant' was embarrassing; some euphemism might be employed – 'expecting' perhaps, or 'in the family way'.

The men's painting-class appeared curiously oblivious of the change in Leila's silhouette. The sculpture students cheerfully slapped more clay on their work each week, while Leila herself retained an admirable dignity as if unconscious of her swelling body.

It was not the first time that such a scandal had disgraced the Slade: when Nevinson was still a student, another model had produced a child. According to his book *Paint and Prejudice,* not only he, a proud philanderer, but seventeen other men including 'poor virgin Tonks' were all accused of being the father. When a friend remarked how much the baby resembled Nevinson, he gallantly offered to marry the girl, but met with 'a very rude refusal'.

Professor Brown received an indignant anonymous letter, possibly from Miss Williams, about this second unfortunate occasion. He was violently angry. During the break, Leila was handed an envelope containing a curt note from the Bursar dispensing with her services forthwith.

The same afternoon, Brown stormed into the men's life-class, accusing them indiscriminately for abominable, unpardonable conduct – their behaviour had been irresponsible. The students stood open-mouthed; Alvaro looked the most innocent.

It is easy to imagine that Leila's three lovers met without delay at the Roebuck to discuss this problem. By now Nevinson was already married to a beautiful and suitable girl, Kathleen Knowlman. For him, the arrangement with Leila had never been more than a temporary convenience: among artists in need of a model this was quite usual. But, more wary than the other two, and fearful of venereal disease, he had taken precautions from the beginning. He was on leave, having volunteered as a Red Cross ambulance driver.

Under all these circumstances it was therefore much to his credit that it was he who took the initiative and approached the Royal Free Hospital to reserve a bed for Leila's confinement.

Early one morning, in labour, she was bundled into a hansom. As soon as the Roebuck opened, the three men met Theodosia, who had resumed her rôle as confidante. Nevinson and Rothenstein suggested that Chile, being Leila's favourite, should visit the Royal Free first and decide which of them the child resembled most. After all, for months Nevinson had been away. Alvaro modestly protested that Rothenstein, being the eldest, should have priority, but eventually agreed to go. Nevinson insisted on lending him his bicycle – a new, expensive and noisy model with a motor. Chile would return all the sooner with the news. By now Leila's friends, the Maple Street 'toms', had joined in the animated discussion and agreed that this solution would please her. They sent affectionate messages and, muffled in the men's overcoats on top of their dressing-gowns, waved and cheered Alvaro from the kerb. With much spluttering from the engine, his bowler hat clamped on his head, he shot up the Tottenham Court Road, weaving his uncertain way between the cabs and drays.

More drinks were ordered all round: time passed in an atmosphere of agreeable merriment until Alvaro reappeared and, grinning with pleasure, announced: 'It's a boy!'

Above the clamour of congratulation, he patted Nevinson on the back and added that without a doubt 'it' was his. Theodosia noticed that, as a married man, Nevinson's reaction lacked the enthusiasm he had shown on a previous and notorious occasion. Thinking to console him, she remarked kindly, with a glance at Rothenstein who was thirty-four, that all new-born babies looked like old men. Nevinson was twenty-six. He departed without delay. By now Alvaro was treating his friends to a final round of drinks. It was decided that Leila's lovers and friends would all meet again when the Roebuck reopened.

By this time Nevinson had returned from the ward and confided how struck he had been by the child's uncanny resemblance to Little Albert.

Poor Rothenstein was too nervous to pilot the smoking bicycle through the blacked-out streets: he took a cab.

When he returned to the Roebuck, he said there was no doubt about it. Alvaro was clearly the father: Leila's child was the image of Chile.

Like many mothers of illegitimate children during the Great

War, Leila failed to register the birth. Being unable positively
to identify the father, she could not complete the form.

She disappeared. Her three lovers must surely have been re-
lieved, all of them by now being preoccupied with other girls.
Were she alive today, she would be in her nineties. If Alvaro
were the father, their son's blue-black hair might now be grey.

6

By now Alvaro was more conversant with English art criticism
whether of a serious or a mocking sort. The second edition of
Blast had appeared in July 1915, having been delayed for a year
by practical difficulties caused by the war. This issue was equally
controversial, but Alvaro was able to understand it more easily
than the first. Currently, the Vorticists, including Wadsworth,
Nevinson and Epstein, were holding an exhibition at the Doré
Galleries in Bond Street.

Due to his talent and personal charm, Alvaro was accepted by
even more lions at the Café Royal and enjoyed listening to them
roar. When sober he might venture a cryptic remark and, when
his reserve was liberated by alcohol, he would contribute to the
arguments and even hold forth. John was still his idol; in the
current number of *Blast*, Wyndham Lewis admitted that John
had 'incomparable power' and was 'a great artist . . .' while re-
senting 'the pseudo-gypsy hordes' that John had launched on the
town. But, to Alvaro's satisfaction, some of the Camden Town
men, such as Gilman and Ginner, were more or less uncondi-
tionally admired. Among the beatitudes of the great English
Vortex were – listed at random – War Babies, Selfridge, the
scaffolding round the Albert Memorial and all ABC tea-shops.
With this last blessing Alvaro warmly concurred. The ABC tea-
shop nearest the Slade had been a favourite refuge of his and
Leila's.

Among those blasted with no punctuation but in less heavy
type than before were – listed at random – 'Brangwyn etcetera,
Orpen etcetera, Bevan and his dry rot, Birth-Control, Mestrovic,

the Roman Empire, Lyons' tea-shops (without exception) and the Architect of the Regent Palace Hotel . . .'

Picasso and Matisse were severely condemned in a maddeningly arrogant review of Contemporary Art. The editor asserted that 'the extreme langour, sentimentalism and lack of vitality in Picasso's early stylistic work was a weakness, as definite as consumption or anaemia'. The same objections were made to the 'decorativeness' of Matisse. Fun was poked at Roger Fry and the Omega Workshops – 'Mr Fry's curtain and pincushion factory in Fitzroy Square'.

Picabia and Kandinsky were damned with faint praise; but it was the Futurists who were applauded for producing 'the best modern Popular Art'. It was left to the Vorticists to reform them and other contemporary groups, including the Expressionists and Cubists.

Although not to his personal taste, Alvaro could only admire many of the Vorticist illustrations, specially those by a past student, Wadsworth, and Lewis Himself. Henri Gaudier's contribution had been written just before he was killed at the front. [Henri was to be immortalised in H. S. Ede's *Savage Messiah*.]

It was easy for Alvaro to discuss the complex situation in the art world with Leila but impossible to explain to Mama and his sisters – even Susana who was the most interested. Despite their official Chilean neutrality, both had become horribly aware of the ambiguity of their situation, loving the English as a nation and as individuals and having German blood through their beloved grandmama. Their distress at the enmity of nations was echoed in their personal patterns of behaviour. Both of them had to find a middle way somehow.

From what Alvaro confided in her, Susana gathered that he still felt a staunch, unshakable loyalty to John, and loved Dorelia and their children. Also his fidelity to the Slade and to Roger Fry were unquestionable, despite the increasing hostility between the various factions which had splintered away from the original London Group. Those artists who stood by Fry and continued to admire Matisse and Picasso, however much derided by the Vortex and others, were already known as the Bloomsburys, or the Bloomsbury Group. Due to the complications of their emotional lives some wag later referred to them as 'pairs living as triangles in squares'.

All his life, as a Latin among lions, Alvaro's loyalties were divided; he was torn in two and eventually destroyed in the struggle to remain neutral. At this date, where art was concerned, the middle way led to rather harmless experiments in what had become known as the post-impressionist style. Many of these attempts, which recorded his excited reaction to scenes in pubs, circuses, boxing-rings and theatres, won praise from Augustus John, but Alvaro still felt dissatisfied, feeling they were too ephemeral. Once more his main solace was to return to the great Spanish tradition of portrait painting through which he was best able to express himself.

There were few people to whom he could explain his predicament. Often he became inarticulate, finding himself one of the audience, rather than playing a part; sometimes he was transported by alcohol and music and would whirl away to the sound of a tango or a Strauss waltz.

It was probably through Roger Fry that Alvaro first met Edith Sitwell. Fry was painting her at his studio in Fitzroy Street, which had once belonged to Whistler. Alvaro and Edith were complementary opposites and were immediately attracted to each other: she was so strangely beautiful and spiritual, he so handsome and physical. She was seven years older than Alvaro and was astonished to find a young Chilean art student writing English verse; poetry was their obvious bond.

Sickert's new studio was nearby in Fitzroy Square. He was most hospitable to the more promising students from the Slade and the Westminster where he taught. They were privileged to be invited to weekly tea-parties at his studio. It was Edith who took her elder brother Osbert to tea in 1916. Alvaro was already a favourite of Sickert's and it was through him that Alvaro discovered the London swimming-baths where, when not in the water himself, he sat on the edge drawing or painting 'pink people'. Roger Fry so delighted in his sketch book that he asked to buy it and Alvaro gave it to him.

Sickert was an early riser and a keen, strong swimmer at the Marylebone baths. After such exertions, he would give breakfast-parties in Fitzroy Square. The smell of coffee, sizzling bacon and fresh bread from the baker around the corner would waft down the rickety stairs to greet early birds. Later, in his memoirs, Osbert Sitwell wrote: 'Often I would meet at these breakfast-

parties Nina Hamnett, Alvaro Guevara, W. H. Davies and Aldous Huxley.'

On these occasions, Sickert was so preoccupied with frying eggs, slicing loaves or boiling milk, that conversation was restricted to comment on sensational headlines in the morning papers just arrived – the latest scandals of the Tichborne case or the horrors perpetrated by some maniacal murderer. Sickert was also fascinated by Haselden's cartoons in the *Daily Mirror*.

The Sitwell brothers, in return for Sickert's hospitality, would invite him to dine at Swan Walk or Carlyle Square. Osbert recalled in *Noble Essences*: 'Among others present [were] Arnold Bennett, C. R. W. Nevinson, Aldous Huxley, Nina Hamnett, Alvaro Guevara, Roger Fry and Clive Bell . . .' After dinner, charades were acted in the drawing-room at which Alvaro excelled. It was Sickert who introduced him to Walter Taylor, the painter and collector who, although not appreciated by some younger members of the Bloomsbury Group, became a generous patron of Alvaro's and commissioned him to paint a portrait of himself – one of his most successful works. Walter Taylor was the affectionate – and useful – godfather of a boy called Freddie Mayor.

In September 1915, Susana wrote in her diary: 'Air-raid over London last night. Went to see damage by zeppelins.' For a long time she had been working for the Serbian Relief Fund during the day, and washing dishes in hospital kitchens at night. She was prepared to do anything which might assist the war effort and take her mind off Leslie. As she boarded the last bus from Charing Cross to Holland Park, the conductor shouted: 'Look sharp Miss – jump on quick!'

There was a sinister droning noise getting closer all the time, punctuated by bangs and flashing lights in the sky. Fifteen people were killed a few minutes later. The bus crawled along the whitened kerb through the black-out. While Mama Guevara waited for her at home, she passed the time knitting dish-cloths, or other boring things.

Susana let herself in and cried: 'Come to the window Mama – look, it's an air-raid: the Germans are dropping bombs!'

Mama Guevara decided it was high time that she and the girls left London for Chile: they had suffered enough. She wrote to

Lucho at once. Obviously he and Joyce must stay at Harrogate because of the family mill. Edmundo must complete his education at Wellington College. As for Alvaro, he refused to leave: his career would be in jeopardy. But how would he manage?

It was not until the following spring that their passages were finally booked on the Royal Dutch liner *Tubantia*. Alvaro accompanied them to the station where a crowd of friends were waiting with flowers. They all looked suitably sad but surprisingly agitated: 'Don't bother to get out of the car!' they cried, 'Look at the poster!'

Alvaro read out loud: '*Tubantia* Sunk in Channel.'

'Sunk? But whatever shall we do?'

Mama Guevara was bewildered and Sibila was crying. Lucho took charge: they must return to Holland Park. Fortunately the flat was still free.

The next night Alvaro sat calmly drawing beside Susana's bed. She had collapsed in despair: Cousin Erich was a prisoner in Siberia. The war would last for ever! Every week she posted a parcel to Leslie, but each one came back: she refused to believe that he was dead. The London streets were horribly depressing, crowded with wounded soldiers, many of them limbless or hobbling on crutches, others blinded or with half their faces shot away. She always imagined that one of the cripples might be Leslie. To comfort her, Alvaro said he was sure that the USA would shortly come to the Allies' aid.

He had heard at lunch that the *Tubantia* had carried a cargo of Edam cheeses. Inside each cheese was an ingot of German gold, destined for Buenos Aires to bolster German credit. The secret was known only to a few in the German High Command. But – what a joke! – it had been too well kept! The U-boat captain who torpedoed the ship knew nothing of the plan. In less than three minutes the liner had gone to the bottom – with its cargo of two million marks of illicit gold!

Characteristically, Susana soon recovered her fighting spirit. When she reported, as usual, for work at the Serbian Relief Fund she was officially informed that the Crown Prince of Serbia was due that day and she – having worked so hard and so long for the cause – was to be presented. She was awarded the Order of Saint Sava and was the first South American woman to be decorated for war service.

The SRF sponsored an exhibition for the Serbian sculptor Ivan Mestrovic at the Victoria and Albert Museum. When Susana stood in the entrance selling programmes, a stranger with close cropped black hair, wearing a huge red bow tie, came up and said: 'You must be a Guevara! Resemblance *extraordinary*!' She was astounded, particularly as they had not been introduced!

When she told Alvaro the next day he already knew about this encounter. The unknown was Jacob Epstein, an old friend of his who had described the meeting the previous night at the Café Royal.

On another occasion noted by Susana in her diary, Alvaro was working all the morning on a canvas from more sketches he had made at Marylebone swimming-baths. He was obsessed by the glistening bodies half-submerged in the shimmering water.

Mama and the girls were unaware of Alvaro's social life: the few clues they had were not particularly significant. Susana still adored him but refrained from asking many questions, wisely advised by Mama.

She noted that one morning the parlourmaid announced that Mrs Rosa Lewis' motor was waiting outside for Mr Guevara. Alvaro put his brushes down and looked at his watch. From the drawing-room window the sisters watched his departure in a chauffeur-driven Daimler.

In a week or so he casually referred to a portrait he was painting of the late King's cook – adding as an afterthought: '*favourite* cook!'

'Cook!' Mama echoed in horror and astonishment, 'King Edward's cook!'

Patiently, Alvaro explained that Mrs Lewis was not only a favourite and fabulous cook but a highly respected, excitingly paintable and altogether admirable woman. She looked less like a domestic than a Duchess. In fact, she was the Duchess of Jermyn Street: she owned the Cavendish and her clientele included aristocrats and Royalty. The *jeunesse dorée* shared their secrets with her. All the most interesting and amusing people in London flocked to her hotel.

A stunned silence followed. It was broken by Mama, who asked, thinking of the Majestic in Paris and Harrogate no doubt: 'But is it a *nice* hotel?'

Sibila: 'Does that motorcar belong to her?'

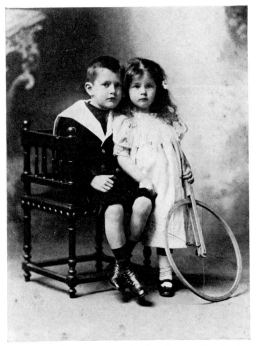

Alvaro and Susana at their sister's wedding in 1899

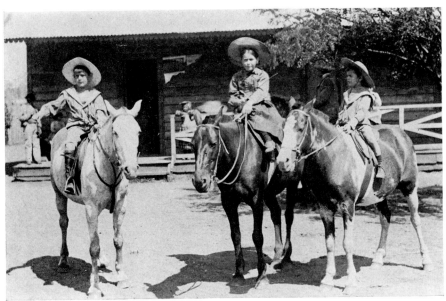

(*l to r*) Alvaro, Sibila and Edmundo

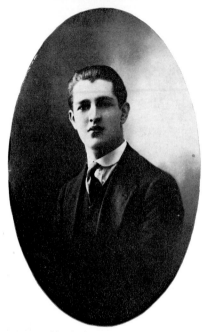

Alvaro in 1912, aged 18

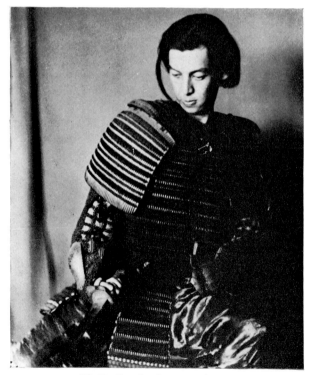

Michio Ito, the Japanese dancer

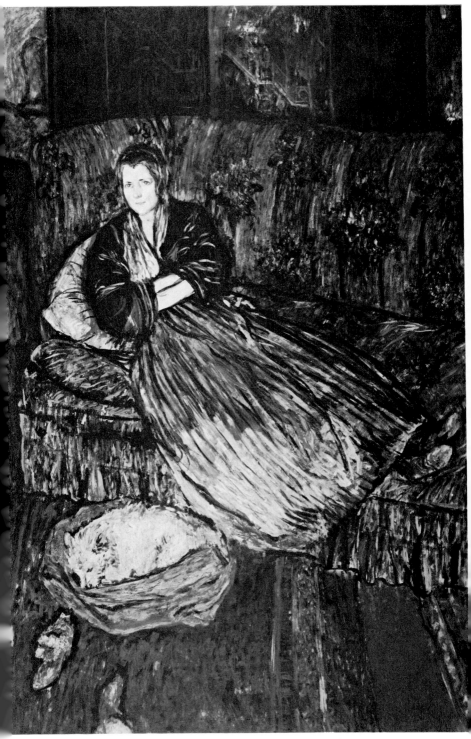

Mrs Lewis of the Cavendish. Portrait of Rosa Lewis 1915

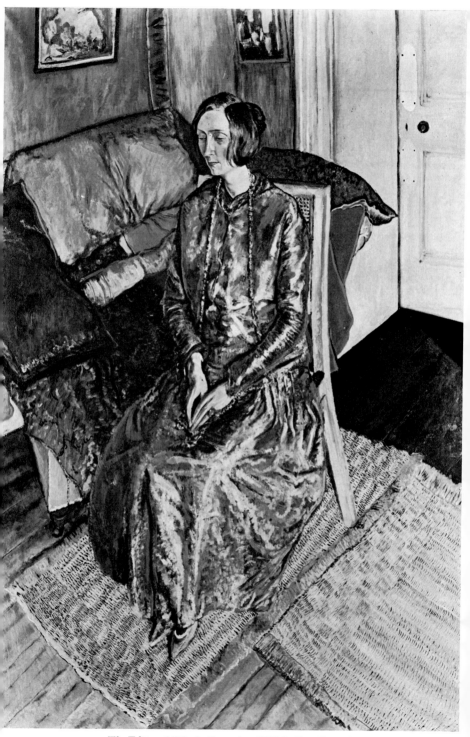

The Editor of Wheels. Portrait of Edith Sitwell 1916

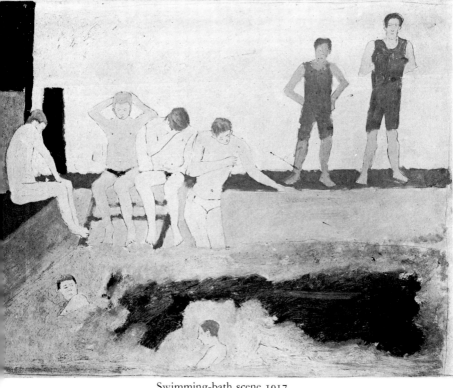

Swimming-bath scene 1917

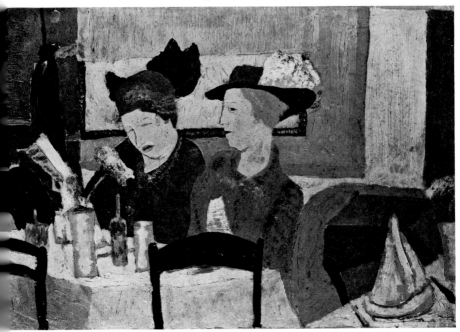

Cafe scene 1917

Portrait of Ronald Firbank 1919

Portrait of Nancy Cunard 1919

Self-portrait 1921

Suddenly Alvaro remembered an appointment for one o'clock. Once more he had been invited out to luncheon. Would he get there quicker on his bicycle or in a hansom? He leapt downstairs, but Mama stopped him in the hall and asked where he was going in that crumpled old shirt? Usually he was so immaculate. She persuaded him to change his clothes, but before slamming the door, he announced that clothes did not matter, he was only lunching informally with Lady Cunard to meet an amateur boxer.

When he returned he told Mama and the girls that the boxer, was the Prince of Wales. For once Her Ladyship's social instinct had forsaken her. The contest was off. Alvaro was classed as a middle-weight: the Prince was a light-weight, alas – 'but he was delightfully natural and easy to talk to'.

The following month, May 1916, Lucho decreed that Mama, Sibila and Susana were to return to Chile via the USA, sailing on the *St Louis*. He was confident that the Germans would not dare torpedo an American ship.

Sure enough, the Guevara ladies landed safely in New York. But despite an enormous replica of the US flag painted on its side, which was illuminated at night, the Germans did torpedo the *St Louis* on its return.

Happily for the Guevara girls the Villemins were in New York, though the reason for their being there had been most unfortunate. They had lost their school in Paris and everything they owned, including a library of ten thousand books. Madame had now become involved with many charitable societies whose aim was to raise money for the Allies. She naturally took on her ex-pupils as protégées and invited them to assist at the Allied Bazaar. Susana, in fancy dress, raffled tickets for a Goya portrait of General Lafayette. A Miss Elsa Maxwell was engaged to entertain the guests and was more successful on this occasion than on another when she had fallen heavily on Queen Mary's feet. The gracious Queen had not flinched but tactfully looked the other way. Miss Maxwell was to realise her ambition and become a notorious hostess. In the far future she was to give one of her most spectacular parties in the Paris studio belonging to Alvaro and his wife. She wrote in her memoirs *I Married the World*: 'Mrs Benjamin Guinness was the moving spirit of the Allied Bazaar.'

The Guevara girls were introduced to this grand and charming lady, who was accompanied by her two daughters, Tanis and Meraud, and to Nijinski, whom they had seen dancing in Paris. It was Meraud whom Alvaro was to marry thirteen years later; now, aged eleven, she was a slight, pretty child.

7

Nancy Cunard's intimate friends, including Alvaro, were astounded when, in 1916, she announced her intention of marrying a worthy but only fairly interesting man, Sidney Fairbairn of the Brigade of Guards. His family came from Australia. Society and Her Ladyship were aghast. In desperation, Maud sent for Sir Bache, who was hoping for a reconciliation with her. Both he and G.M., hastily resurrected for the occasion, did their utmost to dissuade Nancy but to no avail.

Alvaro must have found the wedding a diverting experience. To the embarrassment of Sir Bache, Her Ladyship insisted he fling handfuls of coins to the crowd clustered round the church. When Nancy caught sight of her adored Evan Morgan during the reception, she tore off her veil and flung it to the ground.

Nancy and Sidney Fairbairn moved into a house in Montagu Square, given them as a wedding present by Maud, who despite her appalling extravagance still had plenty of money of her own. Poor Sir Bache had become a rather pathetic figure and having suffered many reverses of fortune had been obliged to sell Nevill Holt and move to an inn at Wandsworth. He could only afford to make a modest marriage settlement.

It was a foregone conclusion that the marriage should prove a failure. Presumably Nancy used it as a pretext for leaving home, as many girls do. In consequence, at least for a while, the friction which results from two volatile people being too close to each other diminished. Mother and daughter still not only shared many literary and artistic tastes, but also a huge acquaintance

95

obviously antipathetic to Sidney's bridge-playing friends in the Brigade of Guards.

Now that Maud had resigned as a match-making mother and achieved her social ambition, she grew more natural. Moreover, due to her passion for Sir Thomas, she became extremely active and influential in the musical world, pouring money and personal effort into any project in which he was involved. G.M. sat at home pitiably neglected, fulminating against 'mummers', and writing her innumerable letters.

It was thanks to Maud, and the Sitwells in particular, that Alvaro and Nancy kept in touch. In 1916, Edith published seven of Nancy's poems in an anthology called *Wheels*, named after the title of one of Nancy's contributions. This venture of Edith's was intended to represent those contemporary poets whose work had been rejected or excluded from Edward Marsh's *Anthology of Georgian Poetry*. Intended as a quarterly publication, after only a few editions *Wheels* ceased to roll, but not before attracting much controversial attention.

Alvaro designed the end-papers for the second number from sketches made for an oil painting, called *Trickcyclists* commissioned by Maud, which he did not complete for another two years. Edith included a very free and beautiful translation of a Spanish poem by Alvaro, who was painting her at the time. He entitled the portrait *The Editor of Wheels*. In the autumn of 1919 it was hung in the 26th Annual Exhibition of the International Society of Sculptors, Painters and Gravers at the Grosvenor Gallery where it caused a sensation.

Edith had fallen in love with Alvaro. His feelings for her were not physical but certainly romantic and spiritual. They formed a deep relationship and she introduced him to many intellectuals in her circle.

It seems reasonably certain that Alvaro met Ezra Pound through Maud Cunard in 1916. Pound was intrigued by the idea of a promising young Chilean painter writing poetry in English. Moreover, after a few drinks, Alvaro expressed original, even shocking, theories about Russian literature and expounded a most particular philosophy.

Recently, both Pound and Yeats had conceived an intense interest in Noh. These medieval Japanese plays used traditional ritual, with stylised movements and attitudes, to symbolize various

emotions and combined these with the dance and the mask in a peculiar dramatic interpretation.

One night Pound met the young Japanese dancer Michio Ito, Alvaro's friend, at the Café Royal and succeeded in persuading him to recreate Noh in London with the aid of books on the subject sent from Japan.

With this project in mind, Yeats wrote *At the Hawk's Well* as the first of these modern Noh plays, and this was produced as an experiment on 2 April 1916 in Maud's drawing-room in Cavendish Square.

Presumably Nancy and her new husband were among the brilliant audience; and Pound brought T. S. Eliot who was wearing corduroys and carrying a bowler and tightly rolled umbrella. The costumes and masks were by Edmund Dulac. Henry Ainley played the young Cuchulain and Michio Ito the Guardian of the Well. Masked, and disguised as a predatory bird, Michio Ito had a devastating effect on the audience.

There were two possibly valid reasons for the omission of Alvaro's name from the Garsington visitors' book during 1916. The first and simplest explanation being that he was not invited and the second that even if he were, he was disinclined to accept being under great pressure of work.

If in fact Ottoline did not invite him, this may have been because, even though subconsciously, she was aware that for totally different reasons, he and Lawrence were by then united in their criticism of her androgynous circle of pacifists. It was probably on their visit to Garsington the previous summer that Lawrence had conceived his cruel portrait of Ottoline as Hermione Roddice in *Women in Love*, although the book was not published until 1920. Ottoline was the type of woman who inspired extreme reactions. Aldous Huxley, too, caricatured her as Priscilla Wimbush in *Crome Yellow*, published a year later.

So far Alvaro had remained a confused neutral – politically, socially and sexually. He had not yet learned to accept that it was quite normal to feel sensually aware of somebody of the same sex. Michio Ito was performing at the Palace Theatre in 1916 and therefore preoccupied. Alvaro was thankful to escape such temptation from impulses he feared sinful. He was helped by the attraction he felt for a girl who had lately come into his

life, Marie Beerbohm, a cousin of Iris Tree's. By now, many of his English friends were in uniform and, however mistakenly, fighting for their country, risking losing their limbs, senses or their lives. Girls, such as his sister and Lady Diana Manners, who were engaged to marry these brave men, were also 'doing their bit' and bound to attract his respect, whereas various members of the Bloomsbury Group each struggled with their apparently selfish problems to avoid conscription. These 'conchies' appeared to lead comparatively comfortable lives in their English country houses. Of course they were distressed when their friends such as Rupert Brooke either died or were killed.

Where Alvaro's work was concerned it was greatly encouraging that Augustus John admired his experimental paintings – interiors of music-halls, public-houses and suchlike which Sickert had inspired. In fact John took the trouble to write on his behalf to the American patron and collector John Quinn on 16 February, 1916: 'Guevara I consider the most gifted and promising of them all. He is a Chilian [sic] and has been working at the Slade. Geoffrey Nelson will shortly be roped into the Army, probably for garrison duties as he is so shortsighted. Mark Gertler's work has gone to buggery and I can't stand it. Not that he hasn't ability of a sort and all the cheek of a Yid, but the spirit of his work is false and affected ... I spoke to Nelson and Guevara who agreed with me that a show might be got together for New York later on. It was a very decent thought of yours to think of the younger men and take the trouble to act on their behalf, but as I have explained circumstances are against the plan being carried out at once ... He [Guevara] has lent me a remarkable painting of the interior of a pub.'

Also, Roger Fry had become so enthusiastic about Alvaro's painting that he had offered him an exhibition at the Omega Workshops, as well as recommending him to design a room which was referred to by the critic of *Vanity Fair* [an American magazine which merged with American *Vogue* in 1936] as 'a really fine post-impressionist sort of room. The only other gem of the kind lately seen in England being Wyndham Lewis' at the Eiffel Tower Restaurant'. Apparently Fry provided Alvaro with several assistants to accomplish this commission which, being identified with one particular artist, was against the strict principles of anonymity of the Omega associates.

Nina Hamnett and her husband Kristian also designed and executed a modern room for Omega at about the same time. It would seem that this job proved particularly trying for as soon as it was completed their two year old marriage came to an end. Kristian left Nina for ever and she became Roger Fry's mistress.

Once Alvaro's exhibition of twenty-eight pictures was hung at Omega, Augustus John's opinion of his work, about which he had written so recently with enthusiasm, suddenly underwent a change. From the Euston Hotel he wrote: 'Dearest Dodo . . . Guevara has gone mad. Accompanied by Marie Beerbohm he runs about the town arranging sales. He asked me how much I would sell the "little ones" for – I was on the point of protesting indignantly that I wasn't open to barter my children [Vivian and Poppet], when he explained he was referring to *his* less expensive works. I went again to his show and realised the hollowness of it all.'

Marie Beerbohm was a frequent companion of such emancipated girls as Nina Hamnett, Nancy Cunard, Sybil Hart-Davis, Iris Tree and Inez Holden. She was tall, willowy and delicate. Her brother was killed in the war and she found the air raids in London terrifying. She was restless and hated to live in one place. Rather than be alone for one minute she fluttered from party to pub to café looking pathetically wistful, or fainting, to be revived by love and champagne. Carrington made it clear in her letters that she despised Marie but for a while her frail femininity appealed to Alvaro.

Although he so much admired and even attempted to compete with Augustus John with his portraits, most of the canvases exhibited were painted in a style which Sickert had encouraged. He now paid Alvaro the compliment of a long, if confused, review in the *Burlington Magazine*. It seems that no catalogue of the exhibition was printed, probably the richer customers such as Lady Cunard and Lady Ottoline Morrell who called at the Workshops to buy lengths of hand-painted fabrics, lampshades and furniture decorated by the associates, were handed a type-written list. A few paintings were sold and it was on the strength of this venture's favourable reception by the critics that Alvaro was offered a one-man show at the Chenil Gallery in Chelsea the following February. He had already contributed to mixed shows

there and the gallery was popular with his contemporaries.

The Chenil exhibition was a great success; not only was one of the pictures, *Music-Hall*, reproduced in *Colour*, but also many illustrations appeared spread over two pages in *Vogue* between the rambling but enthusiastic text.

Not long after this show, before leaving for France as a war artist, Augustus John's admiration revived and Alvaro, together with Nina, attended yet another John party. Little Edward Wolfe, lately arrived from South Africa, was an art student at the Chelsea Polytechnic and grateful to Nina Hamnett for introducing him to Roger Fry. He was able to earn a few welcome pennies painting lampshades and trays at the workshops.

Teddy Wolfe was tremendous fun and kept everyone in fits of laughter acting out his experiences as a boy in a travelling theatrical troupe. He had not only talent, but tremendous vitality and charm. Alvaro was immediately attracted to this young Bloomsbury recruit and asked him back to his studio 'to see his work'. When Teddy rejected Chile's advances 'he was terribly nice about it'. Teddy made the excuse that he was quite dazzled by Dorelia, '*darling* Dodo'. Dorelia was accustomed to adoration but emotionally involved with Henry Lamb at the time – to the exclusion of others.

According to Carrington, the little Wolfe was destined to cause a flutter in the Bloomsbury dovecot. This metaphor was scarcely appropriate. Although at times the Bloomsbury doves billed and cooed to each other, more often they were quarrelsome.

Apart from Ottoline, another original hostess who invited Alvaro to stay in the country for week-ends, and to her London flat, was Mrs Violet Gordon-Woodhouse. Osbert Sitwell avowed that he had only met two women of genius in his life and that she was one of them.

In the spring of 1918, a young Chilean, Silva Vildosola, was privileged to attend one of this lady's musical parties. Soon after, he wrote to friends in Santiago: 'She always entertains artists who can not only appreciate her collection of archaic instruments – clavichords, harpsichords and spinets – but the sensitive expertise with which she plays them, and the ambiance she creates. Guests arrive on tiptoe, awaiting an interval in the mysterious music before collapsing into comfortable chairs in the drawing-room . . .'.

'A long-haired, bearded Spanish cellist whispered to me: "Don't you know your compatriot, the painter Guevara? You must be about the same age." Guevara was standing nearby and appeared sunk in contemplation ... He is tall and muscular with the physique of an athlete; but he wore the absent expression of one who searches for some elusive and subtle truth ... However, during a pause in the music, he became friendly and invited me to call on him the following day.

'The Fulham Road studio was vast, crammed with work and revealed a typical artistic disarray. At first, to one accustomed to strictly representational art of formal photographic portraits such as those commissioned by the bourgeoisie, the paintings were startling: long, languid unusual-looking women ... One picture was of a lovely young girl with red-gold hair cut short like a page boy's. She was standing on a beach, wearing a dark dress printed with huge flowers. Guevara murmured her name: "Dorothy Warren – Lady Ottoline's niece."

'Another portrait was of a tall woman with very long arms and with her head on one side [Mrs Falconer Wallace]. Her figure was draped with some heavy stuff. There was a large picture of a woman in blue with somewhat negroid features [Lady Mary Star?]. One of a man with a copper complexion had been painted against an evening sky, intensely green [The painter, Adam Slade?]. It was possible to imagine the temperament of each sitter. They had not posed but relaxed in an utterly natural way, communicating the intimate truth about themselves with confidence to their unprejudiced interpreter ... careless of their hair or make-up ... aware that such superficialities were extraneous.'

Alvaro was far from talkative at this meeting, yet Vildosola recognised that he was 'confronted by a powerful and original personality with prodigious talent, proud and sure of himself socially, yet without a grain of conceit as a painter'. Although only twenty-four, for his age, he seemed deeply thoughtful and introspective. The only time he showed animation during Vildosola's visit was when he smilingly confessed that his only ambition was to be recognised as an exceptional amateur boxer.

He escorted his guest around the studio, moving as if in a trance with a faraway expression on his face as he silently displayed an amazing collection of pencil and charcoal sketches,

recording everyday things that had caught his eye in the street or in pubs and cafés.

'There were endless studies in oil, watercolour or gouache of music-hall scenes; of actors and acrobats rehearsing before empty houses, dancers practising their pirouettes in working clothes, and grotesque marionettes in exotic dress; studies of nudes diving into swimming-baths, with groups of boys fooling about the shallow end, remarkable for the sequined water and the reflected light on their wet bodies . . . Perhaps the most intriguing of all was a series of drawings done in the East End – where Orient meets the Occident in the metropolis – Chinese theatres, brothels and opium dens . . .'

Vildosola was impressed by the varied life his compatriot obviously led, and within a week of this encounter, four of the portraits he described in this letter to Santiago were exhibited at the Seventh Annual Exhibition of the National Portrait Society at the Grosvenor Galleries. Guevara's pictures were conspicuously hung alongside those by such established painters as Philpot, Nicholson and McEvoy. The critic in the April issue of the *Connoisseur* wrote that although the exhibition 'contained no pictures that appeared destined to find their way into the National Gallery, at least there were clever examples of nearly all phases of art fashionable at the moment, and a few that attempted to anticipate the vogue of the morrow. Senor Alvaro Guevara may be numbered among the latter. His greatest assets are a feeling for broad decorative effect and an assurance of handling that commands attention . . . Perhaps his best picture was of Miss Dorothy Warren; a portrait in which the sitter's attractions had apparently been largely sacrificed to compose her figure into a preconceived decorative arrangement, reminiscent in style and colour of Mr Augustus John in his realistic moments. The most successful portion of the picture was the flowered gown of the sitter, which was painted carefully and with conviction . . .'.

Sir Claude Phillips' review in *The Daily Telegraph* was very complimentary, the same could be said of the one in the April issue of *Colour*.

In May, only a few weeks after this triumph, although not a member of the International Society of Sculptors, Painters and Gravers, he submitted two important oils for selection, *Music-Hall* and *Trickcyclists,* which were well placed.

However, it would seem that Maud did not particularly like the finished *Trickcyclists* nor did she wish to hang it immediately. She agreed that he might keep it for the time being. Presumably he wished to improve it.

According to Vildosola, Alvaro remained becomingly detached and not at all intoxicated by his success. On reading the various reviews, Augustus John should have been proud of his protégé. However, bogged down in France himself as a war artist and unable to fulfil lucrative commissions, possibly his feelings were ambivalent for he wrote to Nina Hamnett on his return: 'I hear Alvaro has some interesting portraits at the Grosvenor – he seems to have collared my Mrs Wallace in my absence – drat him!' Mrs Falconer Wallace's husband Alexander was a Governor of the Bank of England.

John had been sent back from France for striking a Canadian officer. Wearing uniform instead of whatever picturesque disguise he felt suited him – maybe a sombrero and cloak, gold earrings and long hair – he was impelled at times to establish his individuality in an aggressive manner. The consequent respite from this last attack was celebrated at the Café Royal. He spotted Alvaro there in earnest conversation with David Garnett, who said later that Chile and his discussions 'were always on a high intellectual plane'. On this occasion they were analysing the works of Dostoyevsky, and other Russian writers, whose books Garnett's mother had translated. Both men were hedonistic and sometimes found their own sex attractive but, while admitting that he thought Alvaro both captivating and handsome, Garnett added that they were 'both totally preoccupied with women at the time'.

By now, where Alvaro's heart was concerned perhaps Dorothy Warren had taken Marie Beerbohm's place. 'Dorothy always swept men off their feet' according to Lucy Norton and Adrian Daintrey, but 'her affairs were short-lived'.

On this particular night at the Café Royal, the tête-à-tête between Alvaro and Garnett was interrupted by John, still in uniform, already fairly drunk and surrounded by friends. Alvaro was delighted to see him. He and Garnett moved over to join the party. Having consumed about half a bottle of brandy John, during some argument, ground out his lighted cigarette on Chile's cheek to the horror of everyone. Far from retaliating savagely,

103

Alvaro did not even flinch but ignored the pain and went on to air his views on some esoteric subject. Although his face was badly scarred for days, he never referred to the incident. Augustus John was privileged – *le maître*.

One of his next visits to the Café Royal proved more agreeable. For once Alvaro was sitting alone when an exceptionally attractive-looking young man came in unaccompanied, wearing an apparently new and very elegant greatcoat, such as might be worn by a musical comedy Field-Marshal. Alvaro beckoned to his favourite waiter, possibly Johnny Papani, and dispatched a note to the stranger's table, suggesting that he join him for a drink.

The young man succumbed to a tempting adventure. When he sat down he saw that Alvaro had drawn his portrait in pencil on the marble-topped table. The head was a remarkable likeness, the figure too; but the greatcoat, which he had designed himself, was omitted: his host had drawn him in the nude. He introduced himself as Beverley Nichols and the result of this encounter is described by him in retrospect: 'I went to stay with him at his studio ... It was a very revealing experience, some of which is printable, and some of which is not. He taught me to see through – or rather with – the eyes of a modern artist who was also a genius. I hope and believe that I was receptive, but I was sometimes very puzzled. There was an enormous canvas in the middle of the room showing a number of bicyclists, and across the canvas he had made a pattern of lines formed by pieces of thick black cotton attached by drawing pins. We had a fierce argument about this because I could not understand how art could be created by such methods. But many things he made me see for the first time. I remember that one night we stopped under a tall building and he made me look up at it, and showed me how to foreshorten it, and also how to bring in the clouds as part of the essential design. This is a very crude way of putting it, but after a while I felt that he had only to open his eyes to see a picture, and to compose it almost instantaneously.

'He painted a very fine portrait of myself – not in the nude but in the greatcoat! He gave it to me but, alas, it mysteriously disappeared some years later. He also gave me a most beautiful picture of a woman which was obviously inspired by Picasso's *Woman with Absinthe* ... I took it with me to Oxford and hung

it in my room at Balliol. Then, one day Sacheverell Sitwell burst in, in a state of great agitation and said that Chile was on his way to Oxford with a knife, because he was going to murder me for having stolen the picture. I beat a rather hasty retreat, leaving the door open, because I do not think that this was altogether an idle threat. On several occasions, during our brief and stormy relationship he had threatened to strangle me. He was immensely strong and quite unpredictable when he had been drinking. Whether he was a "good influence" on the young I neither know nor care. He certainly enriched my life.'

During the summer of 1918, after much melodramatic urban excess, an invitation, illustrated by an olive branch, to stay with the Johns in Dorset was both palliative and welcome. This was by no means the first or the last time that Alvaro visited the Johns. No doubt *le maître* felt a twinge of remorse after his vicious attack at the Café Royal. Like many self-destructive people, at times John hated himself and usually turned against those whom he liked or loved, relying on their devoted compassion, counting on their tolerance. When drunk, he could never be bothered to disguise the irritation he suffered from boredom. Probably, he had suddenly found Alvaro unforgivably dull. Members of his court were unable to survive without an impatient brutal attack unless they could stimulate, or at least amuse.

Perhaps his recent experience of irksome military discipline and convention had done nothing to improve this distemper. But, however delighted he felt to be leading a civilian life once more, between Mallord Street and Alderney Manor, it would have been characteristic during gloomy moments of introspection for him to feel guilty over the manner in which he had gained his freedom.

On the train to Dorset, Alvaro met a new student at the Slade, Rodney Burn, who 'considered him a very gifted and important painter', but knowing his reputation 'was aware that he could be violent and cruel as well as immensely protective and kind'. Young Tom Monnington, who had replaced Guevara as the staff's favourite, confessed that he 'found him quite frightening at times'.

Fortunately for Rodney Burn, Alvaro was sober and charming throughout the journey. 'He expressed his great admiration for

Constable's sketches and said he had plans during this holiday to approach landscapes in that way himself. '

There had been many changes at the Slade over the past two years. Brown was about to retire, but Alvaro still called on Tonks, who was proud of his ex-pupil's success and 'much admired him as a colourist'. Alvaro was encouraged to talk to the painters in the life-class and to join them working from the model. At least two of his studies hung on the walls to provide inspiration.

Not only Tom Monnington, but most of the students were frightened of Chile. Once aware of his presence the prettier girls would rush around the labyrinth of passages, hair and skirts flying, opening studio doors and warning inmates in a breathless whisper: 'Chile is back on the prowl!'

Alvaro fancied an innocent, rather feminine boy who was loved platonically by Fred Beddington. Fred was not very powerfully built and dared not risk a confrontation with the notorious boxer Guevara, although he shuddered to think of his friend's seduction. Recently, Alvaro had challenged a hefty Irish man to a fight during the lunch hour and suffered a heavy defeat much to the satisfaction of some frightened students. Perhaps he was overconfident after drinking with 'toms' at the Roebuck.

After exchanging much school gossip and views on art and artists, past and present, Rodney found he was overcoming his reservations about the unpredictable, belligerent Chilean. In fact he discovered he liked him! Now he could understand better the strange affinity between him and Augustus John. 'Guevara, like John, either talked extremely seriously or, when he had drunk a lot, frivolously – or at least incomprehensibly . . . Guevara was extraordinary.'

'Extraordinary' is an adjective frequently used to describe Alvaro. The three or four letters and few verbatim quotations which have survived him seem commonplace on the whole, and yet he acquired this inexplicably rare reputation among critical and discriminating people. Why was he found so extraordinary? Was it due to the sharp contrasts in his character – gentleness and violence? Such inconsistencies, added to a combination of originality, talent, charm and good looks sometimes act as an open sesame. Yet even with such advantages a foreigner would normally have found the doors of many English social and artistic strongholds closed. Despite this wary insular prejudice,

Alvaro – a Latin among ferocious social, artistic and literary lions – seems to have been as divinely protected as Daniel.

Alderney was an artist's paradise over which Dorelia presided as the ministering angel, spreading her loving protective wings over the rambling house, creating miracles of spontaneous beauty and easy comfort. In the wild sweet-scented garden even tropical plants flourished under her spell; frost never blackened the silver leaves of the eucalyptus, remembered later as 'a slender, shimmering wand'. Blossom overflowed the secret paths, showering a confetti of petals over the lawns where lavender, alpine rosemary and thyme mingled with the lush grass. The ambience she created was not only enchanting for artists but provided a perfect background for the young.

Alvaro was a great favourite with the surviving children by John's first wife, Ida Nettleship: David, Caspar, Robin and Edwin who were all in their teens by the last year of the war. Dorelia's family by John was also devoted to Chile; the youngest child Romilly was then only twelve.

Alvaro taught all the boys to box, insisting that it was not only physically rewarding but mentally therapeutic: it would teach them to concentrate on one target by clearing their minds of distracting thoughts.

David was musical. As he grew up, he and Alvaro established an increasingly friendly relationship. Caspar 'regarded old Chile as a big warm-hearted man'.

Robin 'adored him and always had the curious feeling that he was a visitor from another planet – a stranger'. Years later, he 'considered Chile one of the most interesting characters of this century' and felt that 'wit was the quality that made his pictures so rare'. The impression Alvaro made on the boy was not only psychological. After hitting him on the chin during a boxing bout, Robin 'suffered a permanent dent in his knuckles'.

When Robin confided that he 'longed to visit South America because it must be so romantic', Alvaro replied that he personally was not happy there, 'the people were so *stupid*'. Robin protested that surely the extreme south, places like Arauco, must be wonderful? Alvaro merely shrugged and said that he 'would probably find nothing there except a Scotchman [sic] making money. Like all the marvellous places one hears about they're bloody when

107

one gets there'. This was surprising considering how at home he seemed in Arauco, – at least, that was the impression he had given to Susana.

Alvaro also made 'a strong impact' on Romilly who 'felt delightfully out of his depth when Chile really got going on the science of fisticuffs. He was such a gentle person outside the boxing ring'. Little did Romilly know that his hero could be just as unpredictable and violent as his own father.

Alvaro took all the children for walks and bought them sweetened condensed milk from the village shop which they drank out of the tins as they traipsed home through the woods and fields searching for *cêpes* and mushrooms.

Thanks to Dorelia's practical wisdom, except on such excursions, in fine weather the children wore no clothes. She let their hair grow long, simply cutting a fringe in line with their eyebrows. They looked like a band of savages as they bathed in the streams or played hide-and-seek among the rhododendrons. But, unless asleep curled up anywhere indoors or out, they were never still. There was no nonsense about Dorelia: she expected them to groom their ponies, tend the animals on the farm, collect new-laid eggs, pick fruit and gather windfalls. At dusk they returned to the kitchen door, their mouths stained with raspberry or blackcurrant juice, laden with pails of milk, trugs full of peas and beans already shelled, sweet young carrots and onions, bundles of kindling or armfuls of logs.

One child might be set to work sawing wood or chopping herbs assisted by Alvaro, or take turns with him making butter, winding, winding, winding the handle of the primitive churn.

A shouted command from their father to pose as a model for the whole afternoon was the least welcome task. Alvaro, among other guests, sat to John for hours.

John always thought babies were delicious things to have about. 'The little ones', Poppet and Vivian, were described most delightfully by Roy Campbell as 'galloping around the house and garden on two very large, but spotlessly clean pigs, which had become affectionate household pets'.

There were rollicking evenings with John in the local country pubs, dancing and singing. The house-party would fraternize with gypsies around camp fires. Caravans were attracted to the neighbourhood.

After this stimulating yet relaxing visit, Alvaro went on to Cornwall alone at the end of the summer. He had various friends and acquaintances in the neighbourhood of St Ives, among them the D. H. Lawrences and Bernard Leach, the potter. He was not an habitual correspondent but wrote to Duncan Grant while he was there.

Duncan had become increasingly involved in the complicated emotional permutations of Bloomsbury; when Alvaro returned to London, Duncan wrote to Lytton Strachey on 13 October 1918 that he was 'rather pleased at seeing Chile again after his long disappearance in Cornwall where he had seen a ghost – a spotted dog, which turned in a complicated way from black to white and vice versa (with a variety turn in the spots) . . .' By curious coincidence on another occasion Walter de la Mare described a similar apparition at St Ives. The house still exists where the canine ghost appears.

Alvaro had timed his return to attend the Sitwells' party for the Russian Ballet on October 12. It was the last important social function before Peace was declared. Of course Duncan and all the Bloomsbury clique were there: Lady Ottoline's party included Leonide Massine. Lydia Lopokova met Maynard Keynes for the first time. There is no record of how Alvaro celebrated the Armistice.

Nancy's disastrous marriage to Sydney Fairbairn lasted less than two years: but away from Maud's vigilance during this period, her character matured and her personality was overwhelming. Poetry still obsessed her. She had become fiercely opinionated, an impassioned defender of the underdog and a champion of any unpopular cause. She was the indomitable rebel against prejudice and social convention.

It had not yet occurred to Alvaro to make advances to Nancy. He had always been bewildered by her passion for that queer Evan Morgan, with whose eccentricities he and most of his friends were only too familiar.

Her Ladyship knew nothing about this side of Evan's character and approved of him as a second son-in-law; after all he was Lord Tredegar's heir. It was simply a joke that

109

Lady Tredegar was, in most people's opinion, as mad as a hatter and preferred making bird's nests to needlework in her leisure.

During this period, Maud and Nancy became more antagonistic. Late one night, when Her Ladyship caught Nancy on the stairs, returning from a wild party with her discarded stays rolled up under her arm, she lost her temper. 'Nancy told her to shut up and go back to bed with her titled Tommie' – Sir Thomas Beecham had been knighted that year.

Physically, Nancy had grown even more attractive. According to David Garnett: 'She was very slim with a skin as white as bleached almonds, the bluest eyes one has ever seen and very fair hair.' Raymond Mortimer found her 'incomparably bewitching'. There was 'a mixture of delicacy and steel in her build, hips, legs, ankles all of the slenderest, arms and wrists weighted with massive ivory bracelets from Africa that they seemed too fragile to support. Her walk was also enchanting . . .'

In Harold Acton's opinion she proved an inspiration 'to half the poets and novelists of the twenties . . . Her small head so gracefully poised might have been carved in crystal with green jade for eyes . . .'

Her eyes were obviously her most attractive feature and have been described as jade, turquoise and sapphire; she outlined them heavily with kohl, which made a dramatic contrast with her ash-blonde hair; at that date such daring use of make-up was considered *outré*.

Not only men admired her. The year that Alvaro fell in love, Mary Hutchinson found she was: 'wonderful, made of alabaster and gold and scarlet, with a face like Donatello's Saint George . . . The façade was exquisite, made of gold leaf, lacquer, verdigris and ivory'.

During the summer of 1918, while Alvaro was in Dorset and Cornwall, Nancy refused to return to live with her mother in Cavendish Square, preferring to share a rambling country house in Oxfordshire with Sybil Hart-Davis.

She arrived by dogcart with her French maid, who was dismayed by the landscape and remarked 'C'est un peu lugubre'. She was severely reproved by Nancy, who spoke and wrote per-

fect French. If condemned, even a dull landscape must be defended.

Rupert Hart-Davis was then an observant boy of eleven, and thought Nancy 'very Bohemian'. He noted 'her high squeaky voice', and that she smoked incessantly, and preferred salads of dandelion leaves and weeds to orthodox lettuce. 'There seemed to be a perpetual party. The guests were variegated – young officers, wounded and whole, artists and writers, Augustus John in uniform of a War Artist— Chile Guevara, the Sitwell brothers, over from some camp or barracks . . . Between the wild parties there were quiet days without visitors, when Nancy would spend all day in the drawing-room writing. "Sh!" we were told: "Nancy's writing a poem" . . .'

It was this summer that Alvaro gave her his poem *St George at Silene*.

He was well aware that she was then in love with a charming, good-looking young man called Peter Broughton-Adderley. His feelings were mixed when he heard that Peter had been killed in active service. Nancy's reactions were typical: she raved less from grief than from outrage at the injustice of war towards an innocent victim.

When rumours reached Her Ladyship of how indiscreetly and promiscuously her daughter was behaving, 'drowning her sorrows in drink and making embarrassing scenes,' once more she consulted Sir Bache and G.M. They all agreed that the sooner Nancy was divorced and remarried the better: of course Sidney would behave like a gentleman and take all the blame, although in consequence, he might have to resign from the Brigade.

But who should take his place as a husband? Nancy had notoriously queer tastes and most of her friends were unsuitable anyway.

Alvaro was still in touch with Maud; he confided in her how much he admired her daughter. The more that Her Ladyship thought about it the more convinced she became that 'a marriage could be arranged'. G.M. objected violently. He had been jealous of 'that sallow Chilean' ever since Maud first took him up and commissioned him to paint her portrait and that ridiculous picture *Trickcyclists*.

She protested that whatever G.M. thought of him, considering

he was only twenty-four, Alvaro was remarkably well established. It was rumoured that his portrait of Edith Sitwell would shortly be hung in the Tate. It had been bought by Sir Joseph Duveen, Walter Taylor and George Eumorphopoulos. Alvaro was by no means penniless. He was handsome and aristocratic. Moreover, Nancy had known him and and liked him for at least five years. Maud was sure that they had never had *une affaire* – she always rolled her French r's very prettily. When she saw Alvaro and Nancy together, her feminine intuition told her that they were 'romantically attracted'. If they saw more of each other, such advantages, allied to their common interest in poetry, would bring them closer. Sir Bache's mumbled objections to foreigners were brushed aside.

Maud must have had this matrimonial solution in mind when she encouraged Alvaro to paint a full-length, life-sized portrait of Nancy during the winter of 1919. Nancy wrote later: 'Chile's sincerity became all the more evident ... while he was painting me. Hours of silence would slip away as the day drooped into December murk. Then, stopping, he would read me as like as not a poem he had just written, and I would think how much of a painter's poem it was – each thing in its place, full of colour, as if seen and created there. Now and again appeared an obscurity, yes; but never one due to loose thinking, rather to some twist of words. The perspective, too was very individual, and that word recalls how upset was many a critic by the perspective in his splendid portrait of Edith Sitwell ... How striking it is in tone now, possessing the same pristine vitality, and already bearing the stamp of permanence.'

The sonnets dedicated to her by Robert Nichols pleased her less than Alvaro's, nor was she impressed by Robert's sincerity. He sent her the original manuscript extravagantly bound in crimson, with a gold 'N' embossed above a wreath of bay leaves encircling her name. According to her: 'he had the awful need of dramatising himself ... these sonnets tell of every kind of lurid occasion that never arose at all between us.'

She was never made aware of the theatrical side of Alvaro's personality; with her he was always natural. She did not consider him 'a tragic figure like his compatriot, Lautréamont, the author of *Les Chants de Maldorer*. A sarcastic one, rather. His irony was interspersed with pleasant pieces of naïveté, which may have

come from the fact that very Spanish, or rather Chilean, did he remain.'

Admittedly, Robert Nichols was an exhibitionist. Certainly he loved her to the point of madness when he threw a revolver at her feet imploring her to prevent him from committing suicide if she rejected him. Robert Nichols, although a friend of Alvaro's, could never understand why she preferred her Chilean admirer as a poet and a man.

It was the year after the war, while Alvaro was courting Nancy, that he met the budding poet Roy Campbell, then an Australian boy of nineteen, possessing exceptional originality and verve, who had worked his passage from 'down under' and was dubbed 'Zulu' by Marie Beerbohm the first time he appeared at the Café Royal. He was already appreciated for poetic ebullience by all the most interesting men in London and Oxford, including the Sitwell brothers, Wyndham Lewis, Augustus John, William Walton and T. S. Eliot. He also appealed strongly to such girls as Marie, Nancy, Iris and Viola Tree, Nina Hamnett, Betty May – the feminine avant-garde.

Chile and Zulu were mutually attracted at once and each assumed heterosexuality in the other. Indeed only homosexuals ever believed Alvaro was one of themselves. It was mainly with him that Roy 'sank into that strange underworld of indigence and folly known as "Bohemia" '.

Chile led his new friend through the damp, foggy streets of post-war London by now invaded by the foul-smelling, noisy motorcars to which Roy objected so strongly. Alvaro introduced him to the Chinese and Negro quarters, with which he was already so familiar. Together they explored the sleazy, Dickensian slums, the shabby pubs, doss-houses, brothels and opium dens around the docks. On these clandestine excursions they used only their eyes and ears; neither spoke much.

Both valued John as 'a King among men . . . with the majesty of a pagan Jupiter'. They agreed that he was not only a great artist but a very great intellect, possessed of rare human understanding entirely without pedantry. They enjoyed roguish larks with his clownish retainer Horace de Vere Cole, who found favour with 'King' John as court jester.

Most of de Vere Cole's hoaxes are too well-known to be retold, but in those early days Roy would collapse with laughter

113

watching him and Alvaro knock on prosperous-looking front doors, insisting to the prim parlourmaid or pompous butler that just a second ago they had seen one of their innocent wives or sisters hustled unwillingly into the house by the wicked master. To indignant protestations from the shocked servants, they shook their fists and furled umbrellas, demanding vengeance, threatening to call the police, or force an entrance. They were always able to describe their victim minutely, having followed him home. Sometimes they were even invited to search the house. On taking their leave at last, they would bow and Cole would solemnly declare that they must have been mistaken. Meanwhile they would have turned every room upside-down, storming about, poking about under beds and emptying drawers and wardrobes.

Or they might accost a well-to-do elderly gentleman who had obviously picked up a tart and accuse him of disgraceful behaviour: the lady in question was their poor misguided aunt, escaped from a lunatic asylum. She must be saved from herself and her shameless seducer! This prank was most unpopular with prostitutes who lost many a potential customer in consequence. Some, however, hastily abandoned by a frightened escort, were quite willing to take at least one of their rescuers home.

Roy Campbell slept anywhere – 'not only in love-nests, but Salvation Army or Seamen's hostels . . . he slept on the floor in Geoffrey Nelson's basement. Geoffrey was still a scrounger', although more solvent than hitherto. Like Nevinson, he had landed a patron in Lord Howard de Walden, who guaranteed to buy so many of his pictures a year.

Often encouraged by Augustus John, or enthusiasts like Lady Ottoline Morrell, it was becoming fashionable to be a patron. For the past three years, Eddie Marsh had given Gertler a small allowance and the key to his house in return for a choice of the painter's work. Perhaps the most eccentric patron of all was Bomberg's: an old Jew who lived in a filthy house and kept his money in a cupboard. As well as providing pictures, Bomberg was required to slave at menial tasks, receiving his reward in tattered bundles of ten shilling notes.

Quite the weirdest acquaintance Roy made through Alvaro was old Stuart Grey: he looked like a magnificent tramp, or a bearded prophet. A once prosperous Scottish lawyer, he had given away a fortune and led a hunger-march from Edinburgh to London.

114

He had since became a hot-gospeller in Hyde Park – a John the Baptist for the hippies to come. Grey's knowledge of the law enabled him to commandeer grand empty houses in Mayfair and throw them open to the flotsam and jetsam which gathered around his soap-box: vagrants, meths drinkers, tarts and crooks. Furious complaints from ducal landlords were to no avail. The police were powerless. Although not invoked for hundreds of years, there was some ancient law which Stuart knew by heart, regarding the right to squat in unoccupied property.

Stuart himself had no wish to take advantage of such aristo-cratic accommodation, as he carried his food and lodging on his back like a snail, in the shape of two vast rolls of linoleum. At night he would erect one as a conical wigwam crowned by a rusty saucepan, often among the shrubs in Regent Square. He used the other roll as a counterpane, bits of which he would stew or eat raw as a change of diet from the mildewed scraps which he salvaged from dustbins, or bought for a penny from restaurants.

According to Roy Campbell, 'no one ever saw a penny of what was "lent" Geoffrey [Nelson]', so that when Stuart caught bronchitis, Roy insisted on installing a ramshackle brass bedstead for him in Geoffrey's basement as repayment for an old loan – there was no need to provide a mattress or any bedclothes.

Cosseting and luxury on such a scale gave old Stuart's virility such a boost, or perhaps it was due to the aphrodisiac effect of gnawing linoleum, that he was able to persuade a policewoman of whale-like proportions to lay down her truncheon, strip off her navy-blue uniform and fornicate or snore beneath the undulating coverlet. He was then in his seventies. When he became too old to enjoy such a rigorous existence, John provided him with a pension and a comfortable cottage.

Alvaro's studio was not available for such eccentric guests at the time for he was not only painting and making love to Nancy, whom he hoped to marry, but overwhelmed with portrait com-missions and deadlines for submitting pictures to various exhibitions.

Nevertheless, when Johnny Papani, a favourite Greek waiter from the Café Royal, retired and invested his savings in delapid-ated premises in Beak Street, he agreed to decorate part of the house to serve as a restaurant to be called The Harlequin.

115

Apart from designing a post-impressionist room for Roger Fry in 1917, Alvaro had already improvised decorations for a 'dive' in a Limehouse cellar belonging to sailor friends of his and Roy's, by draping the damp brick walls with fishnets and hanging glass floats, hurricane lamps and fronds of seaweed from the ceiling. It was perhaps the first time that anyone had thought of such a simple and economical scheme, which also used cobwebbed wine bottles as candlesticks and shells as ashtrays. Although Papani was impressed, really he wanted the walls of The Harlequin to be covered with panels painted with exciting scenes. Roy offered to help Alvaro execute these and they were both rewarded by plenty of retsina and kebabs cooked by Mrs Papani, who had fourteen children to help her.

A born poet, Roy somehow found time to write *The Flaming Terrapin* and to fall in love with a marvellous girl whom he determined to marry, although he was only nineteen. According to a family retainer, her family had hoped that she would marry 'a gentleman with a place in a park' but sensibly, as it turned out, her parents gave their consent to the match. Old Stuart connived at the romance and Stulik offered to give them a wedding party. However, Roy and his bride felt that they should accept this favour from Johnny Papani.

Everyone from Bohemia, Chelsea and Bloomsbury attended, including of course Augustus John and Wyndham Lewis, who later wrote a graphic account of the proceedings. Various popular boxers were invited. Like Alvaro, Roy too was a keen boxer. He wrote later in 1919 that 'in the London art world Jacob Kramer, Chile and myself were the three best fighters by a long way, though Chile only developed his full strength when he was quite old, [thirty] . . . in the end he only lost to Godoy in the whole of South America'.

Nuptial celebrations at The Harlequin continued far into the night, long after Roy had taken his bride to bed. The honeymoon couple were disturbed by an outburst in the restaurant which Roy felt obliged to investigate. Kramer was noisily protesting that John had insulted him – he would punch off his head. Alvaro was too drunk to defend his King; but through Roy's timely intervention an ugly situation was avoided. Kramer meekly apologised and 'the party roared itself away merrily into the small hours of the morning'.

A glorious honeymoon was spent with the Johns in Dorset, after which the newly-weds moved into a ramshackle flat above The Harlequin. To Alvaro, Roy's ideas on marriage were scarcely appropriate to such enlightened post-war days. He did not expect the same subservient obedience from an emancipated English wife as he would have from a Latin. He appreciated Nancy as an equal and would have been prepared to accept her independence – up to a point . . . Roy, however, felt differently and, when he thought that his bride was becoming rather cheeky, decided to teach her to respect him by hanging her upside down by the heels from a fourth floor widow. When police, summoned by startled pedestrians, arrived, he shouted down: 'We are only practising our act!' The marriage proved an enormous success and his wife worshipped him for the rest of his life.

Sad to say, despite such a promising start to this Greek restaurant, one Sunday night as Roy Campbell described in his book *Light on a Dark House*: 'Johnny was there by himself, when the whole four storeys of 50 Beak Street collapsed and killed him, thus relieving him of the terrible anxieties and debts which, owing to the non-payment of bills by artists and models, were driving him mad, so that he often told me he contemplated suicide'. Perhaps it is too much to hope that Mrs Papani, the fourteen children and the waiters, who were at the cinema at the time, took refuge in an empty house in Berkeley Square belonging to Lord Rosebery, who had objected more vehemently than anyone else to old Stuart's activities.

Meanwhile Maud had certainly brought Alvaro and Nancy closer, both physically and mentally. 'They were well-suited – both animals!' declared Robert Abdy. 'Bertie' Abdy was a handsome, eligible young man who adored Maud and, like G.M., hated Chile.

According to John Banting, another painter, the mere fact that Her Ladyship recommended Alvaro as a husband, 'was enough to put Nancy off'.

While protesting her deep affection and admiration, she refused to marry him. With his Latin temperament, Alvaro found this unacceptable. Surely their relationship was idyllic? To his horror and shame, she freely admitted having been physically unfaithful with various men. Could she not see that his own

infidelities were unimportant but that even in these emancipated days such conduct was unacceptable for a woman?

She seemed particularly intimate with the decorator and photographer Curtis Moffat. It was he who had introduced her to ethnography. Together they scoured the junk shops and English ports for Africana – masks and beads, fertility symbols, carvings in ivory or wood, heavy native bracelets and necklaces made of seeds, shells, or more sinister materials – all the weird, primitive souvenirs which sailors brought back from their voyages to the dark continent and pawned to buy a few drinks around their home docks.

8

Oliver Brown of the Leicester Galleries was not only impressed by the vast quantity of work which Alvaro had achieved during his remarkably zestful life of the past few years but also by its high quality.

An astute dealer, Brown had been studying Alvaro's form since his student days and noticed the success of his early exhibitions at Omega and the Chenil. Many original works shown since at the Grosvenor, Grafton and other West End galleries of prestige, sponsored by reputable societies, had attracted flattering attention from the critics.

At random, the titles of these pictures in post-impressionist style were indicative of the artist's divided personality: *Music-Hall, Maître d'Orchestre, Trickcyclists, Splits* and *Chair Dancers* showed his choice of worldly subjects; *The Descent from the Cross, Crucifix, The Virgin of the Seven Swords, Medusa's Trial* and *Signs of the Zodiac*, the mystical.

There was no doubt, however, that the most spectacular expression of his talent sparkled in his extraordinary portraits. During the autumn of 1919, *The Editor of Wheels* had once more been exhibited, this time at the Grafton Galleries.

The picture was now formally presented to the Tate. As yet there was no section or department set aside for foreign paintings. Despite persuasive pressure not to prejudice its acceptance, Alvaro's attitude had remained diffident as well as adamant: he had refused to change his nationality and wrote: 'I am an Anglophile like my father. England has adopted me, but Chilean I am and shall always remain.' Susana was proud of his patriotism

119

and many others respected his principles. Nevertheless the picture was accepted.

In Brown's and other professionals' opinion, the portrait of *Walter Taylor, Esq.* which Alvaro had shown at the Grosvenor Galleries the previous spring was one of his best works. He knew that Alvaro was far too busy with commissions to work for a one-man show at the Leicester Galleries for at least two years, but with this project in mind, invited him to lunch at Queens, a popular restaurant in Sloane Square, and famous as a rendezvous for artists and their patrons.

Although Alvaro seemed quite pleased by Brown's proposition, he appeared much more enthusiastic about a boxing match which was apparently arranged to take place that night: he was booked to fight the Police Champion. Under these circumstances, Brown was amazed how much he drank: not being in training, how could he expect to win? Alvaro merely shrugged and grinned. After a generous luncheon, he suggested accompanying Brown back to the West End, on their way, they might call on a friend of his. Brown decided to humour him and was dragged off to a derelict Mayfair attic, where he was introduced to a mad, ragged character, probably a communist – Stuart Grey of course.

It was an honour to be promoted by Brown and Phillips: the hallmark of recognition was stamped on the canvases they exhibited. Years ago they had earned a reputation for being avant-garde, when they sold Van Gogh's *Sunflowers* and *The Chair*, Cézanne's landscapes, Degas' bronzes and some paintings by Lucien Pissarro to national galleries or important private collections. They now dealt for many contemporary artists whom Alvaro knew and admired, including Sickert, McEvoy, Epstein, Paul Nash and Nevinson. According to all Alvaro's friends, Brown and Phillips took a sympathetic personal interest in their 'stable'. Brown had just introduced Nevinson to Keppel, an American art dealer, who admired the war etchings in Vorticist style which the Leicester was then showing. Perhaps it was only later, when painting again displaced boxing as his main interest, that Alvaro was able to appreciate the compliment that Brown had paid him.

Nevinson agreed to go to New York for an exhibition of prints, rather reluctantly as he and Kathleen were moving house and she was expecting a baby: both would prove expensive. He

was involved in various rows: with Roger Fry, the London Group and also the Tate which he nicknamed derisively the *Slade* tête-à-tête.

Despite these unfortunate quarrels, Nevinson still had many friends. Alvaro was invited to the farewell dinner given for him and placed next to Ronald Firbank. In the middle of the pompous speeches and somewhat chaotic proceedings, Firbank began to giggle in an uncontrollable and embarrassing way. Scowling at him to no avail, Alvaro drew an immaculate hand-kerchief from his breast pocket – all the men were formally dressed – and stuffed it into Firbank's mouth as a gag. To the speakers, the ensuing choking and spluttering were even more disturbing than the giggling, and at last Alvaro was obliged to drag him away. Grant Richards wrote to Firbank at Oxford: 'I believe J. L. Garvin is still looking for you with a knife.'

Alvaro had already begun painting what Firbank referred to later as a 'perfectly brutal study' showing him huddled up in a black suit squirming on a small uncomfortable chair, beside him a jar of suggestive orchids. The room was curtained, leaving a shaded twilight behind his head, and a yellow glimmer from an elaborate ormolu candelabra provided a different and sinister light. Rugs floated like rafts at his feet. Perhaps the picture should have been called *Human Shipwreck*?

After the exhibition of this controversial portrait at the New English Art Club, somewhat reluctantly, Firbank agreed to negotiate with the Tate to lend them the 'detestable painting'. According to Lady Firbank's letters, the directors had to adjudge the picture as a work of art and they accepted it during the summer of 1921.

Soon after finishing the picture, Alvaro was at the old Alhambra Music-Hall with Beverley Nichols, when Firbank staggered towards them. Nichols recalled that: 'When he was within a few yards of us he fell flat on his face, and was violently sick. Chile looked down at him with mild interest, and remarked "*that* is how he should have been painted – dead drunk on the floor".'

Despite these mishaps it would seem that painter and victim remained on speaking terms at least, as it was Alvaro who introduced him to Duncan Grant in Jermyn Street, where Firbank

121

lived at the time. According to Duncan Grant, it was 'like being introduced to an elegant grasshopper in white kid gloves and boots'.

Oliver Brown of the Leicester Galleries usually planned his exhibitions a year or two ahead. He had just given Picasso a show. He now calculated correctly that the time was appropriate to meet Alvaro again for a serious discussion and positive booking. According to rumour, his affair with Nancy was going badly: he might disappear to Chile, or even commit suicide. Another protégé of the Sitwells, Modigliani, had recently killed himself in Paris.

He invited Alvaro for drinks at the Six Bells in Chelsea. Despite the ups and downs of his private life, his painting record since they last met on business had been fantastic. Brown congratulated him: what stamina he had! What an advance he had made since their last somewhat distracted meeting at Queens. His full-length portrait of Nancy at the Modern Society of Portrait Painters in Piccadilly had been well received by the critics. *The Studio* review had been especially pleasing. And had he not been made a member of the New English Art Club, where he had shown so many works including that *extraordinary* and brilliant portrait of Ronald Firbank? And what of his new full-length portrait – *Mrs Lewis of the Cavendish*?

Brown considered that *The Author of Modern Sculpture,* a portrait of Kineton Parkes, was the obvious companion to *The Editor of Wheels* and should join Edith at the Tate and he would not have been surprised if Rosa Lewis, the Ladies Curzon and Cunard and of course Nancy, as well as Dorothy Warren, Dorothy Brett and Iris Tree would all end up in public galleries or important private collections one of these days...

So individual was the style of these portraits, or interiors with figures as Alvaro preferred to call them, that he refused to sign them. 'A painter's work is identified by his style of painting, not by a written signature,' he said. This dictum, Brown remembered, had inspired *The Nameless Picture Exhibition* at the Grosvenor Galleries. Alvaro's large picture of Iris Tree, sitting on a four-poster bed in Curtis Moffat's flat, drew more attention from the photographers and press than any other unsigned exhibit. He went on to emphasise how well all Alvaro's recent work had

122

been reviewed in the most prestigious art magazines and newspapers.

Naturally, Alvaro found this interview reassuring. He agreed to produce about fifty canvases for a show to take place in a year or so. He would like to paint more landscapes. He sounded typically vague but Brown was satisfied. He said he thought that Alvaro had been overworking: perhaps he needed a holiday?

Alvaro decided that Brown was right. If he disappeared to Paris for a few days and played a provocative game of 'hard to get', it might bring Nancy to heel, as well as lighten his melancholy.

For many reasons Paris was alluring: Nina had promised to introduce him to Ford Madox Ford and Ezra Pound would probably be there; Marie Beerbohm thought that she would be around and knowing Alvaro's plight, encouraged the idea, including introducing him to Picasso.

He could also look forward to a reunion with his compatriots Madame Errazuriz and Tony Gandarillas. Tony would be sure to have young Christopher Wood in tow and several members of the Bloomsbury Group were planning a visit to their 'artistic Mecca'. Alas, the trip which promised so well proved a failure. All his friends were hospitable, but Alvaro was poor company, drowning his sorrows in drink. He did not meet Picasso.

When he returned to London he discovered that Aldous Huxley too was obsessed by Nancy to the exasperation and despair of Maria, his lovely young Belgian wife whom Alvaro had known since Garsington days when she was Lady Ottoline's protégée.

Alvaro was in favour with Ottoline again in early 1920. That year she had rented a furnished house, 15 Vale Avenue, in Chelsea and invited him and his beloved Edith and Willie Walton to a party with a motley collection, including three of his old friends from the Slade, Dorothy Brett, Mark Gertler and Iris Tree. Ottoline must have felt that there was safety in numbers for she also invited Wyndham Lewis. Storm clouds were already gathering on the horizon for a prolonged row between him and Edith. Presumably, when Clive and Vanessa Bell and Duncan Grant arrived, they would have avoided Lewis, having never forgiven him for his attack on Roger Fry in 1913. Maynard Keynes and Francis Birrell and their allies would have

been joined in ignoring him. Sadly, the controversial Omega Workshops had closed the previous spring.

Alvaro could well understand a vendetta but the intricacies of these English intellectual feuds and schisms evaded him, or at least he pretended they did, and to avoid taking sides took refuge in 'Chile's neutrality'.

Apart from Edith, the literary world was fortunately represented by some of Alvaro's other friends – among them T. S. Eliot. It is likely that Aldous Huxley had not been personally invited but had been brought along by Middleton Murry with whom he had undertaken an editorial job on *The Athenæum*. Maria was not with him; she was seven months pregnant with Matthew and was still nervous of meeting the lions in Ottoline's arena.

It would seem that Ottoline's flair for stage-management had deserted her when arranging this hazardous party: she was, for example, unaware that Aldous was deliberately absorbing additional material from the scene, noting her every word and action for *Crome Yellow*.

Augustus John's late appearance proved a distraction, if not a relief – it was only a short walk from his house in Mallord Street.

John thought that Alvaro was a fool to have fallen in love with Nancy and said so. It was obvious to everyone that Chile worshipped Edith, their visits to the ballet and concerts, her tea parties and poetry readings, her love, her wit and sympathy, all proved a solace, but Nancy obsessed him. He had heard at last how courageously Maria Huxley had behaved. Rather than dangle on tenterhooks another moment watching the miserable Aldous waiting for Nancy to telephone, Maria had issued an ultimatum: he must choose between them. She was leaving with their two year old son the next morning. She began packing everything they owned. Sensibly, Aldous left for Italy with her and their child.

Alvaro determined to follow Maria's drastic example. He proposed to Nancy for the last time. They must either get married at once or he would leave England for Chile – God alone knew when he would return . . .

Nancy loved him in her fashion but was bound to refuse him. After her rejection, Alvaro found London unbearable. No one

124

else of either sex satisfied him. It was torture to visit their favourite haunts, or attend parties or private views, where she might be with a rival. Painting and poetry lost their appeal since she was no longer there to discuss them. His material success, unless shared with her, brought him no joy. The knowledge that others, including Huxley, were suffering the same misery did nothing to relieve the permanent ache. Wherever he went he ran into mutual friends. Their sympathy was far from consoling, only humiliating. In company, he became either morose or bitterly sarcastic.

Her assurance of lifelong devotion proved no comfort: his masculine pride was hurt. He felt no animosity towards George Moore, judging that such a curious relationship could in no way be compared with the total bliss which he and Nancy had experienced. He endured sleepless nights tormenting himself, imagining her in the arms of one of the many men they knew. He resorted once more to 'toms'. He was suffering from *la maladie d'amour*. The painful period of transition between such a passionate and emotional love and some future platonic relationship, however loyal, yawned ahead like a wound that would never heal. Even his most optimistic friends, like Augustus John, Roy Campbell and Geoffrey Nelson, feared that it would take at least a year before he recovered his health and self-confidence. They agreed between themselves that he should leave London and its depressing associations.

Mama Guevara was now installed in Vina del Mar, a few miles from Valparaiso. All her daughters, including Sibila and Susana, were married and she longed to see her son. It was inconceivable that a man so talented and successful should be rejected. From his letters she inferred that he was seriously ill. She wrote urging him to join her. He needed a change of scene: the climate and life in Chile were so completely different; in a few weeks he would recover his health, forget this English girl and find a compatriot who would be more appreciative. He should not return to England until he felt fit and able to meet the unconventional Miss Cunard with detachment – he could be certain of becoming one of her dearest friends – mere lovers would come and go. Alvaro packed his paints and books, his Savile Row suits and his handmade shoes and his beloved bowler hat, and left for Valparaiso on Christmas Eve 1922.

Relief was mingled with regret when his intimate friends read in *London Opinion*: 'Alvaro Guevara the young painter, whose amazing work has been so much discussed in London, is off to his native land, Chile, for an entire year to paint from South American life for an exhibition he proposes in Europe. "Chile" ... is well-known in smart and unsmart Bohemia, and ... is the youngest artist to be hung in so important a gallery as the Tate.'

Another paper reminded its readers that Alvaro 'had a passion for painting *submerged* people, and used to hire the Chelsea baths in order to produce very interesting pictures of pink people in pale water'.

9

Soon after his reunion with Mama, Alvaro formed an important new friendship.

One night he was invited to take his place as a judge at a professional fight for the Featherweight Championships at the *Estadio Ferroviario* of Valparaiso. He was introduced to the spectators as a compatriot who had honoured his country in English amateur rings. He rose to thank the Federation's chairman in a courteous manner and was much acclaimed by the crowd. One of the fighters, 'a skinny brute, punched the current champion's ear so savagely that it was reduced to pulp and blood spattered all over the judges. On Alvaro's insistence the fight was stopped and the victim was removed to hospital. He became stone deaf and permanently disfigured.'

It was on this gruesome occasion that Alvaro first met his namesake Alvaro de la Fuente, who later described the fight above and wrote that Alvaro was: 'a tall, broad-shouldered, athletic man, unmistakably a boxer. His face was well-proportioned, with high cheek-bones but rather elongated. His widely-spaced eyes were strangely expressive. I sensed his distaste for the fight. He was wearing an immaculate tail-coat and his dress shirt was blood-stained'.

De la Fuente had already heard of Alvaro's reputation as a heavy drinker. But it was not just alcohol which made his peculiarly subtle utterances meaningless to the majority. The usual kind of dirty joke 'offended his physical dignity'. He was particularly unpopular with one group of homosexuals because he ignored them. Since boyhood, he had cherished a passion for cars. He drove very fast and now owned an enormous Packard

127

and a Pierce Arrow: the most expensive and advanced American model with headlamps built into the wings. Most gossip about him was negative and derogatory. De la Fuente knew that although Alvaro was rich, thanks to his brother Lucho's endeavours, he was totally uninterested in money. He could not be bothered with investments or speculation and kept a considerable sum on deposit, which his stockbroker acquaintances found incomprehensibly stupid.

De la Fuente was also aware that it was 'grudgingly admitted in Society that Alvaro had distinguished himself in London as a painter and was gently cordial to fellow artists, encouraging and advising them'. He had been particularly generous to one called Ross, with whom he worked daily, urging him to paint beautiful imaginary flowers and to use cement to create most original sculpture. Ross was related to de la Fuente and had boxed as an art student in Paris. 'Alas Ross was suffering from an incurable disease of the nerve ends, and betrayed by his paramour, an excellent paintress who became a communist, committed suicide in the most horrifying way . . .'

At first de la Fuente also found Alvaro 'a difficult customer' and resented his trance-like silences. 'His manner was somewhat insolent: he would answer one question with another, or merely remark: "elementary", or "obviously", as if nothing anyone said was of the mildest interest.'

However, de la Fuente found him more responsive when they discussed boxing. Alvaro became enthusiastic and even offered to coach him. Once he suggested that they should both give up drink and go into training. This bond of discipline led to closer intimacy because at week-ends de la Fuente was invited to Mama Guevara's luxurious establishment, where he fell madly in love with her favourite grand-daughter, Isobelita, the daughter of Bianca and Gabriel Gómez-Lobo y Bahamondes. De la Fuente wrote: 'She was in her teens, more than beautiful, fine, highly intelligent with the sweetness of honey. Alvaro Guevara painted her in typical style from an unusual angle, as the principal figure in an interior. She became insane before she was twenty. Like a fool this havoc of my heart has wasted my life: I have never married, nor been remotely homosexual. The only outlet I had then was the vicious manner in which I hit the punch-ball, as if to avenge this early disaster.'

Alvaro confided that he too felt he could avenge in this way the personal insults, rejections and injustices he had suffered in the past and knew he was doomed to suffer again. When fighting, he had no other thought or motive: his rival incarnated the cursed enemy who had to be destroyed.

One evening, before their good resolution was put into practice, following round after round of double whiskies at the fashionable English club, a Mr Cummings, then head of a petroleum company in Chile, in an aggressive mood, spoke derisively of Alvaro's career as a painter. Where could it lead? Did he consider himself capable of painting the rare, spectacular two-seater Model T Ford which Mr Cummings had recently acquired? This automobile was popularly known as 'Ford's Egg' because of the unusual streamlined design of the body.

'The assembled company was fearful lest Alvaro should lose his temper at this impertinent challenge, and knock Mr Cummings for six: he had been known to react in a violently belligerent way with far less provocation.' To de la Fuente's delight and everyone's relief, Alvaro simply drawled that he would accept the challenge on condition that Mr Cummings would commit himself, on his word of honour, in front of the assembled witnesses, to drive his motorcar himself after its transformation for one month from the date of delivery. Foolish Mr Cummings agreed.

Without delay, Alvaro shut himself up in his huge garage and converted the Ford into a ferocious tiger with its striped tail curled in a menacing query around the spare-wheel, and its paws laid along the mudguards. He 'disguised the bonnet as a snarling, bestial mask with terrifying fangs and bared scarlet gums. The monster's eyes were murderous whether the headlamps were on or off.'

Mr Cummings was aghast at the result, which he excused to his circle as Alvaro's malicious reaction to a harmless joke. When he drove the snorting beast through the streets of Valparaiso, the elderly inhabitants scattered in terror and yelling urchins pursued or surrounded the tiger.

Mr Cummings' friends, 'earnest gentlemen high positioned in banks, the Stock Exchange, industry or commerce, were horrified by his undignified and mortifying predicament'. One spoke to the Mayor, who in his turn approached the Chief of Police and

the Minister of Transport. Mr Cummings was officially notified that he risked prosecution for causing congestion of traffic and civil disturbance. His grotesque motor car must be stripped at once of its disguise, or else – Mr Cummings chose to have it repainted an uncompromising crimson.

Alvaro decided to enter for the South American Open Boxing Championship, the last rounds of which were to be held at Valparaiso's popular *Estadio Ferroviario*. As a seeded competitor, he was not obliged to fight until the semi-finals. But after dinner one night he went to watch the eliminations with de la Fuente, Ross, his brother-in-law Alberto Helfman and his two coaches, Vargas and Arze.

Among the medium-heavy weights one particular fighter had proved outstanding – a local butcher, Zócimo López. He was an extraordinary-looking man with a gorilla-like face, spidery legs and a huge, deformed chest. No sooner had Alvaro and his party taken their seats than the Chairman of the Boxing Federation approached and implored Alvaro to help him. Zócimo's opponent had not arrived; the crowd was restive; it was an important match; spectators had come from far and wide: he feared they would stampede with fury. As a personal favour, would Alvaro step into the breach? Alvaro was silent for a minute before answering calmly that provided he could borrow the necessary kit and bandages he would oblige. He strode towards the dressing-rooms. An announcement was made; the crowd was appeased. The bell rang. Vargas and Arze had taken their places in Alvaro's corner.

De la Fuente realised that Alvaro must be stiff; there had been no time for massage or limbering-up and his body was cold. Nevertheless, he emerged from his corner 'like a thunderbolt and easily won the first round. In the next, his opponent staggered badly and fell into a desperate clinch'. The crowd roared. Alvaro could not escape this ape-like embrace and the referee ordered them to break. Alvaro, trained under Queensberry Rules in England, dropped his hands automatically and took a step back. There were no such chivalries in Chile!

The butcher took full advantage of the respite and slammed in a brutal right. Alvaro fell with such a crash that the noise was 'like a knight in full armour collapsing. But Alvaro pulled him-

self together bravely as soon as the referee began counting; he was on his feet hitting right and left, but with less strength. López was cunning and knowing him to be dangerously groggy felled him with a savage right hook followed by a straight left. This time Alvaro was down for a count of eight. Again, with suicidal courage, he struggled up and charged with bull-like ferocity . . . but his movements were mechanical now. He went down for the last time.'

De la Fuente sat in a horrified daze, not sure what saved his friend. Was it the bell, or did Ross – who was less of a beast than the others – seize Helfman's white silk scarf and hurl it into the ring? Alvaro had given strict instructions not to throw in the towel under any circumstances. However, Zócimo López was proclaimed the winner and jumped up and down like an orang-outan waving his still-bandaged hands.

Spectators were jeering: 'This fellow may be good enough for an English gymnasium, but not for a Chilean ring!' De la Fuente was affronted. A gymnasium boxer: how insulting!

Somehow Alvaro's friends got him to his dressing-room. With the aid of liniment, massage and ammonia, Alvaro regained consciousness, shook his head and began repeating: 'My God! What an ugly man!' To encourage him, de la Fuente added: 'Foul-fighting, bloody rude bastard!' But apparently Alvaro could neither hear nor see. He started to put both his black evening socks on one foot. His brother-in-law, Alberto, drew the others aside and said: 'This is serious: he must have suffered permanent brain damage. Boxing is only fit for delinquents and lunatics.'

Dawn broke before the nerve-racked party repaired to the Sporting Club de Vina to order bacon and eggs and a bottle of wine a head. When Alvaro spoke at last, he turned to de la Fuente: 'I shall not rest until I have avenged my defeat. *You* must help me. Tomorrow we shall go into training again.' He ordered a second bottle of wine for himself and drank it. Mama Guevara's reactions to his battered appearance the next day were enigmatic.

He brooded over his defeat. It was horribly reminiscent.

At the time of writing, there are no eye-witness accounts of the fights that followed which made Alvaro the Champion and won him the Gold Belt, but one or two people have reported that

Alvaro won his own semi-final bout and went on to beat the butcher, 'that ugly brute,' in the finals.

Soon after this satisfactory victory, he left Vina del Mar with de la Fuente to paint frothing waterfalls and swiftly flowing rivers in the Andes. Water still obsessed him: swimming-baths were replaced by prospectors' camps and glistening swamps; the 'pink people' gave way to the Araucanian Indians.

The two friends eventually reached the Guevaras' country estate in southern Chile on which Papa had lavished so much money. De la Fuente stayed at the farmhouse for a few months but Alvaro remained for another year and was inspired to paint the burnt and blackened trees, victims of forest fires, with their limbs silhouetted against the livid sky above the smouldering volcano. Scarlet *copihues*, sunflowers and sacred vines took the place of English roses. The climate and the life suited him. His health recovered, and he found happiness again – that state between contentment and ecstasy – with a young Indian girl whose portrait he painted.

Despite his blue-black thatch of hair, he always had a passion for hats more usual with bald, vain men. Now he wore a sombrero instead of a bowler and abandoned conventional European clothes for traditional embroidered shirts and black trousers of cotton or leather.

Sitting high in a native saddle, using painted wooden clog stirrups and long silver spurs, he rode a beautiful horse through the forests. The Indians accepted him as before: he understood them and joined in their rites more easily than he had adapted to the accepted behaviour at Garsington and the Café Royal. As an outrider, he would escort weird Indian processions from bamboo huts to sacred burial grounds. While relatives screamed and yelled to scare away evil spirits in the hope that this would prevent them from possessing the corpse, he would fire his revolver in the air and make his horse plunge and rear to frighten the devils still further.

Soon after Alvaro had left London, a young man called Wilson Plant, recently down from Cambridge with a first in European Literature, was suffering from unrequited love for a Spanish dancer. He was only twenty and his family, who had always

disapproved of the liaison, were quite relieved when it ended. Rather naturally he had learnt Spanish from her and thought this would be an asset in South America which he had always longed to visit.

It was odd that he and Alvaro had never met as their mutual friends were legion: Michael Arlen, Edward Lacey, Alfred Roland Childe, Roy Campbell and Tommy Earp . . . Ottoline Morrell and Augustus John were convinced that Wilson and Chile would get on like a house on fire. They shared artistic and intellectual interests with a strong sense of adventure.

When Wilson finally arrived in Vina del Mar via Brazil, Alvaro had just returned with about fifty canvases from Arauco.

Whenever Wilson mentioned Alvaro's name in Valparaiso, the effect was dynamic. The rich in Chile were fantastically rich: most of the Guevara sisters seemed to have married multi-millionaires – he met them at Embassy receptions and fabulous parties. Even at cafés and brothels on the waterfront, everyone knew and admired Alvaro. He was a national hero as an amateur boxing champion at the *Estadio Ferroviario*.

Clutching introductions, one morning Wilson called at Mama Guevara's grand new house. Whereas many Chilean homes were too ostentatious, the Guevaras' was furnished with taste.

When Mama Guevara received him she was wearing an embroidered shawl over her head and a dress with long spreading skirts. In appearance a matriarch, in conversation she revealed an unworldly wisdom. When Alvaro appeared, Wilson found him magnificent.

Wilson too was attractive: he reminded Alvaro of Roy Campbell. Luncheon, served by liveried footmen wearing white gloves, might have been prepared at Maxim's. Mama showed Wilson round the house; in Alvaro's dressing-room he noticed row upon row of handmade, highly polished shoes on wooden trees and wardrobes full of immaculate suits and piles of expensive silk shirts. 'All from England!' murmured Mama.

The two men found that they shared a vast acquaintance and countless interests. Each confided his hopes and fears in the other. Alvaro confessed how much he had suffered from his rejection by Nancy: but it was clear that after two years he had recovered both mentally and physically. He admitted feeling much attracted by Amalia Errazuriz, a beautiful Chilean girl.

She was a distant cousin of Dona Errazuriz. In Valparaiso, Amalia was thought shameless. She smoked cigarettes in public, insisted on wearing trousers and was seen hatless driving her own Ford with no chauffeur or *duena*. She was the kind of woman who appealed strongly to Alvaro – an original, intellectual rebel. Like Nancy her interests were highbrow. Although she had willingly consented to sit for her portrait, he was bound to admit that he had made less progress with the sitter than the painting! This was an evil omen.

After the misery he had endured losing Nancy he needed romantic reassurance. If Amalia refused him, he was sure that throughout his life the same negative pattern would evolve. He would like to have a child but it seemed that his hopes of achieving an ideal marriage were doomed. Both Wilson and de la Fuente realised that from early youth Alvaro had retained a superstitious nature and a cynical attitude towards his fate.

They were astonished that any man so attractive should prove resistible. Although Wilson too was devoted to Nancy, he insisted that she could never remain physically faithful. She had recently had her womb removed, determined *not* to have a child, however many lovers she had. Wilson felt confident that Alvaro was one of the few men in her past who could still look forward to a rare and lasting friendship. Alvaro showed him two over life-sized stone heads from Easter Island which he had bought as presents for her, not only because he felt they greatly resembled him but because he knew that she would like them.

Wilson owned an impressive collection of rare books. What a miracle that they had survived the perilous journey from England via the Amazon! One volume which particularly intrigued Alvaro was the famous eighteenth century classic on optical illusion, *Theory of Vision*, written by the philosopher, George Berkeley, the Bishop of Cloyne. Characteristically he became obsessed with its theories and during the next few weeks made many original if comical experiments using a camera and mirrors. He hoped that Amalia too would find Bishop Berkeley's ideas exciting. Lately his courtship of her had proved more hopeless than ever. He suggested that Wilson should write her a letter, enclosing a select, tempting list of his portable library. Being unconventional she would be sure to come alone. Wilson would then sing

eulogies of Alvaro to the elusive Amalia, or at least discover what it was that prejudiced her against such an eligible admirer.

Alas, the mysterious Amalia ignored the bait. She was not interested in men.

To Wilson, brought up in an atmosphere of hunt balls and High Table, the scale of hospitality offered by prosperous Chileans was overwhelming. The profusion of the wines and liqueurs, the ambrosial quality of the food, the lavishness of the bouquets of tropical flowers, surpassed any extravagance he could imagine.

He and Alvaro attended diplomatic receptions, galas and balls at the President's Summer Residence and spectacular parties at 'that exclusive, fashionable English club', housed in a palatial building in the European style in Vina del Mar.

Being expert dancers, as well as charming, both could pick and choose among the many beautiful women, wearing dazzling jewels and gowned in priceless models from Paris. Their hair, which shone like jet, was dressed high and crowned by Spanish combs. Their complexions, jealously guarded from the sun, glowed like pale satin. The light from thousands of candles in vast crystal chandeliers may have been flattering but Wilson was enchanted. He would watch these birds of paradise flirting with his friend, flashing their huge, dark eyes over feather fans, or veiling a bold inviting glance with cobwebbed lace. Sometimes Alvaro disappeared into the garden with his latest conquest and was lost amongst the floodlit jacarandas.

Only Wilson knew that he might have a treasured letter from Edith Sitwell, or perhaps a recent poem by Nancy in his tail-coat pocket.

Not all the social distractions were so formal: Alvaro spent many nights in Valparaiso, in *hueso* costume. On the waterfront, most of the so-called cafés were in fact brothels. He seemed to have money to burn and much enjoyed gambling at the casino.

The proprietors of these various establishments welcomed him and his entourage with joyful shouts, back slaps and noisy kissing. A slight hush was followed by a cheerful rumble of interest as he was led to the best table. In a moment he was surrounded by the prettiest girls, and older women who made it obvious that they had adored him since he was a boy.

Wilson was impressed. If a brawl threatened, the proprietor only had to raise his eyebrows as a signal. Alvaro would rise from his chair and towering over everyone would simply survey the room and all would grow calm. Very rarely did he have to speak to the culprits; if so, a few words in his deep drawl seemed to hypnotise them. He was certainly fighting-fit and had virtually given up drink, which had sometimes proved his undoing.

On nights when he was billed to fight, the stadium was crammed and the excitement was intense. The crowd went mad and roared his nickname: 'Tolomiro! Tolomiro!' Sailors in the port were familiar with *moais*, the stone images of the Easter Island gods which they thought their hero resembled, with his strange expression and massive head. Grinning delightedly, he waved and bowed acknowledging the hysterical applause. His eyes shone with pleasure like a child's. The boxing-ring was his stage. Proudly wearing his gold belt, once more he was the star performer.

The Guevara ladies resolutely turned their faces from these contests at the *Estadio*: boxing was deemed infra dig by the Chilean upper classes, whereas it was both fashionable and acceptable to the English aristocracy.

Despite the attractions which Chile had to offer, both Alvaro and Wilson ultimately agreed that there was no pleasanter place to live than England.

From cafés on the waterfront, eager for news, they would watch the ships dock with bags of mail, and share each other's letters.

The London artistic and literary kaleidoscope had obviously shifted into even more complex and puzzling patterns during the last four years. Although some disintegration had begun before he had departed, perhaps it was as well that Alvaro, always reluctant to commit himself to either side, had escaped involvement.

Shattering intellectual and emotional feuds were inevitable between rival explosive groups and inflammable individuals such as Wyndham Lewis and Edith Sitwell.

Oliver Brown wrote urging Alvaro to return. His promised one-man show at the Leicester Galleries was long overdue. A firm date must be made. He would share the honours with

Edward Wadsworth, who had made his name as a Vorticist, his work would provide a stimulating contrast.

Brown and his partner Phillips still commanded much prestige. The spacious premises in Leicester Square were usually divided between two painters. Edward Wadsworth was an intelligent choice to share an exhibition with Guevara. He was thirty-seven and Alvaro would be thirty-two: they were old acquaintances, both having attended the Slade and Wadsworth having already held a successful exhibition in the galleries.

Letters, often enclosing newspaper cuttings from London, not only described the latest artistic or intellectual achievements of his and Wilson's more serious friends, but also the dizzy antics of the Bright Young People who perpetrated hilarious and often successful hoaxes on Society. These included sophisticated versions of games such as blind-man's-buff in Piccadilly and follow-my leader through every department of Selfridges, over the counters, up and down in the lifts; they aimed to shock and – literally – set the Thames on fire by pouring gallons of petrol on to the water and igniting it.

One of the stars of this galaxy of Bright Young Things was Brian Howard, who was to become Alvaro's most hated enemy: 'Mad, bad and dangerous to know,' was the description which Evelyn Waugh re-applied to him. Yet he was much loved by many critical clever men and gifted young women – even Nancy adored him. Allanah Harper, who suffered miserably from his cruel and embarrassing pranks, was surprisingly devoted, and Meraud Guinness, then in her early twenties and already dissatisfied by conventional society, found him fascinating.

Allanah was a very pretty blonde with literary aspirations whose path would cross Alvaro's several times. The Aga Khan wanted to marry her and was amazed when his diamond bracelets and jewels were always refused with an innocent blue-eyed stare and a disarming query: 'But what on earth are they *for?*' She refused this oppulent suitor when her mother explained what a Begum's duties entailed. Her friends agreed that she was already worth her own weight in gold; like Meraud she was highly intelligent but bored with conventional social life in England.

It was paradoxical Brian who inspired the most original adventures. Snippets from English gossip columns conjured up an image of an endless succession of freakish parties at which Rosa

Lewis' youthful protégés Charlestoned all night with furious energy.

It was obvious to Alvaro and Wilson that in London the passion for dressing-up had entered a new phase: individual fantasy was now submerged in a general theme.

There were circus ad funfair parties, impersonation parties, Wild West, Cowboy and sailor parties, pyjama parties – crazy parties where Raymond Mortimer went as a sponge bag and Talullah Bankhead wore bell-bottomed trousers and looked *absolutely divine*! Bloomsbury's more temperate contribution was a fancy dress party on the theme of *Alice in Wonderland*.

Although amused to read of such frivolities, both Alvaro and Wilson realised that most of these Bright Young Things would soon fade into obscurity. 'Let's go and watch the British lion cubs at play before they grow old and turn into tame pussycats or ferocious beasts,' Alvaro said with a grin.

Obviously, it was the Bloomsburys' influence which would survive and change the manners and morals of the British both fundamentally and permanently. Their preference for making love rather than war, their tolerance of homosexuality, their uninhibited vocabulary would lead to an extremely permissive society.

Wilson noticed that Alvaro's mood was mercurial on that particular day; by the same post he had heard that Ronald Firbank was dead. Perhaps he felt a twinge of remorse and wished that his portrait had been less cruel and that he had shown more sympathy for this strange man?

For many different reasons both young men felt a sudden longing to return to England. Wilson had recently become engaged to an English girl whom Mama Guevara had chaperoned and entertained during her visit to Valparaiso.

After consultation, Mama agreed that she should sell the house in Vina del Mar. Wilson should go on ahead: Alvaro and she would follow.

Fortunately the railway across the Andes had now been completed so that the journey was not so challenging, or perhaps as exciting, as the one Alvaro had made in 1909. He was thirty-one and it was 1925.

It was no change for the Guevaras to travel with excess baggage. Packing cases crammed full of Wilson's books, countless

souvenirs, Alvaro's fifty-odd crated pictures, cabin trunks of clothes, his enormous presents for Nancy Cunard – their arrival stunned the hall porter at a Kensington hotel. In a few days Alvaro was invited to stay in Wilson's house in Connaught Street.

10

Old and influential friends rallied round on Alvaro's return. They were at least unanimous in their welcome. There was much back-slapping and embracing at the Café Royal, the Eiffel Tower and other favourite haunts. Hostesses again plied him with invitations; everyone was delighted to give their own versions of the scandals which had taken place while he was away. He listened to innumerable accounts, some confused, some articulate, perhaps hoping that by the time his exhibition was over he would seem less of a stranger to Nancy.

The timing of his reunion with Edith proved fortuitous. He found her looks even more interesting and exquisite than when she had sat to him for her portrait. Their feelings for each other were still emotionally romantic. She had gained much self-confidence. He admired her original style, her choice of strange jewels to decorate her beautiful hands, but the quality which pleased him most was the refinement of her wit – rather than rely on a sense of the ridiculous, her humour had matured with a subtle tang, sometimes even a bitter sharpness which he could both share and appreciate. She had much to tell him. He had already gathered that she and her brothers had become an English intellectual legend. How sad it was, she said, that he had missed *Façade* – there had been two private performances. William Walton had written the music and Edith had been invited, as a challenge, to accompany his creation by reciting twenty-one of her poems into a sengerphone. Diaghilev had been in the audience. The first public performance had taken place at the Aeolian Hall in June 1923, but of course not everyone had been

intelligent enough to understand or appreciate it and some unenlightened critics had condemned the whole affair as 'idiotic' especially *her* contribution! Noel Coward, that tiresome, supercilious young man, had walked out. She would never forgive him! Over thirty years later she did, and they became firm friends despite the parody he had written of her in a sketch, featuring an absurdly affected poetess, Hernia Whittlebot with grapes in her hair.

Although Alvaro had never heard of a sengerphone, he begged her to continue ... Ah, yes, so much had happened while he was away! Sachie had married Georgia, the sister of Frances Doble, that attractive Canadian actress; and now a ballet, *The Triumph of Neptune,* which he had produced and for which Gerald Berners had written the music was about to take place – next month – it was already booked at the Lyceum. Alvaro must join their party.

Before that important event took place, there was his exhibition. The Sitwells' loyal affection proved invaluable. Oliver Brown was delighted when, on his own initiative, Osbert wrote an introduction to the catalogue. This thousand word eulogy began : 'The "come back" of that young lion of English painting, Mr Alvaro Guevara, has been quietly staged, but his painting supplied the necessary and authentic sound of trumpets which such an occasion required. Those lovers of modern art who have survived the irritations of the last few years will remember Mr Guevara as one of the most interesting of the younger painters, and have no need to be told that he is a remarkable and original personality. He belongs to us by his own choice; it is futile pretence to lay claim to the work of this painter, for he is [so] obviously Spanish in his taste and technique ... In Mr Guevara's work the sequined light sparkles and flows round every object, even round dull English objects ... the twentieth century is not going to be like the nineteenth ... We remember our artist's still-lives ... but now he returns to us with native subjects : the great river slowly flowing, the giant trees swinging back in their tropical tangle, the crucifix, which is still at the back of every Spanish mind, and last, but not least, his own portraits. It may seem to some of us that Mr Guevara is more convinced of his own good looks than those of his other sitters; but very beautiful and delicate works are these two self-portraits ... My own pre-

ference is for the Chilean interior, with those figures and those bright rugs sailing on an ocean of black floor; former examples of which genre caused the heathen so furiously to rage not so long ago. I remember well the screaming that greeted them, and cries of "Aren't they funny?" "Oh my! The figures are sliding off the floor!" or "Are they supposed to be skating?" To this order belonged that splendid, but rather cruel, study of the late Mr Ronald Firbank, and it would be interesting to a student of modern literature to know where the picture is now . . .'.

Osbert Sitwell went on to suggest, tongue in cheek, 'that lovers of art would do well to club together and commission Mr Guevara to paint a portrait of Lord Wavertree, that notorious art expert who was brought up in Rome. This might bring to his notice, too, the fact that the nineteenth century is passed and done with.'

As a purely social event, the gossip columnists lapped up the private view. One remarked: 'Whatever one might feel about the Sitwells, their bitterest opponents would not deny that they managed to collect the most interesting people in the artistic world.' In another journalist's opinion the best picture was 'of marionettes that Senor Guevara found in a little shop in the Gloucester Road . . . his ambition is to have a marionette theatre of his own'.

A fashion reporter noted that 'Osbert's new tie (part, no doubt, of his trousseau for America) was much admired for its blue design of motors, dogs and policemen . . . Dorothy Warren was wearing the ideal Eton crop beneath a high-crowned severely brimmed black felt hat, a good frame for her perfect profile. Michael Arlen was there, not too pleased with the English climate. Mrs Alfred Sutro was wearing a rust-coloured hat, and Nina Hamnett had chosen brown. Mrs Guy Wyndham was very joyous with her husband and her famous mother Ada Leverson, whose costume combined artistically peacock with powder-blue, and I noted the coming-in disposition of silver galon bows upon dark and simple millinery.'

The *Daily Sketch* noted: 'Many well-known people were walking about the galleries and discussing the relative merits of the various paintings, including Mr Osbert Sitwell and his brother Sacheverell – producer, by the way, of a Victorian Ballet at the Lyceum Season of Diaghilev Ballet. Mrs Sacheverell Sitwell was

also to be seen, and those brilliant young composers, Constant Lambert and William Walton. Mr "Dick" Wyndham was wandering about too, in very rough tweeds and with his dog on a lead.'

Mama Guevara did not attend the private view, but sat quietly in her hotel, waiting for her son to bring the critics' reviews which she knew, despite his nonchalance, would have a profound effect on his morale after the negative reactions in Chile.

The following day Alvaro rushed into her bedroom waving copies of *The Sunday Times* and *The Observer*. Both papers had given generous space to the exhibition and praised the Leicester Galleries for 'its characteristic predilection for pronounced contrasts'. Frank Rutter of *The Sunday Times* had written: '... in the paintings of Chile by Mr Alvaro Guevara, abundant life is pre-eminently expressed ... these pictures are as passionate and warm as Mr Wadsworth's are ascetic and cool ... Mr Wadsworth refrigerates oranges and lemons, Mr Guevara can make blues palpitate with heat.'

In Mr Rutter's view, Alvaro 'had made an immense stride forward as a colourist. He was always an inventive designer and a fine draughtsman, but though it includes an admirably modelled "Head of a Woman", the present exhibition reveals him mainly as a landscape painter, and his "Campos Santos" with its intensely realised water, may be cited as an example of that blend of vivid actuality and formal decoration which gives a peculiar distrinction to Mr Guevara's paintings'.

The Observer critic, P. G. Konody, asserted that although unmistakably Spanish there was a connection between Guevara and Utrillo. Chilean Guevara found his subjects on the river banks and forest lands of South America, while Utrillo devoted himself to French suburban streets; what the two had in common was the 'limpid clearness of atmosphere and a certain acid quality of the light, the coldness of which does not prejudice the general effect of warm sunlight. In these landscapes, as indeed in all his recent work – portraits, stage scenes, interiors with figures, still life, and so forth – Mr Guevara, whilst still retaining his independence of vision and grasp of abstract organisation, has abandoned those ultra-modern tendencies which in the past led him to defiance of perspective and to other departures from the normal. He has sown wild oats, and his present mature achieve-

ments hold the promise of an even more brilliant future.'

The following week, Alvaro's friend, Tommy Earp, gave him a highly complimentary and long review in the *New Statesman*, stressing that he had not fallen into 'the mannered exoticism of Gauguin. Without allowing the natural brilliance of the Chilean landscape to dazzle his sense of control and lure him either to a Wild West romanticism or an unregulated blaze of colour for its own sake, he has combined faithfulness of representation with technical restraint.'

The *Apollo* critic wrote that colour was still Alvaro's strength and absolutely original, '. . . not a modification of light, but rather a result of a cosmic will to escape from darkness . . . They sparkle and glitter; they sing. His next quality is one of spatial sense: you feel you could walk into the room, or lay your hands upon a rug-covered table-top. Last, but not least, is his sense of portraiture.'

At this time Clive Bell was reviewing art exhibitions for *Vogue*, and in his opinion Guevara had 'always seemed to be influenced by Matisse: the influence is, I suspect, unconscious, for Mr Guevara is anything but a learned painter. At his very first exhibition at the Omega Workshops I recollect remarking that influence and surmising that it was an influence of the right kind, the result of a profound impression rather than of conscious imitation.'

Not all the reviews were as positive, for example, Anthony Bertram of *The Saturday Review* found that Alvaro 'returned very much more himself than he was, or at least very much less anybody else. His rich, mysterious colour, the shimmer of putrescence about his pictures, the unholy holiness are all quite distinctive. His work has the fascination and repulsion of death rotting under a hot sun. We may not care for this aspect which Mr Guevara presents, but we must admire the power of his presentment. We are not surprised to find an introduction by Mr Osbert Sitwell. Mr Sitwell's method of looking forward is to look back and sneer. Mr Guevara's method of painting the present – surely always the artist's business? – is to show the corpse of the past.'

Alvaro's show was a gratifying success. The telephone in Wilson's house never stopped ringing. He had helped Alvaro hang the show, but now he had joined the Colonial Service and

was about to get married. Before the two friends parted, Alvaro confided that he was finding the subtle divisions in the literary and artistic scene even more complicated. Wilson realised that rather than commit himself to any particular group of English painters and consolidate his position, he might dash off at a tangent and experiment again.

Alvaro's head was not turned by success; he proved a valuable, or at least useful, friend to a less fortunate young English painter, Adrian Daintrey. Adrian had only remembered Alvaro as an unusual character at Slade parties. By chance they met again one day at the Leicester Galleries.

In his book I MUST SAY, Adrian recalled that he was 'one of those foreigners who feel completely at home in England, not only in one stratum, but wherever their interest happens to take them. But he gave the reassuring feeling of being always himself . . . He had considerable *bonhomie* and tact. He greeted me as an old friend, asked after my work, and said he would like to see some of it. Where was it? I told him that it was outside London, at Wimbledon . . . Many people would there and then have made an excuse rather than commit themselves to a pilgrimage . . . He would be there tomorrow morning at 10 a.m. Sure enough when I went to meet him at the station he had turned up. Chile, who was dark and powerfully made, was dressed in a very smart suit and not in the least what my mother expected. Nor was she less surprised when he later spoke to her gaily and simply about the need for her to have faith in me. He said he was very tired, as he had been out late the night before with the Duchess of Marlborough and her son Ivor Churchill. Whereupon he was given some coffee. He then inspected my paintings . . . "People will say they are like Duncan Grant, but I think they are better. In any case, you have never seen Duncan Grant's paintings." This last was true at the time; I was delighted with the praise. He then said that he knew someone in London who was running a gallery and that this person might be interested to see the pictures and he would get in touch with her.

'Once more Chile was as good as his word and the next day telephoned to say that he had arranged for me to meet Miss Dorothy Warren that very afternoon, and that I should bring some canvases with me. He closed his remarks by saying, "I wonder what you will think of her." Indeed, Dorothy Warren

gave me plenty to think about by her remarkable looks. Her immediate ambience was one of warmth and friendliness and magnetism. Although she wore fashionable clothes, it was evident that she was not purely a Society woman. She was, in fact, what was rare at the moment . . . both elegant and educated.'

As a result of this, Adrian shared the first exhibition in Dorothy's newly opened gallery on the corner of Maddox Street with Paul Nash who had already considerable standing among the *cognoscenti.*

Not long after this constructive reunion, Alvaro invited Adrian to a dinner party at the Eiffel Tower which, he explained with a modest grin, he had planned regardless of expense, to celebrate his expected victory in an important boxing match.

Alas, having been knocked out, Alvaro was not fit to attend, but various friends drank his health raising their glasses to his empty place and wishing for his immaculate reappearance in their midst.

Once more Alvaro was made warmly welcome by the Johns at their Chelsea house. By now 'the little ones', Vivian and Poppet, were old enough to appreciate that 'Chile was tremendous fun'. Over forty years later, at an exhibition of Vivian's paintings at the Upper Grosvenor Galleries, Edwin John, one of Ida Nettleship's sons, when asked if he remembered and, if so, if he had liked Alvaro Guevara, replied, 'You mean Chile Guevara – *remember* him? But of course; he was marvellous, an exceptional man – quite extraordinary! We didn't *like* him, we adored him . . .'

Alvaro not only visited Mallord Street when the Johns were *en famille*, but was yet again invited to their uproarious fancy dress parties.

Lately, a young married couple, Anthony and Clare Crossley, had moved next door. Clare was a beautiful artistic girl; both Augustus and Dodo admired her. She sat to him and she and her husband were told that they could drop in at any time.

The first evening party they attended, in fancy dress of course, was crowded and chaotic. Clare only knew a few people and felt rather shy. Chile Guevara and various other guests in hilarious disguise were pointed out to her as well as Nina Hamnett who arrived with a boxer – her favourite man at the time. As the wine flowed and the evening wore on, owing to the crush many people

146

were obliged to sit on the floor. Nina's boxer became wedged beside a quite harmless-looking, not particularly flirtatious girl. They were stuck: there was no escape for either of them. Suddenly Nina rose up in a jealous rage and grabbed the girl by the hair and almost scalped her by dragging her up and over the sofa. Her hairline parted from her skull and her face was streaming with blood. Most of the guests were out of control but Dodo dealt with the emergency and begged her young neighbours to remove the screaming victim. They did so at once and summoned a doctor who arrived in time to save a million hairs with innumerable stitches.

It was at about this time that Allanah Harper called on the Johns and was enjoying a peaceful discussion with Augustus when George Moore arrived. At the sight of Alvaro's pictures on the wall he lost his temper and shouted: 'How *can* you hang such rubbish? Call that painting?' Glaring at an oil sketch of the interior of a pub, he stormed on, pointing out that one of the chairs had only three legs. 'That Chilean! Can't stand the sight of him or his trash.' Augustus hotly defended his protégé and while the two men argued fiercely, Allanah felt ill at ease. Perhaps it was as a result of this scene that Alvaro's pictures were removed from the London house and ended up in Caspar's bedroom in the country.

When *The Triumph of Neptune* took place, it was a triumph for the composer, the author and the whole ballet. According to reporters, the stalls at the Lyceum were crammed. Sacheverell Sitwell looked pale and nervous sitting beside his wife who wore pink flowers on her white ermine. On the other side of him sat William Walton. Miss Viola Tree, Eton-cropped and wearing black was in a box with Lord Lathom and Miss Elizabeth Ponsonby in bright red velvet. Massine was standing in the aisle talking to Diaghilev.

Before the final curtain, flowers were showered on to the stage. M. Lifar caught several wreaths, one of which he flung round the shoulders of Gerald Berners who was standing by. The audience shouted for Sacheverell Sitwell, who finally appeared looking young, shy and distinguished.

The gossip columnists noted that Miss Edith Sitwell was escorted by the Chilean painter Don Senor Alvaro Guevara and that Osbert was not present as he was in the United States. They

147

added that had he been at the Lyceum that night, he would have realised that England was fit for Sitwells to live in.

Among many men Alvaro met again at the Eiffel Tower with Stulik were Aram Mouradian and Michael Arlen.

Arlen had just published his best-seller, *The Green Hat* in which the main character, Iris Marsh, was obviously based on Nancy. Aldous Huxley too had used her with notable success, as the model for Marjorie Carling in *Point Counter Point*.

Alvaro had known Mouradian on and off since Bradford days as Mouradian too had started life there in the wool trade. He was in London on a visit from Paris, where he lived now. He had gone into partnership with the Dutch dealer Van Leer in the Rue de Seine.

Like most naturalised Armenians, Mouradian showed enviable acumen in business. As a talent scout, he found a valuable ally in young Freddie Mayor, who was one of the first London dealers to show controversial modern French pictures in his gallery off St James's. Although he was still only twenty-three, Freddie's infallible instinct and discriminating taste had already earned him respect. He was fortunate in having as a godfather Walter Taylor, that well-known patron of the arts and great collector. It was thanks to Mayor that Walter Taylor had commissioned Alvaro to paint his portrait in 1918, which the critics had agreed was one of his best. [It was sold by the Mayor Gallery to the Contemporary Art Society in November 1936 but at the time of writing, despite exhaustive enquiries, is missing.]

Mouradian agreed with Mayor that Alvaro's exhibition at the Leicester was interesting, and not only artistically for both knew 'their onions' in the French sense. Guevara was worth watching.

One evening at the Café Royal, Alvaro offered Mouradian a lift to Paris in his impressive American Packard, yet another new model which attracted gaping crowds wherever it went. Unlike Lucho, Mama Guevara never accused Alvaro of financial extravagance; an efficient motorcar, or even two, were to her essential.

Unwittingly, Mouradian accepted this offer with enthusiasm. A moment later, Augustus John, in his usual jolly way, crowned 'Silly old Chile' with a brandy bottle, shouting that if he left London now it would be the end of him as a painter.

PART THREE

The Lone Wolf

1925-1951

II

Mouradian had some cause to regret accepting a lift to Paris in Alvaro's roadster. He felt dwarfed by the Easter Island heads which filled the back seat. He was petrified and crouched down in his bucket seat scarcely daring to peep through the windscreen. Alvaro drove through northern France as recklessly as if he were in a remote part of Chile, without speaking for hours at a stretch. When he did, the things he said were so oracular and strange that they merely added to Mouradian's bewilderment.

'I love lizards, not only as toys but friends. In spite of their hooded eyes, they look up at one with respect.'

Mouradian concluded that Alvaro was not only a highly dangerous driver but mad. He determined to abandon the Packard and escape to the nearest railway station at the first opportunity. He was unable to put this resolution into practice; his trembling legs would only allow him to stagger as far as a wayside café for a cognac.

Never having regarded a lizard as a toy or a friend, he wondered if these spasmodic utterances were designed to compensate for the boredom of long silence in a restricted space. As they approached the outskirts of Paris, miraculously intact, Mouradian was able to relax and Alvaro became more communicative. He divulged that he was obsessed with the ideas of the Surrealists, a new group of painters and poets with whom Nancy was involved according to Maud. Mouradian remarked that Alvaro was never just normally interested, but *obsédé* by some new craze. It was rumoured, Alvaro said, that some Surrealist poetry

149

recently printed was nothing more than the result of an old-fashioned game called 'Consequences' – played by this brilliant group on a high intellectual plane. Perhaps Alvaro was being sarcastic. His English governess had taught him and his sisters to play – a piece of paper was handed round and each of them contributed a line, which they concealed by a fold before passing it on, for another to be added. He had also played this game with Mark Gertler, Geoffrey Nelson and Nina Hamnett during air-raids.

Mouradian had heard that another Surrealist inspiration was known as *la période des sommeils*: one poetic member of the group would express his subconscious thoughts aloud while in a trance, probably under the influence of alcohol or drugs, while the audience wrote down their various impressions. The young poet René Crevel excelled at this. He was a violent revolutionary, but he could be both sensitive and charming: he was often ill and away in Swiss hospitals being treated for tuberculosis. Most of the Surrealists were communists.

Alvaro sighed: he was totally uninterested in politics.

It suddenly occurred to Mouradian that Alvaro's long silences were trance-like too – maybe he took some sinister drug he had discovered in Chile. If so, he would find plenty of encouragement in Paris. Jean Cocteau was already an opium addict. It was he who had made *Le Boeuf sur le Toit* 'all the rage' – just as Augustus John had adopted the Eiffel Tower and the Café Royal in London. At *Le Boeur*, however, there was the additional attraction of music and dancing.

Alvaro did not confide in Mouradian that Tony Gandarillas' friend Christopher Wood sometimes enjoyed opium: some people thought that it improved his painting. During the last few months in London, it had become the norm to smoke a pipe at certain parties. Madge Garland was one of the few young girls who did not indulge and remained sitting bolt upright drinking lemonade while others stretched out on the floor. Alvaro admitted that he enjoyed an occasional pipe but preferred to visit the dens and flophouses in Limehouse and sketch the recumbent inmates so gracefully served by the little Chinese – at least they kept still!

When at last the Packard nosed its way down the narrow Rue de Seine, Alvaro and Mouradian celebrated their safe arrival with a few drinks at *Les Deux Magots*. Despite their terrifying drive,

Mouradian's feelings towards Alvaro had not changed; in fact he would have been willing to share an *appartement* with him, but Alvaro had already decided to take a room at l'Hôtel Windsor in the Rue Beaujour. He was almost sure that he would stay in Paris for some time and would eventually find a studio somewhere in Montparnasse. He preferred to live alone and would probably install Mama Guevara at l'Hôtel Majéstique.

Typically Alvaro reverted to his current preoccupation, the Surrealists. He felt that the painters among them had an affinity with the Pre-Raphaelites, especially Dante Gabriel Rossetti, whose work he had recently studied: Rossetti had resorted to drugs and the results were quite admirable.

He now looked forward to visiting the Galerie Surréaliste in the Rue Jacques-Callot and to meeting the poet Louis Aragon, who by all accounts had been Nancy's most intimate friend for the last two years – of course this was not indicative of her being physically faithful . . . But they had travelled all over Europe together and Alvaro would like to hear their impressions of Spain.

Michael Arlen had advised that if Alvaro wanted to meet Nancy again and the group of thirty-odd Surrealists, she and Aragon foregathered most days at *l'heure de l'apéritif* at the Café Cyrano in the Place Blanche. They certainly made an attractive pair. On a visit to Paris, Allanah Harper had noticed them together in various restaurants 'both superbly good-looking and completely engrossed in each other'. On these occasions they ignored Aragon's entourage, which included such interesting men as André Breton, Paul Eluard, Yves Tanguy, André Masson, Max Ernst, Salvador Dali, Joan Miró and the photographer Man Ray and his model Kiki. Alvaro was interested to hear that Nancy would be sure to introduce him to Tristan Tzara the Rumanian poet, 'that mystery man of ethical and artistic revolution who had founded the Dada movement'. He wondered if he would meet Francis Picabia whose Dada pictures were all the rage especially since his last show in America. He had no idea what a colossal influence Picabia and his circle would have on his own future.

Everyone said that Nancy was still devastating: her green eyes fringed with black were more cat-like than ever. Her thin arms were covered from wrist to shoulder with ivory African

151

bracelets. When she was drunk, they proved effective weapons – strong men had been knocked out by them.

Alvaro smiled. After so many years, he deemed it more prudent to meet her fairly sober early one morning, rather than call at her apartment. Iris Tree had described 'the permanent parade of genius and their molls from one café to another – the Cyrano, the Dôme, the Rotonde . . .' and the Sitwells had prepared him for her latest Parisian home at St Louis-en-l'Ile. Before moving there, she had rented the studio where Modigliani had committed suicide. The Sitwells, loyal patrons as ever, had done their best to sustain him during his darkest hours. They had actually bought his unpopular work, paying as much as fifteen pounds for a picture, and Nina Hamnett had bought a few drawings for as little as three francs each.

Alvaro hoped that the Easter Island heads would appeal, but perhaps she no longer cared for such things? Mouradian assured him that not only she, but all the Surrealists, now had a passion for ethnography and collected primitive sculptures, fetish figures, carvings, grotesque masks and even beads from Africa, New Guinea, North and South America and the South Seas. Her studio was full of such exotica. It was an extraordinary mixture of primitive *objets*, boule furniture and contemporary pictures, including a large Picabia of a man with four pairs of eyes, a black arm and his torso dotted with a scarlet rash. Van Leer and Valleton hoped that Mouradian would succeed in persuading Pic to give them an exhibition.

During the next few days Mouradian discussed Guevara's painting with his partners. He was soon in a position to offer Alvaro a show – the date was provisionally booked for 1928, possibly early December. Alvaro grinned with pleasure and invited Mouradian out to dinner. They ended up at a rather dark *boîte de nuit*. Mouradian peered through his spectacles: the flappers, very made-up and wearing short, fashionable skirts, turned out to be boys. He was shocked when he saw Alvaro dancing an energetic Charleston with one and expressed his disapproval. Alvaro merely shrugged his shoulders and said: '*Mais, voyons, mon vieux, ce n'est qu'un petit coiffeur.*' Such frivolous encounters were harmless, even delightful – serious relationships with women caused appalling pain; it seemed that he had a lethal touch where love was concerned with them.

His reunion with Nancy was successful. He was no longer in love but admitted that he found her personality magnetic. She was unique. In a curious way they still bewitched each other. Now it was Mouradian's turn to smile. Nancy's affectionate welcome had given Alvaro confidence; perhaps he sensed that it would soon be Louis Aragon's turn to suffer as he, Aldous Huxley, Curtis Moffat, Michael Arlen and countless others had. Nancy would never be satisfied for long with one man: she was an inquisitive adventuress. He described her as a 'a butterfly of steel'.

Happily, she had been thrilled by her 'very fine present'. She confided her intention of leaving Paris for a village in Normandy, La Chapelle Réanville: it was only an hour's drive, less, in Chile's posh car. Sir Bache had recently died leaving her a few thousand pounds, so she had bought an old barn in mellow, honey-coloured stone which would convert into a house with four or five bedrooms and a studio. The property was called Puits Carré because of its square well, which would serve as a wine cooler in summer. Bottles on strings could be lowered into its depths. The branches of two tall limes swept the ground and would form a shaded dining-room in hot weather, scented with delicious tassels of pale blossom. There were exciting wild flowers, herbs to make salads, a million fascinating insects: of course she would provide mosquito nets. Alvaro noticed that her delights in *la nature* had not diminished since the country walks she had enjoyed with George Moore as a child.

Each drank glass after glass of wine to celebrate their reunion, as they had during that memorable winter in London in 1919. Her gestures grew more expansive: the bracelets rattled. Spellbound, Alvaro listened and watched. Many men had painted her since she had stood for him in Maud's drawing-room, wearing that long fur coat, her elegant black boots and little cloche hat. Since then, Oska Kokoschka. Wyndham Lewis, John Banting the young English painter and the American Eugene McCowan had all produced their versions. Even Brancusi had sculpted his abstract impression.

Nancy found that she still loved listening to Alvaro. She wrote in *These were the Hours*: The effect was never dull, often lyrical, sometimes comic. He had a mythology of his own. His irony was interspersed with pleasant pieces of naivete, now simple, now complex, now direct, now devious, those astonishing

verbal images of his would often come out on the wings of fantasy . . .'

Alvaro wondered if she might regret moving to Réanville. Would she not miss the bustle of Paris, the parties, where she appeared in a sensational gold lamé suit, the cafés, the abandoned dancing at Le Boeuf and *bals musettes*? No, she could lead both lives. The real purpose of the move was to found her own press, much against the advice of friends such as John Rodker and Leonard and Virgina Woolf. They had warned her that she would be permanently exhausted and covered with ink from head to foot. Nevertheless, she was determined to learn how to handset type: she wanted to master the whole process of printing – maybe even binding special editions herself. She intended to produce solely contemporary unpublished English poetry. Chile's poem *St George at Silene*, which he had given her towards the end of the war, would be one of her first efforts. Alvaro was flattered.

Alvaro soon found a fifth-floor studio in Rue Simon-Dereure, off the Avenue Junot, and sent for Mama, who was missing him and bored in London without him.

By the spring of 1928, true to her intention, Nancy had not only bought a massive hand press, well over a hundred years old, but had converted and moved into the house at Réanville. She installed the press in the shed next door and to teach her the technique she had engaged an experienced printer, a M. Lévy. The fact that he understood not a word of English did not signify as he was so meticulous; she not only spoke, but wrote perfect French with *panache* and could express herself with enviable style.

Alvaro was a frequent visitor at Puits Carré. Sometimes he and Nancy drove down together in the Packard. He already knew how physically fastidious she was, now he noticed that when she unpacked, everything was neat as a pin, nothing was ever forgotten or creased: she was a perfectionist. After a hectic few days and killing late nights in Paris, dancing till dawn at Le Boeuf, or prolonged drinking and violently controversial but stimulating intellectual disputes, she was completely under control. When they arrived, she might wash her hair with no bother, pinning two fair crescents in front of her ears, and curl up like

a cat on the sofa to polish her ivory bracelets or manicure her fashionable red claws. Sometimes she would sew, deftly putting a stitch here or there in apparently immaculate clothes. Maud sent her cast-off models from Vionnet or Poiret twice a year, which she either gave away to less fortunate girls such as Janet Flanner and Solita Solano, or altered for herself.

John Banting remarked that: 'She swept, polished and dusted with zest ... She was as fastidiously neat as any of the creatures of the woods she loved ... Everything was in place and shone with its own personality.' She would write in bed, surrounded by papers in orderly piles. She taught Alvaro to cook. Delicious meals were served under the limes with no apparent effort. Later John Banting recalled Chile 'as a fine tall dignified man and one might say handsome – a Spanish rock, and not very talkative'.

Louis Aragon was often there. Alvaro was not unhappy, feeling only admiration and no resentment. There were plenty of genial tarts, professional and amateur boys and girls willing to provide sexual, if not emotional, satisfaction: with characteristic irony he told a friend that whereas beggars could not be choosers, at least buggers could. He had given up hope of falling in love, or finding his ideal, though secretly he longed for a romantic marriage and children of his own.

In her memoirs Nancy said how much she admired 'his tenacity, his often madly argumentative nature, the resoluteness with which he went about his work'. She did not think that he was 'a tragic figure as was Lautréamont. A sarcastic one rather.' She found his English 'was excellent, but it had a sort of "plus" quality about it that was remarkable to hear ... and if his thoughts flew at times in dizzy gyration they were also often soberly subtle.' She could 'remember no giddy soarings when it came to discussions of painting. On those occasions he was the serious artist and was much esteemed as such, and as a friend ...'

When Mouradian made discreet enquiries as to how Alvaro's work was progressing, or looked at all priggish, Alvaro would tease him and say: *'Il n'y a que du temps pour s'amuser avec le joli petit coiffeur, tu sais. Je suis epuisé.'*

Fortunately, as two foreign ladies in Paris, Mama Guevara and Mouradian's mother made friends. Madame Mouradian admired Alvaro's mother: what a good stabilising influence she

had on her boy's mercurial temperament, so garrulous or taciturn. 'Mama Guevara was wonderful.'

Having recommended Alvaro as a promising painter and a personal friend to Van Leer and Valleton, Mouradian was obviously anxious. The fact that he had so soon become on intimate terms with all these Surrealist poets, and that Nancy was actually printing *St George at Silene,* as one of her first ventures, might distract attention from his painting. Although like Brown, Mouradian loved the company of artists, they were enough to drive a sane man crazy; they were so unpredictable. Picabia had now agreed to have an exhibition at Galerie Théophile Briant after the one booked at Van Leer. Mouradian would have to pay him a visit in the South of France and find out exactly what was going on. Not that this excursion would prove much hardship – far from it: by July, it would be nice to get away from Paris. But there was publicity to prepare for the press, catalogues to print, and many practical problems involved, of which Alvaro seemed typically unaware.

When summer came, Nancy longed for some respite from the exigencies of converting Puits Carré and entertaining many friends from England. M. Lévy too, deserved a change: the ancient machine was a challenging monster and had by now exhausted them both. Nancy had christened her press The Hours. She and M. Lévy often worked half the night as well as all day.

If Nancy needed a rest, she could scarcely have chosen anywhere less appropriate than Venice: in the twenties during August and September the exotic cosmopolitan set congregated there. The canals, palazzi, hotels and cafés all buzzed with petty intrigue and scandal. She described the life she led for several weeks to Norman Douglas as 'spectacular ... that blazing Lido strewn with society stars in glittering jewels and make-up – that brilliance of Grand Canal barge parties – those spontaneous dawn revels after dancing in sinister new night bars'.

This so-called holiday proved a turning point in her life, as well as the *coup de grâce* to her relationship with Aragon, and also resulted in a bitter and vindictive feud with Maud, deeply regretted by many mutual admirers, including Alvaro.

Since her debutante days and the extravagant parties given by George Gordon Moore, the American millionaire, Nancy had found Afro-American music irresistible. She was already

156

susceptible to primitive art – in fact even in those ignorant and prejudiced days, black was beautiful to her.

One night in Venice during that memorable summer, her cousin Edward Cunard took her to the Lima Hotel, where a group of four coloured musicians, Eddie South's Alabamians, captivated everyone with their swinging, rhythmic jazz and improvisations.

She was transported into a state of euphoria. When dancing with Alvaro in London and Paris, she had often breathlessly accused him of having South American Indian blood. Others had found similar explanations for his uninhibited dancing. As an aristocrat, he was amused: a latin among lions, how could he explain to Europeans that, if he had indeed even a *soupçon* of native blood, no one in Chile would have told him so – such a suspicion was totally inadmissible, even for a servant.

That night at the Lima Hotel she danced as if possessed by the spirit of Africa. At the end of the last number, when her cousin ordered another bottle of wine, she invited the four Alabamians to her table. She found their grace and sartorial elegance delightful. From this moment she was not only obsessed by African art and music, but by Negroes themselves, especially one member of the band called Henry Crowder.

Certain destructive influences sprang from this encounter, but one was ideally constructive: the Negro cause became her favourite lame dog, to be defended, championed and promoted. The affinity she had found with African art and music and Henry led her to her most important work: an anthology: *Negro*.

During the summer of 1928, Alvaro had remained in Paris working towards his exhibition. Mama Guevara and Mouradian's mother thoroughly approved – at this time of the year many tourists arrived from England, and North and South America, who enjoyed being escorted and entertained by those who knew their way around. Mouradian had left for the Riviera to stay with the Picabias.

Unknown to Mama, Alvaro was becoming increasingly intimate with an amazing couple, Harry and Caresse Crosby. Caresse had started life in the United States with the less glamorous name of Polly Jacobs. Her family background was rich and distinguished. She had been launched as a debutante in London and was the only American girl to be presented at court the same year as Sibila and Susana Guevara. She had been invited to the identical

garden party as Maud and Nancy Cunard. When Polly's hat blew off, King George V had chased it across the lawns and, red-faced after such exertion, returned it gallantly to her; she had clamped it on her head back to front, the ribbons dangling over her nose. This was a typical incident in the pattern of her *mouvementé* life. During her London Season, she had been introduced to many people whom Alvaro knew.

Still in her teens, she married first a godson of J. Pierpont Morgan, Dick Peabody. They had two children. The daughter Polleen was to prove a valuable ally of Alvaro's. Secondly, Caresse married another relation of J. Pierpont Morgan, his nephew Harry Crosby, who shortly after the wedding was appointed to the Morgan Bank in Paris at a salary of twenty-five pounds a month.

Caresse was a high-spirited, exceptionally pretty girl. Between marriages, and various romantic adventures, she had not only acted on the stage and for the silent movies, but had also designed a revolutionary brassière. Again like Nancy, an indomitable rebel, she objected to being encased in a cage, constructed of pink batiste and whalebone, which stretched from under the armpits to just above the knees. In her book *The Passionate Years* she confessed to finding such garments 'hellishly binding ... If petting had been practised ... even to get one's finger beneath the corset cover took a lot of wriggling.' She patented her innovation, which, once two buttons had been undone, could be instantly shed. Caresse had perfect breasts, which she could now reveal proudly and frequently at informal parties. Like Christopher Wood, Alvaro was only attracted by perfect breasts.

Every morning at 8.30 she would put on a daring bathing dress and paddle Harry up the Seine in a scarlet canoe, from a flat rented to her by a family friend, Princess Bibesco. At the nearest *quai* to the Place de la Concorde, Harry disembarked immaculate, and walked to his uncle Morgan's Parisian branch. Sometimes, Alvaro would wave to her from among cheering spectators from one of the bridges; it was a common sight to see her valiantly paddle back upstream. This daily exercise was 'so good for the *breasts*, my dear!'

To occupy herself during the day, she attended at art school, La Grande Chaumière, where Fernand Léger taught. It was here

158

that she met Giacometti and many other students who became famous later.

Soon after Alvaro arrived in Paris, Harry decided that he had no ambition to become a partner in Morgan's bank. He and Caresse were avid readers: he was sure that he had a vocation as a writer and craved time to concentrate on latent intellectual gifts. Life was short: he and Caresse had both inherited enough money to do as they pleased. Uncle Jack Morgan 'didn't seem to mind' when they broke the news *chez Foyot* over an expensive dinner.

Happily for these literary aspirants, Walter Berry, a friend of Proust and Henry James, was a cousin of Harry and lived in the Rue de Varenne among his beautiful books, avant-garde pictures and rare oriental treasures. Hitherto his hostess had been Edith Wharton. Edith had begun life like Polly Jacobs, as a privileged American but with an even less auspicious name, Pussy Jones. Paul Theroux, described her in 1973 as 'The Yankee Jane Austen'. She was between thirty and forty years older than Caresse and certainly her literary superior. However, according to Pussy Jones' biographer, Louis Auchincloss, she had no lovers and her marriage to Teddy Wharton had been a bitter disappointment. In one of her poems, *The Last Token, A.D. 107,* she identified herself with a girl in the Roman arena about to be devoured by a lion: 'Farewell!' she cried, 'I meet your eyes . . . beloved, this is death.'

Of course Edith resented Caresse taking her place as Cousin Walter's hostess and inviting her peculiar friends, including Alvaro. However, Caresse organized such successful parties that she became Cousin Walter's favourite. He agreed with her dictum that 'a woman without a touch of bitchery was like milk without vitamin D,' and when he died he left his fortune to her and Harry. He had genuinely admired her poetry and had encouraged her to submit it to an American publisher who had accepted it enthusiastically.

The Crosbys gave grand luncheon parties in a magnificent Sicilian dining-room in the Rue de Lille but, from 8 p.m., they entertained more intimate friends from their vast bed.

According to his mood, Harry would dress for these Pompeian occasions in a black silk djellaba or an elaborately embroidered kaftan. Caresse could choose some provocative garment from

many exquisite kimonos and titillating chiffon negligées trimmed with swansdown, or lace tea-gowns. Voluminous robes made of towelling were provided for the guests, who were greeted with typically American martinis and invited to enjoy a bath, as soon as they arrived, in the sunken marble tub which accommodated four people. There was a tempting selection of colognes and bath salts. A white bearskin was thoughtfully laid in front of the open fireplace and a many-cushioned divan on which couples could recline, dry, massage themselves, or each other, with scented oils.

After these relaxing or stimulating lubrications, two or three tables would be set up round the vast bed. The only wine provided was champagne, and the meal always began with caviar.

It was not surprising that these sensual parties were a success, for many of those privileged to enjoy these 'glamorous nights', lived in squalid studios or attics, where the primitive plumbing was sordid and disgusting. For instance, like most opium smokers, Bébé Bérard was always filthy, so presumably more agreeable to sit next to after such hygienic indulgence. Alvaro's own bath had a temperamental oil lamp beneath it which had to be lit to heat the water. The metal became too hot to stand up on and it was risky to sit down except on a pile of soggy mats. Fortunately he was able to bath in a more civilized manner when he visited Mama Guevara at the Majéstique, but for aesthetic reasons he thoroughly enjoyed an evening at the Crosbys.

12

Alvaro scarcely noticed Caresse's pretty daughter by her first marriage. Polleen was an extremely observant child, who preferred to be known as Polly. Her mother had warned her that her stepfather Harry 'detested children'. In consequence she was forced to spend most of her life insulated behind baize doors and permitted to emerge only when Caresse rang a particular bell.

One afternoon when her governess was out, Polly felt more bored than usual; the forbidden territory of grown-ups became irresistible. She crept through the house to her mother's room, opened the door and peeped in. Several people she recognised were squirming about naked on the enormous bed. Caresse shouted: 'Go away!' Polly slunk back to her lonely quarters, envious of the intimate warmth enjoyed by grown-ups.

She became increasingly infatuated with Harry. To be accepted by him was a challenge. Before she was twelve she succeeded and they established a rather special, even secret, relationship, and he dedicated poems to her which she delighted in as personal compliments.

Harry was a disciple of Zoroaster: he worshipped the sun and while in Egypt he had one painfully tattooed between his shoulders. He was 'also mad about black': it was his favourite 'colour'. To the horror of his conventional American relations, he would wear an artificial black camellia in his buttonhole. He owned a black whippet called Narcisse – even Picasso appreciated this elegant pet, when Caresse took it with her to call. Other black dogs owned by the Crosbys were given such provocative

161

names as Clitoris and Kiss, which evoked many sophisticated jokes among their all-embracing aquaintance.

It was a remarkable coincidence that the Crosbys should display this preference for black at the same time that Nancy, their intellectual rival, was herself discovering that black was beautiful.

Whereas Caresse had succeeded in getting her poems published, Harry still had to see his work in print. On a walk through the back streets of the Latin quarter, they discovered a most sympathetic and agreeable printer, whose efforts hitherto had been restricted to a miscellany of modest orders such as visiting cards and wedding invitations. They engaged him forthwith and so founded their own imprint, first known as *Les Editions Narcisse* and then as The Black Sun Press. Their aim was not only to print their own and a few other original works but to reprint a selection of books which they particularly admired in luxury limited editions. For this purpose they cultivated such controversial authors as Joyce, Hemingway, Huxley and Lawrence, many of whom Alvaro already knew. Lately Lawrence's exhibition of pictures in London had been closed by the police and thirteen works impounded – often more than twelve thousand people had queued to see them.

At this stage, it was obviously important for the Crosbys to ingratiate themselves with the more avant-garde critics. With the motive they invited Allanah Harper to Rue de Lille for a tête-à-tête cocktail. Since the twenties she had made her name in literary circles in Paris. She discovered Harry and Caresse in a somnolent state lolling about on the bearskin gazing drowsily at a skeleton dangling from the ceiling. They excused the sweet soporific atmosphere as due to their having smoked opium.

Nervously perched on the edge of the towelling chaise-longue, Allanah attempted to make conversation. Her efforts were to no avail while her hosts waved beringed, manicured hands vaguely at the skeleton: she inferred that in some way it helped them to regain their sinister Nirvana.

Later Caresse wrote: 'Opium is a drug that need not be more habit-forming than tobacco. It is the handmaiden of dreamful ease, the unraveller of pain, the Nemesis of passion and deceit. I believe that it illumines the brain rather than obscures the reason ... marijuana is criminally dangerous – the violent crack-

162

ing in one's brain, the rocking of one's surroundings, the desire to hurt, are all part and parcel of this wicked weed.'

On reading and hearing various accounts of the social life which Alvaro led during these two years in Paris before his marriage, it is difficult to imagine how he found a moment to work; Nancy and Caresse were only two of his involvements.

The previous year at the same time as Nancy had discovered her Puits Carré at Réanville, the Crosbys had fallen in love with a beautiful but dilapidated old water-mill belonging to Armand de Rochefoucauld. So impulsive were they, that Harry, who enjoyed cultivating the image of eccentricity, tore a white piqué cuff from his wife's wrist, on which to write his host a cheque for the property.

Jean Jacques Rousseau had lived there when he was infatuated with the Duchess of Montmorency; it retained an extraordinary magic. Alvaro appreciated the ambience when he left his hot studio in Montmartre. Many of his old friends such as the Lawrences and the Huxleys were also invited, the parties were as original as the Crosbys themselves.

Energetic Caresse had converted the ruin into a comfortable house within a few months. The old water-wheel was still static, but now the waterfall cascaded into a swimming-pool. It is unlikely that Alvaro referred to these visits to the Crosbys except obliquely, when Nancy returned from Venice to a grim, dripping autumn at Puits Carré. When Caresse wrote her racy autobiography, Nancy's name was conspicuous by its absence.

Alvaro's loyalty obviously belonged to Nancy first and foremost. To make up for time lost during August and September, she and M. Lévy, wrapped in blankets, worked far into the night wrestling in turn with the monster. The Hours Press programme had changed a little through letters which had arrived lately. George Moore had written affectionately, wishing her success with this rash but courageous venture. He had always resented Maud's and Nancy's inexplicable penchant for Alvaro: the thought of some trashy poem by 'that Chilean' filled him with gloomy disapproval. He enclosed his own *Perronik the Fool*. Perhaps Nancy would, indeed should, be well advised to print this contribution first and 'get off to a good start'. He was furious when, after writing this encouraging letter, he heard that she contemplated printing poems by Roy Campbell and sent her a

telegram: 'Severely disapprove of Zulu stop am leaving my pictures elsewhere G.M.'

Also, Louis Aragon had offered her his French translation of Lewis Carroll's *The Hunting of the Snark*. Having heard of its conception, many other established writers including Norman Douglas, Arthur Symons and Richard Aldington wished to be involved, or identified with, the birth of The Hours.

Despite these literary windfalls, Nancy reassured Alvaro that having given her word she would not disappoint him. As a compromise, she would produce both *Perronik* and *St George* in time for Christmas. He could still rely on publication to coincide more or less with his exhibition. She was delighted to hear that the young Surrealist René Crevel had offered to write a foreword to the catalogue, just as Osbert Sitwell had done for the Leicester show. René was also a friend of Caresse Crosby's and it was probably on a visit to Le Moulin that he had suggested this to Alvaro of his own accord.

It required severe self-discipline for Nancy to keep her promise and meet this taxing dead-line. A new element had invaded her life. Henry and she were already lovers. He and the Alabamians had arrived in Paris. He was weary of late hours at The Flea-Pit, a *boîte de nuit* in Montmartre, where he and the band had landed a job. Nancy was at pains to keep away. Henry always felt ill after the endless free drinks sent to him by the enthusiastic clientele and the interminable crap games which were bound to follow with white Americans, before they tottered back to their hotels at dawn.

Like Alvaro, Henry was a thoughtful rather silent man, although on occasions, especially after plenty of alcohol, he could become extremely articulate and 'rhapsodically rollicking'. Like Alvaro he was also proud; but at last Nancy persuaded him to allow her to rescue him from The Flea-Pit and install him at Réanville with a hired piano. Presumably M. Lévy knew by now not to raise an eyebrow but many others reacted fiercely, especially when rumours of this latest scandalous *affaire* of Nancy's reached London.

It was a frightful shock to Maud who had become a vital and important pillar of the Establishment. She was subjected to all manner of distressing insults from such doyennes as Lady Oxford.

Nevertheless, Henry was of the greatest assistance in pre-

paring *St George* for Christmas. He took on various mundane tasks: marketing, doing up parcels, driving the car: he became indispensable to Nancy for a while.

Alvaro had designed the covers and the endpapers. He scattered little red leaves over the thick grey paper which looked like tears or drops of blood.

At Puits Carré in freezing November, Nancy 'found the simple sewing of the cover and pages together a pleasure', while Alvaro cooked their steak *au poivre* which they ate in the warm kitchen, with the Easter Island heads watching them: a strange foursome, Nancy, Henry, M. Lévy and Alvaro.

It was gratifying for both Nancy and Alvaro that when Ezra Pound reviewed *St George at Silene* in a respected contemporary paper, *The Dial*, he too was reminded of Italy even before the Renaissance: 'Senor Guevara has dug up the secret of the Pre-Renaissance; he has heard of St George as Carpaccio presumably heard of him. By simple ignorance of all criteria of English verse he writes with real naïvete at a time when the grovelling English are breaking their backs to attain the false. The secret of the Pre-Renaissance, of Simone Martini, for example, is interest in the main subject of a composition, the decadence, culminating in Gongorism, is perfection of detail, or attention to detail and oblivion of the first aim. I doubt if any skilled poet could deal with a saint's legend without boring the reader intolerably; Senor Guevara will merely infuriate the clever... Were I called upon to explain why this poem is readable I should ascribe it to the fact that the author is a well-known painter and that the habit of discipline in his own art has given him the fundamentals of aesthetic in another, so that his clichés and inversions do not almightily matter; if he had faked he would have ruined the whole thing, but there is no touch of pretentiousness or precosity; his artifice is rhyme, always very simple, and utterly without inhibition.'

The very day that Alvaro and Mouradian had arrived in Paris, on 25 April 1927, Edith Sitwell had written to Gertrude Stein: 'One of my greatest friends, Alvaro Guevara, has come with his mother to live in Paris. He is a painter, and also a writer, of real genius – not one of those dear little intellectuals. It would be a great kindness to me, and a great kindness to him,

if you would allow him to go and see you and Alice. And yours is such a fine atmosphere. It would be an awful thing if a man with a mind like his had to have it fretted away by the vulgar little clothes-moths that sit drinking and pretending to be geniuses in the cafés.'

The following month, Edith herself was hoping to arrive in Paris to see 'Sachie's' ballet on her way to the Castello di Montegufoni. Although her brothers were devoted to both Maud and Nancy, the reference to 'vulgar little clothes-moths' was possibly a shaft of jealous invective aimed at Nancy and her group of admirers, despite their poetic affinity when the Wheels were rolling.

Allanah Harper had reviewed Edith and Sacheverell's poems in *Le Flambeau*, a Belgian literary magazine, and it was through Edith's appreciation of this article that she and Allanah had met and made friends two years before. In the same issue Allanah had written a short notice of Nancy's *Parallax*. Allanah thought the title smacked of some patent laxative. In Edith's opinion it was a pity that she 'had bothered to mention it at all'.

Edith confided in Allanah that she had adored Alvaro for years and would have married him had it not been for the advice of certain well-meaning people, with motives which have been identified later as extremely mischief-making. She and Alvaro preserved and enjoyed a rare and exalted friendship. In fact, he had never proposed, but always worshipped her as a romantic intellectual: her appeal for him was emotional, not physical.

Gertrude Stein lived with Alice B. Toklas, whose life was dedicated to her. It was a privilege to have an introduction to this famous pair, especially from Edith Sitwell. They were 'at home' on Saturdays to an assortment of painters, sculptors, collectors, critics, composers, writers and certain distinguished tourists – *tout Paris* in short.

This cavalcade had begun about twenty years earlier when Matisse had brought his friends to visit Gertrude and her brother Leo.

Alvaro had been warned that Gertrude disapproved of the Surrealists on the whole, although she had a tolerant maternal affection for that brilliant, naughty, delicate boy René Crevel. She would scold him when his behaviour was too outrageous and they would exchange loving letters.

Miss Stein felt that the Surrealists were 'the vulgarisation of Picabia', one of her favourite painters, in the same way that the Futurists had proved to be 'the vulgarisation of Picasso'.

Like Dona Errazuriz, she had realised Picasso's potential when he was very young, and had, like 'the lady from Chile' been perspicacious enough to buy his controversial work. She had even commissioned him, or allowed him, to paint her portrait, which he said would probably resemble her in a few years.

On the strength of Edith's letter, Alvaro's first invitation from Gertrude and Alice was a personal one for a day when they were not officially 'at home'. It is certain that after this initial encounter, both women took a tremendous fancy to Chile and that he became a frequent, welcome visitor. It was through them that he met Picasso.

Arriving at Gertrude's *atelier*, guests were admitted by an apple-cheeked, smiling maid. The high, whitewashed walls were almost covered with paintings, tier upon tier, by Cézanne, Matisse, Gris and Picasso – certainly the collection merited its world-wide reputation. As well as these marvellous works by now famous artists, Gertrude had also bought many pictures by an English artist: Sir Francis Rose. She had never met him nor, surprisingly, had Alvaro.

It was Alice who greeted the stream of visitors who called. She had an infallible memory and insight. She could distinguish the genuine from the fake and she knew instinctively if some one would bore Gertrude, who might feel tired, or be upstairs writing a masterpiece in children's exercise books.

To Picasso, Alice looked like a pretty gypsy with her large earrings and small feet and yet when she poured out tea and offered the guests petit-fours, she might have been a sophisticated hostess like Lady Cunard. However, their tastes differed; everything Gertrude and Alice chose was simple and good – the table-cloth, the silver, the china and ornaments, pottery jars of flowers chosen according to season – roses, wild currant or azalea – nowhere was there anything frivolous, and each piece of furniture glowed with the rich patina which comes from polishing with love. Alvaro felt at home. The large, comfortable sofa and arm-chairs were upholstered in leather and horsehair. By contrast, the little Louis XIV chairs were covered with jewel-like tapestry in

vibrant colours, which Alice had stitched on the canvas to designs by Picasso.

When Gertrude herself appeared, she seemed to Alvaro like a monument. She was short, stout, massive, with a beautiful strong head, noble features, and intelligent piercing eyes. No wonder she was admired by Picasso. Both she and Alice had very prominent noses, Alice's nose was the more aquiline and she was passionately attracted by women with large or unusual noses. In her opinion Edith Sitwell had the most beautiful nose in the world.

Despite ten years' difference in their ages, it was not surprising that Picasso and Alvaro made friends – they enjoyed an instinctive Spanish affinity. Picasso had every reason to favour Chileans – Dona Errazuriz had been one of his first patrons and Tony Gandarillas was a familiar and popular figure in Paris. Just as artistic and intellectual circles in London were involved with sympathetic patrons among the more intelligent and original aristocrats and *nouveaux riches*, so a similar hybrid society existed in most European cities; a pattern which had survived since classical days.

Tony's protégé Christopher Wood was a frequent visitor to the enviable Gandarillas *appartement* – what a fantastic view it had over the roofs of Montparnasse! Young Kit regaled his beloved mother in frequent letters with naïve and enthusiastic accounts of the dazzling parties he was privileged to attend as Tony's friend, and the descriptions of famous and infamous people.

He still confided in her his exaltation or despair: like Alvaro, the most trivial impression, or event, would always suffice to precipitate him from Olympic heights to Stygian depths. What he did not confide was that Jean Cocteau had encouraged him to smoke opium and that he and Tony often indulged.

Inevitably, Alvaro was invited to many of the same studios, the same grand balls and *fêtes champêtres*. He and Kit foregathered at favourite cafés. Alvaro had always found Kit beguiling, but like all wellborn Chileans, was respectful of the proprieties and resisted pursuing him while he was Tony's guest.

Not only gossip, but intuition and observation told him that although Tony was still devoted to Kit, he was becoming rather bored. It was evident that, as Kit grew older, he became increasingly susceptible to girls. Like Alvaro, only those with per-

fect figures attracted him. Tony disapproved of one with whom Kit was mildly infatuated. Kit admitted that she certainly did not appeal to him as much as Meraud Guinness, whom he had met three years before in Cannes with 'Naps' Allington.

By now, Alvaro had heard Meraud's name so often from innumerable friends and their paths had frequently so nearly crossed that it was remarkable they had not met by 1927. Neither he nor Kit suspected that within about eighteen months they would be rivals.

During the summer, these social, artistic or literary lions, uninterested in devouring unappetizing tourists, abandoned their familiar hunting-grounds, lairs or dens and dispersed to prowl in fresh jungles on the Côte d'Azur.

While Nancy and Caresse were each resolving similar problems, converting their rural properties and founding their respective private presses, Tony Gandarillas took Kit Wood to the Villa Arlette at Cannes.

In his letters to his mother, Kit raved about 'Le pays de Bonheur . . . lovely free life, the beautiful people, the bathing parties, dinners, luncheons, picnics and dances'. But he confessed that like their friend and neighbour Picasso, he found the atmosphere distracting. Days flew by, it was difficult to work although he had made a quite successful portrait of Lady Carisbrook, one of the sweetest women he had ever met: he did not care much for Lord Carisbrook as he could 'never forget that his sister is the Queen of Spain'. Lord Berners, the great comic, was staying nearby with Lord Ivor Churchill and Lady Cunard, all three patrons of young artists and Alvaro's friends, and had invited Kit on a painting expedition (Berners had already bought one of Kit's paintings). If anything, Kit found life on the Riviera 'a little too smart . . . but the snobs of London and Paris do let themselves go'.

Mrs Wood must have been particularly interested to hear that her son had 'found that sweet girl again', Meraud Guinness, and that her parents owned a beautiful estate only a mile or two away from the Villa Arlette, and that he saw her 'pretty often'. She had a 'lovely sailing boat' and he went 'right up into the mountains with her and her beautiful sister-in-law, Joan Yarde Buller [now Princess Joan Aly Khan] who married her brother [Loel] the other day'. Perhaps Mrs Wood felt apprehensive on

hearing no more from her son for ten days. When a letter at last arrived he protested that he had thought of her all the time: his negligence '... was not because of any girls for all the girls in the world wouldn't make me forget my Mother whom I love more than any of them'. With a wry smile, Mrs Wood may have re-read, or at least remembered the gist of treasured letters dated two years before, when he had written: 'To travel with women requires a lot of unselfishness and if there is one thing I detest it is to be dancing attendance on them. The more I see of them the more determined I am never to marry ... for my life it would be a great handicap.' And: 'I have no wish whatever to get married. It is a silly idea ... it seems to me ridiculous ... I pray that I shall never do such a rash thing. As if we didn't see enough of women without marrying them ... it's misery I should imagine.'

Within the next few days Kit's mother heard that he was 'very much in love' with Meraud, and 'it has all made a bit of a scandal here ... I think she would like to marry me, but as she will be enormously rich one day ... her father and Mother would like her to marry a Duke'. She had dined with His Royal Highness Prince George, the Duke of Kent, the night before: 'it will be useful for me to know him better, he is the nicest of the Princes, good-looking and very smart'.

Although Tony Gandarillas was a great friend of Prince George and 'adored Meraud', he hoped very much that she would choose to marry Kit as she could help him. Kit assured his mother that Meraud was 'the sweetest gayest smartest thing in the world, and just the sort of girl you would adore ... she could quickly force me on to success by her sheer and incomparable charm ... I worship the very ground she treads on, and am proud to be capable of so great a love'.

News of the romance soon reached Alvaro not only from the scandal sheets in French and American papers and mutual friends, but countless gossipy letters written from sumptuous villas or yachts along the Riviera or picture postcards hastily scribbled in fashionable cafés.

Tony Gandarillas took an imminent elopement for granted; the thought of Kit marrying this adorable heiress delighted him. By the time the lovers had fled and the *Haut Monde* had deserted Cannes, Tony would be alone, so he wrote inviting René Crevel

to join him at a small hotel in an unspoilt, picturesque village called Vence in the pre-Alpes. The pure mountain air was reputedly good for victims of tuberculosis; it would be a change for René from those depressing sanatoriums: he begged him to leave Le Moulin where he was staying with Harry and Caresse. René was in love with Tchelitchew's sister Choura and suggested that she should accompany him – she too had tuberculosis.

Tony had felt distinctly unwell himself for some weeks now and was suffering from what was then generally known as 'that distressing universal and painful complaint'. Tante Eugenia had been nursing him, but he feared he must shortly undergo an operation. René could paint, they would share and enjoy a peaceful convalescence. He thought that Choura might be bored.

Speculation was rife in the social and diplomatic world. Mrs Guinness was appalled at the thought of her fascinating, eligible daughter throwing herself away on an impoverished painter. Volubly she expressed disapproval even to her guests including Eddie Marsh. He was far more interested in Kit's welfare than Meraud's and passed on the news in his letters to 'Darling Ivory' [Ivor Novello]. Mrs Guinness brought formidable pressure to bear on Meraud and her unsuitable admirer; perhaps it was fortunate for everyone that Benjamin Guinness was preoccupied with high finance elsewhere. Mrs Guinness severely warned Kit that her husband would never consent to such a *mésalliance,* moreover, there had been far too much talk that summer on the Riviera, and the less he saw of Meraud in the future the better. Kit confided all this and more in his mother.

The Guinness family had visualised a brilliant match, a spectacular wedding, patronised by Royals, an invitation list including all the smartest and most distinguished people as well as privileged friends and relations from America. Although Bridget Guinness was artistic and a gracious and generous patron to many gifted painters she was alarmed by Kit's reputation and feared for her daughter.

When Michael, Earl of Rosse, described by the gossip columnists as 'the most travelled young peer of all', visited Notre Dame de Vie with his sister, Lady Bridget Parsons, they did not care much for Benjamin Guinness but were devoted to his wife, who liked to be called Zara. 'Meraud lived her own life . . . Her

friends were all avant-garde by contemporary standards, and scarcely mixed with the normal crowd.'

Meraud's brother Loel was one of the keenest and ablest members of the volunteer auxiliary squadrons of the Royal Air Force, Squadron 601. He would fly regularly between London and Cannes in his coupé Moth.

Kit assured his mother that both he and Meraud hated the idea of 'awful weddings, where the girl is led like a bullock [sic] to the slaughter . . .' They were seriously considering running away. 'Many sensible and experienced people' with whom they had discussed their problem, including Tony Gandarillas, were sure that 'the family would make the best of it' as a *fait accompli.*

13

Francis and Germaine Picabia lived near the Guinnesses at Mougins in a luxurious but totally different manner. Germaine remarked that 'when Mme Guinness was collected by her liveried chauffeur, she was always most elegantly hatted and begowned. She carried a parasol to protect her complexion from the sun. She wore the sheerest flesh pink silk stockings and long white or pastel suede gloves, also of course ropes of real pearls and several diamond and emerald brooches – and bracelets from wrist to elbow . . .' Even on the hottest mornings she looked deliciously cool. Germaine had often noticed her unconventional daughter Meraud, 'hatless and disastrously freckled'.

Francis Picabia was an exceptionally attractive man, handsome and marvellous company, although Nina Hamnett complained that he was too fat and hopelessly clumsy as a dancing partner. He had always been extravagant. When Mouradian arrived at the Château de Mai, he noticed at once that since his last visit plenty of money had been spent on improving the property inside and out: as well as decorative, the rooms were comfortable. The garden now boasted terraces and a swimming-pool. In the garage were new expensive motorcars. Picabia and Guevara certainly had tastes in common! Not many artists Mouradian knew lived in such affluent style.

Within a few hours he observed more than the material changes: an extraordinary state of affairs existed at the château. Germaine, the *femme en titre* for whom Picabia had left his wife Gabrielle, was still a lovely and elegant hostess; perhaps she was a trifle too *mondaine* for an artist's wife, but she loved to entertain

173

their many interesting friends who included Pablo Picasso and his sociable and elegant wife Olga, Fernand Léger and his adored wife Jeanne, Paul Eluard, Gertrude Stein, Marcel Duchamp, Jean Cocteau, René Clair, Isadora Duncan – Isadora disagreed with Nina Hamnett and enjoyed dancing with Pic *et combien d'autres* . . .

Germaine regaled Mouradian with amusing stories of their life at Mougins. Recently, Brancusi had brought over a party of pretty American girls who found the new blue pool so tempting that they had shed their clothes and bathed in the nude. *Quelle vision charmante!* This ballet of water nymphs had caused a *scandale dans le village.*

Germaine and Picabia's son Lorenzo was a charming boy of six, about the same age as Picasso's child Paul. It was such fun for them to play on the beach together. Germaine had lately engaged a Swiss girl called Olga to look after Lorenzo and help in the house. Olga wore her hair in two plaits; she was certainly an industrious, conscientious girl. It was obvious to Mouradian that she was as much in love with her master as was her mistress Germaine, who either dismissed the fact or was unaware.

As if this situation were not enough to complicate life at the Château de Mai, there was a very pretty English girl – Miss Meraud Guinness. She preferred to be known as Michael, her second name – apparently the Russian Grand Duke was her godfather and as a compliment to him she had received this name at her christening.

Picabia introduced her as his pupil. After discussing his proposed exhibition at the Van Leer Gallerie, he drew Mouradian aside and said meaningfully: *'Soyez gentil, mon vieux, avec ma petite élève!'* She would like a show of the work she had done with him at a good gallery in Paris. Surely Mouradian could arrange something? Mouradian was not only anxious to please his host, but astonished to discover how outrageous, if original, young 'Michael's' work proved to be. He found himself agreeing to fit *la petite élève* into the gallery's winter programme. She would follow a Chilean painter who was already well-known in London. His paintings were traditional by comparison. If Picabia were to write an introduction for her catalogue, the show might provide a sensational contrast to Guevara's and create a different kind of publicity.

It was clear that master and pupil were strongly attracted despite the wide difference in their ages. Mlle 'Michael's' charm was irresistible. Under the vines, Germaine confided to Mouradian that she had first met her with her father some months before at Picabia's exhibition in Cannes. She had been wearing the most gigantic dark glasses that he could imagine over those tantalising blue eyes. She had expressed a movingly genuine enthusiasm for the paintings. Her accent, her lilting voice, her tinkling laugh, were bewitching, did not Mouradian agree? Germaine was sure that he could well understand how she had taken this engaging child to her heart. Was she not adorable? So gifted, and pretty as a butterfly.

Mouradian nodded sympathetically while Germaine continued her eulogy. Poor little girl, her father was a multi-millionaire, his estate was nearby. She was in love with a young English painter. His name was Christopher Wood. Mouradian had never heard of him? Anyway they had eloped, unsuccessfully, to Paris – typically, her passport forgotten, and *hélas*, she could not marry in France without her parents' consent. Naturally as he was penniless and she was an heiress they disapproved. But Mouradian must not get the wrong impression : she was really *good*. This young man smoked opium – surely his mother, with whom it seemed he was extremely close, would have a fit if she knew? Fearing that he might become addicted, darling Meraud had thrown his pipe and paraphernalia into the Seine.

Germaine had met her again in Cannes at Le Boeuf sur le Toit – a complementary branch of the one in Paris. She was obviously unhappy. The atmosphere at home was painfully strained. Naturally, the Guinnesses were bewildered and disappointed to find their eldest daughter so Bohemian.

Meraud had confided in Germaine that she longed to escape from Notre Dame de Vie and take refuge with them for a while. Of course Germaine had agreed. Indeed it was she who had suggested this solution.

Mouradian listened incredulously as Germaine continued her naïve explanation of the presence of Pic's innocent *petite élève*. She had arrived in a little Citroen. She had painted it herself, azure blue like her eyes. It was bursting with luggage, everything she possessed : painting gear, a white cockatoo in a cage, a big

175

scruffy dog on a lead of multi-coloured strings. The most fragile things, lace petticoats, expensive chiffon negligées, were stuffed as buffers between an amazing jumble of objects in battered cardboard boxes. Jewellery, both genuine and fake, glittered between bundles of love letters and broken pastels: real pearl necklaces tangled with false ones bought for a few francs. Orderly Olga pursed her lips with disapproval as she helped to unload. She told Germaine she found the guest excessively plain, mottled with freckles – and totally undisciplined. Wherever she went she would create chaos. On the other hand Francis and Germaine, being artistic, could appreciate Meraud's gaiety and were entranced by her fantasies. So were their friends. Marcel Duchamp for one found that since her arrival the villa pulsed with a fresh vitality. Surely Mouradian had noticed the change? He had.

Germaine could not resist giggling as she continued to regale him with Meraud's exploits. Not long ago they had given a party for the child's birthday, her twenty-fourth. Olga had baked a cake. Meraud had climbed up into the rafters of the studio and, perched on the highest beam, had hurled chunks of cake at the guests below as if they were famished dogs, looking up at her and begging. Olga was horrified. What manners! What a mess she made, this Miss! Every morning her room was a pigsty, and yet, as Mouradian could see she had a natural chic, always looked immaculate.

Each day Mouradian became more aware that the three women were all desperately in love with Picabia. The atmosphere crackled with tension, but Monsieur le Sultan was flattered. His ardent love-making gave Germaine every reason for confidence. She had nothing to fear from *sa petite élève*. The child was just a natural flirt; the relationship between master and pupil was innocent.

It was evident to Mouradian that Germaine was totally ignorant of the true situation. Picabia so encouraged Meraud, not only over her painting, that she was convinced that his feeling for Germaine must have become platonic long ago. She was terribly sweet but after all they had lived together for years and now she was in her thirties – really old!

Olga waited in more ways than one.

The atmosphere had become potentially explosive by the time

Mouradian left for Paris – but he hoped that at least Picabia's exhibition was firmly booked.

One morning when Olga was dusting Germaine's room, she could contain herself no longer and burst into tears. She felt it her duty to warn Madame: she was being deceived, master and pupil were alone together in the studio for hours; they must be plotting to run away together!

Germaine was touched, but she misinterpreted Olga's concern.

After this, events moved fast and an emotional crisis arose when Germaine and Meraud felt compelled to tell each other the truth and reveal the exact nature of their love for Picabia. After this embarrassing confrontation, Meraud wisely left for London. Happily, both women having a sense of perspective, their friendship was, for the time being, preserved. Germaine retained her original impression of Meraud; she might be rather giddy and foolish at times, but this was excused by her youthful verve. She was, and always would be, honest and compassionate, impulsively generous – in short, without guile.

But it was Olga who scored. She was no fool. Now it was she who tidied the studio, cleaned the palette and brushes and sorted the canvases into orderly piles ready for shows to come. *Le maître* had never felt more comfortable or better served. At the end of the day, his slippers were not only placed neatly by his chair but somehow Olga was always waiting to help him put them on.

When Mouradian returned to Paris, according to chatter at Les Deux Magots and Le Dôme, it had been 'an eventful summer for everyone who was anyone'. He called at Alvaro's studio almost at once and was 'simply astounded by the pictures' which he had not seen until now. He had expected something vaguely post-impressionist, or even traditionally Spanish: he was quite unprepared for these Surrealistic experiments – twenty-four vivid paintings of uniform size, entitled *Les Fleurs Imaginaires*. Recovering his equilibrium, he confessed himself surprised but was bound to admit that 'they had got something yes, although quite extraordinary – they were certainly decorative and original'. It should have been obvious to him as an experienced dealer that since Alvaro's arrival in Paris he had been much under the influence of Nancy and her entourage.

Alvaro then produced René Crevel's introduction to the cata-

logue. It was very different from Osbert Sitwell's for the Leicester. Mouradian recognised at once that it was virtually impossible to translate into English. He attempted a few stumbling phrases: 'Begonias and archbishops – er – conchological carnations? Bouquets of twisted mother-of-pearl some dinosaur might sport, or *pin*? and then some rot about the green paper cleavage of an iguanodon . . .' He threw down the page. 'Really! Of course it was all *rubbish* . . .' Nevertheless, both René's foreword and the pictures should provoke a lively controversy in the press and among the blasé French critics.

Mouradian explained to Alvaro that his visit to Mougins had proved even more fruitful than expected. He planned that Picabia's exhibition should precede Alvaro's and be followed by Pic's *petite élève; une Anglaise-Americaine. Le Maître* had agreed to write an impressive foreword, indeed they had already discussed it: Pic had drafted it. One paragraph read something like this: 'Here is another of them. Why on earth does she paint when she is so rich? Well, that is just the reason. Disheartened, disgusted with the circles where money takes first place, she had sought refuge in herself . . . She has realised that her true expression could only exist in the egoistic joy of art. She loves life, free, independent life. She has driven convention to the furthest boundaries. That is why one can believe in her and await infinite possibilities.'

Having heard so much about Meraud already, Alvaro much looked forward to meeting her at last. Wherever she went she seemed to attract sensational gossip. And not just because she was supposed to be rich. Not long ago, the French and American papers had reported that the celebrated Lily Langtry was about to sue her husband, Sir Hugo de Bathe, for divorce. It was rumoured that Sir Hugo hoped to marry the youthful heiress despite at least forty years difference in their ages. According to Tony Gandarillas, her affair with Kit Wood was on the wane. Since last summer, Tony had changed his mind about the desirability of the match. Mouradian admitted that although Meraud was undeniably charming and seemed to take painting more seriously than the rest of her life, she was a butterfly, perhaps 'a flibbertygibbet'. Alvaro found this expression so comical that he repeated it.

Tony had recently been complaining that it was unreasonable

for Bridget Guinness, herself artistic, to be so unsympathetic towards her daughter for having inherited her gifts. Meraud's portrait of Alice Astor, later Princess Serge Obolensky, was reputedly excellent. Bridget seemed determined to smother Meraud's ingenuity. Tony's mood was gloomy; his wife had started divorce proceedings.

Meraud's enthusiastic reception in London did not pass unnoticed by the press. David Tennant and his actress wife, Hermione Baddeley, planned a party for her 'at which each guest would dress as some modern picture by Picasso, Gauguin, Cézanne or Matisse . . . This idea emanated from the fertile brain of Mr Brian Howard in honour of Miss Meraud Guinness'. The gossip columnist presumed that 'she would go as one of her own pictures, or one of Picabia's, her master'.

During these junketings in London, according to Germaine, Meraud wrote 'letters full of feeling' to her and 'letters full of tenderness to Francis . . .' The summer at Mougins drew to a tranquil close.

Towards the end of October, Meraud joined the Picabias at a friend's flat in Paris. She found Olga and her status very changed. She had shingled her hair, discarded her overalls and now dressed with a certain chic. She was no longer plain but to be reckoned with as a *jolie-laide*. She and Francis had obviously grown far more intimate during the past weeks. They employed the familiar *tu* addressing one another and behaved in an affectionate way together.

Perhaps Germaine enjoyed Picabia's *vernissage* at Galerie Théophile Briant and the ensuing festivities more than he did. Parisian society had never appealed to him, nor had he ever exulted in success. All he cared was that the outstanding bills should be paid, that he could continue to paint as he pleased, and perhaps buy a Bugatti. On the other hand, Germaine could not resist being swept up into a whirl of parties, where her feminine vanity was assuaged. During last summer's deflating experiences, although still beautiful, her self-confidence had reached a low ebb.

While Germaine was preoccupied, Francis, Meraud and Olga amused themselves in the Latin Quarter and patronised *les bals musettes*. It was unthinkable for Germaine, a lady, to accompany

179

them, whereas Meraud and Olga, being foreigners, could be regarded as tourists. Indulgently, Germaine explained how kind and characteristic it was of Francis to show them the sights: thank Heavens, he did not expect her to accompany them on such absurd escapades!

Bals musettes were popular with the French working classes, who jigged up and down very fast like animated puppets to an impromptu accompaniment of whistles, accordions and tapping feet. When the sweating dancers paused to rest and refresh their energy with a glass of *pastis* or rough red wine, the musicians passed round the hat.

Like other English girls before her, such as Nancy Cunard and Nina Hamnett, Meraud was excited by the violent apaches with their black slouch caps pulled down over one narrowed, smouldering eye, red kerchiefs tied round their necks, hand-rolled cigarettes dangling from their lips. They entered stealthily as wild tomcats, ready to pounce on a rival bandit entwined in some dark smoky corner with a favourite, or dancing too closely with a pretty *midinette* who had taken their fancy. The girl would be torn roughly away and hurled aside. While the music tootled on unconcernedly, the men would fight like animals and knives might flash. There was something passionately sensual about this Latin atmosphere which appealed particularly to Meraud.

Some shrewd café proprietors, observing what a thrill it appeared to be for prosperous foreigners, especially Americans, to imagine themselves in a den of thieves, laid on fixed apache 'acts'. Many rich tourists were bored by more sophisticated nude cabarets in their fashionable music-halls and *boîtes de nuit*. They thought they were seeing life in the raw. They could write to the folks at home about it. Lurid and expensive postcards illustrating these amazing scenes were pressed on them by the waiters, who pocketed the money given them for stamps.

It was the artists who attracted the *beau monde* to such places. Just as in London Augustus John established Stulik's Eiffel Tower and the Café Royal, so Jean Cocteau, through his personality and improvisations on the piano, made Le Boeuf sur le Toit in Paris the most popular *café dansant*. Mouradian for one noticed that Meraud had become addicted to the place, and was always surrounded by admirers.

It was surprising that she, Picabia and Olga did not run into

180

Alvaro, Nancy and Henry at Le Dôme or Les Deux Magots, but the Hours Press was preoccupied at Puits Carré putting the finishing touches to Alvaro's *St George at Silene*, hoping that publication could coincide with his exhibition. Also he was busy with framing, and was paying some attention to Mama, lately neglected at her hotel.

Picabia took Meraud to call on his first wife, Gabrielle Buffet, and their three children, who lived at Versailles. The two women at once made friends despite the difference in their ages.

During this autumn of 1928, it became apparent to Olga that Francis was up to his usual tricks. While she watched him flirt with Meraud, she agreed with Shakespeare that men were deceivers ever but cared not, as long as *she* was not deceived. Once more Germaine and Meraud were tortured by his deviousness. Once again the emotional tension between Germaine and Meraud reached breaking point. Olga kept her own counsel. If her mistress were so foolish as to welcome a cuckoo in the nest it was not she, Olga, who would be thrust out and ultimately rejected. She was confident that the *petite élève* would soon find a younger man more to her fancy. The time left before Alvaro's and Meraud's meeting was dwindling.

On 1 December 1928, Alvaro was working at the gallery taking down his paintings when the street door opened and Meraud drifted in. Her walk was one of her most graceful assets; each step she took was sure and poised, but gave the impression of the prelude to a dance: without the aid of wires she might suddenly fly, or float, away into the firmament. At once Alvaro recognised his dream: the butterfly ballerina. He had waited for her a long time: since his first visit to the circus at the age of six, and he was now thirty-five.

He dropped a *Fleur Imaginaire* and hurried forward to help unload the packing-cases. Her figure was more feminine than Nancy's, less angular; slim, not thin, but then of course she must be at least eight years younger. Her face was mobile, expressively humorous, not exactly pretty.

Mouradian appeared. Having introduced them, he sat back like an indulgent Buddha to watch the scene unfold. He realised that through a series of accidents he was responsible for a collision, rather than a peaceful meeting, between two stars. By

instinct, he knew that there would be repercussions – sparks, perhaps thunderbolts. Clearly Alvaro was already smitten with a *coup de foudre*. This was ominous, and yet Meraud's influence on Picabia had not proved as destructive as Mouradian had originally feared. She had behaved sensibly and well. As an afterthought Pic had written above his preface to her catalogue: 'She has eyes full of sighs.' There were no sighs now: her blue eyes glittered. She tinkled with bell-like laughter while the twenty-seven extraordinary pictures signed *Michael* were ranged against the walls. How should she hang them? Her hands fluttered. Chile would help. Germaine was right, her voice and accent were adorable.

One large canvas entitled *La Sirène* was of a weird pink mermaid with a vapid expression, swimming among fantastic fish, sea-anemones, seaweeds, shells and corals. A sinister one-eyed octopus glared through the water. What could this mean? Was her style influenced by the Dadaists, Surrealists or Futurists? Presumably the critics would decide. In a portrait of the Picabias, Pic's head was duplicated in cellophane, superimposed and ornamented with pins. She explained that there were exactly one hundred and thirty-four of them, representing the sharp, shining ideas that emanated from his brain. A well-drawn portrait of young Lorenzo Picabia had an extraordinary decoration of elegant dogs – possibly greyhounds – all over the canvas partly painted and partly formed by silhouettes in transparent paper. Many pictures were not exclusively collages, then fashionable in Paris, but pasted with cut-outs over the basic composition.

When at last the exhibition was hung to everyone's satisfaction, Alvaro saw her home to a small, cheap hotel in the Rue des Beaux Arts. Oscar Wilde had died there leaving a choice of famous last words: 'I am dying as I have lived, beyond my means', or: 'This wallpaper is killing me: one of us must go.' Contemporary inmates would ask each other: 'My dear, which would *you* rather he had said?'

When Alvaro attended Meraud's *vernissage*, he spotted Kit Wood among the crowd which, despite wintry weather, spilled out on to the pavement in the narrow Rue de Seine. Meraud was dressed in scarlet velvet. She sported a printed cotton kerchief tied in apache style round her neck, rather than pearls and rubies. Although she and Kit had exchanged many letters, it

182

was nearly a year since they had met. When all the other guests, including Alvaro, the Picabias and Olga, had left and the press interviews were over, she agreed that they should dine alone together. Kit wrote to his mother:

'Meraud's show went off all right, she sold seven pictures ... None of her parents were there. She dined with me that evening. I am very fond of her but that is all and although I don't regret for a moment all I went through last year I don't think on seeing her again our marriage would have been a great success. I find her almost devoid of any serious [conversation] and it's a thing I find impossible to be with people who can only laugh. She has lost all her looks too – she is very sweet and I see her often. I don't know what she will do. I think at the bottom of her heart she would like to marry me, and it would be the easiest thing in the world now.'

Despite Kit's negative reaction, the following day the gossip columns in New York, London and Paris seemed to indicate that Meraud could still charm reporters. According to the London edition of the *Daily Mail*: 'Miss Guinness is the daughter of Mr Benjamin Guinness, of London, Pittsburgh, Cannes and New York. Mr Guinness is a multi-millionaire. Mrs Guinness is one of the most indefatigable hostesses in London. Miss Guinness cares neither for money nor for social entertaining ... her tableaux are already extremely personal and exclude the bourgeoisie.' The paper's Paris correspondent wrote: 'Miss Guinness would not discuss M. Picabia's judgement of her, but told me she had been in love with art ever since she was a child. "I studied under Mr Tonks at the Slade School in London and afterwards in New York under Archipenko. For the last year I have been working with Francis Picabia both in Paris and in the South of France." Miss Guinness's pictures are frankly impressionist and, to the ordinary eye, would appear somewhat unusual.'

The art critics were less confident, in fact bewildered. According to another article headed *Art or Insanity?* many recent exhibitions had resulted in the view that 'such art was nothing but the expression of disordered minds, strikingly similar to the familiar art productions of insane asylums ... She makes no effort to explain her art. "I paint as I feel and think," she says, and leaves it at that ... when she was informed that certain of the London critics considered her art as hardly within the realm

of sanity, Miss Guinness merely smiled and granted that the critics were entitled to their opinions.'

One critic remarked that she was not above using postage stamps to 'decorate a portrait if postage stamps would help convey her impression of anybody'. Influenced by her master, Picabia, she had been known to stick wavy bits of string on portraits to represent the lines of her sitter's wrinkled foreheads. She was: '... one of the boldest of the younger moderns, and predicts that the time will come when the conservative school of art will be considered as childish and puerile'. She described herself as a painter whose hobby was Society, not as an ex-debutante who amused herself painting.

It was soon obvious to everyone, not only Mouradian and Mama Guevara, that Alvaro had fallen in love. He was courting Meraud at l'Hotel d'Alsace in typically correct Chilean fashion. When he first called in his vast Packard he was amazed to find a lady, let alone an heiress, living, and receiving countless lively visitors, in a shabby little room – it was always overflowing.

Before each call, he dressed with care in one of his best Savile Row suits and wore a discreetly dark silk tie silhouetted against an immaculate white silk shirt. His bowler hat was not forgotten, but now he carried it and in the other hand he clasped a bouquet. Only the most expensive, luxurious flowers were good enough for his beloved. Sprays of sexual orchids, looking bizarre and incongruous, survived for days before withering on a dusty shelf. Gertrude and Alice could have told him that in December she would have preferred snowdrops and aconites or Christmas roses.

She greeted him as 'Chile' and gently teased him about his conventional appearance. He looked like a doctor in his well-cut dark suits and polished Lobb shoes. He should go to her brother's tailor who often came over from London for fittings with patterns of beautiful light tweeds and checked worsted. Alvaro certainly knew more about their manufacture than she did, but she found him so unusual and handsome that it was worth taking some trouble: she led him to Hermès and Lanvin, where they chose more dashing shirts and ties together.

He soon realised what excited and appealed to her – including the cafés and bars where fights were so deliberately provoked to entertain the customers. He was pleased to find her tastes unusual

for her class – after all she was an artist – but he did not much care for her entourage, which included her great friend, the dilettante young English writer Brian Howard. As soon as Brian knew where she was, he had installed himself at her hotel. Although he was homosexual, he frequently proposed marriage after some hilarious escapade. They understood each other. She was always surrounded by lovely people, sexy boys: surely they could all have tremendous fun? Alvaro detested him. It was the old story of the mosquito and the elephant. Brian was intensely irritating. There came a moment when, in a violent frenzy of jealousy, he could no longer tolerate Brian's stinging jibes. He hit out blindly as if swatting a fly, picked him up, and threw him out of the window. In the nick of time, Brian grabbed the curtains and instead of crashing to the pavement below swung back into the room. Exasperated, Alvaro seized him once more and flung him out. Again Brian managed to save himself and scrambled back on to the sill. After this Alvaro gave up. At least he had avoided prosecution for manslaughter or attempted murder.

Passers-by on the Rue des Beaux Arts were presumably diverted by many such hair-raising spectacles. Another resident of the hotel was the acrobat Roland Toutain who would practise his acts, or amuse himself, by swarming up and down the façade, or clowning from the narrow parapet to the accompaniment of yells and cheers from the inmates hanging out of the windows. Kristians Tonny, the Dutch painter who had been an infant prodigy, also lived at the hotel. Later he painted a portrait of Gertrude Stein and her poodle, Basket.

When Benjamin Guinness heard that his recalcitrant daughter was not staying with acceptable friends in Paris, but living in a shabby hotel, he increased her allowance from five hundred pounds a year to a sum calculated as appropriate to cover the cost of meals and a room at the Ritz, or at least the Georges V. No Guinness could visualise staying anywhere else. This princely gesture provided ample wherewithall to keep various hangers-on, condemned and despised by Alvaro as cadgers – *sales maquereaux* – and to pay for many a night at Le Boeuf. Meraud had no illusions; it was not only her charm which made her so popular. However, she had worked hard for her show and suffered heart-rending affairs with Kit Wood and Francis Picabia. She now set

185

out to enjoy herself and share her fun with others less financially fortunate.

When more conventional friends ran across her, they found her life 'such a lark' that they were willing to connive and relay selected scraps of judicious gossip to her parents. What was dear Benje thinking of? It certainly did his reputation no good as a multi-millionaire. Poor Meraud must be horribly hard up! It was not their business of course but as loyal family friends they thought he ought to know that it made a very bad impression – only the other day at Le Dôme she was wearing an old coat – last year's model – and laddered silk stockings!

The resulting cheques were most welcome to the entourage. As Alvaro noticed, Meraud was always absurdly generous. However, he was not her only altruistic admirer. She continued to meet Kit Wood who had revised his opinion of her after the private view and admitted to his mother:

'. . . it has upset me seeing Meraud again, and I suppose it was a temptation to start again, but I didn't and won't now. I feel she is without knowing it rather a dangerous influence to someone who has a very serious life to lead for the next few years as I will.'

Mrs Guinness was particularly distressed and disturbed when she heard on the grapevine that Meraud was once more seen about with that totally unsuitable, unstable boy. Although Eddie Marsh and other artistic friends spoke well of him, 'he simply would not do'. She was also disturbed to hear rumours of her elder daughter being pursued by some Chilean painter. Obviously Meraud was in an undesirable *milieu*. Mrs Guinness confided her anxiety in a handsome, artistic young man whom she considered a possible match for her daughter. He was titled and had been married before to a Russian lady: a Bohemian and older than himself. The mere fact that he was divorced might appeal to Meraud: she had always been contrary. Sir Robert Abdy, affectionately known as Bertie, had always found her a vivaciously attractive, intelligent girl at London parties.

When he called at her hotel in Paris and by a jerked thumb was shown up to her bedroom, it was too much. Lying on the bed was some unidentified diaphanous garment. All kinds of extraordinary and noisy people drifted in and out. He took her

out to dinner and discreetly refrained from mentioning the occasion to her parents.

By now, the Guinness' consternation was such that some desperate action had to be taken. A loyal old friend, Mrs Patrick Campbell, was despatched to Paris, with their trusted cook, Mrs Danverell, as her companion. These two good ladies were engaged, with all expenses paid, to spy on Meraud and report their impressions exactly.

Meraud was well disposed to like Mrs Pat Campbell, who was her godmother – a fairy godmother indeed: when fire had broken out at Meraud's christening, everyone's first thought had been to save the dogs. Mrs Pat had rescued the baby.

Alvaro disclosed to Mama Guevara that he was determined to marry Miss Meraud Guinness. The time had come when he would like to present her as his future, or at least intended, wife. Meraud on her side was equally curious to meet Mama Guevara. Old Mme Mouradian considered her 'a great lady', although because she had no regard for European fashion, she might seem rather naïve, she was good and wise. When Meraud asked Alvaro to describe her, he said: 'She is like a cathedral.'

When at last they met, Meraud agreed: in some way she was monumental. Although her features were strong, almost masculine, her face appeared quite small shrouded in a grey shawl or a black mantilla. The layers of cloaks and skirts were tent-shaped; her dignified silhouette was less like a cathedral than a pagoda.

When Alvaro and Meraud told her excitedly that they had just received a telegram from Mrs Guinness informing them that their cook was accompanying an actress friend of theirs who was shortly arriving in Paris, Mama Guevara simply nodded and did not betray her surprise. She quickly remembered that the last cook who had cropped up in her son's life, Mrs Rosa Lewis, was a friend of Kings. At once she ordered her chauffeur and car and offered to accompany Alvaro and Meraud to the Gare Saint-Lazare to meet the train. She was silent on the way to the station and refrained from admitting that she had never met either an actress or a cook socially, or that she firmly believed all actresses to be 'of questionable morality'. Naturally she had no idea that Mrs Pat was highly distinguished. She greeted the two women with polite amiability. When Alvaro suggested that,

after the visitors had unpacked and felt sufficiently rested, all five should dine in Montmartre at some modest but amusing place, Mama Guevara agreed. Later that evening when they were all informally seated in a restaurant of Meraud's choice, Mama remarked with engaging sincerity that she felt a little confused – which of her guests was the cook and which the actress? According to Alvaro's account of the occasion, Mrs Pat 'laughed very heartily and saved us embarrassment'.

At first Meraud's friends found it irresistibly comic to see two eminently respectable, rather dowdy, elderly ladies sipping cups of Lipton's tea or *cafés crèmes* in a corner of Le Boeuf, while exchanging amused or scandalised glances, or whispering behind gloved hands as they peered through thick smoke in a series of noisy *boîtes de nuits* and *bals musettes*. Knowing they would be doggedly followed wherever they went, the ringleaders, such as Brian Howard, were encouraged to indulge in wilder and even more bizarre excesses. With aching feet, the poor spies trudged after their hysterically giggling quarry. Fearful of losing the scent, they would urgently wave their baggy umbrellas at passing taxis only to find themselves ushered into questionable haunts such as Le Chien Qui Fume, or waiting wearily in the early hours of the morning while their prey danced and played hide and seek round Les Halles, the fruit and vegetable market, pelting the porters and each other with cauliflowers and beans. The wretched vigilantes drooped with fatigue over marble tables swimming with wine and cigarette ash.

After a few days Meraud's obvious affection for the two emissaries endeared them to all her friends. They were encouraged to join in the fun and were delighted.

Small wonder that Alvaro became their favourite with his impeccable manners and consideration: his Packard was often ready to give them a lift! As a Latin he had been brought up to act with respect towards the older generation. His gallant courtesy impressed Mrs Pat, who reported favourably on his behalf to Mrs Guinness.

The sequel to the departure of 'the spies' was the arrival of Bridget Guinness herself in Paris, anxious and inquisitive.

Presumably her social secretary had pointed out the latest news of her daughter in the English press. *The Daily Chronicle,* then widely read, referred to Meraud as 'one of the most discussed

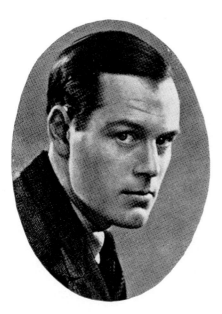

Christopher Wood

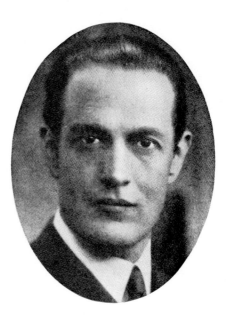

Alvaro in 1929

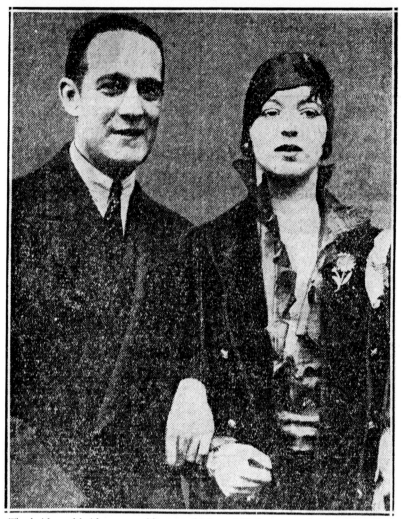

The bride and bridegroom: Alvaro and Meraud Guinness on their wedding day,
22 January 1929

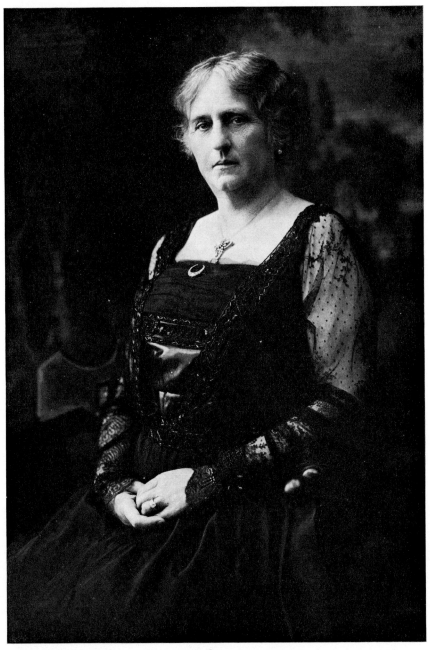

Mama Guevara

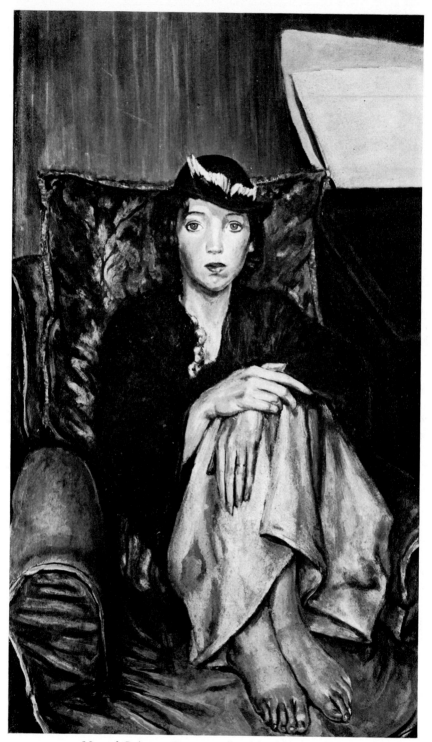

Meraud Guinness Guevara, painted by Alvaro in 1929

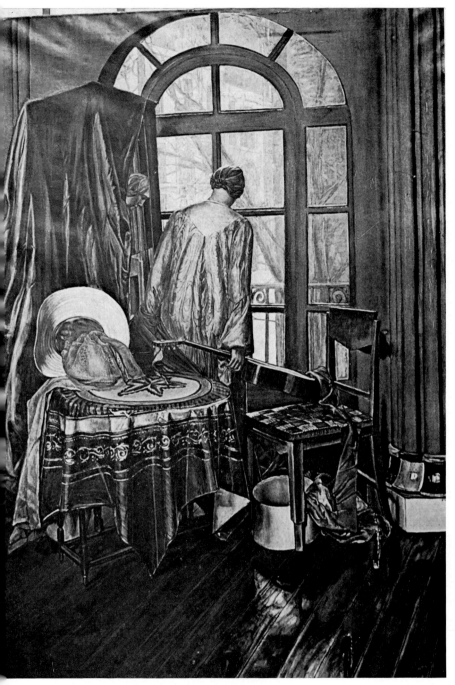

The Lanvin Dressing-Gown 1930

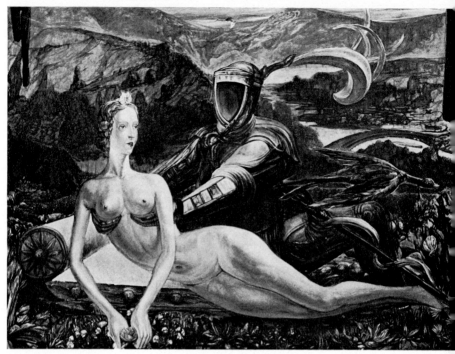

The Faceless Knight 1934

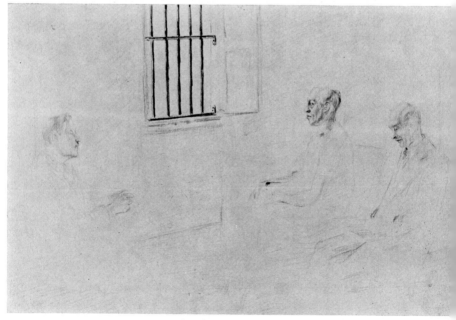

Cherche Midi prison 1941

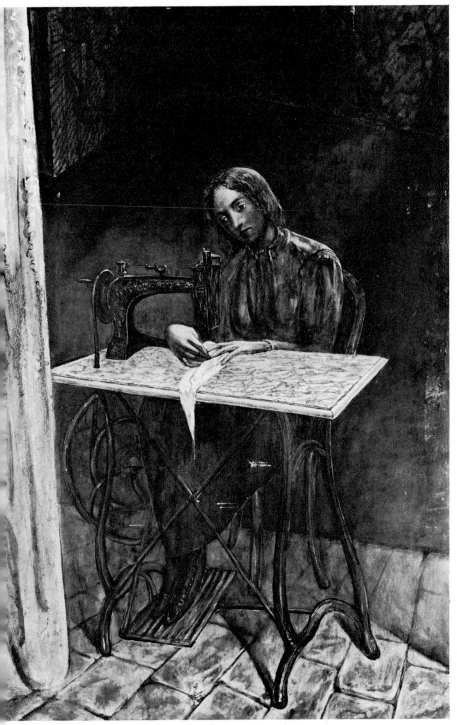

The Sewing Machine (*c* 1935)

Nini (1948?) Maruja (c1943)

La Tour de César

women in Paris'. The reporter went on to say that she was always dressed in an ensemble of myrtle green and a cloche hat of leaves and added that he had met her with the well-known painter Guevara. He had 'learned from them that Christopher Wood had deserted Paris for Cornwall . . .' Good riddance! But *always* dressed the same? Had the wretched girl given her entire wardrobe away?

When, under pressure, Meraud admitted that of all her admirers Kit Wood was still her favourite, her mother was extremely vexed. She insisted that Meraud's father would never consent to such a match and were she to flaunt her independence he would never speak to her again. Fretfully, Bridget asked: 'Why can't you marry the Chilean?' adding with a shrug, 'At least he's a gentleman.'

It was a pity that, being a Latin, he was presumably a Roman Catholic – but after diligent enquiry, she had lately learned, not only from dear, devoted Mrs Pat, that Alvaro was accepted in England as a highly successful portrait painter by the famous and distinguished: his work was already hanging in the Tate. He was no fortune hunter to be despised but, according to many friends, rich, presentable and talented: Mrs Pat had reported that he had a commanding presence, a courteous and dignified manner, and moreover he was so well connected in the diplomatic world that it would only need pulling a few strings for him to become appointed to the Court of St James – not at once perhaps, but eventually . . . she imagined Benje would be content, or at least resign himself to his daughter becoming the Chilean Ambassadress. Apparently, despite a ruling abolishing all titles made by the Chilean President, bizarrely named O'Higgins, Meraud could certainly claim to be a Spanish comtesse.

Fortunately for Alvaro, Mrs Guinness had heard only such reassuring and complimentary gossip. No malicious whispers had reached her concerning his ambiguous sexual life, his passionate violence, his drinking bouts and his obsession with sordid scenes in pubs, cafés, brothels, opium dens, boxing rings and music-halls. No one had described how frightening he could be, how taciturn, how unpredictable his moods, attributed by some to a sinister drug to which he had been introduced in Southern Chile by the Araucanian Indians. Had she heard these things, perhaps she might have understood the nature of the lethal

attraction that he had for her daughter. Happily ignorant of this side of his character she already visualised a spectacular wedding: it would be a relief to see Meraud safely and suitably married. But she was reckoning without Meraud herself who, besides vacillating between conflicting emotions aroused by Kit Wood and Alvaro, still regarded the idea of a conventional wedding as an anathema.

Soon after this meeting between Meraud and her mother, Alvaro begged Meraud to marry him and she revealed her violent aversion to the social formalities involved. She found the thought of being disguised as a foolish virgin thoroughly bogus. She loathed the idea of being paraded like a silly little doll in white satin and pearls, dragging a train attended by a retinue of brides-maids in full fancy dress and little pages in velvet suits as a spectacle for hundreds of guests from both sides of the Atlantic.

Knowing Alvaro's love of theatre she was surprised to find him so sympathetic. She was unaware of the tragic dichotomy in his attitude to emotive experience: how he was still tortured by the traumatic effect of his sister's wedding when, wearing a black velvet suit, he had borne her train and played such a humiliating and bewildering rôle which culminated in her in-explicable rejection. He found it impossible to explain that the most awful and wounding episodes of his youth were all con-nected with some form of ceremonial. The vision of German Grandmama lying in her coffin wearing black satin, her soul condemned to limbo by his relations because of her Protestant faith, had always haunted him. His horror of losing his identity when Papa demanded he should change his name before his first Communion; the macabre ritual in the Valparaiso slums, when the vultures had led the police to the rotting corpse of Griselda's baby; the fact that he and Susana were nearly killed while worshipping the moon – all these circumstances contributed to a deep-rooted fear of religious ceremony. This prejudice was at war with the profound interest he shared with Nancy Cunard in the occult, in Indian and African superstition, magic and mystique, with the irresistible attraction of theatrical drama and the intoxication of music.

For a while this confusion in his mind made him inarticulate; then slowly in his deep resonant voice he agreed quite simply

that a clandestine marriage with absolutely no fuss would be much more romantic and exciting.

Perhaps his unexpected reaction influenced Meraud in his favour. She decided then and there to elope with him. A secret wedding, a surprise for all her friends, would at least be fun. Moreover, her acceptance of Alvaro meant escaping from the dreaded confrontation with her father over Kit. Uncertainty was misery: decision came as a relief.

Alvaro had an idealistic approach to marriage. He confessed that he felt deeply ashamed of his homosexual experiments. Never, never again would he commit these sins. Yes, he was convinced that they were dreadful sins! Meraud would rescue him. She was marvellously, exceptionally forgiving and understanding. As his wife, she would command his infinite respect. He would never wish her to meet any women such as Nancy, Dorothy, Marie or Nina.

When Meraud protested that neither had she led a blameless life, they agreed to forget the past and make a fresh start together.

Meraud sensed that although his faith in Roman Catholicism had lapsed, 'he was deeply religious inside'.

She had shared her artistic interests with many fascinating men, but Alvaro was certainly the most unusual. Was it because of his contrasting moods of violence and gentleness, the dynamic energy and volubility at variance with prolonged idleness and silences, or was it despite these conflicting qualities, that she felt the more drawn to him? He was the fortune teller's 'stranger' in a tea cup which she had drained to the dregs: tall, dark, handsome and mysterious.

She fell in love with him. But supposing her parents heard of his homosexual adventures, or that he had smoked opium now and then? What a terrifying thought! They would then disapprove of him as much as they had of Kit and the whole dread pattern would be repeated. She must steal a march on the gossips: the sooner they married informally the less likely this would be.

When Alvaro relayed Meraud's unconventional theories about marriage to Mama Guevara she retained her habitual calm. With hands folded in her lap she did not betray by so much as a twitch of a thumb any surprise or dismay – even when pacing around her suite at the Majéstique, he tried to explain another of

Meraud's ideas which she might find difficult to accept: honeymoons should take place before weddings.

Mama had been baptised as a Lutheran and obliged to embrace the Roman Catholic faith in order to marry fifty-five years before as a Danish girl in Chile. Since then she had never been to mass, and was uncertain when to cross herself or genuflect. She would imitate others, content to avoid giving offence. She took her time now, before replying that a civil marriage in a Registrar's office involving no religious ceremony had never occurred to her. However, on consideration, the entire project seemed quite reasonable under the circumstances. Indeed, Alvaro and Meraud could embark on their premarital honeymoon the following week. She would alert her chauffeur as she herself would be delighted to accompany them. She rose to ring the bell for her maid.

When Mme Mouradian called for tea with Mama at the Majéstique she was both aghast and amazed on hearing such a plan advanced as a sensible solution to the lovers' problems. Mama thought it would be far easier for them to resolve the perplexities of whatever wedding they wished, if they saw each other every day for at least two weeks. They would get to know each other more intimately away from the hurly-burly of Paris. She added how delightful it would be to visit Munich.

It was impossible for either Alvaro or Meraud to object, or explain that this was not the kind of honeymoon that they had expected. In the event Meraud was bored stiff. She sat in front with the chauffeur and pored over the maps in a determined attempt to curtail the trip. Alvaro sat in the back of the car with Mama and her mountains of luggage. He and Meraud became more and more attracted when so frustrated and longed to return to the congenial atmosphere of Paris.

14

A few days later, the English press announced that Meraud had returned to her home in Carlton House Terrace; her parents were away; she was in London to design sets for Mr Cochran, together with William Nicholson, Oliver Messel and the French painter, Paul Colin – presumably the uninitiated linked her name with his. Some columnists added that not content with painting, she had been at work on a ballet, for which Lord Berners might write the music. The *New York Herald Tribune* reminded its readers that when Meraud lived in Washington Square, she had contributed monthly articles to *Vogue*. Although she was clearly qualified to write on fashion, she had chosen to write 'of comparisons between English and American Society'.

Alvaro's arrival at the Eiffel Tower to stay with his old friend Stulik passed unnoticed save by a few habitués who spotted his vast Packard outside. The following day he bought a special licence to marry Meraud at the Registry Office in Henrietta Street, unaware that the lists posted at such places were eagerly scanned by reporters for fashionable names. Within hours, headlines in the evening papers gave the lovers' secret away. 'They dined quietly in Limehouse rather than in the West End,' defying the superstition that it was unlucky for a bride and bridegroom to meet the night before the wedding. It was unthinkable for Alvaro to let his elusive fiancée out of his sight for fear some hated rival might whisk her away. She had admitted to being 'rather flighty' by temperament; she was less like a butterfly than a will-o'-the-wisp.

When Meraud got home that night, the telephone rang in-

cessantly. News of her precipitous marriage – *Romance in Bohemia* – had already reached the New York papers. There was no peace. The Eiffel Tower was described by the press as 'a quiet hotel off the Tottenham Court Road,' but Alvaro found many rowdy friends waiting to congratulate him over round after round of drinks. Determined not to suffer a hangover, he begged Stulik to excuse him and escaped.

A good hour before the ceremony was booked to take place, he drove to collect his bride from Carlton House Terrace. Pandemonium reigned. Meraud had been flustered and delayed by calls from her parents in Cannes. Mercifully, they had given their blessing. Benjamin Guinness had cracked the whip and alerted other members of the family to attend the wedding and – by proxy at least – lend the informal proceedings his approval. Many people pointed out that 'Meraud's unconventionality had saved old Benje *pots* of money': not that he need care about this

The bride and groom, accompanied by her uncle and aunt, Mr and Mrs Richard Guinness, her brother Loel and his wife, and her younger sister Tanis, arrived very late at Henrietta Street. Alvaro appeared calm but was afraid that something would go wrong at the last minute. At once they were surrounded by photographers and journalists. Not only the gossip columns but fashion magazines strongly approved of her tailored, gold-buttoned suit of plum-coloured velvet, her blouse of navy-blue georgette with its petalled collar. 'Pearl earrings peeped from under her matching cloche hat, trimmed with a crimson feather which caressed her cheek.' Even her handmade shoes, navy-blue with red strapping, were included in the colour scheme. She was elegance personified!

To the William Hickeys of the day, Alvaro was disappointingly dressed. They had hoped that he would provide a contrast as a flamboyantly Bohemian artist. Instead he wore a dark suit, black shoes, a white shirt and conservative tie. Of course he carried his bowler hat. It would have made a better story had he been scruffy and penniless but the columnists contented themselves by stating that he 'was extremely handsome, tall, attractive, as well as a distinguished painter whose work already hung in the Tate,' adding how popular he had proved in London. All the accompanying ladies wore light-brown fur coats – sable or

mink: it was a cold wintry day on 23 January, 1929. The bride-groom was nine years older than the bride.

Meraud was startled by the impatient, murmuring crowd of sightseers and reporters waiting outside the Registry Office. 'We are going to live for Art,' she whispered breathlessly; 'our honey-moon will be a week-end – in Paris perhaps. We are too busy to waste more time. I have spoken to my parents. Yes, I wrote to them, and have spoken to my father on the telephone since. We have his and my mother's blessing.'

She and Alvaro at last escaped and ran along the corridor to the Registrar's office, exclaiming happily when they discovered at least sixty friends and relations waiting, but alas more members of the press had followed them. 'Am I late?' Meraud cried, fluttering from one favourite to another, bestowing kisses. 'But there are no flowers! I must have flowers, *masses*, please!' She was only wearing a spray of diamond daisies. Several volunteers including Lady Dean-Paul and her daughter Brenda and Zita and 'Baby' Jungman offered to rush out and get them; but it was Viola Tree who made a dash to Covent Garden market and returned with daffodils and white lilac in dripping bunches and improvised a bouquet.

Comparatively few of Alvaro's friends knew of the event. He stood apart with the Nevinsons. Kathleen Nevinson remarked that the Office seethed as if it were housing a cocktail party for Bright Young Things: 'The whole room was a-twitter, like a tree full of starlings!'

Noting that the Registrar, a Daumier character, was looking stuffy and fidgety, at last Mrs Richard Guinness protested: 'Really, Meraud darling, it's terribly late, you *must* pay attention to your own wedding!'

There was a hush and the Registrar beckoned to Nevinson, assuming he was the bridegroom, as he was the only man present who looked like an artist. He was wearing a flaming red shirt, a flowing bow tie and a sombrero.

Alvaro stepped forward grinning. When it was time for him to produce the ring and Meraud held out a manicured hand, her wrist glittered with diamond and sapphire bracelets. Amid much giggling, a huge solitaire diamond ring remained obstinately stuck on the marriage finger, despite frenzied tugging. It was presumed to be her engagement ring, but Alvaro had either for-

gotten to provide this love token, or deemed it unnecessary as she owned so many jewels already.

The wedding over, Meraud laughed gaily and insisted: 'You must sign the Register, Uncle Dick!' Her aunt, a famous hostess who entertained her guests with 'Hutch' at the piano and other fashionable cabaret acts, invited everyone to an impromptu champagne party in Great Cumberland Place. Alvaro had wisely booked a suite at the Savoy. Many of the Bright Young People had become rather faded by the late twenties: they repaired to the Cavendish for a gossip with Rosa Lewis. 'Chile's a nice boy: good luck to him!' she said, sipping her glass of sherry. Other, brighter members of the set had not given up trying to shine. A full-page photograph of a tipsy-looking hoax wedding group, with Elizabeth Ponsonby as the bride, appeared in the *Sketch*, a glossy Society magazine, opposite another of Alvaro and Meraud in the Registrar's Office surrounded by ladies in their fur coats and cloche hats, including Mrs Pat.

That night at the Café Royal, a crowd of Alvaro's old friends gathered to celebrate. It was generally felt that although an excuse for heavy drinking, the news in the evening papers gave no cause for rejoicing. Bomberg for one, shook his head and prophesied that having married into Society, as a painter Chile was finished. Others protested that although this bride was obviously artistic – her designs for her show in Paris and for Cochran were not half bad it seemed – the *Star* reporter was probably correct when he wrote under the prominent headline THE BRIDE WORE RED! that she 'was not altogether indifferent to the claims of society life, for one of the most attractive balls of last season was that given for her by her mother at Carlton House Terrace, when four hundred guests attended in masks, which were not removed until midnight'. An anonymous cynic said: 'We must wait and see; they are both rich and may wear their masks *after* midnight as most people have to when married.'

An indefatigable female sleuth, 'Miss Gossip' of the *Daily Sketch*, tracked the honeymoon couple down to the Savoy. She wrote that 'no one would have guessed that the very composed, pretty girl, wearing no hat on her shingled head was so newly wed. She was buying newspapers, standing by her handsome husband. He seemed concerned, but her manner was casual and

196

vague.' Obviously Miss Gossip got short shrift from Meraud.

After a few days' peace hiding at the Savoy, Alvaro took a flat in Fitzroy Square belonging to a Mrs Nelson – possibly a relation of Geoffrey's. It was large and comfortably furnished. He and Meraud had many Bloomsbury friends. She was busy with her sets for C. B. Cochran, taking work seriously, and Alvaro was painting her portrait. They were both enjoying a constructive life. He still relished the odd visit to the Café Royal alone, or a pub crawl with an old friend such as David John. They might call in on the Wheatsheaf down the road and run into various other men who included the aspiring young writer Anthony Powell, then in his early twenties. He had already heard of Chile from the Sitwells and wondered later if the impression he received of him at parties or pubs between 1928–1929, was due to his 'own over-imagining'. He always thought that there was 'something very *melancholy* about him, as if he had had a bad experience some time in his life'.

Having won his bride, perhaps this was in fact one of Alvaro's happiest times, but both he and Meraud 'found journalists a pest'. Within a few weeks, *The Sunday Dispatch* produced a column headed GARRET HOME OF HEIRESS TO MILLIONS – ARTIST BRIDE 'TIRED OF SOCIETY'. A photograph of them both painting in their so-called 'attic-studio' appeared beside many paragraphs of trivia. A point which seemed to escape all the columnists was that a daughter of Benjamin Guinness was not necessarily heiress to a large part of his fortune, as she might have been under the *Code Napoleon*. These gossips were ignoring the custom practised in England among the richer families in order to preserve their estates intact, of leaving the bulk of their fortunes and property to the eldest son or even, as death duties mounted, to his son. Seldom were daughters left more than a sufficient income for life. Although Meraud was Benjamin Guinness's eldest child, he had a son, Loel.

Small wonder that the newly married couple decided that they would prefer to live more privately in Paris, where Alvaro already had a studio.

The Guinness family accepted Alvaro with good grace. He seemed anxious to please. Meraud could have done far worse. Of course it was disappointing that he lacked ambition: even a

diplomatic career did not appeal to him, nor did he seem particularly keen on his exhibitions being promoted by well-established galleries in New York, London or Paris. Meraud and this Chilean fellow were constantly avowing that 'they lived for art'. Let them get on with it; they were uninterested in money, bored with Society and content to live like gypsies in a hugger-mugger way. Time would tell. Having made her bed, Meraud could lie on it.

For their part, the Guevara relations and friends in Valparaiso and Vina del Mar were agog to welcome, entertain and introduce Alvaro's fascinating bride to Chilean Society. Mama Guevara had returned to Vina del Mar. Newspaper cuttings referring to the wedding were eagerly handed round. Elaborate plans went ahead for spectacular balls, receptions and rival parties in their fabulous houses. Surely the Brauns were as rich, or richer than the Guinnesses?

It was taken for granted that the newly-wed couple would arrive within a month or so. When Alvaro gently explained to Meraud how impossible, unthinkable it was for a *lady* to drive her own car unaccompanied and explore the city and the country, or set foot in waterfront bars and cafés, let alone attend boxing matches, Meraud's enthusiasm waned. Only social misfits, like that unfortunately eccentric Amalia Errazuriz, would dare flaunt convention to the extent of smoking in public, or sitting with crossed legs, or appearing gloveless and hatless. Were Meraud to do any of these things, the family would find it acutely embarrassing.

With regret, Meraud wisely decided to give a honeymoon in Chile a miss. Instead, a few weeks after the wedding, she and Alvaro moved from Bloomsbury to a flat high up in Montmartre with a striking view of Paris. When various friends such as the Beaton sisters and Madge Garland called, they were shocked to find that Meraud and Chile were not only content with their extraordinary surroundings but 'divinely happy': *Bohemian* was the mildest expletive used to describe their eccentric life.

Cecil Beaton was in Paris and achieved one of the most triumphantly successful photographs ever taken of Nancy Cunard, her eyes tragically ringed with kohl, massive ivory bracelets on her arms. When he called at Rue Simon-Dereure to photograph Alvaro and Meraud painting from a swarthy nude, they were

198

both wearing conventional clothes – looking as if they had just returned from lunching at the Ritz. The result appeared in *The Tatler*, but scarves had been strategically placed over the model's nipples and *mons veneris*.

When a friend of Susana's called, she wrote that she had discovered Meraud painting, totally absorbed, on top of a ladder, dressed in an exquisite negligée of pink chiffon and lace.

In the enormous room which served as the Guevaras' studio, a huge bath, painted mauve, was prominently displayed: it was stacked full of canvases. Meraud explained to her guests that to sacrifice a particular room for a bath seemed a waste of space. The water was heated by a primitive stove underneath. Alvaro was quite accustomed to the system, which survived in most old-fashioned *ateliers*. It was quite possible to keep clean with a kitchen sink and a *bidet* – a device that was still, even to Bright Young People, in the words of Evelyn Waugh, 'too shy-making'. Certainly, both she and her husband were amazingly *soignée*.

In the same room, other furniture included a combined cashier's till and desk, presumably foraged from a defunct café, and a dining-table covered with scarlet oilcloth. A twisted chimney-pot stood in the middle as a centrepiece. Both Alvaro and Meraud raved about its pleasing design. The only other decoration was a profusion of brilliant-coloured ostrich plumes which trailed about the floor at random. The bedroom lamps were shaded with chimney cowls of aluminium. According to one visitor at least, Picabia's portrait of Meraud 'was quite revolting'.

As for the kitchen, where Alvaro and Meraud did their own cooking, there was scarcely any room to operate since Alvaro had installed a vast dresser, now laden with a chaotic jumble of every conceivable pot and pan. This magnificent piece, which he had failed to measure in the Flea-Market, left only the narrowest path along which to squeeze to the cooker. Descriptions of how the Guinness heiress chose to live lost nothing in the telling, but at least one gossip column admitted that Chile and Meraud 'were the happiest and most contented couple one could find'. Another of 'Senora Guevara's odd and impulsive ideas', was reported: 'She wants to build a villa on stilts at Cannes.'

When the Nevinsons arrived in Paris, Kathleen was delighted to see how blissful Alvaro and Meraud appeared to be. Watching

them as they walked arm in arm through the streets, she 'saw Meraud looking up at him with true love twinkling in her blue eyes'. The Nevinsons met them again on the Riviera, where according to his account of the meeting in *Paint and Prejudice,* they were 'mixed up with the crazy crowd at Juan les Pins. There were Russian princesses and film actresses from Ufa in Berlin: some with diamonds, some with marmosets, some with doves on their heads, some with husbands, some with keepers, some with a roving eye ... There were monocled beachcombers who had a fixed scale for introducing young ladies to peers and millionaires ... There was a sensation when Guevara brought his wife along to the Casino to find us. We had missed them at their villa at Mougins. Meraud was dressed like a little *fille de matelote,* and Guevara was *au rapin.* Some silly English people looked very hot and haughty at the presence of those two tramps at our table, and when the Casino servants bowed low, they muttered among themselves and asked questions. Then Meraud, who had been sitting with her arms folded, stretched out one hand for a cigarette and the other for a glass. I have never seen such a transfiguration as that on the painted faces round me when they saw diamonds and emeralds on those two little hands. Their requiring dignity [sic] changed to amazement and eagerness; then unfortunately a waiter not only told them who Guevara was but mentioned the word Guinness. At once it became impossible to sit at the table with all the people round, leaning on us and craning their necks to hear what we said. Meraud was wonderful. She remarked that the people were very dull, and would we go and sit with them elsewhere.'

Introducing each other to individual friends now took priority. Alvaro was right in sensing that Meraud would get on famously with the Crosbys, especially Caresse, although Meraud was ten years younger. From his point of view this was to prove a fatal friendship.

Parties in the Rue de Lille were no less exotic than those the previous year and week-ends at Le Moulin were extremely diverting. Young Polly, now a precocious twelve year old, still adored Harry and detested her mother. She longed to grow up, and already made up her face, impatient for the day when she would be totally accepted by him. She admired and envied Meraud for the dynamic effect she had on men, and suspected that flirtatious

Caresse was strongly attracted by Chile. As far as Polly knew, wife-swapping was the norm in their sophisticated entourage: she had become increasingly observant.

When the Guevaras were invited to Le Moulin with the Lawrences and Huxleys, whom Alvaro had met years before with Ottoline, he suggested to Meraud that they had both better read *Point Counter Point*. Obviously, he must have read it, knowing that one of the characters was a portrait of Nancy. When Aldous asked him what he had thought of it, 'Not much,' was his only reply. Nevertheless, Alvaro knew that Edith Sitwell, whose opinion he always respected, considered Huxley far more talented than Virginia Woolf who had just published *Orlando*. Edith had not only been shocked by Virginia's attachment to Vita Sackville-West but also by Vita's attempt at seducing Mary Campbell – her sympathies were all with Roy: but for a flaw in fate, Miss Sackville-West would have been 'nature's gentleman'.

D. H. Lawrence died of tuberculosis in Vence the following year aged forty-four. He had been a frequent caller at the Guevaras' *atelier* in 1929. Meraud admitted that she would leave these two old friends closeted together while they discussed and criticised the androgynous influence of the Bloomsburys and what they had originally considered to be its detrimental effect. They still agreed with Edith Sitwell's early condemnation – the Bloomsbury Group had *civilised* all their instincts and senses away. Young Picasso had told Gertrude Stein, who in turn had told Edith, that this type of intellectual made him scream with rage: 'But who does the work?' Picasso had shouted. 'Stupid, tasteless people like me!'

As usual, Alvaro was torn between conflicting loyalties. Eventually, Edith had condemned Lawrence's *Lady Chatterley's Lover* as 'a nasty, bad little book,' adding that she would 'never be interested in the goings-on to be witnessed on Monkey Hill,' although she had always admired *The Plumed Serpent*.

Also Alvaro was anxious for Meraud to meet his beloved Gertrude Stein and Alice B. Toklas. Their first meeting has been described by Francis Rose, whose painting greatly appealed to Gertrude, although unappreciated by Picasso and some other contemporaries. Meraud had known Sir Francis for some years but he had not yet met Gertrude and Alice and he was keen to meet Chile.

She asked him to tea. By happy coincidence, that afternoon, Gertrude and Alice were out shopping when Alvaro and Meraud ran into them. Alvaro introduced his wife, who at once invited them back to the *atelier* nearby. Gertrude and Alice had no idea whom they might meet.

When Francis Rose arrived, he had his chihuahua in his pocket. He and his pet were greeted by an appalling noise – a zoological riot. Alvaro opened the door to reveal a dogfight between a Dalmatian, a large white poodle and two smaller dogs. Meraud was shouting; others were screaming. Alvaro solved the problem of receiving an unknown guest with a squeaking pocket and controlled the fray by shoving him into a safe corner behind a quiet, stout, grey-haired woman who was devouring cake and seated at the scarlet table, apparently oblivious to the pandemonium.

The cake slowly disappeared and when the dogfight subsided she turned to him and said: 'You are Francis Rose.' He said: 'Yes.' She asked him if he wanted to see her collection of his pictures. He had no idea who she was, so was surprised but again said: 'Yes.' She replied: 'Well, later.'

When the tea-party was over she and Alice took him back to the Rue de Fleurus. The belligerent white poodle was theirs – the famous Basket. Gertrude called Francis her real discovery and two years later she sponsored his first show in Paris and later wrote a preface to the catalogue of his London exhibition.

In turn, Meraud was able to introduce Alvaro to the Picabias. The entire *ménage* became permanently admiring and devoted to him. But alas, this introduction too was ultimately to prove destructive. Germaine was growing increasingly disillusioned with Francis and he inclined more and more towards Olga, who was full of sound common sense but gave herself no airs. Although Olga became fond of Alvaro, she disapproved of his influence on Picabia: expensive motorcars and drinking in cafés must be discouraged.

When Michael Rosse, who was engaged to Oliver Messel's gifted and glamorous sister, arrived in Paris with Robert Abdy – recently married – it was obvious that both young men being fond of Meraud and her mother, the Guevaras would be invited to dine and the Picabias included in the party. Both Michael and Robert thoroughly disapproved of Chile; indeed Michael

Rosse admitted later that he had been quite frightened of meeting him, having heard of his reputation for taking sinister drugs and indulging in various unsavoury vices and violence. Alvaro was unaware of Bertie Abdy's prejudice, dating from the old days with Nancy, and that night did nothing to improve these Englishmen's opinion of him.

Meraud later confessed that as a married couple she and Alvaro 'were on the *fringe* of many bad things but not really deeply involved'. But she was young and craved excitement; she withered at the first touch of boredom like a character in a Noel Coward play.

Mama Guevara had written enticing accounts of life in Paris to Susana. Although she had not seen Alvaro since the early twenties, apart from Mama, Susana had remained more loving and interested in him than the rest of the family. When she and her American husband, Harry Watts, arrived in Europe, she was most curious to meet his wife and they arranged a rendezvous at Le Touquet.

Having read so much newspaper gossip about Meraud's dazzling jewellery and elegance, Susana was 'not a little shocked' when her sister-in-law 'turned up at the Casino wearing no stockings and, instead of diamonds, junky ten-cent-store rubbish'. Alvaro had recently painted her with bare feet but wearing a hat. This was an intelligent portrait which summed up her bizarre inconsistencies.

The following week, Susana and her husband were invited to lunch at the Guevara *atelier* in Paris. Susana was much impressed when Alvaro himself cooked the steak on a charcoal grill and served it on pewter plates with a sauce of Roquefort cheese. He claimed the sauce was his own invention but in fact he had learnt it from Nancy.

Susana bought two of Meraud's pictures and four of Alvaro's, including a self-portrait, painted in Arauco.

Alvaro was becoming increasingly possessive and dreaded accompanying Meraud to either grand or informal parties, cafés or *bals musettes*. He imagined that even the errand boys or porters at *Les Halles* eyed her with lust and him with envy. Wherever she went she was surrounded by admirers. He lost confidence and became agoraphobic. Meraud complained: 'He

never wanted to go out!' Like a maniac entomologist, he tried to pin his precious butterfly through the heart, as a prize specimen, trapped under glass.

The only friend of whom he was not insanely jealous was Gertrude Stein. Although fond of Gertrude and Alice, Meraud deeply resented being limited to their company. Furious scenes ensued. The only way Alvaro could relieve his feelings was by brawling in cafés, street fighting, boxing and excessive drinking.

In December, Kit Wood wrote to his mother that he had seen Meraud in a restaurant but he 'did not speak to her: she was looking very unhappy'. Although his moods were still ephemeral, and he was smoking opium again, on that particular day Kit was in good form having just heard from Emerald Cunard that her lover, Thomas Beecham, was to commission him to design the scenery for a new opera. He was probably unaware that Meraud had just heard of Harry Crosby's death in New York. Some reports said that he had shot himself after killing the twenty-two year old wife of a friend. Caresse had been quite unprepared for this tragedy, having seen him in apparently happy circumstances only a few hours before. This suicide pact seemed inexplicable. The drama was a mystery for Polly; from what Harry had confided, she was sure that the *affaire* had been casual.

Equally mysterious was Kit Wood's death a few weeks later. He fell under a train at Salisbury station. By coincidence, Neville Lewis, the South African painter who had once attended the Slade and was now married to Alvaro's friend Theodosia, was on the platform at the time and identified the body. Although Neville had seen Kit buy a book from the bookstall to read on the journey, many people wondered if Kit's death was an accident or a suicidal impulse. Naturally Meraud's and Alvaro's horror and distress were mutual.

That winter the feeling of gloom had been general. Wall Street had crashed. Not necessarily as a result of this, Benjamin Guinness had moved from Carlton House Terrace. Bridget rented a flat in Paris but still enjoyed the estate of Notre Dame de Vie at Mougins. According to *The Evening News* 'it was she who had really discovered and "made" Antibes ... people never thought of going there until *she* invited them ...'

To console her for the loss of their London home, Benjamin found a farm in Normandy, near Lisieux and not far from

Deauville. This house was to prove an important background for future dramas involving Alvaro.

Benjamin hoped that Meraud would soon have a child. If and when she did, the studio in Rue Simon-Dereure would prove unsuitable; there was no room for a nursery. With this in mind, he encouraged her to take a most attractive house in the Rue Notre Dame des Champs and Bridget provided Meraud with a second beautiful villa appropriately named l'Enchantement on the Mougins estate. Previous tenants had included friends of his wife; the Rudyard Kiplings and Elizabeth Russell (von Armin) author of *Elisabeth in Her German Garden*.

During their first summer in this paradise, Alvaro's sister Sibila came to stay with her five year old son Octavio. Sibila was separated from her husband 'who had been banished to Southern Chile because of his political convictions'. This was no hardship to Sibila, whose marriage had proved unhappy.

Having given birth to five children, she was suffering from a uterine prolapse and soon after her arrival entered a small nursing-home in Nice. Octavio, an attractive child who spoke only Spanish, was left with his Uncle Alvaro and his new Aunt whom he thought very pretty and nice. It would seem that Alvaro had controlled himself and was less jealous and possessive.

One day when Octavio was swimming, he was attacked by a stingray. His leg swelled alarmingly and his fever and suffering were so grave that Meraud took him to a hospital in Nice – the thought of being near his mother was a comfort. A large poisoned black dart was removed, tubes inserted to drain the wound; but there were no antibiotics and for weeks he was dangerously ill. Alvaro and Meraud's holiday was marred by anxiety. When they called to collect him for the day, Octavio hoped for a treat – perhaps they would picnic in a vineyard? The reason for this outing was in fact to keep the boy from his mother's funeral; Sibila had died of septicaemia. Octavio could not believe that his mother was dead and always hoped that he 'would find her again at the top of a steep flight of steps . . .' Looking after him cannot have been easy, as he was constantly disappointed and depressed but 'Uncle Alvaro was wonderfully kind and understanding'; he and Aunt Meraud assured him that he would return with them to their new house in Paris – he must not feel stranded in Europe so far away from Chile.

The house in Rue Notre Dame des Champs proved quite exciting. Later Octavio recalled that: 'Alvaro and Meraud were always painting – not pictures necessarily but the walls and staircase – everything was red. There was a piano which Meraud had bought from some café. It played honky-tonk tunes when francs were inserted. Alvaro taught him 'how to fiddle it, so that the coins clattered out in a noisy stream . . .' He took Octavio to the theatre saying: 'Such *treats* made me forget my troubles and feel so transported that I was even convinced that I could fly!' Alvaro told him that he had never forgotten his first visit to the circus.

Octavio loved both Alvaro and Meraud after living with them for a year in Paris. When his rich aunt Dorila Braun came to fetch him, he left rather regretfully for Chile.

These tragic events and responsibilities added to the material changes in Meraud's and Alvaro's lives and provided many distractions.

During October, Augustus John arrived in Paris for two weeks and drew James Joyce. No doubt there were many bibulous reunions between him and Chile in various cafés, and Alvaro introduced him to Meraud.

The house in Rue Notre Dame des Champs was described by Charles Albert Cingria, one of Meraud's friends who was, according to Virgil Thompson's memoirs, 'a Swiss writer unbelievably impoverished, not always clean, not always sober, his mind ingenious, his talk both learned and funny – who lived in an unheated garret with a fifteenth century spinet, a bicycle, and five hundred books and wrote in the most beautiful French prose small brochures about large historical questions, such as the principles of rhythm in Gregorian chant'.

In his preface to Alvaro's last literary work, *Dictionnaire Intuitif*, Cingria revealed that Alvaro spent all his leisure 'participating in Meraud's gay, enchanting fantasies' and continued: 'It was one of the special pleasures of Paris to watch them together at 74 Rue Notre Dame des Champs. The house was like a miniature château in Gothic style. There was a small garden and a pebbled courtyard where some tables stood. There was no hall, the front door opened straight on to the ground floor room, the walls of which were decorated with shiny red leather. Upstairs the walls were covered with interesting canvases. (Chile was

206

painting a great deal at this time.) The side-tables were loaded with every sort of food and drink. Visitors swarmed up and down the stairs and through the house, and even overflowed on to the pavement, explaining, disputing and sometimes even reaching agreement. People there included Ortiz de Zarate, young Kristians Tonny, some British and Swedes . . . Everyone in London and Paris – forming an interesting and distinguished group. Without a personal invitation I only went there with others. I was astounded by the consideration shown to me at once, for we met again after that often enough and also in my *quartier* too.'

Elsa Maxwell described a sensational party which she gave in the Guevaras' studio: 'Excessive drinking turned only one of my parties into a rowdy affair. That was the Come As You Are party I gave in Paris . . . The big idea was that the sixty guests were pledged to appear dressed exactly as they were when the invitations were received. To make sure of a wide variety of get-ups, I had the invitations delivered by messengers at odd hours of the day and night . . . I chartered two buses and personally picked them up at their homes. Parisians are accustomed to strange sights but, after all, there are limits . . . The Marquis de Polignac was attired in full evening-dress save for one conspicuous omission . . . Daisy Fellowes carried her lace panties in one hand . . . Bébé Bérard wore a dressing-gown, a telephone attached to his ear and had white make-up on his face to simulate shaving cream. Several men came in hair-nets . . . I installed a bar in each bus and I neglected to account for Paris's monumental traffic jams in my timetable. The buses began to pick people up at seven o'clock . . .'

Some hours and innumerable drinks later, Miss Maxwell finally gave up trying to bring the situation under control when her plea for a little restraint was met by a volley of hard *brioches* shied at her by the guests. The neighbours cheered her hasty retreat. Forty-five years later Meraud had no recollection at all of this occasion.

On 5 January, 1931, Meraud's mother Bridget died and was buried in the Guinness family vault of the little chapel on the estate of Notre Dame de Vie. She left her marvellous jewels between her children. When Polly Peabody asked Meraud if she

were not nervous of wearing such vast pearls, diamond bracelets and rings, Meraud replied: 'It doesn't matter. No one thinks they are real, you see!' Bridget Guinness left her sable coat to Tanis, her mink coat to Meraud and her squirrel coat to her old friend Mrs Patrick Campbell, who was then in her sixties. Mrs Pat wrote later that her coat lasted much longer than either the sable or the mink.

To Alvaro's joy, during the spring of 1931 Meraud at last became pregnant. He had an affinity with children and was sure that once she had a child, she would become less 'flighty'. When she was assailed by labour pains on December 27, it was Gertrude Stein who accompanied her in a taxi to the American Hospital and remained with her, at times holding her hand, until the baby was born the next morning. This certainly proved the quality of Gertrude's affection – for, according to Bravig Imbs, a young journalist, Gertrude, when at medical school, 'had walked out of obstetrics and had an intense distaste for the procedure of childbirth'.

Within five months the baby was baptized as a Roman Catholic in the little chapel on the estate of Notre Dame de Vie and named Bridget after her grandmother. Once again Mrs Pat Campbell acted as one of the godmothers. The Picabias attended and as a christening present Francis produced a drawing of the baby being supported by graceful, nebulous hands – a concept which was to prove prophetic.

To Alvaro's and both families' regret Meraud did not possess a maternal nature and made every excuse to leave Paris and enjoy life with that merry widow Caresse. Later, according to Meraud's daughter, they were generally referred to as 'those *naughty* ladies!' While they were away on a spree, Polly Peabody was neglected and dumped at Rue Notre Dame des Champs. She described this visit in retrospect: 'Chile was very tender with the baby, who was screaming most of the time and lugged about from room to room in a basket by an old Spanish maid. A painter [Kristians Tonny] who signed his work "Tony" came to stay. He and Chile went out nearly every night.' As usual, poor Polly felt bored and lonely: more and more she loathed Caresse.

Alvaro was painting all day on a huge canvas, an extraordinary picture of a lay figure standing in the window. He called it *The Dressing-Gown* – the figure was in fact wearing a marvellous

silk housecoat of Meraud's from Lanvin. A face was reflected in a mirror looking down through the arched window into the street and over the wrought iron railings to the trees beyond.

Polly, now fifteen, had plenty of time to form her opinion of Alvaro. She was 'sure that he was a *woman's* man, seething with suppressed fury, suffering deeply for the indignity of his position as a rejected husband'. Such was his Spanish pride that he was only able to express his rage and relieve his feelings in the boxing ring. He found it difficult to channel the energy engendered by physical jealousy. Having gained so much love and prestige in the past, he had become accustomed to being surrounded by distinguished friends who adored and admired him. Now he found himself in a situation which he simply could not accept or understand.

Nancy had just published a book of Brian Howard's poems. This was particularly maddening for Alvaro, who had always hated him. Had Alvaro been able to read Brian's diary, he would have been horrified to learn how ill, nervous and thin, as well as crazed with drink, Nancy had become. When he actually read the ill-conceived, vitriolic attack on Maud, which she printed soon after in *Black Man and White Ladyship*, Nancy lost much of his respect.

Whereas Nancy was cruel and mad at times, Meraud was always sane and never deliberately unkind. She was naturally tired after the birth of their baby: of course she had needed a rest and a change. They must make a fresh start: he resolved to be more understanding.

When Meraud returned, she and Alvaro left Paris again for l'Enchantement, but their reconciliation was blighted by Caresse. She arrived in her spectacular motor-car, driven as usual by a handsome chauffeur. She was accompanied by a personal maid, Polly, and a governess. Alvaro found the mere sight of Caresse infuriating. Brandishing a knife and shouting, he chased her down the drive, accusing her of being the most disloyal of friends and a demoralising influence on his wife. This melodrama was watched by impassive servants and the speechless Polly. It would appear that, when under stress, Alvaro often flew to the carving knife.

Meraud finally restrained him, and on his recovering composure Caresse scoffed: 'Really, as a husband Chile is a hopeless

209

bore – only fit to be locked in the broom cupboard.' He cramped Meraud's style, got in the way and stopped their fun: she *must* get rid of him.

Lately Polly had been impressed to hear that one of Meraud's innumerable admirers had attempted suicide by throwing himself off some skyscraper in New York, but now she felt embarrassed and sympathised with Chile. She identified with him: they were both unwanted.

It is difficult to apportion the blame when incompatibility mars a marriage, but obviously the time was ripe for a crisis. This came about soon after in Paris at the Picabias' flat – not only Germaine but Olga and Cingria were witness to the meeting there between Meraud and Maurice, also an artist whose work was admired by Francis.

He came from the Camargue, and later Cingria described him as having a 'rich resonant voice in which he would give passionate accounts of his extraordinarily varied life: he had played diverse roles as a layabout, singer and bullfighter, etc. – he had built breakwaters, cultivated onions and sugarcane'. In fact he could turn his hand to anything. 'He would sing *Salve Regina* in dulcet tones ... he wore startling blue shirts in sharp contrast to his snow-white ties.' He was bigger than Alvaro in every way; taller, more handsome, tougher – perhaps even more original.

Alvaro not only liked but admired him and willingly concurred that this exciting new friend and his fiancée, who lived in Aix-en-Provence, should be invited to join them at l'Enchantement: the Picabias would be near – they would all have a wonderful time!

The consequences of this proposal were to prove far from enchanting for Alvaro and Maurice's fiancée. It soon became painfully clear that Maurice and Meraud had fallen in love – deeply and passionately and that this was not a typical Côte d'Azur romance. The Picabia household realised that the atmosphere at l'Enchantement was dangerously electric: shrugging complacently, Olga remarked: '*Plus ça change: plus c'est la même chose!*' Meraud had this effect on men wherever she went. Olga thanked God that this time Francis was not involved.

Alvaro and Maurice fought in front of their women on the

tennis-court. Possibly Maurice, who hailed from a wild part of France, had never heard of Lord Queensberry.

Alvaro fought with all his might: he was battling for his life, his love; but Maurice was the stronger and tougher: he drove Alvaro back towards the wire mesh, floored him, and knocked him out eventually.

Later Alvaro protested that he had caught his foot and tripped in the lead tape that formed the lines on the red grit and was not properly hammered down.

Soon after this fiasco it was obvious that Maurice and Meraud must leave together for Paris. Meraud insisted that there should be 'nothing horrid about it'. Poor Chile and Maurice's fiancée looked so miserable, surely *she* could come with them? There was no need for tears. They could all remain friends. This wishful thinking was evocative of Nancy. Meraud could not bear to hurt a fly, indeed she too would always remain protective towards insects.

Her bland solution did not appeal to the swatted victims. Wisely, Maurice's fiancée kept her dignity and returned to her family in Aix. She swore eternal love, that she would remain faithful and wait for her beloved.

Yet again Alvaro had experienced an insufferable defeat: a humiliation he would never forget. Perhaps he sensed that this time the result was final: there could be no return match.

Left alone at l'Enchantement, in true Latin style, he went into mourning. He draped the whole house with crêpe and nailed a laurel wreath to the door, festooned with black satin ribbons. He bolted and barred the shutters, locked himself in and lay in the dark on an improvised catafalque, surrounded by white chrysanthemums, lilies and lilac. These were the trappings and flowers of death. He thought not only of himself but of German Grandmama in her coffin. He could not paint. Because of the insult to his masculinity he felt too ashamed to face the daylight. He brooded, drinking or drugging himself into merciful oblivion. Once more he was the bridegroom betrayed. The agonising pattern was repeated: his heartfelt cry echoed from Eliza's wedding: 'He took her away! Why did he take her away? How could she abandon me?'

He became obsessed by disaster – death, destruction, defeat. The news of Carrington's suicide arrived: she had shot herself after Lytton Strachey's death. Over the past two years, there had

been an appalling chain of deaths: Sibila, Harry Crosby, Kit Wood, D. H. Lawrence, Bridget Guinness, Lytton, they were all dead. When would the chain break: where would it end?

It was obvious to the tradesmen or casual visitor who drove up to the villa that it was *en deuil*: callers crept away mystified and embarrassed. Curiously, it was Caresse who rescued him by storming the fortress. Meraud, affectionately concerned, had despatched her like a dove from the ark from Paris. Both women could do without another suicide or scandal: perhaps Caresse wished to atone for her destructive influence.

Assisted by her chauffeur, she banged on the door, rattled the shutters and tore down the wreath, the crêpe and black satin ribbons. At last she was admitted. 'Pull yourself together!' she shouted, 'Just because Meraud has left it's not the end of the world! Marriages fail every day: you two are simply not suited! Why dramatise such a banal situation in this absurd, theatrical way?' She turned from attack to persuasion: he had unusual talent, loads of friends – more in London than Paris perhaps – he must begin *again*, as she had since Harry's death. Meraud would always prove a reliable ally. Yes, she was still fond of him but she was not maternal and should not be blamed for this.

He, Maurice and Meraud could play a game of box and cox between Paris and Mougins – *chassés croisés,* a dance with partners changing places gracefully on the stage. Soon they would all find a civilised *modus vivendi*: they were not savages living in Chilean jungles.

Alvaro would have preferred the customs of the Araucanian Indians. Caresse had forgotten to mention the baby. It was her existence which gave him the will to live and fight to the end. He agreed to return to the empty house in Paris.

15

A conflagration of scandal blazed in New York, London and Paris. The hypotheses were infinite: Meraud had run away with a gangster, a *maquereau* . . . she had joined a circus – or was it a caravan of gypsies? No exaggeration was wild enough to satisfy the gossips in café society.

Although poor Mand Cunard had suffered far worse embarrassment from Nancy's affaire with Henry, Benjamin Guinness was horrified by the stories which reached him. He insisted that by falling in love Meraud had behaved abominably. His sympathies were all with his son-in-law. A nurse was engaged to look after little Bridget and installed with her in a cottage on the Normandy estate. Alvaro's love for the child was pathetically evident and he was therefore welcomed at Lisieux for week-ends. In many ways he found these visits a solace. The mere sight of his daughter was a joy and painting out of doors was therapeutic.

At first Benjamin found him an appreciative guest and made allowances for his moodiness. After all, he had been disgracefully treated and being a Latin and a reputable painter, an artistic temperament did not come amiss. But gradually he realised that Alvaro's presence at house-parties was a questionable asset. Rather than help entertain the guests, he would either disappear for hours to the cottage where, according to the nurse, he told the child extraordinary stories, or hide in the woods daubing away. He seemed to have no sense of time. When he felt inclined he could be undeniably charming and at meals he might monopolise the conversation with his nonsensical theories or some incomprehensible rubbish. At other times he could be

silent or laconic and appeared to feel under no obligation to amuse the glamorous ladies on either side of him. Benjamin expected his entourage to toe the line up to a point, or at least earn their keep by proving good company. After several such visits his condemnation of his daughter was less whole-hearted. He was bound to admit that she too was artistic – as well as lively and pretty – and that her husband could be a dull dog at times. He was an oddity.

Down in Provence, Meraud was in her element. At last she had met her match. There was no question of divorce; Maurice was 'not interested in silly bits of paper like marriage certificates'. Only for as long as they loved one another was their relationship valid. Freed from conventional restrictions Meraud was able to enjoy a thrilling romantic life with Maurice, his relations and friends.

Alvaro could never truly detest his rival and he bore Meraud no malice; somehow through letters and occasional meetings they reached a rare understanding, just as Caresse had predicted.

Away from his child, Alvaro became increasingly despondent. To be a rejected husband left moping in Paris was abhorrent to a Latin and his humiliation was best understood by South Americans. Anita Berry, an Argentinian, now proved a valuable friend. Later Harold Acton wrote: 'She was solicitous about his health at the time and tended to "mother" him . . . She was dumpy and plain, older than him, but had a golden heart. She was not rich but an indefatigable patroness of the arts, organising exhibitions for modern painters in Oxford and other cities . . . Chile's friendship with her must have been platonic.' On a convalescent trip to Italy she chaperoned him and another South American lady, dark and handsome, with whom he was presumably having an affair, who was very intense and danced the tango with him. (Alas, this consoling enchantress must remain nameless.) However, when the threesome arrived in Florence, Anita Berry introduced the lovers to Harold Acton, who remembered Chile 'as a strikingly burly figure, pale and dark, rather shy and hesitant except when flown with wine . . .' Harold Acton 'knew his portraits of Edith Sitwell and Nancy Cunard (both of whom adored him in different ways) also of Ronald Firbank and Dorothy Brett, and admired his shimmering paintings . . . Chile had obviously been very ill and looked depressed

– a sick poet, dreamy and melancholic. With me he was extremely modest about his work. In the early thirties, I fancied myself as a poet and Chile showed me his recent poems, which impressed me considerably – complex and Surrealist, for so apparently simple a man. As he must have thought in Spanish, the effect was pleasantly Pre-Raphaelite in the true sense. One felt they had been written by a Latin . . . Ezra Pound much admired him – I doubt if he actually proposed marriage to Edith – Nancy was always rather promiscuous but she remained very fond of him . . . As for Nina Hamnett, whom I personally thought repulsive, she was very determined. I seem to remember she had a boxer lover, and that Chile had a penchant for boxers and boxing – perhaps only as a subject for his paintings.'

This trip to Italy did not prove a complete cure for Alvaro's malaise. In the autumn of 1935, his old friend from the Slade, Theodosia Townshend, was passing through Paris and spotted him drowning his sorrows at the Dôme. Her marriage to Neville Lewis had also come to grief so she was able to commiserate. Although she and Alvaro had once felt so physically attracted, this reunion was ill-timed emotionally for both and there was no future in their relationship. Most of Theodosia's news was sad and provided Alvaro with an excuse for yet another drink . . .

Iris Tree's marriage to Curtis Moffat had not been a success: a divorce was imminent. Poor Carrington . . . dear Roger Fry were dead. Gertler was ill with tuberculosis. Both he and Sickert had recently exhibited at the Leicester Galleries. In turn Theodosia found Alvaro's confidences depressing. A young friend of his called René Crevel had recently committed suicide by slashing his wrists. Everyone had adored him. It was rumoured that he was engaged to Choura Tchelitchew at the time. Alvaro's saga seemed one of endless tragedies. Despite his loyalty to his wife, she wholeheartedly condemned Meraud for having deserted him. This lugubrious occasion was the last time that Alvaro and Theodosia met.

He continued to see various old friends when they were passing through Paris, such as Mand Cunard who had now changed her name to Emerald. It is a sad omission that no details of his many meetings with Artur Rubinstein, Igor Stravinsky and George Gershwin have been forthcoming. Meraud does not remember anything particularly interesting about their visit to stay with

Ford Madox Ford at Toulon or their meetings in Paris. Alvaro much admired his short stories and particularly liked one that was published in *Blast*.

The Nevinsons were most distressed to hear that Meraud and Alvaro had parted. When they called at Rue Notre Dame des Champs, Alvaro would smile in welcome and embrace them, then leave them alone at one end of the studio while he sat in the window looking down into the street. Because they loved him, far from resenting his silence and this apparent discourtesy, they understood his sadness and appreciated his rarity. They 'much preferred to be with him silent to being with some casual acquaintance who might be chattering inanities'. Kathleen did not think that he was watching the street scene from the balcony as if he were at the theatre, as he had done as a small boy in Valparaiso, nor was she sure, although he had a strange and faraway look in his eyes, that he was drugged during their visits. Perhaps transcendental meditation was practised by Alvaro and some of his friends.

When Geoffrey Nelson arrived in Paris, he was accompanied by William Scott, a much younger painter friend. These two had originally been drawn to each other through their shared admiration for Dylan Thomas. Augustus John had introduced them to him. William Scott said later: 'Geoffrey was still extremely handsome although rather red in the face. He seemed to have modelled himself in manner and voice on Ellen Terry's son, the theatrical designer Gordon Craig.'

Both Geoffrey and William were completely heterosexual. Geoffrey was in love at this time with the rich widow of a successful Spanish painter. Geoffrey told William that he had known Alvaro from Bradford days even before they were students at the Slade. He had no idea of Alvaro's bisexuality. He supposed that he was still rich in his own right. He also presumed that he was generously compensated by the Guinness family for Meraud's desertion.

A rendezvous at the Dôme was arranged. Young William was agog to meet this exciting friend of Geoffrey's, but the occasion was not a success.

Geoffrey was a francophile. He loved to talk French, especially after a few drinks. Young William, whose knowledge of the language was limited, felt bored and left out, especially when

216

they were joined by an Arab friend of Alvaro's whom he gathered was an art critic. William was bound to admit that 'this extremely ugly man was a dynamic personality'. While the others jabbered away William was able to observe them with a critical eye.

'Both Geoffrey and Alvaro were attractive but Alvaro was taller and a more muscular type. Geoffrey dressed like an artist, or at least in an avant-garde way in corduroy suits, bright coloured shirts and blue ties to match his eyes. Alvaro might have been a prosperous business man in his well-cut dark suit and white shirt.' As the evening wore on William sensed that Alvaro rather resented his presence. When conversation turned to painting, Alvaro said that he found self-imposed discipline essential. Everyday he painted several still-lifes.

News from London was encouraging. Freddie Mayor was exhibiting the collection of his godfather, Walter Taylor, including two of Alvaro's paintings: *East End Restaurant* and *The Quartet*. It was also gratifying that Freddie had sold one of his best works, a portrait of Walter Taylor, to the Contemporary Arts Society.

It was obvious to English friends that Alvaro preferred to look back rather than forward. Talking to those who had known him in his heyday salved his wounded pride.

By 1936 Susana had had five children. She longed to see Alvaro again and decided to take her two eldest daughters, Banda and Henrietta, on the traditional cultural tour of Europe which would serve as a valid excuse for a holiday.

To her dismay, the night before leaving Chicago, her doctor told her that she was pregnant yet again. Undaunted, she neither confided in the girls nor postponed the trip.

By the time she reached the Gare du Nord in Paris she had a high fever and an alarmingly identifiable pain. Alvaro had assured her by letter that he would meet the train, but now he was nowhere to be seen. Jostled by hundreds of shouting, gesticulating travellers and sweating porters shoving past with barrows of luggage, poor Susana feared she might faint. The girls were far too young to appreciate her predicament, added to which she had little money left after the long, expensive journey.

The platform emptied save for a few other stranded tourists. Bravely Susana struggled into a taxi. She was unfamiliar with

Montparnasse – if only dear Mama were still at the Majéstique! Alvaro had always seemed so absent-minded: perhaps he had forgotten, had shut up the house and gone away?

Eventually the taxi drew up at 74 Rue Notre Dame des Champs and a pair of large wooden doors were thrown open in welcome by a smiling manservant who introduced himself as Juan and his wife, the cook, as Angelina. They bowed respectfully and explained that Don Guevara had engaged them some time ago; they were Spanish refugees.

'But where is Uncle Alvaro?' the sisters cried. Juan explained that his master had left early in search of a stove for Dona Susana's bedroom.

Susana smiled. How typical of Alvaro to neglect meeting the train in order to buy a stove on a hot summer's day! While the servants carried up the baggage, Susana stopped to admire the pretty walled garden and Alvaro suddenly walked in. They greeted each other with 'tears of joy'.

When this emotional scene had subsided, Alvaro pointed to some stones lying in a flowerbed and told the girls that they had his permission to take them back to Illinois and sell them as souvenirs of James McNeil Whistler. He had lived there!

Since Cingria had visited the house, the use and arrangement of most of the rooms had changed. The servants now occupied the ground floor which included the pantry and kitchen. Susana thought that her bedroom must have been the drawing-room in Meraud's day. The walls were painted Delft blue. There was a white marble chimney-piece: the general effect was fresh and innocent and even the curtains and rugs were white. A luxurious bathroom separated it from a dressing-room where the girls were to sleep. Now they all congregated next door in the library while the servants unpacked. Banda and Henrietta were quite unaccustomed to such gracious living and service. The hired hands in Illinois would not dream of running their baths or putting out warm towels for them.

Alvaro remarked that Banda looked like the painting *Beata Beatrix* by Rossetti of Elizabeth Siddal, his wife, which hung in the Tate, and added how much he admired Rossetti. He then led them up the winding staircase to the top floor. The girls had already assumed that their aunt Meraud was away. When he

opened the studio door he announced dramatically: 'This is where the great Whistler used to paint!'

Susana noted in her diary that 'there was a large skylight. Propped against the walls were many pictures finished and unfinished – still-lifes, landscapes, abstracts and all kinds of experiments. There was a huge canvas on the easel. Alvaro said that he had just started this life-sized portrait of two women. One of the sitters with cropped hair looked very stout and masculine. Alvaro explained that this was the writer Gertrude Stein. The small thin woman with an aquiline nose who sat at her feet was Alice B. Toklas, her friend.'

He had sketched in the figures with a thin wash of ultramarine. 'He always began portraits like this and hoped to finish the picture when Gertrude and Alice returned from the country to Paris.'

On the dais was the armchair in which Gertrude had obviously sat. For years, poor Susana had not had a moment to paint, so bogged down had she been with domesticity. Alvaro gave her some watercolours and suggested that she should do some sketching during her visit. 'Paint what you *want*, what you *feel* – an artist paints everything and anything,' he said.

It would seem from Susana's account that she refrained from confiding how ill she felt – perhaps she had recovered after a good night's rest and in any case was reluctant to spoil an idyllic holiday.

Certainly Alvaro arranged a most strenuous programme of sightseeing and even took her and his nieces to Salvador Dali's private view at a small gallery. 'At the entrance stood the model of a female nude. The mannequin's torso was covered with dozens of tin teaspoons, two imitation raw eggs were glued to its chest, dripping yolks and whites. On her head was a fringed lampshade. A bunch of wheat was held modestly in her hand in place of a conventional figleaf.'

After several exhausting days traipsing round Sainte-Chapelle, Notre Dame, Sacré Coeur and the Louvre, Alvaro announced that they were all invited by Benjamin Guinness to Lisieux for the week-end.

Susana was amazed when he bought them all third class tickets for the train. They scrambled up 'on to the hard wooden seats and squeezed between noisy, sweating women and children, laden

with bundles and baskets. The heat and smell were overpowering.' She began to feel ill again.

One of the Guinness' Rolls-Royces was at the station to meet them. The chauffeur expressed respectful surprise: why was Don Guevara not accompanied by the Baronessa? Susana had the impression that this lady usually accompanied him for week-ends but felt too nervous and fatigued to ask questions.

'On arrival, it proved a bewitching property. The exterior of the converted farmhouse was black and white – plaster and beams.' There was a lovely old dovecote and the roofs of the stables were thatched. Fishponds and a lake stocked with trout lay behind. The park was vast and varied by bosky copses.

Inside the house, the walls were lined with linenfold panelling. Benjamin Guinness was apparently ill and did not appear for luncheon: he sent for Alvaro, who disappeared upstairs to see him. Benje had recently married for the second time. 'His new wife presided over the houseparty which included her stepson Loel and his beautiful new wife Lady Isabel, who had black hair and blue eyes. She was Lady Diana Cooper's niece. The other guests were Merle Oberon and a young American who talked about his six Rolls-Royces.'

Alvaro was late for luncheon and made himself charming to Merle: 'I believe you are a film star?' he said. Susana could not believe he had ever set foot in a cinema: the theatre and music-halls were more to his taste. She found the new Mrs Guinness rather strange and alarming as she complained about the indoor servants and the stableboys. Susana remembers her describing a sinister 'little bomb that Benje was making. It could produce a thick fog over any town which the enemy's air force planned to destroy and obscure their targets.'

It was clear that Alvaro worshipped his little girl, who was only five, and insisted that her name was not Bridget but Nini. She spoke only French, whereas Banda and Henrietta spoke English and Spanish.

Susana had never seen Alvaro so genuinely happy as when Nini and her governess accompanied them to the station in the Rolls after this confusing week-end.

They passed fields of corn, and Nini, sitting on Alvaro's knee, cried: 'O Papa, quelles jolies fleurs!' He asked the chauffeur to stop so that she might pick some of them. Susana would 'always

remember her sitting on Alvaro's lap looking like a Renoir child model and clutching in her little hand a bouquet of wheatears, blue cornflowers and scarlet poppies'.

That night Susana went to bed early, utterly exhausted by her so-called 'holiday'. She could not sleep for the tramp of footsteps past her room and up the staircase. Above, in the studio, noisy Spanish voices rose and fell excitedly. The words 'Franco' and 'Espagne' were shouted angrily now and then. At last she drifted into sleep, only to be woken at dawn by Alvaro's friends taking their leave.

After breakfast when they were all in the walled garden waiting for a taxi to take them to the train, Alvaro said: 'Pablo Picasso was here last night. He is very upset about Franco's domination of Spain. I do wish you had not been feeling unwell as I should have liked you to meet him – my friend Picasso I mean.' He turned to the girls and asked with a grin: 'Are you sure you don't want to take some Whistler souvenirs back to the States?'

During the spring of 1938, William Scott and his young wife Mary, a sculptor, took a studio at Pont-Aven in Brittany, the village which had inspired Gauguin, Pissarro and Renoir: artists had flocked there ever since.

Geoffrey Nelson arrived from St Tropez where he had been painting in a desultory way since the breakdown of his short-lived marriage. Knowing him to be a gourmand, William took him to a small hotel, renowned for its excellent cooking. Within three hours of his arrival, Geoffrey proved that his sex-appeal had in no way diminished. After producing a delicious meal, *Madame la patronne* joined her guests and before midnight welcomed Geoffrey to her bed. This happy conquest not only satisfied his physical appetite but solved his financial problems: the best things in life were free.

When he showed the Scotts the catalogue of his recent London exhibition, they were impressed to see so many items marked 'sold' to such discerning patrons as the Contemporary Art Society, Sickert, Augustus John, Lord Howard de Walden and other collectors of prestige.

Over glass after glass of *premier cru* and succulent dishes provided by the hospitably indulgent proprietress, William, Mary and Geoffrey decided that they should start a summer

painting school at Pont-Aven: the hotel and all of them would benefit. They concocted a prospectus, confident that both Sickert and John would underwrite it and all art schools would display it. 'Little Albert' Rutherston, who was now Ruskin Master of Drawing at Oxford University would also support it. Geoffrey's mother could interview students in London, report on them and collect fees *in advance* to cover all basic expenses, including board and lodging – Madame thoroughly agreed with this. Geoffrey knew the idea would appeal to Chile, who was still assumed to be rich. Madame hoped he would join them.

Alvaro found the proposal attractive and looked forward to a reunion with Geoffrey, whose life sounded so satisfactory. Presumably William's French had improved since they last met. He planned to join them the following summer for several weeks. However, when the time came, the political news was ominous. Alvaro was part fearful, part incredulous that war with Germany threatened again. Meraud was still in Provençe but she kept in touch. Both agreed with Benjamin Guinness that if the situation worsened, little Nini should leave Europe for the United States with Lady Eden, who was already planning to evacuate the children, or grandchildren, of many of Benjamin's friends. For this reason, Alvaro felt more drawn to Normandy than Brittany. When the situation became increasingly serious, Nini and her nurse left for London, where citizens were queuing for gasmasks and there were already sandbags in the streets.

Despite the crisis, Alvaro felt disinclined to leave France for either England or Chile. He had experienced one war in London already, and had been deeply confused by the reactions of his friends. News from there was depressing. Gertler had just committed suicide; his exhibition at the Leicester Galleries had not been a success.

Various Chileans expected Alvaro to return to London rather than Santiago since his brother-in-law, little Octavio's father, had just been appointed Ambassador there, with Tony Gandarillas as Third Secretary. Senoret had not remarried since Sibila's death.

Alvaro's anxious preoccupation at this time was to maintain friendly relations with the Guinness family, who would always have some contact with Meraud and Nini. When France was

invaded he was staying at Lisieux again. Within a few hours, conflicting rumours, all of them ugly, reached the household. The enemy was advancing at terrifying speed, meeting with the feeblest resistance. Many of the French seemed to prefer the thought of German occupation to the threat of their own communists. Benjamin had already left for Switzerland to attend to high finance. Presumably Loel as a member of the Auxiliary Air Force, soon to be recognised as 'one of the few', was already in England. The rest of the house-party, their chauffeurs, valets and personal maids, piled into Rolls-Royces, with Paris their goal, confident that the capital could never fall despite the pessimists.

Progress along the roads, choked with pedestrian refugees, was maddeningly slow. When the mechanised Guinness cavalcade drew up outside the grandest hotel in the largest town between Lisieux and Paris, demanding accommodation, there was none to be had; the reception rooms were crammed with exhausted, querulous rich, surrounded by their Vuiton luggage, grateful even for the dining-room chairs on which they drooped in fatigue.

Alvaro at once assessed the situation and with a small suitcase, strode out into the town. Obviously the local brothel would be crammed. Finding a group of children playing *le hopscotch,* he offered ice-cream all round if they could lead him to one of their homes where he might find a comfortable bed. He had a way with children: they introduced him to a *petit-bourgeois* house in an unfashionable *quartier.*

Having slept soundly in a feather bed with hand-laundered sheets, breakfasted well, washed and shaved, he returned immaculate and refreshed to the hotel to join the disgruntled, dishevelled party. This included a Miss Sylvester, secretary to Benjamin Guinness. She was an elderly maiden lady, who dressed primly in long black skirts and starched high-collared blouses. When the Nazis marched into the hotel, demanding to examine everyone's papers, *permits de résidence,* etc., hers were not in order. She was arrested as an unmistakable enemy alien and despite protesting squawks, bustled off to the local prison. Alvaro hastened to rescue her. He was untouchable: Chile was neutral again. He spoke German well and succeeded in securing her release, but not before he had witnessed horrifying incidents. A

French boy was shot dead in front of him, as an example to his compatriots, so many of whom were collaborating, simply because he had cried: *'Sales Boches!'* when the conquerors arrived.

La drôle de guerre began in Paris. Neutrals queued outside their respective embassies and consulates demanding exit permits. Alvaro found the mere thought of another war in Europe as terrifying as an impending earthquake in Chile. He escaped from the horror of reality and his own practical problems by locking himself in his studio for hours on end, painting ferociously. He emerged only occasionally to sit drinking in cafés. An old friend and compatriot, Lucho Vargas, who had lived in Paris for years, found him at the Dôme one night and expressed surprise that he had not already left for Chile. Alvaro shook his head. He preferred France, even on her knees. War could be no worse than an earthquake. There was nothing much *les Boches* could do to him.

Spain was neutral, but Picabia found war so repugnant that Olga was removing him to Switzerland – he had left Germaine. Picasso, whose new girl friend was French, had decided to stay. This must have required some courage as he was an avowed communist and Hitler had denounced his paintings as degenerate. Although it was decreed that all Jewish property was to be confiscated, Gertrude and Alice refused to leave France – they moved to the country. Many more Americans would remain in Paris: Polly Peabody, Janet Flanner, Sam Putnam and various other artists and journalists.

Mouradian, most patriotically British, had been sent to an internment camp, but Geoffrey Nelson was not only tolerated, but accepted by the German officers who had replaced the painters at Pont-Aven. Presumably his friendship with Madame had protected him. Were he to leave, her cooking might deteriorate. Geoffrey wrote vaguely about joining the French navy, but perhaps due to gastronomic excesses he had not felt too fit lately.

Alvaro's Chilean friend suggested that, in truth, Alvaro's reluctance to return to Chile was due to the fact that Meraud was still in France, somewhere near Aix; or perhaps he had fallen in love with a Parisienne? He warned him that transfers of money from neutral countries would possibly be blocked indefinitely. If so, how could he hope to survive?

224

Alvaro ordered more drinks and drawled that money – fools' gold – had never bothered him. He was simply in love with Paris but planned to be unfaithful to her with Angoulême for a few days, painting landscapes.

So it was that when the Germans took Paris in June 1940 Alvaro was away. Much later he described in a letter to Susana how he had 'returned to find Hitler's motorized divisions had devoured Paris like a monstrous wave. Each and every soldier knew the precise place to stop. There was not a single error, it was so perfectly planned and calculated. My eyes were opened in amazement for I realised the great danger that the world now faced. Some of my best friends, Jews, disappeared. The Gestapo killed without rest.' Alvaro found he was penniless. However, as a neutral he was an asset to Benjamin Guinness, who still rented a vast *maison particulière* in Paris, full of valuable things. He suggested that Alvaro should move in and share these sumptuous premises with Miss Sylvester, his retired secretary, who, according to Meraud was not interned due to her advanced age.

As caretakers they would receive some remuneration. Were the Germans to requisition the property, Alvaro might prove capable of safeguarding the contents.

It is difficult to imagine two less compatible characters than Alvaro and this strictly conventional old maid whose life he had saved. Perhaps she felt at a disadvantage by being indebted to him? Anyway, she thoroughly disapproved of his way of living and his friends. As domestic privations increased and supplies of food and fuel diminished, so their relationship sank to the barest exchange of banalities.

During the harsh winters, rather than sit in one room burning rubbish in the ornamental grate, listening to a priggish spinster grumbling as she darned her last woollen stocking, he disappeared to the Louvre for most of the day to draw and sketch. Since the Germans allowed the minimum heating there to preserve the masterpieces, there was no room to sit: the galleries were crammed with wailing, unwashed children and miserably deprived people. The crowd generated some extra warmth as well as an acrid smell.

In fine weather Alvaro made careful drawings of the streets and buildings in the city he loved, fearful that it would soon be

destroyed. Some week-ends he would squeeze into one of the rare crowded trains to visit friends in the country such as Gertrude and Alice. To Miss Sylvester's disgust instead of returning with butter and ham, or even a rabbit, he might bring back a jar of Alice's jam or a cabbage, clutching a drooping bunch of flowers or a berried branch in one hand. Without speaking, he would sit down at once to dash off a sketch of them. Disgruntled, Miss Sylvester complained to Benjamin Guinness that instead of spending money on food Alvaro squandered it on drinking with undesirable friends. She also feared that he was not simply eccentric but probably mad. There was one of his French friends called Thomas whom she particularly disliked, though when Alvaro visited him and his wife in the suburbs he usually came home with an odd cheese and a dozen eggs. However, when Thomas came to Paris, Alvaro often returned intoxicated.

Walking through Montmartre one night and passing a certain building, Alvaro gave Thomas a nudge and said: *'Voila! Le bordel des curés.'* Thomas, an ordinary married man with no interest in homosexuality, was mystified but he always remembered this phrase. He remarked to his wife that like many others in Paris too proud to collaborate, Alvaro was not only physically starved but mentally strained.

Miss Sylvester and Thomas were not the only ones who began to question his sanity. A well-known Chilean writer, Salvador Reyes, a friend of de la Fuente's, had remained in France as a war correspondent and rented a house in a village on the Seine. He invited Alvaro to stay for several week-ends. The first time, he begged him to bring some food – even a slice of pâté. But his guest arrived empty-handed and he was unable to conceal his dismay. Alvaro asked: 'Where is the best black market around here? I could find nothing in Paris. Lead me to it and I will buy whatever you like.' He referred to the black market as if it were a popular shop in the main street.

Salvador Reyes wrote: 'I realised that he lived in a world of moonshine. I never asked him to bring anything again. One evening we went for a walk along the towpath. He stopped now and then to watch the barges and told me confused, bewildering stories. He was preoccupied with fantasies ... lost in a limbo, beyond imaginary horizons. He walked slowly, arms folded, a look of agonised sadness on his face – the look of a frightened

226

child. Yes, this mature man, this brave boxer, now gave the impression of a lost and abandoned child. He was scared of the future and felt he was doomed. His voice became indistinct. All the time I knew him, he never really laughed . . .'.

There was nothing for Alvaro to laugh about during these arid days. The news, which filtered through American journalists in the cafés, was always bad. During an air-raid in London, 9 December 1940, a bomb had fallen on the warehouses of James Bourlet and Sons, in Bourlet Close, W.11 and everything stored on the premises, presumably including all Alvaro's pictures, was destroyed.

The traumatic vision of flames devouring his portfolio of drawings from the Slade haunted him. In addition, at least fifteen paintings, unique records of those London scenes to which he was sentimentally attached, were now reduced to ashes: *Music-Hall No. 1, Female Jugglers, Women Dancing on Chairs, Weston's Music-Hall, High Holborn, Theatre Interior, Boxing* – they were all gone . . . The remaining examples of the *Swimming-Bath* series must also have perished. How symbolic and significant it was that the holocaust had claimed *Signs of the Zodiac* – this alone was an evil omen. Not only had he lost pictures illustrating and interpreting the scenes which had so impressed him, but many portraits of people who had influenced him or attracted him intensely, canvases that he had refused to part with: that full length 'nameless picture' of Iris Tree sitting on a four-poster bed, Philip Gardner, Kineton Parkes and innumerable others. He mourned for these images burned alive on the funeral pyre. Had anything or anyone survived? Typically, he analysed and dramatised the tragedy: had he a lethal touch? Would his sitters too suffer a similar fate? Were the Moslems right after all in believing that their souls would be imprisoned in their portraits and consequently sold to the devil by the painter? Perhaps he should never paint again? Just as he had gone into mourning when his marriage crashed, so now he mourned and resolved only to paint imaginary portraits in monochrome or black and white.

News of Geoffrey Nelson's fate reached him at about the same time. Over-confident of his immunity and resentful of the occupying Nazis who now competed for the favours of Madame, Geoffrey had walked out of her hotel. As soon as he reached the

next village, he had been arrested and sent to a German con-
centration camp where his health had rapidly deteriorated. The
camp doctor, having diagnosed both cancer and tuberculosis,
transferred him to the hospital wing of the internment camp near
Paris where Mouradian was detained. When Alvaro went to see
him, he realised that his old friend was dying. His thoughts were
now wholly preoccupied with death.

It seems surprising that Salvador Reyes continued to invite
such a gloomy guest, but he did, and it was he who left an
account of what happened to Alvaro next.

In 1941, a number of allegedly neutral Germans who had
settled in Chile were arrested and accused of some illicit Nazi
plot, possibly involving the export of arms and gold to Germany.
In reprisal, the head of the Gestapo in Paris was ordered to
arrest an equivalent number of Chileans as hostages and hold
them under suspended sentence of death until the Germans in
Chile were released.

Alvaro was pottering about his dusty studio in the Rue Notre
Dame des Champs when he heard the sinister 'knock on the
door', so dreaded by Parisians. After repeated banging and shout-
ing he opened the gates and the S.S. strode in. Their behaviour
was typically threatening. Being Chilean, at first Alvaro felt
confident and protested his neutrality in vain, waving his pass-
port and papers and demanding diplomatic immunity. He was
given no explanation for his arrest but handcuffed, led away,
shoved into a dark van and driven to the notorious Cherche Midi,
the most brutal prison in Paris. At the last moment, typically
he had grabbed a pencil and sketch book, muttering that he was
only an artist.

Miss Sylvester had assumed that Alvaro, who was so often
away, was collaborating with the enemy. Now, she presumed
that he was involved with *la résistance*, merely pretending to be
daft, probably spying for the English.

On reaching the condemned cell, Alvaro was amazed to find
other Chileans waiting, including a painter, Manuel Thompson,
a retired Colonel Urrutia and a Professor Bunster. Did the
Gestapo choose these hostages at random? There were many
more important Chileans in Paris.

Salvador Reyes had recently learned of the detention of the
Germans in Chile, but it was not for a while that he heard of the

arrest of the hostages, none of whom had been informed of the reason for their imprisonment.

Alvaro drew meticulous portraits of his compatriots. Apart from their heads, only the iron bars over the window were included in this unfinished sketch.

The hostages were not executed. After nearly a week of negotiation between Germany and Chile, they were about to be released when Salvador Reyes was admitted. He wrote: 'I found them not displeased with their treatment. They were not in a dungeon ... were permitted to talk to each other and move about. They told me the food was better than any to be found in restaurants in Paris. With the exception of Alvaro Guevara, once the situation had been explained they accepted it with patience and humour. Only Guevara demanded incessantly to know who had denounced him. He seemed overwhelmed: no explanation convinced him ... With a childish obstinacy he repeated: "Who gave me away? Who gave me away?" shouting these words in English, to the horror of his cell mates, even in his sleep.' Under the circumstances, English was scarcely a language to be recommended and it is interesting that he should dream in English rather than in Chilean or French. Perhaps Miss Sylvester was right and he was involved in *le maquis*. (Coincidentally his words had been almost the same as those he had used on the fatal Eve of St John, when as children he and Susana were worshipping the moon and she was nearly killed by a bullet.)

After their release, Salvador Reyes joined them for dinner at a Basque restaurant of Alvaro's choice, to celebrate with countless carafes of wine and a well-spiced casserole, probably made of cats and sewer rats. The party became hilarious but Alvaro was taciturn. When he spoke, his mood was either paranoiac or introspective.

Nevertheless, he and Salvador Reyes continued to meet in the cafés of St Germain des Prés. Salvador Reyes felt that 'this strange, reserved man was a genius with inner fire, without classification, possessing the complex tortured soul of a real artist – in short, extraordinary'.

Alvaro promised to take him to his studio but confessed that he had lately 'lost all interest in painting. He said this without affectation – he was too fine to be a *poseur*. In future he would

concentrate entirely on writing. Drama obsessed him: a dream circus, a theatre of marionettes . . .' Manuscripts were less vulnerable than canvases. Salvador 'read one of these plays in confused amazement, without understanding. There were a few intelligible passages but, as a whole, theatrically, the work was impossible to produce or direct. The characters came on to the stage disguised as birds, remaining petrified, speaking their lines without moving. Throughout there was no action.' Embarrassed, he searched for some phrase which would not wound, and merely said: 'Of course my opinion is of no value but I cannot visualise this on the stage.'

It was early in 1943 when Alvaro took Salvador to his studio: 'He almost never went there. A thousand things were piled up under a coat of dust. I saw *The Sewing Machine* and many other canvases . . . That visit convinced me that Guevara was a formidable artist but one who would never realise his potential completely . . . He was a mystery, a man perpetually removed from his actual surroundings and the present moment. He possessed all the fundamental elements of art, but morally and psychologically he seemed incapable of using them to full advantage. Why?'

In an undated letter to Susana probably written later the same year, Alvaro reported: 'At first the Germans who occupied Paris smiled confidently . . . last October, though still strictly disciplined, they did not smile and had a hard look in their eyes. It was as if a menacing cloak of fog or smoke hung over the city. My friend Picasso has not been allowed an exhibition of his paintings . . . He is hungry but he does not care, for his new paintings exceed anything he ever did before. The Nazis hate Picasso because he helped the Loyalists of Spain by donating three planes for them to use during the revolution. Derain and Friesz, on the other hand, are looked upon (officially) as geniuses by the Nazis. Lately also Bonnard in Cannes was allowed to sell his work and to exhibit.'

The paintings of well-known neutral painters such as Picasso were stored in the vaults of various banks. At the beginning of the war, Picasso was present when two inexperienced German inspectors arrived to make an inventory of what were regarded as Nazi assets. He led them such a dance around the labyrinthine cellars, and playacted so successfully, pulling out canvases and

shoving them back saying: 'Oh! We've already seen these,' or 'No, these are by Matisse', that the inspectors valued the whole lot at about five hundred pounds.

Other neutral artists were less shrewd. If they left their freezing studios even for a few hours, the Nazis requisitioned them, throwing most of the contents into the street to be burned as rubbish. The soldiers, needing the accommodation, might divide what was left between them. Some of these 'perks' were sent back to Germany. The studio of one neutral painter, a Norwegian, was emptied in this way. Alvaro's studio probably suffered a similar fate. Perhaps one day his large portrait of Gertrude and Alice and other work accomplished between 1929 and 1942 will turn up unexpectedly in attics, or hanging on the walls of some *gasthof* which survived British bombing. None of these pictures was signed but all could easily be identified. Happily, those stored in Mouradian's gallery survived.

Later in 1943, Alvaro's friends were so concerned for him that efforts were made to have him repatriated. He seemed to grow madder and thinner every day. Finally, he was despatched to a Portuguese transit camp en route to Chile.

16

Alvaro's ship at last docked in Valparaiso. Mama Guevara was living in Vina del Mar. It was fifteen years since they had parted in Paris and she was now eighty-six. She had clung on to life in the hope of seeing him again and cabled to Susana as soon as he arrived. She also wrote to her, confiding that she was 'horrified to find him so changed and emaciated'. He had lost twenty kilos since 1929 and she feared that he would 'never recover from his last unjust arrest and imprisonment', adding that he lived in constant fear, convinced that he had been cursed since birth and that people would always plot against him. The shock of the contrast between the robust son she remembered and this stuttering stranger with large scared eyes, who could not express his feelings, 'hastened her death'. For mother and son, this was a painful time. When not pacing the floor, he sat in a trance-like daze without speaking. Within a few weeks, Mama Guevara died. It is not difficult to imagine the effect the deathbed scene, the dramatic funeral and the ensuing emotional family reunions had on Alvaro, already so vulnerable. The similar ordeal of German Grandmama's death was still agonizingly vivid in his mind.

He moved to live with his elder sister Dorila in Santiago and partially recovered his equilibrium.

His nephew Octavio, now a young man of nineteen, had heard such lurid descriptions of his uncle's condition that he dreaded seeing him again. Alvaro had suggested they meet at his favourite haunt – a cocktail lounge in Vina del Mar, although the drive from Santiago would take three hours. It was twelve years since they had parted in Paris.

Octavio found him in better shape than he had expected, 'but his face was ravaged. Instead of taut on the bones, his skin hung in folds. It was amazing how many Pisco Sours [white brandy, white of egg and lime juice] he could knock back without getting drunk or staggering – it did not occur to him to pay for the drinks.'

The famous Chilean painter Matta came up to say hello. Alvaro was far from boring, an observer of people and occasions with a very receptive mind. He talked eloquently on that particular day. He added later to his nephew: 'With your black hair, you look like I did at your age, but perhaps my chin was stronger.'

His relationship with Dorila was not consistently happy; he was obviously a trying guest but he was often out with old friends such as Lucho Vargas, whom he had last seen at the Dôme in 1939. Lucho, the Director of the Museum of Fine Arts in Santiago, wrote to Susana: 'The other day Alvaro knocked on my door – he had just got out of France, a changed man both morally and physically . . . but I see him daily. He has never adapted himself to Chilean life. He is tormented by the absence of his daughter, who is in England. He longs for Europe. He often lunches with the British Ambassador, hoping to get a visa, which is very difficult because of the war.'

Alvaro's old friend and namesake, Alvaro de la Fuente, lost no time in getting in touch and found him trying to discipline himself to paint and to drink less. When his friends asked why he did not paint out of doors, he replied: 'For the same reason that bakers do not sell their bread in the wheatfields.'

In his trouser pocket Alvaro always carried a small tin which had once contained throat pastiles and now held a few pencil stubs and small pieces of drawing-paper which he had cut to the size of a playing-card. On these he would record impressions, unintelligible to anyone else. Before going to bed he would pin a sheet of white paper on his drawing-board and using a thin brush and black or sepia gouache, sketch in the composition referring to his pack of *aides-mémoires*. He admitted that he found the third stage the most difficult; he would have to work in what he described as 'a self-induced trance' using a larger piece of paper, usually light brown, sometimes outlining the figure or figures in gouache, pencil or chalk, introducing a little colour. He explained to de la Fuente that 'by using a very little colour

233

next to a complementary one was far more effective chromatically than using too much'. For the fourth and final stage of painting, in oil on canvas, he had to be feeling 'fighting fit'. Sometimes he would paint from a reflection of his last sketch in a mirror. De la Fuente watched him paint in oil, and gouache, and experiment in encaustic technique.

Once more he became Alvaro's confidant and soon realised that Alvaro had fallen in love again: 'Truly he was damned as he said and this love was condemned: for the beautiful girl was Maruja, his brother Jorge's daughter, in fact his niece. She was deeply religious, a faithful wife married to a splendid, charming gentleman.'

Maruja appealed to Alvaro not only as a mysterious enchantress but because he imagined that she greatly resembled his own daughter Nini. He made innumerable encaustic studies of her face, intending one day to paint a finished portrait. He was inspired; her every expression must be recorded. In some of these studies she looks almost evil, in others she appears a saint: sometimes her expression is bitter or unhappy but always enigmatic, certainly strange. Thirty-four of these heads have survived.

De la Fuente was profoundly disturbed about his friend: this infatuation would be fatal: as soon as the war ended in 1945 he advised him to send for his wife and daughter immediately: they must of course come and live with him in Chile. Emphatically he repeated: 'You must *command* them!' Smiling, Alvaro slowly explained that Meraud was not a typical Chilean wife to be summoned at whim. However, they were not legally separated – they had remained friends and still corresponded. Such circumstances, unacceptable in Roman Catholic Chile, led de la Fuente to advise Alvaro to leave and re-establish his marriage; England was the best place for him; it was there that he had been most loved and respected. He should never have left London for Paris . . .

De la Fuente was so eloquently persuasive that Alvaro eventually agreed. More and more, the idea of a reunion with Meraud and Nini and a return to London obsessed him.

Octavio's father was no longer Chilean Ambassador in England but the Guevara family still had influential diplomatic friends. It was an elderly and distinguished Chilean lady, Dona Concha, whose private chapel Alvaro had decorated, who finally pulled

the strings which were to swing him back like a puppet across the Atlantic. De la Fuente helped him crate all the encaustics of Maruja; Alvaro insisted that he must keep her with him always.

Only Lucho Vargas and Alvaro's younger brother Edmundo were at the station to wave goodbye. To many of his relations, including Maruja perhaps, his departure was a relief. He wrote to Susana from Buenos Aires on 20 September, 1945: 'I am on the way to London. I have been named Honorary Consul. I do hope to see you there. Do not commit the error of going to Chile. It has degenerated in a most barbarous way. The arrogance of the people has no limits and the living members of our family have turned into monuments with voices of thunder. It is not a country for a simple sensitive mortal, for these giant gasbags asphixiate him. . . . Now that Mama is gone, try any other country but Chile – Japan, China or Russia . . . you would love China. I embrace you and your husband – Alvaro.'

Alvaro had always preferred Chelsea to Bloomsbury and felt more relaxed with such friends as Augustus John, Roy Campbell and Matthew Smith than with that group whom he had met at Garsington so much earlier in his life.

Therefore, shortly after his arrival in London, he sought to establish his Consulate in the neighbourhood he remembered so fondly. It was scarred by bombs, but he found a suitable house in Sidney Place, within easy walking distance of the Chelsea Arts Club, Matthew Smith, Augustus John, Rodney Burn and Freddie Mayor.

While negotiating the lease he ran into Polly Peabody who lived in Oakley Street and was married and expecting a baby. They were delighted to meet and each bursting with news of their wartime experiences. Polly was shocked to see how much he had deteriorated physically. He was drinking rather heavily. She explained that she needed a telephone desperately but such a luxury was impossible in post-war London for any but V.I.P.'s. 'That's easy,' he said. 'I can fix it. As Chilean Consul I shall demand priority.' They agreed that he should move temporarily into her house nearby, as a paying guest.

Alvaro was installed without delay, together with the telephone. Polly was not only impressed by this, but by the genuine affection and respect which he was shown by his many famous

contemporaries. She was able to appreciate for the first time 'that in London, he was really *someone*', whereas in Paris and the South of France she had never realised this. She already knew a wide range of socialites, artists and intellectuals – not only through her mother, Caresse. However it was through Alvaro that she now met other interesting men, including Matthew Smith who, despite her heavy pregnancy, or perhaps because of it, asked her to sit to him. He was much involved at the time with his strangely beautiful young friend Mary Keene, referred to by some as 'his hair-shirt' because of her nervous, artistic temperament.

Meanwhile, Meraud too had arrived in London and was for the moment installed in Athenaeum Court. Soon after the outbreak of war in 1939, after eight ecstatic and dramatic years with Maurice and his followers, she had sailed to New York from Portugal.

Her current admirer was an American officer called William Einstein, an aspiring painter who was in Army Intelligence. She introduced him to Alvaro, who introduced them both to Matthew Smith. All four became friends. Matthew found Meraud particularly lovable. Meraud longed to take him and William to Aix-en-Provence.

As soon as Alvaro moved into the new Consulate with his own telephone line, Meraud took his place as Polly's paying guest. Knowing how hopelessly unbusinesslike he was, both she and Polly rippled with laughter at the idea of his being a Consul. He assured them that he had an efficient, bilingual secretary and therefore had almost nothing to do except get on with his book – a novel called *The Dictator*.

More and more friends of Alvaro's were demobilised and arrived in London, including Wilson Plant. On hearing of Alvaro's whereabouts, greatly excited, he telephoned and invited him to lunch the next day at the Café Royal. To Wilson's chagrin, Alvaro sounded vague and accepted his one o'clock invitation without enthusiasm. They had not met since 1926 and he was already fortifying himself at the bar when Alvaro walked in at about twelve. At the sight of Wilson, his eyes widened in surprise, his face creased in smiles; open-armed, he strode across to greet him with back-slapping, unreserved affection.

They talked and drank for nearly an hour until Alvaro looked

236

at his watch and gloomily announced that they must part: he had an appointment at one, with some crashing bore who had telephoned and asked him to lunch; he had better hang about near the door.

For the rest of the day, the secretary at the Chilean Consulate was in full charge.

Alvaro's London life was a faint echo of the one he had led twenty years before. He called frequently at the Slade – almost haunted the place. George Charlton, who was now on the staff, was greatly startled one night when he saw what he thought must be Chile's ghost on the stairs.

'No, I'm sure he wasn't on the prowl for some pretty girl, he loved every inch of his old school and we had all liked him very much.'

Chile greeted Charlton with enthusiasm.

'He did not speak of his marriage or any of his personal experience of the war; he was never one for small talk; but I gathered he had given up painting. This seemed to me a terrible pity as he was quite the most gifted and promising student when we were both at the Slade; he had been the *Senior* student; a very important function. His were the first really modern figure paintings done there. I feel he never had quite the success he deserved.'

He wandered around London calling at random on old friends. The Bombergs lived in South Kensington and according to Lilian, the second wife, when his Consulate closed he would walk round for tea. 'We loved him, he and David would talk about those old days at the Slade and about contemporary art by the hour.'

He also walked round to St Leonard's Terrace and knocked on the door. Rodney Burn, who had liked him so much when they met in the train on the way to Wimborne, found him 'extraordinary, although he did not appear to be drunk and I saw him on and off at the Chelsea Arts Club during that year. But he seemed to talk rubbish and I could not understand or follow him at all. He was remembered by a few of the older men such as Henry Rushbury.' Rodney Burn 'thought that Chile must have had a hard time in Paris during the occupation which had affected his health . . . he said nothing about his marriage.'

Alvaro preserved a deep friendship with Matthew Smith, but

237

he was now rejected by his hero Augustus John. This must have been very hurtful but David John and Alvaro still met and 'used to go on pub-crawls together'.

Viva King, whose husband Willy was head of the Ceramics Department at the British Museum, bumped into him coming out of a pub in South Kensington and invited him back to Thurloe Square: 'He seemed terribly depressed, perhaps he was drunk? I was sorry for him but had always found him rather dull – somehow we could never communicate; he never talked personalities but that night he did mention his daughter – not a word about Meraud. I had always admired his work and to cheer him up said so. When I said "You were a *great* painter," he burst into tears – I think he was very ill.'

Obviously there were many less dismal reunions with friends in London, but there are no records of them except one at the Chelsea Arts Club which he described in his last letter to Susana from 9 Sydney Place on 2 March 1946: 'I thank you very much for the food parcel you kindly sent me but please don't worry about me because after the hunger I suffered in Paris I have become accustomed to eating very little ... Tonight I have just returned from the Chelsea Arts Club where I attended a dinner given in honour of Sir Alexander Fleming who discovered penicillin. He is an old member of the Club. Gabriela Mistral is here in London. A party in her honour was given at J. M. Whistler's house. All the most famous poets of England were there. My old friend T. S. Eliot and others. After the party I accompanied Gabriela to another party given by lesser known poets at St John's Wood. We went in Senora Subercaceaux's car. The poet Gascoyne was directing us but he really *mis*directed us for we never found the place! Then I had to turn back for Gabriela had still to attend another party. Gabriela is going to California and will call on you. I embrace you and your husband. Alvaro.'

238

17

Benjamin Guinness was now seventy-eight and spent most of his time in Switzerland. Nini was fourteen and had just returned from Canada with Lady Eden. She had one or two brief meetings with Alvaro and Meraud in London which made little impression on her: they were strangers. Alvaro must have realised how slightly she resembled Maruja.

Various elderly friends of Benjamin's recommended an excellent school near Montreux where he would be able to visit his grandchild. Before the war, their own grand-daughters had attended *l'Institut Fisher* at Territet. He instructed his secretary to reserve a place there for Nini and to advise Lady Eden.

The Principal replied by return of post. The fees demanded were enormous. However the secretary was accustomed to his employer being charged the maximum and nothing was too good for his grandchild.

To Lady Eden's astonishment, when Nini's departure was imminent, a telegram arrived insisting that the new pupil be accompanied by a governess.

English scholastic agencies were in chaos, waiting for suitably qualified teachers of both sexes to be demobilised. Schools were clamouring for staff; many children were returning from the Dominions and the U.S.A. Panic-stricken, Lady Eden hurriedly engaged Miss Clarke. On meeting this lady at Victoria Station, Nini regarded her with foreboding: 'She was a typical drab, dowdy old maid of thirty-five.' Probably, Miss Clarke was at a more testing stage of life.

By the time this incompatible pair arrived at Territet, Nini

239

was acutely aware that Miss Clarke was 'domineering and eccentric'. Also, despite a flaking painted notice over the gate proclaiming *l'Institut Fisher* as a Desirable Academy for Young Ladies, it was immediately obvious that its original purpose had long been forgotten.

The Principal now in charge was Indian. As she led them through the rambling, dilapidated building she explained that since 1940 the Swiss Government had requisitioned it to accommodate old age pensioners and refugees while they repaired the historic Château de Chillon, and that the former classrooms were used as their dormitories. Lugging their heavy suitcases, Miss Clarke and Nini trudged through the straw on the floor on which the inmates slept until at last their escort unlocked the two rooms set aside for them. In one, there was a primitive, rusty stove. They must buy their own food and cook for themselves. Every morning, a jug of cold water would be placed outside the door.

Exhausted, Miss Clarke and Nini tumbled into the damp, lumpy beds. Next morning, they could see the labourers stripping and washing in wooden troughs set up on the neglected lawns below their window. After use, the troughs were tipped up and as there was no drain the ground had become a noisome bog.

Presumably Miss Clarke had left behind her an even less comfortable life in England. Here at least she would be housed and fed and generously paid. She wrote to her employer requesting more money for unforeseen expenses: her parsimony and thrift were exemplary. Nini discovered several other children housed on the estate, mostly orphans and stateless refugees whose pauper families had abandoned them. She became the ringleader of this wild band. The labourers were their friends; every day they accompanied them to the Château de Chillon to lend a hand, or earn a few francs as guides to the tourists, mostly G.I.S Miss Clarke had nothing to do except shop and produce a meal now and then. Her manner became increasingly strange.

When Benjamin Guinness called to take Nini and her governess out to lunch, Miss Clarke admonished her not to describe the school's unusual regime. She threatened to inform Mr Guinness how badly his delinquent grandchild behaved and thus precipitate an unwelcome change to some more formal estab-

lishment or to the control of a strict disciplinarian. In consequence, Nini remained almost speechless during these outings and when Benjamin Guinness asked: 'Dear child, do you like your school?' Nini, observing Miss Clarke's warning scowl, always replied: 'Yes, everything's fine, thank you, Grandpa.'

At this stage, Benjamin considered that her parents would prove a disturbing and undesirably Bohemian influence.

Wilson already suspected that Alvaro was suffering from tuberculosis as well as pining for his child. All his London friends agreed that a move to Switzerland would solve his physical and emotional problems. Surely some diplomatic appointment would be found, or even created? Strings were pulled once more, and he was posted to Berne as Chilean Cultural Attaché. A grand flat, belonging to the painter Balthus, whom Alvaro knew, was rented for him by the Embassy. Benjamin Guinness offered to make him an allowance.

Out of his gratitude to his father-in-law, Alvaro wrote an elaborate thesis on world finance. While appreciating this gesture, Benjamin was unable to decide, when he read the closely written pages, whether his son-in-law was brilliant or deranged.

Once installed in Berne, Alvaro continued writing his novel, *The Dictator*. He invited Wilson to stay, needing his advice as well as his company. Wilson was delighted to edit the manuscript and they worked together day after day. The English in which Alvaro chose to write was original and compelling. A copy was sent to his friend T. S. Eliot, who was favourably impressed and lent it to Roy Campbell. Roy was most enthusiastic and told Alvaro that he had sent the final typescript to John Rodker of the Ovid Press with a strong recommendation. He was convinced that it would be published.

The Cultural Attaché's duties proving far from exigent, and Berne society providing no inspiration, Alvaro and Wilson drank deeply during the long evenings at home. They determined to discover Nini's address and hatched impracticable plots to kidnap her. Wilson knew that these absurd conspiracies were fantasies but that it comforted Alvaro to invent them, being only too conscious of his dependence on Benjamin Guinness, who for many years had taken full responsibility for Nini.

While Alvaro and Wilson were conspiring, Nini was facing reality. In severe weather, without a hot water supply or central

heating, life at *l'Institut Fisher* grew more and more spartan until finally even Miss Clarke broke down. At Nini's suggestion they moved to l'Hôtel Byron and Miss Clarke made an incoherent telephone call to Mr Guinness's secretary. Her manner was so wildly distraught that he at once sent a chauffeur-driven car to rescue this precious grandchild. An ambulance removed Miss Clarke to a luxurious *maison de repos*, where she remained for an indefinite period as no one ever remembered to cancel the banker's order for her maintenance, Perhaps *l'Institut Fisher*, too, has been providentially subsidised . . .

After a few days, Mrs Benjamin Guinness instructed her private secretary to find a proper finishing school where Nini would receive some belated education and make suitable friends. Within a week she left for Lausanne.

Alvaro had just discovered her old address when Wilson was obliged to leave. Rather than undertake the trip alone or remain on his own in his grand flat, he wandered disconsolately through the streets of Berne, searching in vain for convivial bars or cafés. One day he ran into Francis and Olga Picabia. This reunion was a godsend for all three. Olga could abandon her reservations about Alvaro since tempting distractions were quite lacking in Switzerland. At least Alvaro could not lead Francis astray by encouraging him to drink in bars or visit brothels. She and Francis were struck by his preoccupation with Nini; his novel was finished but he seemed to lack the inspiration to paint. The encaustic heads of Maruja were still in their crate. His reunion with his daughter in London had caused the obsessive image of his niece to fade.

The war being over, Francis was anxious to return to Paris. Somewhat reluctantly Olga agreed. Alvaro, too, decided to rent a studio there so that he could escape now and then from his cultural duties. He hoped old friends might cheer him and provide some inspiration, but when he called on Picasso 'they had a row; not the first or the last', but as Meraud explained later, 'with their Latin temperaments a row between such old friends was soon reconciled – no more than a *tiff* . . .'

Having gained so much prestige by remaining in Paris during the Occupation, Picasso had a powerful influence. In Alvaro's opinion he was abusing this responsibility, his latest work was a hoax; he was pulling the public's leg and admitted it! Alvaro

accused him of leading young painters along a false path – in short, corrupting them by his dazzling facility.

Soon after this quarrel, Alvaro met Allanah Harper at a concert. She had not seen him since his marriage, but he went up to her during the interval. 'At first his manner was gentle and charming – when I asked if he were painting, his mood changed completely and he started attacking Picasso very violently, saying that he was an evil influence destroying contemporary painting. He talked so loudly that I was relieved when the bell rang and we returned to our seats.' He was eating little and drinking heavily. Charles Albert Cingria heard him holding forth noisily and sarcastically in a bar: 'Some fellow confronted Chile, exclaiming, "What an accent you have!" "Certainly I have an accent and if I did not I would affect one. Indeed I have one and, if you'd like to know, it's a Chilean accent which I'm obliged to have as I am a Chilean Consul . . ."'

However, when his nephew Octavio arrived, he 'was impressed how well Uncle Alvaro still held his drink – after eight doubles anyone else would have passed out . . . He was full of strange theories and his pockets were stuffed with minerals. His studio also was littered with bits of copper which he believed would relieve his inexplicable aches. It had never occurred to me that he was even faintly homosexual until one night an unusual, attractive boy walked into the café and a soft, tender, *velvety* look came into his eyes.'

His reunion with Meraud in London the previous year had affected him. It was obvious to Octavio that a far more sympathetic understanding existed between them now than ever before. Meraud's charm was still irresistible, Alvaro's personality as magnetic as ever; but they no longer destroyed one another with jealousy or recrimination, at last they were emotional veterans. Physical passion between them already squandered, each was now invulnerable to the other. Couples among their acquaintance struggling through a first, second, or third divorce had every reason to envy their love, still spiced with old magic, which after fifteen years had matured into tolerant affection.

Meraud's naïvely innocent plea that there should 'be nothing *horrid* about it' when they had parted, so painfully for Alvaro, was granted. They had advanced on parallel lines: their characters had evolved, now each complemented the other.

243

While Alvaro divided his time between Berne and Paris, Meraud found battered, smog-ridden London humdrum and expensive. Her father made her a modest allowance. He considered that she did not, or could not, appreciate the proper value of money. To her, five pound notes were just grubby old bits of paper. If he gave her more she 'would simply throw it away on scroungers'. At Christmas, for example, rather than entertain the right people, she would prefer to go out into the street and bring home hungry-looking strangers to enjoy a meal and sit around the fire.

Sick of queuing in the drizzle with their ration books, Meraud and William Einstein left for Paris but found life there almost as grim. She longed for Provençal sunshine and to paint again. The thought of the local market spilling over with sweet ripe tomatoes, local cheeses, dates, red mullet, all for a few francs, hastened her decision to leave, especially as she heard that interesting old and new friends of every nationality were assembling at Aix. She left Paris without regret and soon found the perfect studio on the top floor of No. 61 in the famous Cours Mirabeau. An exciting crowd of writers and painters, poets and composers, ceramicists and designers scrambled up the many flights of stairs, not only to enjoy Meraud's company and see her latest work, but to devour a *pôt au feu*. A skilled and imaginative cook, she could improvise a nourishing meal for ten for the cost of two in London. Afterwards her spirited admirers would gather at the café below.

Alvaro's solitary life in Berne was a doleful contrast. The Picabias had left. Visits to Paris, the rent of his studio, were more than he could afford and made him feel guilty. Transfers of funds from Chile were rare. When she had any to spare Meraud sent him small sums of money.

To pass the time he spent hours at the zoo making rough sketches. The only detailed studies he made were of a creature with whom he identified – the lone wolf, bored, furtive, frightened: an outlaw abandoned by the pack which it had instinctively rejected. He became more and more introspective and dramatised his situation.

During this dismal winter of 1947, Benjamin Guinness died in Normandy on December 15. On the night of his death, his Alsatian climbed out on to the roof of his house in Switzerland

and howled a lament. The news did not arrive until the following day, by which time the telepathic dog had gone mad and had been destroyed.

Recently, Benjamin had expressed the hope that in the event of his death his son Loel, who had children of his own, should take charge of Nini. Fortunately for Meraud, Loel was more generous than his father and less prejudiced against his sister's Bohemian ways. After the funeral, they agreed that it was time for her as Nini's mother to share some responsibility.

When Meraud visited Alvaro in Berne to discuss the situation, it was painfully evident how ill he was and what a miserable life he led. Always correctly dressed in one of those old dark Savile Row suits, stiff collar and tie, as befitting a diplomat, he was bored and lonely in the land of cuckoo clocks and chocolate.

'But what do you *do* all day?' she cried. Shrugging his shoulders, he said: 'I go to the zoo and talk to the bears, but can no longer be bothered to draw them.'

Meraud rebelled against the lethal futility of his life. What a waste of his potential and time! He should throw those horrid dark suits away and come to Aix. She knew that his spirit and his talent were frozen here. His courage would thaw in Provençal sunshine. He would soon find many sympathetic friends and begin to work again. His present attitude was absurdly negative and pessimistic. She assured him that Nini would soon join them: Loel had suggested this. She too would blossom in that climate. Everything could be arranged.

Since childhood, Alvaro had grown increasingly paranoiac and susceptible to evil omens, suspicious of others' motives and superstitiously preoccupied with all the astrological trivia involving doom and death. Meraud, the intuitive arch-woman, had preserved a totally different philosophy – optimistic and positive.

Before she arrived he had felt numbed; her warm and impulsive welcome galvanised his latent energy. The spell was cast; before she left, she had waved a wand over the lone wolf and changed him back into an artist. He decided to resign as Cultural Attaché and within a few weeks instructed his servants to pack all his belongings. The sketches of Maruja were still in their crate and were included. Did he suspect that he had not

long to live? Certainly he could not have imagined that he would fall in love again before he died.

Nini had always been fond of Grandpa Guinness and had been looking forward to spending Christmas in Normandy with him and his wife, Uncle Loel, beautiful Aunt Isabel and their guests. She spent most of her holidays with the Edens, who had provided her with a reliable and affectionate background since she was eight, and she loved 'Aunt Patricia', as she called Lady Eden. She had lately settled very happily into her new finishing school, where she was already popular and had formed close friendships especially with Americans.

Now, due to the confusion created by Grandpa's death, her mother was to be included in the Christmas party. It was an unpleasant surprise for Nini and she resented the pre-emptive way in which her future was decided within a few days. Apparently even her father had been consulted. When told that she was to leave with Meraud the following week and spend an indefinite period with her in Aix, she was furious and distressed.

She made up her mind not to utter a single word during the entire train journey from Lisieux to Aix. She had no reason to like either of her parents and the news that her father too was on his way was far from reassuring. Meraud referred to him as 'Chile' and Nini gathered that although still married, they would not be living as a 'family'.

Meraud explained that she had booked rooms for herself and Nini at an hotel in the Cours Mirabeau. Her own studio-flat was nearby but too small to accommodate them, especially as an old friend, Charles Albert Cingria, had recently arrived to stay.

Nini kept her vow of silence, gazing out of the train window hour after hour, stubborn and sulky. She determined to show no interest in anyone or anything even after they arrived. With luck she might be returned in disgrace to the beloved Edens.

Sitting opposite her handsome, silent sixteen-year-old daughter, Meraud noted that she was more of a Guevara than a Guinness – more Latin than English. She had Alvaro's strong features, including his determined chin, although with her smart clothes and spoilt expression she had the makings of a typical debutante in what some considered proper Society. As she disliked insincerity even more than rudeness, Meraud was content to ignore

her daughter's behaviour and this further exasperated Nini. When at last they arrived at Aix, and she was surrounded by a boisterous crowd of Meraud's friends, she felt increasingly hostile and lonely.

During the first few weeks the only companions she found were two Mormon missionaries, always sombrely dressed and diligently searching for converts in the cafés. They neither smoked nor drank and everyone else considered them 'madly boring and dreary'. Although Nini spoke fluent French, her recent experience at school had made her more at ease with Americans.

Charles Albert, who was installed in Meraud's flat, was the original and distinguished Swiss writer who had known Alvaro and Meraud during the early days of their marriage. Ugly and eccentric, he was a brilliant musician with a collection of rare antique instruments. He could always captivate a crowd by some impromptu tour de force. As there was no piano at Meraud's, he improvised whole concerts – even of classical music – using a kitchen table as percussion and odd pots and pans supplemented by the extraordinary range of his voice. Nini did not like him. 'He was greedy, helping himself far too liberally to jam and grabbing all the best bits of chicken.'

Alvaro's reunion with Nini was disappointing: she bore only the faintest resemblance to Maruja. At first he was inarticulate while she regarded him with curiosity. Meraud was sad to observe that little sympathy was growing between them. She watched him trying to woo his daughter by telling her what he hoped were entertaining stories. His descriptions of seemingly unpractical jokes shared with a gentleman, referred to later by Nini as 'a Mr Harris Coal', were only fairly amusing. Having spent four years in Canada with 'Aunt Patricia', she had heard vaguely of Picasso, but such names as Sickert, John, Sitwell, Nevinson, Campbell, Eliot and Firbank – household gods to him – were of little interest. She gathered that another painter called Christopher Wood, now dead, had once been 'Mummy's friend', but she had never seen his or any of the others' work even in reproductions, and was on the whole prejudiced against 'Bohemian people and artists'. So she stifled her yawns as this stranger, her father, went on and on about the old fogies whom he had known in his heyday.

Meraud, always sensitive to vibrations emanating from re-lationships, realised that poor Chile was failing with Nini: she disliked him, or at least felt indifferent towards him. How sad it was that their child loved neither of them. It was a mercy when she and Nini did discover something in common: animals appealed strongly. Meraud gave her a large brown dog, and this mongrel served as a go-between. Through him, mother and daughter were at last able to communicate to some extent.

Characteristically, within a few days Alvaro had explored much of Aix and was delighting in the architectural marvels which had flowered in its prosperity – magnificent seventeenth century palaces, mysterious courtyards decorated with sculpture behind great carved wooden doors or iron gates. He rented a flat in the narrow Rue Papasaudis, just behind the hotel where Meraud and Nini were staying; the rooms were rather damp and there was no electricity, but at least it was cheap.

According to Cingria, he proceeded to furnish it 'with infinite taste'. He had always had a discerning eye for unusual and attractive objects, while rejecting the merely chi-chi. Over the following months the Flea-Market yielded many treasures – a huge majolica dish, an alabaster jar, terrestial and celestial globes, decorative antique clocks which had long ceased to work, glitter-ing minerals or corals under glass domes, elaborate wire bird-cages, copper jelly moulds, wooden box-cameras with folding tripods. Particularly, Cingria appreciated the 'splendid banner which adorned the entrance hall, embroidered with fleur-de-lys. A marble copy of Beatrice Cenci (better than the original) reclined on the floor beneath.'

He collected oil lamps for aesthetic as well as practical reasons; mirrors, however damaged, more for their frames; sculpture – even fragments; and books by the hundred piled up against the walls, especially old encyclopaedias and dictionaries.

Apart from the damp, the only disadvantage of these lodgings was that a girl living below persisted in singing very loudly for hours on end. Alvaro bought a large, old-fashioned motor horn which he would toot and honk in protest. Providentially she was carried off by a Chinaman who married her and took her to Peking.

Except for Cingria, whose conversation Alvaro found intensely original and exciting, few people were invited to the Rue

Papasaudis. Nini went there only once, for tea, and it was probably after this visit that he unpacked the Maruja sketches, took a narrow piece of paper, and made a study of his daughter from memory, using the same encaustic technique. His objective portrait of his very normal, healthy and self-contained girl with her bronzed cheeks and the confident carriage of her head, is itself an explanation of why they had failed to reach an understanding. She was a whole world removed from the neurotic or eccentric prototypes who had always attracted him emotionally.

He found it increasingly difficult to eat or drink as he liked without suffering. In the cafés, he had also become more cautiously selective in making casual friendships. André Masson had a comfortable villa outside Aix. Alvaro found his personality and work appealing, but the now famous Breton painter, the ebullient Pierre Talcoat, became his favourite. He was a large, handsome, muscular man, a *bon viveur* and a gourmet who probably reminded Alvaro of Geoffrey Nelson or Augustus John in the old days. Always surrounded by pretty and amusing young women, he could down dozens of oysters and litres of wine at a sitting.

Later, Talcoat described Alvaro as 'a reserved man, little inclined to reveal himself, but he emanated an attentive humanity, open to those who were receptive to feelings beyond what could be seen or described . . . a man of deep concern and of a sharp perception to which I responded so strongly that a great understanding grew between us through our similar outlook on life.'

Alvaro also made friends with Laurin, a hero of the Resistance who had taught Meraud's lover, Maurice, to paint. Early in life Laurin had lost his forearm and had it replaced by a hook, which he kept sharpened and used most effectively against the Germans during the Occupation.

Once more Nini had adapted herself to circumstances, which her uncle heard from casual sources were 'rather bizarre'. Her Mormon missionaries had made one convert – a Frenchman desperate for a visa to the U.S.A. Her uncle suggested that she should leave Aix to spend the winter in Paris with a suitable, titled family. Thus she was returned to the '*monde*' where the more conventional members of her family hoped she might find a husband. When a woman friend of her hostess remarked: '*Tiens! Comme c'est curieux que Madame votre mère, qui a tant*

249

d'allure, s'entoure des pédérastes . . .' Nini innocently asked what she meant. Her embarrassed chaperone hastily changed the subject.

Uncle Loel wished that Meraud would establish a proper home for Nini. He considered that hotel life was unsuitable for a girl of her age. It so happened that one of Meraud's many Provençal acquaintances told her that in consequence of the devastation caused by a recent forest fire in the mountains, a property was for sale very cheaply around La Tour de César, a well-known landmark. The peasants identified the tower as Roman and named it accordingly, but it was in fact a watchtower which had been used by the Knights Templar. Loel agreed to buy it for her. There was no dwelling house, at least not in the accepted sense, just a ramshackle building some way from the tower which had once sheltered a peasant and his family. Nearby, the charred remains of a hut or *cabanon* had survived.

In such wild surroundings there was no need to complicate life with plumbing; even in Paris, Meraud considered modern bathrooms and kitchens a waste of space. Besides, there was no water on the estate except for two rainwater tanks. But there was an open fireplace. 'What more could one need?' she demanded. It was far more important that the view from the top two rooms, over pine forests and unspoilt country, was magnificent. Some of the taller trees were already beginning to recover from the fire.

When Nini returned from Paris, she was aghast to see that no proper road led from Aix to this paradise, only a steep stony track: surely some sort of transport would be needed? To her delight, Alvaro suggested a mule or a donkey. A horse was found in Aix which was later sibilantly described by Nini as 'a small starving Russian stallion'. Of course Meraud had to rescue it. She was asked the same price as it would fetch from the knacker in the market.

Lately, her recent admirer William Einstein had arrived with a young wife to whom he had proposed marriage within half an hour of their meeting on the day she was released from a German prison camp. [Foujita's niece.] He rented a comfortable villa not far away and still being devoted to his old flame and interest in her problems suggested that she should also buy a jeep. She bid for a battered Willis, with a rash of bullet holes in its body and a U.S. star on its bonnet. At once Nini took to the

American Einsteins, who to everyone's relief replaced the Mormon missionaries in her affections and formed a stronger link between her and Chile.

'I've found a suitor for you,' William confided in Nini, 'a very handsome man and rich – the American Consul at Marseilles.' This introduction proved a great success as long as Meraud and Nini were living in their respectable hotel at Aix.

Although Alvaro still looked rather ill and sallow, it was rewarding for Meraud to see that his morale had much improved during the last few weeks and that his friendship with the Einsteins had brought him closer to Nini. He bought a noisy second-hand motorbike, which must have reminded him of the old days at the Slade. On this he roared around the countryside exploring distant villages or arriving unexpectedly to call on friends. Young Mrs Einstein found his appearance extremely attractive: 'He looked like a true aristocrat, his deep voice was impossible to describe. He brought an enthusiastic perfection to any task, however small, that he attempted . . .'

After a few months he even wanted to paint again and he and Meraud agreed to buy an old American army hut between them and set it up in a clearing on her property. It might serve as a studio for them both. Physically he was not strong enough to provide much active assistance, but as they watched it being reassembled and erected he said: 'Let us call it Canada, we can pretend we are working in a log cabin in a coniferous forest.'

The outside of Meraud's house was painted ultramarine, as blue as the little Citroën which had so amused the Picabias years before when she had arrived at the Château de Mai. The blistered shutters were painted a mixture of viridian and emerald green. Cingria described the effect as very Provençal, but the architectural style reminded him of 'a tiny railway station in North Africa, perhaps'.

Although Meraud had been out of touch with her former lover Maurice since his marriage, his cousins Ramon and Louisette, gypsies, turned up in Aix and greeted her as their *chère cousine*. Meraud knew well from the past that Ramon lived by his wits. He could trap larks and snare rabbits and was expert at poaching game from neighbouring estates. He had an infallible instinct for unearthing truffles. He was just the man

she needed to help her and his wife Louisette was a good cook. At last Meraud, Nini, Ramon, Louisette, the large brown dog and the small Russian horse moved into La Tour de César with bales of hay, the odd table and chair and some lumpy beds bought in the Flea-Market.

During the hot Provençal summer, life at La Tour was a permanent picnic. Given unlimited space Meraud felt free to adopt an increasing number of abandoned dumb friends, stray cats and dogs; Nini approved of caring for these but disapproved of her mattress and the lack of certain amenities. She strongly objected to Louisette emptying her *pôt de chambre* out of her bedroom window every morning on to the pebbled terrace where they breakfasted. Accustomed to the standards set by Uncle Loel and 'Aunt Patricia', Nini was irritated by the hours it took to boil rainwater in an old tin can over wood in the open fireplace.

Louisette was capable of producing appetising dishes but sometimes her methods were disturbingly primitive and her manner towards Meraud, who was after all her employer, was too familiar, even aggressively rude. She refused to be paid by *sa chère cousine* – as a proud gypsy this would be beneath her dignity, but whenever Meraud was about to take either the jeep or the horse and dilapidated trap to market, she made it clear that she expected some token of appreciation – a piece of silk or a string of beads might catch her fancy.

On these excursions to Aix, Alvaro was often collected for the day. He no longer attempted to describe the past to Nini. She knew nothing of his youth in Chile. When he took the reins of the rickety trap, he did not refer to the Guevaras' elegant carriages, their coachmen in livery, nor to Mama's chauffeur-driven Rolls-Royces in London and Paris. When he drove the jeep, if he regretted his beloved Packard and Pierce Arrow, he did not say so. If he rode the skinny old cob no one knew if he thought wryly of the Guevaras' stables full of thoroughbreds, the glorious days galloping over the hills on his favourite sorrel with Susana, Wilson Plant or de la Fuente.

Even to himself he became inscrutable. Catching sight of his reflection in a fly-blown looking-glass, he may have smiled quizzically at the image, so different from that glimpsed in some ornate mirror in one of the many Majestic hotels or stately homes he had once frequented. His hair was still thick and

252

black, but instead of a smooth olive face under a treasured bowler, his skin was now lined and bronzed and his eyes shaded and cooled by his simple straw hat. Faded blue cotton trousers and vest such as French peasants wear, with sloppy *espadrilles*, had replaced the Savile Row suits, white silk shirts, Lanvin ties and handmade shoes from Lobb's. These informal clothes became him.

His circumstances were indeed changed. For reasons he did not care to explain, his income had dwindled to a few pounds a week. What did it matter? Since searching for buried treasure as a boy, money had always been fools' gold to him. His and Meraud's relations were rich, but the main thing was that she and he were happier together than they had ever been. To Nini, his acceptance of the way Meraud lived was a weakness; he never interfered or exercised the slightest masculine authority but seemed content to bask in the sun doing nothing, what he called *meditating*. The only constructive part he played in the *ménage* was to stroll around planting orange and lemon pips, peach and cherry stones in the fire-blackened clearings. A froth of blossom would appear one day, long after he was dead.

Meraud's *coterie* found life at La Tour idyllic – especially when the sun went down and it was too dark to paint. More and more people arrived from Aix, as well as visitors from Paris and London, including Matthew Smith. The *ménage* was so picturesque! Scorched branches, dry kindling and rubbish lay everywhere for the taking. Of course Meraud was right; there was no need for an oil stove or a gas ring. Ramon would twist up a discarded length of wire into a barbed coronet, set it on a pile of stones and within minutes the flames under it would be roaring and crackling, hot enough to roast a succulent hare, a rabbit or partridge on the improvised spit. Game abounded. The guests regaled themselves with the casseroles and *terrines* prepared by Louisette, flavoured with truffles or *cêpes* cut from tree trunks in the forest. There was special praise for the wild salads she gathered. Everyone thrilled to the glint of Ramon's earrings, the thrum of his guitar and his and Louisette's *chansons des nomades* under the stars in the firelight.

The sweet smell of juniper smoke, the fragrance of crushed sage, rosemary and thyme where they sat or lay, added a narcotic element to these evenings. Watching the potatoes blacken in the embers, the fir cones suddenly flaring like marigolds until their

petals turned white and powdered into ash, Alvaro must have been reminded of those visits to Augustus and Dorelia, and to Nancy at Puits Carré.

One day Cingria returned with Jeannot – the most devastating creature. With fronds of golden hair falling over his forehead, he struck Alvaro as a mixture of faun and angel. Jeannot was eighteen; he had been 'discovered' at the age of twelve in Switzerland by Cingria, who had continued 'to take an interest in him from motives he confessed were not purely altruistic'. Jean Cocteau too, was not only captivated by his looks but impressed by his intelligence. His line drawings and poems showed much promise.

Jeannot was enthralled by the ambience which Meraud had created with her gypsies and unusual friends. When Cingria was busy writing, Alvaro was only too happy to show Jeannot around Aix or to discuss his drawings and poems. When they all picnicked together on sunny deserted beaches, or sat in Cours Mirabeau cafés watching the crowds go by, or gathered around the crackling camp fire at night, Jeannot always appeared radiant, whereas Nini so often looked disapproving. He was not spoilt but enthusiastic and creative; his values were right. Alvaro could not take his eyes off him.

The scene evolved like a comedy of errors. For his part, Jeannot found Alvaro charming and interesting – but Meraud was the most adorable enchantress he had ever met! She was such fun, so pretty and gay, lithe as her most graceful cat. Alvaro and Cingria could only look on as Jeannot became increasingly bewitched.

The atmosphere in Meraud's hot flat under the roof in Aix, where Cingria and Jeannot were staying, became explosive. It was true that Cingria had provided this holiday and introduced Jeannot to these exciting friends; but although clever and kind, he was after all the same ugly old man whom Jeannot had known for ages. He resented being cooped up with him; when love drifts in, loyalties fly out of the window.

They quarrelled. Cingria found La Tour de César more to his taste and moved in with Meraud, Nini and the gypsies. Of course 'there was nothing horrid about it', just a touch of summer madness.

For a while Cingria cut Chile and Jeannot dead if they ran

into each other in the street. Alvaro and Jeannot shut themselves up in the Rue Papasaudis with the bric-à-brac. To the Einsteins, Talcoat and others, his behaviour seemed more and more eccentric: to fall in love again in his fifties was a disturbing twist, an emotional bonus which he was at pains to accept. Jeannot did not stay for long but joined the others at La Tour. Feverishly Alvaro began to write again. What had he learned from life? Its meaning became increasingly obscure and surrealist. He began his *Dictionnaire Intuitif*. Reluctant to become involved with the burlesque being played around Meraud, he insulated himself from it completely. Rather than emerge from his flat for a minute, even to put his rubbish in a bin on the street, he would sit up at night cutting paper and cabbage stalks to shreds, grinding corks and eggshells in an old mincing machine so as to flush them down the lavatory. At least *he* had some plumbing.

Nini and Jeannot were about the same age but she was unaware of the passionate permutations by which she was surrounded, being preoccupied with her American Consul. He would collect her from the Einsteins' villa or they might have a rendezvous in Aix. William warned her that if this eminently suitable escort caught so much as a glimpse of the *ménage* at La Tour she would never see him again.

That summer, both Alvaro and Nini were the victims of a mischievous fate. Puck was laughing. Motoring along a lane, Nini and her admirer caught sight of a dog. 'Stop!' she cried. 'I'm sure it's one of ours, one of Mummy's strays. He's got away again; we must take him home.' The frightened, scruffy dog was enticed into the car and driven back to La Tour. William Einstein was right; this was the last time that Nini saw her beau.

Inevitably, Meraud too proved right, and when winter came all those who had been temporarily divided reformed a loving circle around her *cheminée*. But no wheel of fortune with Meraud at the hub was going to run smoothly for long. Within a matter of weeks Alvaro's luck also changed.

It was as if the devil himself had arrived when the only man he had ever detested appeared at La Tour – not Maurice, he had never hated him: he had almost respected him. After all, when it came to a fight, the best man was entitled to win.

Brian Howard's arrival was quite unexpected. Just as he had

saved himself twice when Alvaro threw him out of Meraud's hotel window in Paris, by scrambling back into the room unscathed instead of breaking his neck, so now there would be no means of getting rid of him: he was like a persistent wasp which ruins a picnic.

Naturally, Meraud welcomed him and was kind to his martyred homosexual companion, Sam. In the past, Brian had been one of her favourites, but many hearts, not only Alvaro's, sank when he announced his intention to live near darling, darling Meraud for the rest of his life: she knew everyone and everything and could help him buy or rent a villa near Aix.

At first even Nini had to admit that when sober, Brian's biting wit and gift for sarcastic repartee made him scintillating company. She had no idea that twenty years earlier her father had attacked him so violently. However, Alvaro had mellowed since those turbulent days, and he was no longer physically fit. Even under provocation, far from attacking this intellectual bully, he ignored him. Nini noticed that if they turned up at Lat Tour at the same time, while Brian held forth at one end of the room, Alvaro would either sit hunched in a corner apparently detached or engage in some earnest philosophical discussion with a kindred spirit such as Pierre Talcoat or William Einstein. Fortunately, Cingria had already removed Jeannot to Switzerland . . .

Invariably, Brian was half-drunk by the time he arrived. After another bottle of wine his behaviour became so aggressively insulting that eventually everyone, including Meraud, agreed that his destructive presence was to be discouraged. Only Alvaro appeared indifferent towards him.

Brian invited Meraud and Nini to join him and the long-suffering Sam for dinner *Chez* Tholonet, the famous restaurant near Aix, on Christmas night: an occasion not particularly celebrated by the French. In advance he had ordered roast turkey and Christmas pudding, insisting that at the crucial moment the pudding must be borne into the restaurant *flambée au cognac*.

Nini grew more and more nervous as Brian became increasingly viperish. Anxious to please the eccentric English *gentleman*, the highly respected chef had been at pains to improvise this traditional English dish at short notice. The venture was not a success and a sad-looking version of *le poudingue* arrived without a flicker of flame. Brian made a frightful scene, shouting

obscene insults at M. le Patron. Nini had never felt so embarrassed. However, Meraud rose to the occasion and disappeared into the kitchens, endearing herself to the offended staff who were more used to compliments than complaints. After some dangerous experiments, she at last succeeded in igniting the pudding and heralded by the ammoniac smell of burning hair, bore it in triumph to their table, her fringe shrivelled and her eyebrows singed.

After this and other even more unpleasant scenes, Meraud and all her neighbours determined that Brian should not move into Aix, or indeed anywhere near them. Estate agents and would-be vendors of 'desirable residences' which he inspected – fabulous villas with swimming-pools, panoramic views, exotic gardens, felt obliged, as friends of Meraud's, to point out confidentially certain disadvantages: the water supply was capricious – the well was inclined to dry up in the summer so the plugs didn't pull; when the *mistral* blew the draughts were appalling as the shutters didn't fit; or the swimming pool leaked. Certainly the Provençal tiles on the roof were picturesque, but they did not keep out the rain and dry rot had set in. Really, to a friend of Mme Guinness Guevara they could hardly recommend such a property!

Some traitor in his cups divulged the conspiracy to Brian. He stormed up to La Tour and, cursing Meraud, accused her hysterically of plotting to get rid of him. He had counted her as his most trustworthy friend – he was so disillusioned by her treachery that he was going to kill himself.

'What a good idea,' she said calmly. 'How can I help you? Ramon has a gun but I'm afraid he won't lend it. All I ask is that you don't do it here. It would be such a bore coping with the police or giving evidence at some tedious inquest when I might be painting. Now, you can either have some cheese wire or a sharp knife – but I must insist, as an old friend, that you should go down to the main road or back to your hotel, so that you don't make a mess on my property . . .'

Completely deflated, Brian staggered down the track. He left the next day for Cannes.

Some years later, after the death of Sam in an accident, Brian did commit suicide in his own typically theatrical way. He was genuinely mourned by many who had loved him, Meraud in-

cluded. Presumably Alvaro, who had never laughed, could have told himself that he who smiles last, smiles longest . . .

At La Tour such dramas were commonplace, but in a few weeks there were other changes. One at least was constructive. Meraud agreed with Ramon and Louisette that it was time for the caravan to move on; after all, gypsies were flitters and rarely camped for long in one place; fireflies, Ramon and Louisette had created their ephemeral magic. Like Thamar, Meraud dropped them into her *oubliette*. She had only to wave a scarf from La Tour and they were replaced. Another couple, Raoul and Suzanne moved in. The change was a blessing, approved by Alvaro (and even Nini) and all Meraud's friends.

Pretty Suzanne had been Meraud's inexperienced young *femme de ménage* at her flat in Aix. She had learned a lot since then, not only through Meraud's domestic training . . . Raoul was a mechanic, and they had a daughter – a slightly built child whom they brought with them. Their standards were totally different from those of the gypsies; Raoul at once set to work installing some plumbing and, after wrestling with saucepans on a trivet over a wood fire, Suzanne took the intiative and paid the deposit on a brand-new cooker in a modern shop in Aix.

Now it was Uncle Loel's turn to take over responsibility for Nini; she was eighteen and in his opinion it was high time she returned to Paris to 'come out' in Society. Few debutantes of 1950 were as privileged as she. For her coming out ball, Uncle Loel hired the most fashionable premises in Paris, 12 Rue de Poitiers. *La crème de la crème* arranged to give dinner parties beforehand. Lady Diana Cooper, then the British Ambassadress, agreed to be the hostess at a dinner party for Nini and a selection of young people including eligible diplomats and officers from the smartest French regiments. Daisy Fellowes offered to entertain the more amusing young marrieds; Aunt Tanis, indeed everyone chic and beloved by international Society, rallied round to make the occasion a success. A ravishing dress from Jacques Heim was ordered for Nini. Meraud explained that Alvaro would not be well enough to attend. Lady Diana vaguely remembered Chile from the old days when she and Iris Tree were at the Slade.

It was unanimously agreed that Meraud, being the most artistic member of the Guinness family, should co-operate with Cecil

Beaton over the decorations. Everyone was confident that between them, they would devise a sensational theme. This was a challenge as, before the war, throughout the twenties and thirties, every imaginable decor had been exhausted at hundreds of parties. Cecil Beaton felt both confused and frustrated when Meraud insisted most vehemently on *economy*, saying: 'We have scarcely any money to spend.' Always sensitive and considerate, how could he ask if it were she or Loel who was paying?

It was Cecil Beaton who suggested a rustic scene as an amusing contrast to the opulent background and sophisticated guests. Meraud applauded this inspiration. It had the advantage of being cheap. Instead of vast floral confections of roses, lilies and orchids, at the foot of the staircase and in corners of the magnificent rooms there would be corn stooks, sheaves of barley and wheat – enlivened by masses of cornflowers, poppies and wild marguerites, artificial perhaps. Somewhere – in the ballroom maybe – it might be fun to have a haystack; as the evening wore on, the more energetic or somnolent guests might climb a farm ladder to romp about or even sleep on the top of it.

When news of these hectic preparations reached Alvaro in Aix, and Susana in the United States, they both recalled how years before, in Normandy, Alvaro had ordered the chauffeur to stop the Rolls-Royce in a lane so that Nini could pick *les jolies fleurs* in a field and clutch the little bouquet as she sat on his knee chattering affectionately in French.

So many guests accepted that Lady Diana and Meraud decided at the last minute that the beautiful courtyard in Rue de Poitiers would need to be included and decorated. Cecil Beaton thought that stuffed birds perched in the floodlit trees or suspended on invisible wires from the branches would make the bucolic effect more dramatic. Meraud and Cecil drove around Paris scouring the junk shops and taxidermists.

Recalling the occasion twenty years later, Lady Diana admitted that although some of the older generation enjoyed it, for various reasons the ball was not 'an unqualified success'; she was acutely aware that Nini, far from appreciating what was intended as a fabulous treat, was hating every minute of it. Indeed, at one moment, she left and had to be coaxed to return to the ballroom and dance until the end. It occurred to Lady Diana that the poor child might be pining for some beau she had met in Aix – a

penniless artist friend of her parents perhaps? Another factor which contributed to the general underlying anxiety was the news from the Embassy that war had broken out in North Korea – many of the guests could scarcely disguise their fear that this disaster might lead to the Third World War. Somehow, the bucolic atmosphere was sinister; the black crows hovering over the scene like vultures reminded her of death. However, despite this unpromising beginning to her Season, Nini, ever adaptable, became engaged within a few months to a most suitable young man.

When Meraud returned to La Tour exhausted, she was horrified to find that, thinking to please her, Alvaro and Raoul had smartened up her jeep; they had patched the bullet holes, knocked out the dents and painted it a uniform grey. She loathed grey and regretted the change in her rusty old friend. A realist, but imaginative, she preferred people and things with their faults and scars undisguised. She loved Alvaro and others in spite of what they were, rather than because of what she might ideally prefer or imagine them to be. This seemingly unconventional creed amounted to the forgiveness of sins.

While Nini was being courted and fêted in Paris by her M. Pierre Firmin-Didot, in a totally different milieu Jeannot met Curtis Harrington. An American boy in his early twenties, Curtis after leaving college had been sent to Europe by his father to absorb *kultur* and to learn languages. He was clever and had already made three experimental movies in surrealist style, which had been shown at private film societies in Munich and Paris. Cingria had admired them and it was through him that Jeannot and Curtis had met and become good friends. Curtis planned to leave in September for the Film Festival in Venice. The thought of spending the next six weeks in deserted Paris, where all the most stimulating people had already been replaced in the cafés by American tourists, was depressing. Jeannot too felt restless and was penniless; Cingria had not offered to take him away that summer. At least Curtis received a five or ten dollar bill enclosed in a letter from his father nearly every week.

Jeannot suggested: 'Why don't we go down to Aix? You should see Provence. We can cadge lifts and take buses. There must be plenty of boats from Marseilles to Venice.' He added that Meraud might lend them her flat. Curtis needed little persuasion.

Jeannot had already described how at this time of year Aix was alive with artists, and how the previous year he had made friends with Meraud and Chile; as a married couple they sounded exceptionally attractive.

When at last the boys arrived in Aix, Jeannot called at La Tour and Meraud did indeed offer them her Cours Mirabeau flat. On meeting the legendary Mme Guinness Guevara, Curtis agreed that 'she was *adorable*, absolutely fascinating, always surrounded by a stunning throng of young of all ages'. Fortunately for them, the boys were often invited for meals and Curtis revelled in the company and the cooking. Alvaro was often there. Nothing that Jeannot had said about this couple had been exaggerated. Meraud looked no more than thirty-five and sometimes she seemed 'more like a kitten than a cat. Alvaro was tall and thin; he moved like a sleepy tiger. His hair was black and his face was very brown although he always wore a hat. His clothes were casual but clean.' When the boys were alone, Jeannot would regale Curtis with stories about these friends; Chile was only jealous of one man in her life; yes, it was unlike him but he had once admitted this. No, Jeannot could not remember his enemy's name – not a recent lover, certainly not William Einstein, whom everybody liked. As far as Curtis could see, she had no lover now but was surrounded by hoards of doting friends.

Number 61 Cours Mirabeau was within a stone's throw of Alvaro's flat. Soon a routine was established and all three met every day. Other impoverished and cunning inmates of 61 watched the post; they pounced on letters addressed to Curtis with American stamps and held them up to the light. If five or ten dollar bills were enclosed, by the time Jeannot and Curtis, who often overslept, rushed down the many flights of stairs leading from the attics to the café, they would be told that the postman had not called that day.

Alvaro was well aware of their plight. He knew Aix like the back of his hand; every morning he led them to the market. The stallholders greeted him affectionately, recommending a choice of the particular fruit and vegetables they knew he liked. Jeannot held Alvaro's purse and paid. Curtis walked behind with the basket. Jeannot would drop a few centimes from the change, as if by accident, among the grapes and spinach as he tipped them in, or held his hand behind his back, signalling to Curtis, who

261

with luck might discover a palmed franc. If so, he would lag behind and, once Alvaro and Jeannot were out of sight, would dash back and buy a kilo of potatoes, an onion, a few grams of pasta or rice, and then innocently join them at a small shop in a back street belonging to Alvaro's favourite fishmonger or butcher. Curtis thought Alvaro absurdly fussy; he was obviously spoilt, rich and stingy. Curtis and Jeannot could have devoured a hunk of horse, a bucket of snails or a string of black sausage. Americans being traditionally hospitable and generous, Curtis was at first shocked and later resigned when Alvaro only ordered some delicacy for himself – a small fillet of fish, an *escalope* of veal or a little minced beef. As if to add insult to injury, on the evenings when Meraud did not invite them, he expected Jeannot to do the cooking in their flat, using their gas.

While wolfing mounds of *pommes frites* or spaghetti, they watched him toy with some enviable dish. Not only this was annoying; Alvaro was writing some boring dictionary – it was intuitive, he said. Far into the night he and Jeannot would discuss philology, philosophical disputes and obscure definitions in French. Curtis had only picked up a smattering of the language. He felt left out, just as William Scott had in Paris with Alvaro and Geoffrey Nelson. Hour after hour, as the evening dragged on, their conversation, comparing Aristotle and Plato, the cosmos and the infinite, became less and less comprehensible to Curtis. Eventually, he and Jeannot would accompany Alvaro back to Rue Papasaudis; only two or three times did he invite them in for a glass of wine. The place looked like a junk shop.

As the weeks went by, Curtis realised that, although Alvaro never complained, his face was growing grey under his tan. He drank very little and his food, however well cooked by Jeannot, would be pushed aside, his whole body twisting in a spasm of pain. Even the most bland and delicate dish seemed impossible for him to digest. He also realised, after talking to Meraud or one of their friends, that Alvaro had 'very little money and was most reluctant to sponge on her as so many did'.

Love is as hard to hide as a cold but Curtis noticed nothing. Watching Alvaro and Jeannot with their heads together talking interminably and always in French about this boring old dictionary which began with *l'Absolu*, Curtis wondered how and when it would end. A love as strange as this was incompre-

262

hensible to him. He was sure that Alvaro was still in love with his wife, jealously and possessively, however hard he tried to disguise the fact. Although Alvaro was admittedly still attractive, he was now fifty-seven, an old man and sick. Sex could be no longer of the slightest interest to him, whereas Meraud was still full of vitality.

For Alvaro, the high spot of the week was Sunday, when he and the boys would sit on the wall of the cemetery. It made a change because the town's playing-fields were opposite and they could watch noisy football games, even joining in the shouting, and cadet parades. 'We are in the front of the stalls,' Alvaro would say, or, if they climbed on to a tomb: 'Now, we are up in the gods, the balcony.' Crowds seemed to fascinate him. He enjoyed watching the ice-cream sellers and the citizens of Aix strolling by in their Sunday best, their children sucking at straws in bottles of lemonade, dodging the cyclists.

The time was drawing near for Curtis to leave for Venice. Typically, it was darling Meraud who suggested that before he left he should show his films to a select audience and so she hired a small hall in Aix for the event. The place was packed, and Curtis was touched when Alvaro arrived looking immaculate, dressed in a dark suit, a white silk shirt and Lanvin tie, his black hair groomed and shining as if the occasion demanded the same respect as some important private view in Paris. After the showing, everyone applauded. Alvaro came up to congratulate him, smiling, in fact beaming; he kissed Curtis on both cheeks and slapped him on the back. After all, Jeannot was right; 'Meraud was a lovely person and Chile a regular guy.'

When Curtis left for Venice, many of the others returned to London or Paris, and Jeannot moved in with Alvaro. By now he loved him intensely and emotionally; being so close to him physically, the experience was certainly erotic, but he found it impossible to explain to himself, for want of words, not included in Alvaro's dictionary, why he was not *in* love. There was nearly forty years difference between them. If only they had met ages ago in London or Paris. If only Alvaro were not so desperately ill. In love, as in war, the important factor is timing.

Cingria returned to Aix. Perhaps Meraud had sent for him as the one friend who would understand the situation completely. Nini too reappeared with her fiancé for a brief visit, full of

their wedding plans; the marriage would take place at the Basilica of Sainte-Clotilde and the reception would be held at the Ritz. Her dress would be exquisite. For the honeymoon, Uncle Loel had put a fabulous yacht at their disposal. Alvaro gave them his blessing.

Soon after she and her fiancé had left, Jeannot met Meraud in Aix and told her that he was sure Chile was dying. According to the best doctors, the X-rays showed he could only live a few weeks – perhaps a few days. The cancer attacking his liver and lungs was so far advanced that it was impossible to operate. Cingria tried to comfort her. Her shoulder shook and she wept as she repeated : 'Poor Chile, dear Chile . . .'

Meraud was not one to give up or give in. Some positive action must be taken immediately. She and Jeannot returned to Aix in the trap and, as if by chance, she called at Alvaro's flat, where he was lying in bed, and said : 'Darling, you have a bad cold and this room feels damp. I'm sure it would be sensible for you to come back to La Tour with me.' Yes, there was a room upstairs – it was warm. Raoul had installed some plumbing. Charles Albert could move into 'Canada' – No, of course he wouldn't mind, and Jeannot would be near: the Einsteins opposite would welcome him.

Alvaro agreed. Meraud and Jeannot left to prepare for their invalid. Meraud asked : 'Should we call at the hospital first, see the doctors and ask them to produce a trained nurse to look after him?'

'No. I will look after him.' Jeannot replied firmly. Meraud warned : 'I hope you realise what this will mean – not only the physical but the emotional strain of watching someone you love die.'

'We both love him and we'll manage,' Jeannot insisted.

Alvaro was collected in the jeep. Suzanne had spread some washing to dry and bleach in the sun on the bushes. This reminded him of Griselda so many years ago in Chile. Also some children were flying a beribboned kite. Many similar things he noticed were nostalgic; was that a vulture overhead? No, it was only a hawk about to swoop on a vole.

He asked that the bed, bought in the Flea-Market and so disapproved of by Nini, should be moved nearer to the window as the view was so magnificent. It would be even better if someone

could cut a branch from that tree – the design, framed by the shutters, would be improved. No one had a ladder tall enough to indulge this whim.

During the next week or so, he would get dressed and join the others outside for lunch on the pebbled terrace. Meraud and Jeannot noticed that his beautiful thin, brown hands trembled a little and his fork clattered against his enamel plate. He hardly touched the rusks and raw minced beef put in front of him. He grew more emaciated every day but never referred to his ill-health and, although no one had told him the results of the X-rays, everyone at La Tour was convinced that he knew the truth and accepted it with admirable dignity.

Cingria remarked that he appeared more noble; how proudly he carried himself and how gracefully. He confessed that he had always suspected that Chile had Indian as well as Spanish blood. Alvaro seemed amused: how could *he* tell? No member of his family would ever have admitted this, indeed no one in all South America would have dared whisper such a suspicion – but he was not in the least offended.

As his suffering increased he stayed upstairs, stretched out on the bed staring out of the window. The doctor called frequently to inject him with morphia. When conscious, he might catch a glimpse of Meraud trying to relax in the sun, deftly shuffling her old pack of cards as she played Patience, or sketching one of the sixteen dogs who lay sleeping around her and the innumerable cats, seeking for scraps under the table or feeding their kittens in a patch of shade.

She and Jeannot took it in turns to look after Alvaro during the day: at night one of them would sleep fitfully beside him in a chair. He would regain consciousness without warning and talk lucidly. After his last injection, Meraud was surprised when he chose music as a topic; he had never told her how, before and after the earthquake, he had played Chopin's *Funeral March*. He asked her what she thought of his favourite composers: Beethoven, Schubert and Chopin. She had had no idea that he had once been thought a child prodigy by his music professor, Herr Schaub, and the Guevara family. Perhaps Alvaro had never discussed music with her before, knowing that she preferred contemporary to classical music? Before sinking into a coma, he also talked about boxing; he had always enjoyed a fight, but had not

265

always won. The last opponent had been an ugly brute – a butcher . . . Who had stolen his Gold Belt?

When the doctor called on October 11 he said that Alvaro might revive for a moment or so but that the end was very near. Although as far as they knew, he had never attended Mass, everyone at La Tour assumed him to be a lapsed Catholic – no one realised that he had never been confirmed. Meraud rushed out of the house, clambered into the jeep, and drove frenziedly down the precipitous lane to Aix. Hatless and breathless, she ran into the cathedral and spotting a little priest, grabbed his arm: 'You must come at once. My husband's dying. Please hurry. I can drive you there.' The startled priest climbed into the jeep beside her. Clutching his soutane, he scrambled up the last few metres to the house and went up to the room where Alvaro lay. They were left alone while the others shivered around the fireplace, loading it with any rubbish they could find to make a blaze: old letters, a broken comb, newspapers . . . No one spoke. A few flames rose and then sank.

The little priest came slowly down the stairs murmuring a prayer and told them that Alvaro had received absolution. He died the same night – 11 October, 1951.

Meraud and Jeannot found the *Dictionnaire Intuitif* lying open beside his bed; having begun with *Absolu*, he had reached 'H' – *Harmonie*:

'La discorde vient chasser la mort dans son plus insidieux déguisement, qui est l'harmonie, qui nous tue en flattant nos sens, nous faisant tomber dans une somnolence comme celle que donne le parfum d'une fleur venimeuse qui attire toujours avec sa promesse de dormir.'

Epilogue

The news that her father was dead reached Nini three days before her wedding was due to take place on October 15. Uncle Loel cancelled the reception at the Ritz but the marriage service took place in an atmosphere that was both emotional and dramatic. The bride and groom left at once for the funeral.

After the Mass in Aix Cathedral, Alvaro's coffin lay temporarily in the cemetery where he had once enjoyed watching the world go by. Meraud and his closest friends agreed that he would not have wished to remain permanently among the elaborate marble tombs and iron crosses. She, especially, felt sure that he would have preferred to be buried near La Tour de César in the country parish of Saint-Marc. The heart of this wild region is a strange place reached by a steep narrow road through a wood. Saint-Marc consists of a little church with a small walled-in graveyard on one side and the *mairie* on the other. There is an inn and one cottage.

In Provence, October can be like an Indian summer. While Meraud arranged with the priest and the mayor for space to be found for Alvaro and paid for the few square metres of consecrated ground, Cingria wandered about and noticed a few drowsy people lolling on the patchwork of gravel and burnt grass in front of the church. Others were sitting on outcrops of stone in silent meditation. As he wandered further, he discovered the skins of foxes, rabbits, moles and hares nailed to the trees or hanging from cords to be cured in the sun. Another intimate friend of Alvaro's, who visited Saint-Marc, felt that these sinister remnants of wild animals crucified upside-down in the wood were

267

evil. It was as if some witch, shut out from hallowed ground, had been at work. Alvaro would have detected an evil omen.

After a short service, the coffin was sunk deep into the consecrated rock. Almost as soon as the sparse topsoil was smoothed over, Meraud began to make a design in majolica to cover the grave. In the centre she placed a large angel with the muscular shoulders of a fighter, strong enough to support the wings of some mythological bird. Alvaro's name and the dates of his birth and death formed a simple border. Each one of the hundreds of hand-painted tiles was baked in a wood-fired kiln belonging to a friendly ceramicist and fitted like pieces of a jigsaw puzzle into the whole. The background and overall effect was celestial blue.

There are occasional frosts and *tremblements de terre* in the locality and over the years these acts of God have shattered her work. Now, Alvaro's grave is but a fragmented image of her original idea. Wild flowers have seeded themselves in the cracks; blue splinters have been scattered over the path and the effect among the typically French conventional memorials so carefully tended and decorated with plastic roses and tin wreaths is extraordinary.

When Meraud read all Alvaro had written of the *Dictionnaire Intuitif*, she determined to have it privately printed in a limited edition for his friends. Cingria was already dying but he began writing an introduction. Meraud left for England to arrange a posthumous exhibition of such works of Alvaro's as had survived. John Rothenstein, Director of the Tate Gallery, much admired Alvaro's painting and was enthusiastic, but after several meetings he and Meraud reluctantly agreed that there were not enough pictures to fill a large room at the Tate. Eventually it was Freddie Mayor who offered to put on the show at his own gallery in South Molton Street, in November 1952.

The exhibition proved a great success and Meraud wrote to Susana, telling her that about ten pictures had been sold: 'One to Mr Winston Churchill (a portrait of me), the self-portrait he painted when he was thirteen and the picture of Mrs Rosa Lewis to my brother Loel . . .' The full-length portrait of Nancy Cunard was sold to the National Gallery of Victoria in Melbourne.

There were many reviews: *The Times* art critic, Alan Clutton-Brock wrote: 'At the Slade where he was rightly considered a

prodigy, another Mr John or even more so, at the age of thirteen, he had painted a self-portrait ... which is an astonishingly mature and sensitive work ...' *The Observer* critic, Neville Wallis praised Mr Mayor for reminding 'an enlightened society ... of this exotic artist who flitted through the twenties like an iridescent dragon-fly'.

Much too late for this exhibition, Meraud discovered the thirty-four heads of Maruja in 1971, thick with dust on top of a cupboard at La Tour. When asked the identity of the sitter, she had no idea who the 'dark lady' could be; perhaps Chile had been inspired, or obsessed, by a face he had seen in a café, or possibly by a photograph in some magazine ...

Even after they had been married for twenty-two years, Alvaro never insulted his wife by divulging the slightest detail of the other women in his life. He preserved his Latin respect and ideal of marriage to the end. When possible emotional and physical diversions always remained secret. He shared with many earlier artists a concept of love divided between the sacred and the profane. He could never shed a sense of guilt from these extraneous physical or even emotional experiences – he was conscious-stricken by the many sins which he knew would always be committed in the name of love – betrayals, intrigues, disloyalties, lies ...

Cingria finished his introduction to *le Dictionnaire* just before he left La Tour for the last time during the summer of 1954. Desperately ill, he was taken to Geneva by ambulance and died within three days. Naturally, Meraud suffered most terribly from the loss of her greatest friend so soon after Alvaro's death.

It was some comfort when *le Dictionnaire*, printed by Suzie David, was acclaimed by all Alvaro's friends – copies were sent to a great many people including at random Augustus John, the Sitwells, Stravinsky, Picasso, Gabrielle, Germaine and Olga Picabia, Matthew Smith and T. S. Eliot. Jean Paulhan wrote enthusiastically to Meraud asking for permission to reproduce extracts in the December 1954 issue of *Nouvelles Revues Françaises*.

Characteristically, Gertrude Stein had written of Meraud: 'Paint she is.' She is still painting, whether at La Tour or in her studio in Paris; it is a unique experience to stay with her in

either place. She is surrounded by her own lively pictures – oils and collages – and the books written by her friends. She will never seem old or be alone, as her personality is both sympathetic and magnetic. Her eyes still fascinate like blue butterflies. She is still as supple as a ballerina and as graceful as one of her cats.

Jeannot still lives on the estate in what was once a ruined *cabanon*, now converted into a civilised cottage. He and a friend actually make, as well as design and decorate, rare musical instruments. Raoul and Suzanne have proved faithful and practical retainers. Nini has produced three grandchildren for Meraud and now adores her.

Art critics, dealers and collectors still have to assess Alvaro's work; this is in no way a critical biography. The reader may judge that in the end Alvaro and Meraud Guevara suffered an essentially loving marriage.

Appendix I

Editorial Comment

PAGE 38
The Slade School was founded in 1871. The first Professor of Fine Art was E. J. Poynter. When Alvaro Guevara enrolled Poynter was 77 and had become Sir Edward Poynter, bt., P.R.A.; he had maintained his connection with the school as official Visitor. In 1893 he had been succeeded as Professor by Alphonse Legros who had retired in favour of Frederick Brown. By the time Alvaro joined in 1913, Professor Brown had engaged a Victorian surgeon-turned-artist, Henry Tonks, as assistant professor. The other members of the teaching staff were Ambrose McEvoy and Philip Wilson Steer. The same year Roger Fry was appointed the school lecturer on the History of Art. Like William Orpen, Augustus John had proved a brilliant ex-student and retained a loyal interest in the school.

PAGE 60
All the work done at the Omega Workshops was anonymous and none of Alvaro's work has been identified. The post-impressionist room which Roger Fry privately commissioned Alvaro to design, and lent him Omega Workshops assistants to execute during autumn 1916, has not been found at the time of writing.

PAGE 208
Eventually Pablo Picasso became the owner of the Domaine and some of the estate of Notre Dame de Vie at Mougins, near Cannes.

PAGE 249
Ortiz de Zarate was another Chilean painter who had been a cloes friend of Modigliani and was still one of Picasso's favourites in the '30s. He drank to excess and dressed like a Russian Grand Duke of the nineteenth century. So unstable was his temperament that according to gossip, he was in and out of 'loony-bins' but

271

fortunate in sharing with Cingria the generous patronage of Alden Brooks – a very rich man. He survived to paint Meraud three times, but at the time of writing, there is no trace of these portraits.

PAGE 264

According to Whistler's biographer James Laver, Whistler had lived at 86 Rue Notre Dame des Champs in a very similar house. Meraud Guinness Guevara says that 74 was owned by a contemporary American painter known as The Angel of Paris.

PAGE 283

Sir Charles Orde, British Ambassador to Chile from 1940 to 1945, has no recollection of Alvaro Guevara ever calling at the Embassy.

PAGE 284

According to his framer Focardi, Picasso also experimented in encaustic technique, which was used by the Egyptians in the Roman period for their *Mummy-portraits* on coffin lids. Surviving examples of these have revealed that the method consisted of mixing floral and vegetable dyes with hot wax as a medium and applying the colour to a prepared surface with a variety of tools, probably including a feather brush.

PAGE 331

Pablo Neruda, the Nobel Prize-winner, said in 1972 when he was Chilean Ambassador in Paris, that he wanted to translate *Dictionnaire Intuitif* into Spanish, but he died before he could accomplish this.

D. H-H.

Appendix II

Chronology

1873
Luis Ladron de Guevara, aged thirty-six, marries Ida Juana Maria Reimers Bode, aged sixteen. Twelve children were born between the years 1874 and 1897 in Valparaiso.

1877
Lucho Guevara born.

1880
Horacio Guevara born.

13 July 1894
Alvaro Guevara born.

1895
Sibila Guevara born.

25 May 1896
Susana Guevara born.

August 1897
Edmundo Guevara born.

1 June 1902
Horacio Guevara goes insane, commits suicide at 130 Queensgate, London, S.W.7.

Summer 1903
The Guevaras visit their *fundo* – Curileo in Arauco. Alvaro makes friends with the Indians.

25 June 1904
Meraud Michael Guinness born in London.

1905
Alvaro is taken to the circus. Ever after, he admits this was the first inspiration in his life and had a profound influence on his painting.

Spring 1906
Alvaro refuses to be confirmed in Roman Catholic faith.

16 August 1906
Lucho arrives from England.
Earthquake in Valparaiso. Later Alvaro admits that this was

the most terrifying experience of his life and that it deeply affected him.

1907

Alvaro completes first self-portrait.

1908

Alvaro takes first painting lessons.

1908

Alvaro's life-sized portrait of his mother is exhibited in Keisingers' window, Valparaiso. Shortly afterwards Alvaro receives his first commission.

1 December 1909

Alvaro leaves for England with his closest sisters, Sibila and Susana, and with an elder sister Raquel and her husband Albert Helfman.

1 January 1910

Alvaro, his sisters and brother-in-law arrive in London.

1910

Alvaro attends Bradford Technical College in preparation for his entry into the family's wool mills there. He secretly attends Bradford Art School and fails his examinations at the Technical College.

May 1910

Contemporary Arts Society founded in Philip Morrell's house – committee included, among others, Ottoline Morrell, D. S. MacColl, Charles Aitken, Bowyer Nichols, Roger Fry and Clive Bell.

Summer 1910

Alvaro's parents arrive in England with their youngest child, Edmundo, and move into the Majestic Hotel, Harrogate.

8 November 1910 – 15 January 1911

Roger Fry, with Desmond Macarthy as secretary, arranges first Post-Impressionist exhibition at the Grafton Galleries, 8 Grafton Street, W.1. It includes work by Van Gogh, Matisse, Cezanne and Picasso.

31 July 1911

Lucho Guevara marries Joyce Nelson at Knaresborough Registry Office.

March 1912

The first Futurist exhibition in England held at the Sackville Gallery, Sackville Street, W.1.

25 July 1912
Alvaro's father dies, aged 71, at the Majestic Hotel and is buried next to his son Horacio in Harrogate Cemetery.

Summer 1912
Lucho Guevara marries Joyce Nelson in the Presbyterian Church, Prospect Square, Harrogate.

1912
Alvaro wins a scholarship to the Slade School of Fine Arts, University College.

1912
Alvaro and his mother move to 79 Holland Park, London, W.11. Sibila and Susana in Paris. Edmundo attends Wellington College.

5 October – 31 December 1912
Roger Fry arranges second Post-Impressionist exhibition at the Grafton Galleries, 8 Grafton Street, W.1.

6 January 1913
Alvaro enrolls at the Slade School of Fine Arts.

Early 1913
Alvaro meets Augustus John.

8 July 1913
The Omega Workshops, Fitzroy Square, organised and directed by Roger Fry, officially opens. Duncan Grant and Vanessa Bell are directors.

End Summer Term 1913
Alvaro wins prize for Head Painting and a Certificate for Drawing at the Slade.

End Summer 1913
The Guevaras move to Essex House, Campden Hill Road, W.8.

Early 1914
Alvaro meets Nancy Cunard for the first time at the Eiffel Tower Restaurant.

Summer 1914
Alvaro shares 'Leila' with C. R. W. Nevinson and Albert Rothenstein.

End Summer Term 1914
Alvaro wins scholarship worth £35 to stay at the Slade for two more years.

July 1914
Alvaro, Sibila, Susana, Edmundo and their mother visit Aboyne, Scotland.

August 1914
Outbreak of World War I.

September 1914
Alvaro meets Michio Ito the Japanese dancer.

November 1914
Lady Ottoline Morrell resumes her 'Thursday Evenings'.

Spring 1915
The Guevaras move from Essex House to 47 Holland Park Avenue, London, W.11.

Summer 1915
Alvaro wins Melville Nettleship Prize for Figure Drawing at Slade. Also wins First Prize for Figure Painting and First Prize for Head Painting.

June 1915
Alvaro stays at Garsington with the Morrells. Bertrand Russell, Duncan Grant and Maria Nys (later Mrs Aldous Huxley) are among guests.

July 1915
Alvaro stays again at Garsington.

Summer 1915
Guevara begins portrait of Rosa Lewis.
Probably meets Marie Beerbohm, cousin of Iris Tree.

Summer 1915
Roger Fry buys Alvaro's swimming-bath sketchbook.

Winter 1915
Exhibition of Modern Pictures organised by the New English Art Club at the galleries of the Royal Society of British Artists, 6a Suffolk Street, S.W.1. Alvaro not a member but shows *Music Hall No. 2* (No. 208).

End 1915
Alvaro enrolls for a further two terms at the Slade on full scholarship.

21 February 1916
Inaugural exhibition of Independent Modern Artists at the Alpine Club Galleries, Mill Street. Work by Alvaro shown but not mentioned in the catalogue.

Spring 1916
Alvaro moves to 1 Warwick Studios, St Mary Abbott's Terrace, London, W.8.

16 March 1916
Alvaro's mother and sisters prevented from taking the Dutch ship S.S. *Tubantia* back to Chile as she is mined in the Channel before reaching London Docks.

18 May 1916
Alvaro's mother and sisters arrive in New York on the S.S. *St Louis*. They meet Mrs Benjamin Guinness with her daughters Meraud and Tanis, together with Nijinsky at the Allied Bazaar.

Spring 1916
Alvaro and Roy Campbell decorate the Harlequin Restaurant in Beak Street, Soho.

21 June 1916
Roger Fry shows 28 of Alvaro's works at the Omega Workshops. Review: *The Burlington Magazine* August, by Walter Sickert.

July 1916
Alvaro exhibits with the New English Art Club at 'The Galleries', 6a Suffolk Street, S.W.1. *Maitre d'Orchestra* (No. 206), *Music Hall* (No. 291) and *Portrait Painting* (No. 293) all hung in the South West Room.

July 1916
Alvaro begins painting Edith Sitwell and forms deep friendship with her.

July 1916
First number of *Wheels* published, edited by Edith Sitwell. Alvaro contributes one poem and designs the end papers at Edith Sitwell's invitation.

Summer 1916
Alvaro leaves the Slade School.

Autumn 1916
Roger Fry commissions Alvaro to design and execute a post-impressionist room with assistants from the Omega Workshops.

10 February 1917
Alvaro's one-man show at the Chenil Gallery, King's Road, S.W.3, includes *Comedians*, *Music Hall*, *Fast Swimmers* and *Tight Rope Walker*. Catalogue missing at time of writing. Reviews: *Vogue* early March, *Colour* February, *West London Press* February 23rd.

April – May 1917
6th Annual Exhibition of the National Portrait Society, at the Grosvenor Gallery, 51a Bond Street, W.1. Alvaro shows *Louise* (No. 13), hung in the Large Gallery.

1918

Alvaro writes the poem *St George at Silene* and presents it to Nancy Cunard.

1918

Alvaro moves to 117b Fulham Road, S.W.3.

February – March 1918

7th Annual Exhibition of the National Portrait Society held at the Grosvenor Gallery, 51a Bond Street, W.1. Alvaro shows the following: *Miss Dorothy Warren* (No. 21), *Adam Slade, Esq.* (No. 40), *Mrs Falconer Wallace* (No. 43) hung in the Large Gallery, and *Lady Mary Starr* (No. 100) hung in the Long Gallery. Reviews: *Connoisseur* April, *Colour* April.

May 1918

23rd Exhibition of the International Society of Sculptors, Painters and Gravers held at the Grosvenor Gallery, 51a Bond Street, W.1. Alvaro not a member but shows *Trick Cyclists* (No. 74) and *Music Hall* (No. 75), both hung in the Long Gallery.

February – April 1919

8th Annual Exhibition of the National Portrait Society held at the Grosvenor Gallery, 51a Bond Street, W.1. Alvaro shows *Artist's Mother* (No. 1) and *Walter Taylor, Esq.* (No. 32).

March 1919

Omega Workshops close down.

May – July 1919

25th Exhibition of the International Society of Sculptors, Painters and Gravers held at the Grosvenor Gallery, 51a Bond Street, W.1. Alvaro exhibits *The Little Princess* (No. 25). Review: *Colour* August.

Summer 1919

Alvaro visits the Johns at Alderney Manor.

October 1919

26th International Exhibition of the Society of Sculptors, Painters and Gravers held at the Grosvenor Gallery, 51a Bond Street, W.1. Alvaro exhibits *The Editor of Wheels* (No. 37), a portrait of Edith Sitwell. Reviews: *New Statesman* October 18 *Colour* November.

Autumn 1919

Alvaro paints Ronald Firbank.

Autumn 1919

Alvaro paints Nancy Cunard and falls in love with her.

7 – 10 February 1920

10th Exhibition of the Modern Society of Portrait Painters held at the Royal Institute Galleries in Piccadilly, W.1. Although not a member Alvaro shows *Mrs Fairbern* [sic Fairbairn, née Nancy Cunard] (No. 128) and Autumn (No. 135). Reviews: *The Studio*, Vol. 79.

Spring 1920

Alvaro becomes a member of the new English Art Club and gives his address as 177 Fulham Road, S.W.3.

Summer 1920

The Editor of Wheels presented by Lord Duveen, Walter Taylor, and George Eamorfapoulos to the Tate Gallery through the National Art-Collections Fund.

June 1920

Ronald Firbank begins negotiations to lend Alvaro's portrait to the Tate Gallery. There is no trace of it up to date.)

7 June – 3 July 1920

Alvaro exhibits with the New English Art Club at the Royal Watercolour Society's Galleries at 5a Pall Mall East. He shows *Medusa's Trial* (No. 17); *Ronald Firbank* (No. 36) and *Football* (No. 56). Reviews: *Connoisseur*, August; *L'Amour de l'Art*.

Winter 1920

Art and Literature, Vol. III, No. 1 includes a reproduction of a drawing by Alvaro of a female nude. Atypically it was inscribed with his initials.

January – March 1921

10th Annual Exhibition of the National Portrait Society held at the Grafton Galleries, 8 Grafton Street, W.1. Alvaro shows *The Author of Modern Sculpture* [Kineton Parkes] (No. 6), hung in the Octagonal Gallery. Reviews: *Studio*, spring.

April 1921

27th Exhibition of the International Society of Sculptors, Painters and Gravers held at the Grafton Galleries, 8 Grafton Street, W.1. Alvaro shows *The Hon. Dorothy Brett* (No. 49). Review: *Colour*, June.

19 May 1921

Nameless Picture Exhibition at Grosvenor Gallery, 51a Bond Street, W.1. Alvaro shows portrait of Iris Tree sitting on a four-poster bed. Review: *Daily Mail*.

6 June – 2 July 1921

New English Art Club Exhibition held at 6a Suffolk Street, S.W.1. Alvaro shows *The Black Hat* (No. 7), *The Woollen Coat* (No. 70), and *The Fur Coat* (No. 81).

Summer 1921

Alvaro and his present mistress accompany Anita Berry on a visit to Harold Acton in Florence.

September 1921

Alvaro's portrait of Edith Sitwell hung in The Tate Gallery exhibition *British Art at the Millbank*. Review: *The Burlington Magazine*, September.

October 1921 – January 1922

11th Annual Exhibition of the National Portrait Society held at the Grafton Galleries, 8 Grafton Street, W.1. Alvaro shows *Viscountess Curzon* (No. 104), *Philip Gardner, Esq.* (No. 106) and *Lady Cunard* (No. 107). Review: *Connoisseur*, December.

24 December 1921 – 28 January 1922

65th Exhibition of the New English Art Club held at 6a Suffolk Street, London, S.W.1. Alvaro shows *Mrs Lewis of the Cavendish* (No. 10). Review: *Connoisseur*, February.

24 December 1922

Alvaro returns to Chile.

January 1923

Alvaro shows a portrait of his mother at the Museum of Fine Art in Santiago. Alvaro leaves for Arauco and becomes friendly with the Indians.

November 1923

Meraud Guinness enrolls at the Slade School.

1924

Alvaro is awarded the Gold Belt for boxing – as Champion of all Weights in South America.

1924

Alvaro paints Amalia Errazuriz.

1924

Alvaro conceives idea of *Fleurs Imaginaires*.

12 February 1924

Christopher Wood first mentions Meraud Guinness in a letter to his mother.

April 1924

Meraud Guinness leaves the Slade School.

1926
Meraud Guinness writes monthly articles for *Vogue*, comparing American and English society.
Summer 1926
Alvaro's mother sells her house in Vina del Mar and returns with Alvaro to London.
Early Autumn 1926
Alvaro and his mother arrive at the Vanderbilt Hotel, Cromwell Road, S.W.7.
September 1926
Meraud Guinness returns to the Slade School for Winter Term.
October 1926
Alvaro moves to Wilson Plant's house in Connaught Street, W.2.
November 1926
Alvaro has one-man show at the Leicester Galleries, Leicester Square, W.C.2, shared with Edward Wadsworth. Osbert Sitwell writes introduction to Alvaro's catalogue. Review: *Studio*, Vol. 92, p. 424.
April 1927
Aram Mouradian, a partner in Galerie Van Leer in Paris, meets Alvaro in London. They drive to Paris together. Edith Sitwell writes on Alvaro's behalf to Gertrude Stein.
May 1927
Alvaro forms deep friendship with Gertrude Stein and Alice B. Toklas.
June 1927
Meraud Guinness attends Slade School for Summer Term.
5 January 1928
Christopher Wood writes to his mother that he and Meraud Guinness have eloped to Paris. They fail to marry as Meraud has forgotten her passport. Five days later they agree with Meraud's mother to separate for a year.
Spring 1928
Edith Sitwell edits Alvaro's essay *Decadence and Materialism in this Age* (this manuscript was not submitted to a publisher and is missing at the time of writing). Alvaro becomes friendly with Picasso.
November 1928
Alvaro has one-man show of 25 *Fleurs Imaginaires* at Galerie Van Leer, 4 Rue de Seine, Paris IV. On the last day he meets Meraud

Guinness who arrives to hang her pictures for the following exhibition. Alvaro decides never to exhibit in Paris again.

2 – 15 December 1928

Meraud Guinness has one-man show at Galerie Van Leer, 4 Rue de Seine, Paris VI. Francis Picabia writes introduction to catalogue.

End 1928

Alvaro's mother chaperones him and Meraud on a motor tour of Germany.

Early 1929

St George at Silene published by Nancy Cunard as an early venture of the Hours Press.

20 January 1929

Alvaro arrives in London to stay with Stulik, owner of Eiffel Tower Restaurant, 1 Percy Street, Tottenham Court Road, W.1. He confides that he is to marry Meraud Guinness.

23 January 1929

Alvaro and Meraud marry at Henrietta Street Registry Office, Covent Garden, W.C.2.

January 1929

Alvaro and Meraud rent Mrs Nelson's flat in Fitzroy Square, N.W.1.

Summer 1930

Octavio Senoret and his mother, Alvaro's sister Sibila, stay with Alvaro and Meraud at L'Enchantement, their villa on the Guinness estate at Mougins, near Cannes.

July 1930

Sibila Senoret dies in Nice.

21 August 1930

Christopher Wood killed by falling under a train.

Autumn 1930

Sibila's son Octavio is taken to Paris by Alvaro and Meraud and stays in their house, 74 Rue Notre Dame des Champs, Paris VI.

Late 1930

Alvaro begins to paint *The Lanvin Dressing Gown*.

5 January 1931

Bridget Guinness, Meraud's mother, dies.

27 December 1931

Alvaro and Meraud's daughter born in the American Hospital, Paris. Gertrude Stein is present.

28 May 1932
Child baptised Bridget in Guinness family chapel at Notre Dame de Vie. Godparents include Meraud's godmother, Mrs Pat Campbell. The Picabias attend. As a christening present Francis Picabia produces a drawing of the baby.

1932
Francis Picabia introduces 'Maurice' to Alvaro and Meraud.

1932
Maurice and his fiancée are invited to L'Enchantement. Maurice leaves with Meraud for Paris. Maurice's fiancée returns alone to her home in Aix-en-Provence.

1935
Alvaro meets Sacheverell and Georgia Sitwell on a Greek cruise. He has his child with him.

1936
Alvaro paints Gertrude Stein and Alice B. Toklas.

1936
Susana takes her daughters Henrietta and Banda to visit Alvaro at 74 Rue Notre Dame des Champs, Paris VI.

2 April 1936
Benjamin Guinness marries again.

September 1936
Walter Taylor's collection shown at the Mayor Gallery. The Exhibition includes two works by Alvaro, *East End Restaurant* and *The Quartet*.

5 November 1936
News item in *Daily Express* says Contemporary Art Society have bought Alvaro's portrait of Walter Taylor from the Mayor Gallery. There is no trace of it at the time of writing.

1936
Loel Guinness marries, secondly, Lady Isabel Manners.

1939
Alvaro's daughter Bridget insists on being called Nini and, aged eight, is sent to Canada by Benjamin Guinness with Lady Eden.

4 July 1939
The late Sibila's husband, Senor Don Octavio Senoret, is appointed Chilean Ambassador in London.

10 – 22 April 1940
Meraud has show at Valentine Gallery, 16 East 57th Street, New York.

May 1940

Alvaro is painting at Angoulême when the Germans invade Paris.

9 December 1940

Almost all Alvaro's work destroyed by fire when Bourlet's warehouse at 11 Bourlet Close, London, W.11, is hit by a bomb including the following canvases: *At the Swimming Baths, Boxing, Music Hall No. 1, Female Jugglers, Weston's Music Hall, High Holborn, Signs of the Zodiac, Theatre Interior, Chair Dancers*; and the following identifiable oil portraits: *Philip Gardner, Kineton Parkes, Esq., Iris Tree seated on a Four-Poster Bed, The Beach Woman* [Dorothy Warren?]. Also twelve unidentified oil portraits of women, three unidentified ones of men, five portfolios of drawings and many other unidentified works too numerous to list.

1941

Alvaro and Benjamin Guinness' secretary, Miss Sylvester, are asked to 'caretake' 69 Rue de Lille, Paris VII.

1941

Alvaro's painting 'goes into mourning'.

(black and white period begins).

1941

Alvaro is arrested by the Nazis as a Chilean hostage and taken to the notorious *Cherche Midi* prison, 'The Death House'.

1943

Alvaro becomes paranoiac and is repatriated to Chile.

1943

Alvaro's mother dies and is buried in Valparaiso.

1943

Alvaro exhibits 123 drawings, mostly of Paris, at the Museum of Fine Art, Santiago.

1943

Alvaro makes many studies of Maruja, his niece.

August 1945

Alvaro is appointed Honorary Chilean Consul in London.

September 1945

Alvaro leaves Chile for London.

1946

Alvaro is posted to Berne, Switzerland, as Cultural Attaché.

1946

Nini attends l'Institut Fisher, Territet, Switzerland.

1946
Wilson Plant arrives in Berne and edits Alvaro's novel *The Dictator*. He submits manuscript to T. S. Eliot and Roy Campbell. At the time of writing this manuscript is missing.

15 December 1947
Benjamin Guinness dies in Normandy.

1948
Loel Guinness agrees to buy La Tour de César, near Aix-en-Provence, for Meraud.

1948
Nini joins Meraud in Aix.

1948
Alvaro moves into a flat in Aix. He begins work on his *Dictionnaire Intuitif*.

Summer 1950
Alvaro meets 'Jeannot'.

Late Summer 1950
A Coming Out party is given for Nini by Loel Guinness. Meraud, her Aunt Tanis and Lady Diana Cooper are the hostesses at 12 Rue de Poitiers, Paris. Cecil Beaton, assisted by Meraud, does the decorations. Alvaro does not attend.

1951
Alvaro is very ill. X-rays show cancer of liver and lungs. Meraud persuades him to move into Tour de César.

11 October 1951
Alvaro dies, aged 57.

15 October 1951
Nini marries Pierre Firmin-Didot at the Basilisque Sainte Clothilde in Paris. Meraud does not attend. Loel Guinness gives her away. The reception at the Ritz Hotel is cancelled. The couple leave for Alvaro's funeral in Aix.

Alvaro's coffin lies temporarily in Aix cemetery, but is subsequently interred in St Marc's cemetery in the Parish of La Tour de César.

November 1952
Memorial Exhibition is held at the Mayor Gallery, 14 Brook Street, London, W.1. Winston Churchill buys the portrait of Meraud, Loel Guinness buys the portrait of Rosa Lewis. National Gallery of Melbourne buys self-portrait and portrait of Nancy Cunard. Review: *Manchester Evening News* 13 November, *Man-*

chester Guardian 13 November, *The Spectator* 21 November, *The Times* 18 November, *Apollo* December, *Time and Tide* 22 November, *Sunday Times* 30 November, *New Statesman and Nation* 20 November.

1954

At Meraud's instigation, *Dictionnaire Intuitif* is privately printed by Susie David with a preface by Charles Albert Cingria.

November 1954

Exhibition of Drawings is held at the Mayor Gallery, 14 Brook Street, London, W.1. Reviews: *The Times* 26 November, *Manchester Guardian* 20 November.

1967

The Editor of Wheels is lent by the Tate Gallery to the National Portrait Gallery (L.138).

December 1973

More than 40 works, supposedly lost in December 1940, are discovered: including a number of the series entitled *At the Swimming Pool*, exhibited at the Chenil Gallery, February 1917, and various Theatre, Ballet, Music Hall, Circus and café scenes.

December 1974

Exhibition of Alvaro Guevara's works is arranged by P. and D. Colnaghi and Co., London.

Appendix III

Genealogical Speculations

South Americans say that the name Guevara is as common in Chile as Smith is in England. Any blood, however, which has produced even two such men as Don Fernando de Guevara, the bespectacled Spanish Grand Inquisitor painted at the end of the sixteenth century by El Greco, and Ché Guevara, that romantic revolutionary idol of the contemporary 'left-wing', must surely be exceptional.

Anyone trying to understand Alvaro Guevara as a painter or as a man may find the following information valid.

The 'Latin among Lions', Alvaro Ladron de Guevara, and his younger sister, Susana, were particularly proud of the reason for their branch of the family being called *Ladron* (or thief) Guevara. Susana, after she had completed her genealogical research, explained that her branch of this large family tree was dubbed 'thief' sometime before A.D. 905 when John Sancho de Guevara was a courtier of King Garcia Iniquez. According to a free translation of the story which Susana heard from her father and which she wrote down for her children, the Moors stormed the Palace of Aragon early in the tenth century and murdered King Garcia and his Queen who was heavily pregnant at the time. One of the courtiers, Don Sancho de Guevara was a witness of this event and when the Royal Guard finally overcame the Moors, he drew his sharp dagger and rushing over to the dead Queen, slit open her stomach and removed the live baby. Having wrapped the political bundle in his cloak, he escaped with it on horseback to a place of safety.

Soon after, when the people of Aragon assembled to elect a new sovereign, Don Sancho reappeared and holding up the baby prince to the crowd, declared him to be the rightful heir to the throne. Somehow he was able to prove that he had taken the child from the dead Queen's womb and it was duly elected as king, and given the name of Sancho the Caesarean. Don Sancho was honoured with the name 'Ladron' de Guevara 'for his pious theft' and awarded various titles and privileges.

According to a document found among the papers of his descendant, Alvaro Ladron de Guevara, on his death in 1951: 'The illustrious House of Guevara, called also Ladron de Guevara, Condes de Onate, is of ancient nobility of the Royal House of Spain and dates back to the ninth century. The name comes from the city of Guevara, in the Province of Alava . . . This city was the birthplace of a sixteenth century Conde de Onate, whose castle was built as a copy of the Castel St Angelo in Rome.

'All members of this House claim Royal descent . . . dating back to Don Pedro Velez de Guevara, Duque de Onate, who married Dona Isabel de Castilla, daughter of Tella de Castilla grand-daughter of Don Alonso, King of Castilla and Leon and Dona Leonora de Guzman.'

The Ladron de Guevaras eventually emigrated from Spain to Chile and settled in Rengo.

Appendix IV

Dictionnaire Intuitif

ABSOLU

Forme circulaire qui nous entoure, avançant comme l'échappée d'une pierre tombée dans l'eau, englobant dans son avance la terre solide. Dans le souffle grandissant de la coupole fragile de notre illusion, la forme en nous se gonfle et dépasse la lune et le soleil, et, s'en allant vers les étoiles, risquant de se dissoudre contre le bleu éblouissant du ciel, mais, capable à ce moment de se renvoyer en arrière.

Ainsi nous sentons brusquement, la terre en nous se réveillant, que nous sommes retenus esclaves dans l'atmosphère. L'espace et le temps sans bornes sont l'Absolu. Immuable, jusqu'au bout de notre destin, tenant à être obéi.

ACCIDENT

Si dans le ciel noirci par le vol d'une nuée d,eux oiseaux s'écrasent l'un contre l'autre, de honte, le soleil rougissant se coucherait à cet instant funèbre.

AMOUR

C'est une chose si volable l'amour que j'ai regretté beaucoup de ne pas avoir mis le mien dans un coffre-fort à la banque, et de n'être sorti dans la vie avec une bonne imitation.

ANALYSE

Glissé des mains d'une déesse sordide sur le point de s'endormir, un flacon d'une drogue venimeuse étiqueté 'analyse' est tombé chez les humains terrestres il y a déjà très longtemps. A son réveil la déesse sordide voyant le résultat de sa drogue est morte de joie.

AVOIR

Avoir un de ces petits meubles très en couleur, sur roues, le déplacer tout le long d'une plage brûlante au mois d'août, et vendre pour quelques sous d'exquises glaces aux trois parfums. Voilà avoir.

BEAU

De tous les butins de la vie le seul qui éclaircit les approches de la mort et de l'obscurité immuable, c'est le beau.

BON

Etre bon c'est vouloir la bonté. Les actes qui suivent ce désir n'ajoutent rien à nos mérites.

CALME

Il faut être muni d'un moteur intérieur pour bien supporter cet état. Sans cela la sérénité du calme terrifie comme elle terrifiait les marins à voile qui sentaient l'approche de la mort.

CANNIBALE

Quand reviendra le temps où de nouveau il sera à la mode de manger ses amis par amour, ou, pour les moins raffinés de manger leurs ennemis à la sauce piquante, critiquant sans arrêt la mauvaise qualité de la chair et en en jetant la majeure partie aux chiens. A ce moment, la perdrix à la broche, le cochon de lait et le sanglier seront distribués aux nécessiteux comme n'étant pas digne du puissant seigneur capable de se payer la tête de son plus distingué voisin.

CHAUD

Une fleur vient de mourir. La chaleur était trop forte pour ses pétales fatigués. Sa gloire de couleur éblouissante est tombée fanée. Et le soleil, après avoir brûlé la fleur, remplace son coeur par un fruit.

CHIEN

Le chien qui sait obéir mais pas commander, se met à nos pieds. Dans son innocence il nous prend pour de grands seigneurs et nous suit partout comme si un jour nous allions quelque part. Mais jamais nous n'arrivons. Dans sa candeur le chien fidèle y perd son temps.

CIMETERRE

L'empereur est fatigué, il veut dormir. Personne n'ose le déranger, même qu'il a laissé tomber son cimeterre, de peur qu'il se réveille furieux.

Quand subitement la foudre éclate avec un bruit de tonnerre. L'empereur sursaute, rouge de colère il cherche le responsable de ce vacarme. Il se ressaisit de son cimeterre et regarde ses sujets dans les yeux. Enfin l'un d'eux ose parler: C'est Dieu qui a fait ce bruit, Seigneur.

Sur ce, il pouffe de rire et dit: C'est bien. Un autre je l'aurais décapité, mais là je ne peux rien, pourtant je me croyais empereur!

COEUR

Des mystiques nous ont donné à croire par des études approfondies que le coeur est le palais que l'âme a l'habitude d'habiter, mais ces études d'une fragilité célestrale laissent les hommes de science incrédules qui prétendent avec un couteau en main eux-mêmes dévoiler la vérité.

DROGUE

La vie est un hôpital avec tout le progrès qu'on a fait; on est né pour être hospitalisé et se soumettre à toutes les inventions que l'homme conçoit. La drogue prend la place du plaisir en donnant l'illusion que la vie est rose jusqu'au moment où l'homme se trouve confondu avec l'outillage de la salle d'opération.

ENTENDRE

Deux personnes ce pourront jamais s'entendre si elles ne sont toutes les deux complètement. Le moindre signe de personnalité fera une brèche infranchissable entre les deux. C'est pour cela que les gens, comme les moutons, se groupent et avancent tous ensemble, sans soupçonner qu'ils sont destinés à l'abattoir après qu'ils auront, souriants, fourni de la laine les premières années.

EPIER

Il y a toujours un espion quand un couple fait l'amour. Ce ne sont pas les portes ni les murs qui empêchent les compères de savoir qui a commis le mystérieux crime qui fait rougir les femmes pâles et qui donne à l'homme un air d'assassin. Pourtant, ce n'est pas un bébé qui a été égorgé, ni un vieux monsieur sans dents qui a eu le crâne fracturé irrémédiablement, mais un crime de poulailler qui fait le quartier murmurer, et bientôt toutes les portes sont remplies pour voir passer le couple coupable: C'est l'histoire du paradis qui se répète toujours.

EQUATEUR

La nuit au milieu du jour est rompue par deux rubis brûlants qui avec douceur et surprise se fixent sur nous. La chaleur étouffante de la forêt tropicale fait monter la chaleur de la terre en transparences éphémères. Nous ne voyons pas au commencement Monsieur, perché entre les lianes, qui se balance lentement en nous regardant avec curiosité, mais bientôt on voit qu'il nous fait signe d'approcher, comme une dame dans un bal qui reçoit ses invités à la porte principale tenant sa queue dans sa main. Il doit nous prendre pour des cousins venus de loin parce qu'il nous attend si aimablement entre deux orchidées, ayant l'air d'un roi dans sa barbe dorée en demi-lune entourant sa figure, un chapeau d'hermine lui tient lieu de coiffure.

ERMITE

L'ermite avec ses cheveux blancs prend solitaire le chemin du désert, laissant derrière lui la ville et les mauvaises odeurs, fatigué d'entendre les voix bruyantes des buveurs qui tapent sur la table pour accentuer la colère ou la gaîté.

L'ermite est dominé par la cloche, et elle est devenue le chapeau qui lui donne mal à la tête.

Maintenant le sage a trouvé sa liberté, et seul sur le chemin un chien le suit un peu, on ne sait si c'est par curiosité ou par superstition, ou croyant que le moine habillé en brun lui apportera la bonne chance. La vérité, c'est qu'il retrace ses pas et rentre à la ville par la porte délabrée, laissant l'ermite avancer seul vers son destin.

ESCARGOT

Quel bruit le silence peut faire quand l'escargot marche, laissant en argent derrière lui sa trace lumineuse. Pour monter à la rose, ce chemin épineux, bien des fois infranchissable, il est obligé de faire marche arrière souvent, malgré qu'il soit équipé comme le chevalier Bayard avec son armure. Mais on devrait savoir que personne n'est aussi friand de telle nourriture. Il avance vers son désir avec calme et souplesse, élevant ses antennes de chaque côté pour clarifier d'une lucidité plus claire que diamant, la lumière du jour, comme le poète aux pieds de sa reine, seulement c'est pour la manger.

292

ESPOIR

Une fleur qui soupire a beaucoup d'espoir dans la vie. Quand
son oeil s'ouvre elle voit l'aurore venir, sécher ses larmes de
rosée, remplir son coeur de chaleur. Mais l'amant égoïste qui
passe, la coupe tout entière pour aller la placer sur les seins de
sa bien aimée.

ESTAMPILLE

Leur grandeur miniature donne l'idée d'une scène de guignol.
Souvent les estampilles ont le portrait d'un roi ou d'un président;
des fois pour varier, on voit des paysages de palmiers, avec des
singes qui grimpent dans la forêt vierge, donnant ainsi une idée
du pays d'où ils viennent.

Mais c'est plutôt la variété des couleurs qui enthousiasme tous
les jeunes collectionneurs. Ils se mettent en rapport avec les
différentes partie du monde, les esquimaux en bas âge couverts
d'épaisses fourrures attendant avec anxiété les envois de leurs
jeunes confrères qui transpirent dans la chaleur des pays tropi-
caux. C'est par cela que marche le service postal, unissant les
différents continents par bateaux, voies ferrées et avions, et pour
que les jeunes gens amusés les collent avec empressement dans
leurs collections.

ESTOMAC

Avec une pondération grave, les vaches mangent l'herbe de la
prairie. Elles mâchent chaque bouchée, doucement mélangeant
avec leurs langues l'herbe finement triturée, avec un mouvement
de droite a gauche à droite, nous regardant avec leurs yeux
somnolents, comme si elles voulaient nous donner une leçon de
la science de manger pour que nous puissions bien digérer. Mais
nous, les hommes, n'avons pas d'oreilles pour leur évangile et
elles marchent paisiblement en troupeaux vers leur martyre, où
dans leur innocence elles inclinent la tête pour bien nous nourrir.
Et l'homme n'ayant pas tenu compte de leurs sages conseils, les
mange trop vite et souffre d'horribles maux d'estomac.

ETALON

Quel bruit épouvantable fait l'étalon qui dans l'écurie s'excite,
essayant de sauter la barrière avec sa crinière dorée en l'air. Il
tape avec ses sabots contre les planches qui le séparent de la

liberté. Son naseau tremble d'impatience, absorbant l'air. On dirait par le mouvement de ses oreilles qu'il entend le lointain hennissement d'une jument, et il répond avec sa voix stridente et sonore, avec la furie de son désespoir. Se levant sur deux pattes il essaye d'escalader l'air. Il fume et perspire et se couvre d'écume.

ETOILE

Dans une nuit claire le ciel étoilé nous fait peur et met un frisson en notre corps. Ce vaste espace nous compare et nous donne la distance qui sépare les seins d'une femme où nous espérons sauvegarder notre futur. Et le ciel s'imprime sur notre dos pendant que nous naviguons avec la femme de notre choix dans l'obscurité de la terre.

Laissés derrière cette illusion nocturne mélangée avec nos rêves, quand le soleil se lève et que le printemps et l'été ont passé, et que la femme, lune pleine, est devenue enceinte, nous savons que nous marchons en procession avec les arbres vers le futur à travers beaucoup de nuits claires.

EVENTAIL

Les oiseaux et les fleurs qui habitent les ailes de ces délicats appareils aériens, chausseurs de chaleur, deviennent vivants avec le mouvement de la main du plus grand ennemi de l'homme. Ce rempart fortifie l'oeil criminel qui a besoin d'un regard fulminant pour rendre l'homme mourant.

FACE

La géographie de la face avec ses portes d'entrée nous paraît la chose capable de posséder le plus de grâce et de beauté. Cette combinaison étrange avec ses promontoires, ses lacs et ses volcans. Ses yeux nous paraissent des étoiles dans certains cas et les narines des exemplaires de tendresse, quant aux lèvres, elles peuvent être pour nous préférables à la plus délicieuse nourriture. Bien sûr! ce n'est pas seulement la face qui allume la passion d'amour, mais elle a beaucoup à faire dans cette entreprise.

FATAL

Le datura avec ses fleurs pendelantes reçoit les rayons de lune, renvoyant son parfum en payement. Plus pâle que toutes ces

promesses de mort, telle Vénus ou Cléopâtre sortant de la mer, elle essaye dans la clarté menaçante d'apaiser l'astre réflecteur. S'entourant de voiles de pourpre fulgurant, elle ne regarde plus au dessus de sa tête, ayant perdu de vue, dans la galaxie des mondes brillants, son étoile. Elle chauffe à sa place, sur son sein, un serpent.

FAUX

Le blé présente ses épis aux faucheurs qui lèvent leur faux haut dans le champ blond. La lame courbe prend impulsion et l'acier aiguisé prend vitesse, séparant la tige près du sol et laissant les tubes clairs comme témoins. Et l'immense champ qu'on voit s'étendre est bientôt rasé et le blé mis dans des greniers. Le meunier viendra l'acheter et bien vite il ressortira en pains chauds du fourneau boulanger pour nourrir les affamés. Mais quand dans les années de sécheresse la faux ne travaille plus, les gens meurent de faim. C'est à cause de cela que la faux est associée avec la mort qui la tient dans ses mains squelettiques, moissonnant le peuple dans des allégories.

FELIN

C'est un moteur qui grimpe sur mes épaules et entoure ma tête en peignant mes cheveux avec sa queue électrique. Je sens ses griffes quand il se hisse avec agilité comme s'il voulait avec sa souplesse donner une leçon d'anatomie sur mes joues et mes narines. Dans la servile caresse de ses poils noirs, je ne reconnais pas celle du chat sauvage qui poussait ses cris il n'y a pas longtemps dans la forêt, avec ses yeux de feu, terrifiant oiseau, lézard et petit gibier. Mais maintenant on l'a châtré, et il est devenu domestique, et préfère à toutes ces escapades nocturnes la vie sédentaire. Je ne vois plus en lui un parent de la panthère.

FENETRE

Quelle danse funèbre font les mouches devant la fenêtre. Pourtant elle est ouverte et l'air entre, mais elles ne s'en vont pas, restant là pour faire ces zig-zags dans l'air.

Dehors le ciel est bleu et les feuilles d'un chêne ordinaire dansent aussi dans la brise à côté de celles d'un chêne vert, mais leur rythme est différent et leur cadence n'est pas macabre et le

frou-frou de leur mouvement a pour auditeur un noyer de l'inde en fleur qui se tient rigide.

FLEUR
Bijou de la coquette nature, les fleurs attirent les abeilles plus que les seins d'une femme attirent l'homme. Leur variété est immense et on n'est pas gêné pour les choisir parce qu'elles sont presque toutes très belles. Mais entre les femmes il y a les horribles mégères qui ne savent pas qu'elles sont des épouvantails qui finissent dans des bordels, et les belles qui malheureusement deviennent laides en mortifiant leurs cervelles, s'ingéniant à paraître comme des couchers de soleil, ignorant ainsi qu'elles sont des aurores pleines de lait pur.

FOULE
Quand l'homme se transforme en foule il devient invisible. C'est un moyen pour beaucoup de se cacher d'eux-mêmes et pouvoir enfin se distraire. C'est à ce moment que les aigrefins de la politique les font marcher derrière bannières.

FOURMI
Quelles spéculations ont été faites sur le résultat de l'étude des fourmis! De cette gentille miniature de civilisation, cruelle et imbécile, on a tiré un modèle à appliquer aux hommes. Les seuls favorisés dans ce système sont les peintres officiels qui, depuis quelques temps déjà, se sont appliqués à imiter les fourmis.

FUTUR
Nous faisons collection de papillons avec le passé. Avec de fines épingles nous fixons chaque heure dans l'été, essayant d'attraper l'avenir jusqu'à l'heure où nous dépasserons la barrière et que le passé viendra nous réclamer pour toujours.

GEMMES
Les perles, les émeraudes et les couronnes de rubis brillent avec leurs plus beaux feux dans les 'Mille et Une Nuits'. Les vraies pierres sont la sueur cristallisée des prostituées, les rouges les vertes et les jaunes pâles sont des lanternes qui marquent la sépulture où l'esprit est enterré dans la chair tout le long de la

voie ferrée du trafic trépidant par lequel le magnat espère s'immortaliser. En nous suffoquant avec de la fumée.

GRAND'MERE

Grand'mère existe seulement pour les enfants. Elle a pour eux quelque chose de merveilleux. J'ai souvenir que la mienne avait toujours pour moi des bonbons ou des chocolats recouverts de papier argenté de toutes les couleurs, des minéraux, des contes de fées. Je gardais toutes les émotions qu'elle me donnait pour aller les planter dans le jardin, croyant qu'elles apparaîtraient, entre les autres fleurs, comme des roses, chacune garnie avec une buste vivant en miniature de grand'maman. Mais jamais je n'ai vu la rose de mes rêves. En réalité je crois ce que disait le jardinier, que les plantes prennent du temps pour pousser, et je suis convaincu que les vacances n'étaient pas assez longues, et que je devais au bras de ma mère retourner à la ville avant le temps nécessaire.

GRENOUILLE

Les grenouilles souvent dans les contes de fées sont couronnées parce que des princes punis par une mauvaise fée ont dû prendre cet aspect, mais quand ils retournent à leurs formes originelles ils retrouvent leurs magnifiques palais et leurs attelages et l'héroïne de l'histoire. Mais ces ovipares quadrupèdes qui inspirent l'imagination du merveilleux, dans la réalité, sont les victimes de la plus atroce sauvagerie des enfants qui en sautant sur elles font leur coeur sortir par la bouche.

GROSSE

La femme qui est grosse sans être enceinte a fait faux chemin et c'est par gourmandise ou par défaut pathologique qu'elle est devenue un monument. Toute cette couverture épaisse qui ferait rêver un cannibale est de trop dans tous les pays où on mange la viande des autres animaux et c'est recommandable de prendre des mesures appropriées pour maigrir. Mais il ne faut pas exagérer et devenir prématurément un squelette qui dépense une fortune en rouge à lèvres pour paraître vivant.

HARMONIE

La discorde vient chasser la mort dans son plus insidieux

déguisement qui est l'harmonie, qui nous tue én flattant nos sens, nous faisant tomber dans une somnolence comme celle que donne le parfum d'une fleur venimeuse qui attire toujours avec sa promesse de dormir.

<div style="text-align: right">

AIX-EN-PROVENCE
1951

</div>

Select Bibliography

AGATE, JAMES, *Ego 4*, George G. Harrap and Co. Ltd, London, 1940.

ACTON, HAROLD, *Memoirs of an Aesthete*, Methuen and Co., London, 1948.

BEATON, CECIL, *The Glass of Fashion*, Weidenfeld and Nicolson, London, 1954

BEATON, CECIL, *The Wandering Years Diaries: 1922–1939*, Weidenfeld and Nicolson, London, 1961.

BEDFORD, SYBILLE, *Aldous Huxley, A Biography* Volume I, 1894–1939, Chatto and Windus, London, 1973.

BELL, CLIVE, *Art*, Arrow Books, London, 1961.

BELL, QUENTIN, *Virginia Woolf, A Biography*, Volumes I and II, Hogarth Press, London, 1972.

BEAUMONT, CYRIL W., *The Diaghilev Ballet in London*, Putnam, London, 1940.

BENKOWITZ, MIRIAM J., *Ronald Firbank: A Biography*, Weidenfeld and Nicolson, London, 1970.

BENNETT, ARNOLD, *Journals*, Vol. II 1911–1921; Vol. III 1921–1928, edited by Newman Flower, Cassell and Co. Ltd, London, 1932, 1933.

BRODZKY, HORACE, *Henri Gauzier Brdeska*, Faber and Faber, London, 1933.

BROOKE, SYLVIA, *Queen of the Headhunters*, Sidgwick and Jackson, London, 1970.

BROPHY, BRIGID, *Prancing Novelist: In Praise of Ronald Firbank*, Macmillan, London, 1973.

BROWN, OLIVER, *Exhibition, Memoirs of Oliver Brown*, Evelyn, Adams, Mackay, London, 1968.

CAMPBELL, ROY, *Light on a Dark Horse; An Autobiography, 1901–1935*, Hollis and Carter, London, 1951.

CANNAN, GILBERT, *Mendel*, T. Fisher Unwin, London, 1916.

CECIL, LORD DAVID, *Max*, Constable, London, 1964.

CARRINGTON, DORA, *Carrington: Letters and Extracts from her Diaries*, edited by David Garnett, Jonathan Cape, London, 1970.

CARRINGTON, NOEL, *Selected Letters*, edited by Noel Carrington, Rupert Hart-Davis, London, 1965.

COOPER, LADY DIANA, *The Rainbow Comes and Goes*, Rupert Hart-Davis, London, 1958.

CROSBY, CARESSE, *The Passionate Years*, Alvin Redman, London, 1955.

CUNARD, NANCY, *Brave Poet, Indomitable Rebel, 1896–1965*, edited by Hugh Ford, Chilton Book Co., Philadelphia, 1955.

CUNARD, NANCY, *These Were the Hours: Memories of My Hours Press, Réanville and Paris 1928–1931*, edited with a foreword by Hugh Ford, Southern Illinois University Press, Cardondale and Edwardsville, 1969.

DAINTREY, ADRIAN, *I Must Say*, Chatto and Windus, London, 1963.

DEVAS, NICOLETTE, *Two Flamboyant Fathers*, Collins, London, 1966.

EASTON, MALCOLM, *Artists and Writers in Paris: The Bohemian Idea, 1805–1867*, Edward Arnold Ltd, London, 1964.

EDE, H. S., *Savage Messiah*, Heinemann, London, 1931.

EPSTEIN, JACOB, *Let There Be Sculpture*, Michael Joseph, London, 1940.

EVERLING, GERMAINE, *L'Anneau de Saturne*, Libraire Artheme Fayard, France, 1970.

FIELDING, DAPHNE, *Duchess of Jermyn Street*, Eyre and Spottiswoode, London, 1964.

FLETCHER, IVAN KYRLE, *Ronald Firbank, A Memoir*, Faber and Faber, London, 1930.

GERTLER, MARK, *Selected Letters*, edited by Noel Carrington, Rupert Hart-Davis, London, 1965.

GLENAVY, BEATRICE, *Today We Will Only Gossip*, Constable, London, 1964.

GOLDRING, DOUGLAS, *The Nineteen Twenties*, Nicholson and Watson, London, 1945.

GWYNNE-JONES, ALLAN, *Portrait Painters*, Phoenix House, London, 1950.

HAMNETT, NINA, *Laughing Torso*, Constable, London, 1932.

HASSALL, CHRISTOPHER, *Edward Marsh, Patron of the Arts*, Longmans, London, 1959.

HEILBRUN, CAROLYN G., *Towards Androg yny; Aspects of Male and Female in Literature*, Victor Gollancz, London, 1973.

HOLROYD, MICHAEL, *Lytton Strachey: The Years of Achievement 1910–1932*, Heinemann, London, 1968.

HONE, JOSEPH, *The Life of Henry Tonks*, Heinemann, London, 1939.

HOWARD, BRIAN, *Portrait of a Failure*, edited by Marie-Jacqueline Lancaster, Anthony Blond, London, 1968.

HUXLEY, ALDOUS, *Crome Yellow*, Chatto and Windus, London, 1921.

JOHN, AUGUSTUS, *Chiaroscuro: Fragments of Autobiography: First Series*, Jonathan Cape, London, 1952.

JOHN, ROMILLY, *The Seventh Child. A Retrospect*, Heinemann London, 1932.

JOHNSTONE, J. K., *The Bloomsbury Group*, Secker and Warburg, London, 1954.

LAWRENCE, D. H., *Women in Love*, Martin Secker, London, 1920.

LEDUC, VIOLETTE, *La Bâtarde*, Panther Books, London, 1967.

LEHMANN, JOHN, *A Nest of Tigers, Edith, Osbert and Sacheverell Sitwell in their times*, Macmillan, London, 1968.

LEHMANN, JOHN, *I am My Brother, Autobiography II*, Longmans, Green and Co., London, 1955

LEWIS, WYNDHAM, *Blasting and Bombardiering*, an *Autobiography* (1914–1926), Calder and Boyars Ltd., London, 1967.

LEWIS, WYNDHAM, *On Art: Collected Writings 1913–1956*, edited by Walter Michael and C. J. Fox, Thames and Hudson, London, 1969.

LEWIS, WYNDHAM, *The Apes of God*, Penguin Books, London, 1965.

LOVAT FRASER, GRACE, *In the Days of My Youth*, Cassell, London, 1970.

MAXWELL, ELSA, *I Married the World*, Heinemann, London, 1955.

MCALMON, ROBERT, *Being Geniuses Together*, 1920–1930, revised and with supplementary chapters by Kay Boyle, Michael Joseph, London, 1970.

MCINNES, COLIN, *Loving Them Both*, Martin Brian and O'Keeffe, London, 1974.

MORRELL, OTTOLINE, *The Early Memoirs of Lady Ottoline Morrell*, edited with an introduction by Robert Gathorne-Hardy, Faber and Faber, London, 1963.

MORTIMER, RAYMOND, *Duncan Grant*, Penguin Books, Harmondsworth, 1944.

NEVINSON, C. R. W., *Paint and Prejudice*, Methuen, London, 1937.

PENROSE, ROLAND, *Picasso: His Life and Work*, Victor Gollancz, London, 1958.

PUTNAM, SAMUEL, *Paris Was Our Mistress*, The Viking Press, New York, 1947.

ROBERTS, CECIL, *The Bright Twenties*, Hodder and Stoughton, London, 1970.

ROTHENSTEIN, SIR JOHN, *Modern English Painters*, Vol. I, Eyre and Spottiswoode, London, 1952.

ROTHENSTEIN, SIR JOHN, *Time's Thievish Progress; Autobiography III*, Cassell, London, 1970.

SABARTES, JAIME and WELHELM BOECK, *Pablo Picasso*, Thames and Hudson, London, 1961.

SALTER, ELIZABETH, *The Last Years of a Rebel; A Memoir of Edith Sitwell*, The Bodley Head, London, 1967.

SITWELL, EDITH, *Taken Care Of*, Hutchinson, London, 1965.

SITWELL, EDITH, *Wheels: An Anthology of Verse*, B. H. Blackwell, Oxford, 1916.

SITWELL, OSBERT, *Noble Essences or Courteous Revelations*, Macmillan, London, 1930.

SPENDER, STEPHEN, *World Within World*, Hamish Hamilton in association with the Book Society, London, April 1951.

SPRIGGE, ELIZABETH, *Gertrude Stein: Her Life and Work*, Hamish Hamilton, London, 1957.

STEIN, GERTRUDE, *The Flowers of Friendship: Letters Written to Gertrude Stein*, edited by Donald Gallup, Alfred A. Knopf, New York, 1953.

STEIN, GERTRUDE, *Autobiography, Alice B. Toklas,* John Lane, the Bodley Head Ltd, London, 1933.

STEEGMULLER, FRANCIS, *Cocteau*, Macmillan, London, 1970.

SYMONS, A. J. S., *The Quest for Corvo*, Cassell, London, 1934.

Tate Gallery, Modern British Paintings, Drawings and Sculptures, edited by Mary Chamot, Denis Farr and Martin Butlin, 2 vols., Oldbourne Press, London, 1964 and 1965.

THOMSON, VIRGIL, *Virgil Thomson*, Weidenfeld and Nicolson, London, 1967.

WOOD, CHRISTOPHER 1901–1930, The Redfern Gallery, London, 1938.

YEATS, W. B., *Images of a Poet*, Catalogue for an Exhibition held at Whitworth Art Gallery, Manchester, 1961.

Index

Burlington Magazine, 99
Burn, Rodney, 105–6, 237

Café Royal, artists at, 56, 59, 64, 80, 82, 87, 92, 103–4, 113, 115, 132, 140, 150, 180, 196–7
Camden Town, artists of, 87
Campbell, Mary, 201
Campbell, Mrs Patrick, 187–9, 196, 208
Campbell, Roy, 113–17, 125, 133, 163, 201, 235, 241
Cannan, Gilbert and Mary, 81–2
Carisbrooke, Marquis and Marchioness of, 169
Carpaccio, Vittore, 165
Carrington, Dora, 49, 51, 53–4, 56, 62, 64, 74, 99–100; opinion of Alvaro, 82; suicide of, 211, 215
Carroll, Lewis, 164
Cavendish Hotel, 92, 122, 196
Cerro Alegre, Guevara house on, 17–28, 31–3, 67; destroyed in earthquake, 34–6; restored, 40
Cézanne, Paul, 42, 120, 167, 179
Chaliapin, Feodor, 47
Charlton, George, 237
Chelsea Arts Club, 235, 237–8
Chenil Gallery, 68; Alvaro's exhibition at, 99–100, 119
Chesterfield, Lord, *Letters*, 18
Childe, Alfred Roland, 133
'Chile', Alvaro's nickname in England, *see* Guevara, Alvaro
Chopin, *Funeral March*, 33, 36, 265
Churchill, Lord Ivor, 145, 169
Churchill, Sir Winston, 268
Cingria, Charles Albert, 206, 210, 218; at Aix, 243, 246–8, 254, 256, 260, 263–5, 267–9
Clair, René, 174
Clarke, Miss (governess), 239–42
Clutton-Brock, Alan, 268
Cochran, Charles B., 193, 196
Cocteau, Jean, 150, 168, 174, 180, 254
Cole, Horace de Vere, 80, 113–14
Colin, Paul, 193

Concha, Dona, 234
Constable, John, 42, 106
Contemporary Art Society, 73, 148, 217
'Cookham', *see* Spencer, Sir Stanley
'Cookham Two', see Spencer, Gilbert
Cooper, Captain of S.S. *Orita*, 33
Cooper, Lady Diana, *see* Manners
Coward, Sir Noel, 141, 203
Craig, Gordon, 74, 216
Crevel, René, 150, 164, 166, 170–1, 177–8, 215
Crosby, Caresse, 157–64, 200–1, 204, 208–10, 212, 214, 236
Crosby, Harry, 157–64, 204, 212
Crosby, Polly, *see* Peabody, Polly
Crossley, Anthony and Clare, 146
Crowder, Henry, 156, 164–5, 213
Cubists, 48, 57, 81, 88
Cummings, Mr, 129–30
Cunard, Sir Bache, 77–8, 95, 111–12, 153
Cunard, Edward, 157
Cunard, Lady Maud (*later* Emerald), 76–80, 99, 103, 155, 158, 213, 215; and George Moore, 77–8, 95–6, 111, 163; and Thomas Beecham, 78, 96, 110, 204; relations with daughter, 95–6, 109–10, 117, 164, 209; favours Alvaro as husband for Nancy, 111–12
Cunard, Nancy, 76–80, 115, 122–3, 158, 180–1, 190, 254; marriage of, 95–7, 109, 111; descriptions of, 109–13, 154–5; Alvaro's full-length portrait of, 112, 122, 153, 214, 268; refuses Alvaro, 117, 124–5, 133–5; on Alvaro's return from Chile, 140, 149, 151–8, 163; as model for characters in novels, 148; printing press venture, 154, 156, 163, 169, 181, 209; interest in black people, 157, 162, 164–5; Cecil Beaton's photograph of, 198; *These were the Hours*, 153; *Black Man and White Ladyship*, 209
Curzon, Viscountess, 67, 122